Digital SLR Cameras & Photography FOR DUMMIES[®] HTH EDITION

P9-CEJ-264

by David D. Busch

John Wiley & Sons, Inc.

Digital SLR Cameras & Photography For Dummies[®], 4th Edition

Published by John Wiley & Sons, Inc. 111 River Street Hoboken, NJ 07030-5774

www.wiley.com

Copyright © 2012 by John Wiley & Sons, Inc., Hoboken, New Jersey

Published by John Wiley & Sons, Inc., Hoboken, New Jersey

Published simultaneously in Canada

No part of this publication may be reproduced, stored in a retrieval system or transmitted in any form or by any means, electronic, mechanical, photocopying, recording, scanning or otherwise, except as permitted under Sections 107 or 108 of the 1976 United States Copyright Act, without either the prior written permission of the Publisher, or authorization through payment of the appropriate per-copy fee to the Copyright Clearance Center, 222 Rosewood Drive, Danvers, MA 01923, (978) 750-8400, fax (978) 646-8600. Requests to the Publisher for permission should be addressed to the Permissions Department, John Wiley & Sons, Inc., 111 River Street, Hoboken, NJ 07030, (201) 748-6011, fax (201) 748-6008, or online at http://www.wiley.com/go/permissions.

Trademarks: Wiley, the Wiley logo, For Dummies, the Dummies Man logo, A Reference for the Rest of Us!, The Dummies Way, Dummies Daily, The Fun and Easy Way, Dummies.com, Making Everything Easier, and related trade dress are trademarks or registered trademarks of John Wiley & Sons, Inc. and/or its affiliates in the United States and other countries, and may not be used without written permission. All other trademarks are the property of their respective owners. John Wiley & Sons, Inc. is not associated with any product or vendor mentioned in this book.

LIMIT OF LIABILITY/DISCLAIMER OF WARRANTY: THE PUBLISHER AND THE AUTHOR MAKE NO REPRESENTATIONS OR WARRANTIES WITH RESPECT TO THE ACCURACY OR COMPLETENESS OF THE CONTENTS OF THIS WORK AND SPECIFICALLY DISCLAIM ALL WARRANTIES, INCLUDING WITHOUT LIMITATION WARRANTIES OF FITNESS FOR A PARTICULAR PURPOSE. NO WARRANTY MAY BE CREATED OR EXTENDED BY SALES OR PROMOTIONAL MATERIALS. THE ADVICE AND STRATEGIES CONTAINED HEREIN MAY NOT BE SUITABLE FOR EVERY SITUATION. THIS WORK IS SOLD WITH THE UNDERSTANDING THAT THE PUBLISHER IS NOT ENGAGED IN RENDERING LEGAL. ACCOUNTING, OR OTHER PROFESSIONAL SERVICES. IF PROFESSIONAL ASSISTANCE IS REQUIRED, THE SERVICES OF A COMPETENT PROFESSIONAL PERSON SHOULD BE SOUGHT. NEITHER THE PUBLISHER NOR THE AUTHOR SHALL BE LIABLE FOR DAMAGES ARISING HEREFROM. THE FACT THAT AN ORGANIZATION OR WEBSITE IS REFERRED TO IN THIS WORK AS A CITATION AND/OR A POTENTIAL SOURCE OF FURTHER INFORMATION DOES NOT MEAN THAT THE AUTHOR OR THE PUBLISHER ENDORSES THE INFORMATION THE ORGANIZATION OR WEBSITE MAY PROVIDE OR RECOMMENDATIONS IT MAY MAKE. FURTHER, READERS SHOULD BE AWARE THAT INTERNET WEBSITES LISTED IN THIS WORK MAY HAVE CHANGED OR DISAPPEARED BETWEEN WHEN THIS WORK WAS WRITTEN AND WHEN IT IS READ.

For general information on our other products and services, please contact our Customer Care Department within the U.S. at 877-762-2974, outside the U.S. at 317-572-3993, or fax 317-572-4002.

For technical support, please visit www.wiley.com/techsupport.

Wiley also publishes its books in a variety of electronic formats and by print-on-demand. Not all content that is available in standard print versions of this book may appear or be packaged in all book formats. If you have purchased a version of this book that did not include media that is referenced by or accompanies a standard print version, you may request this media by visiting http://booksupport.wiley.com.

Library of Congress Control Number: 2011937926

ISBN: 978-1-118-14489-3 (pbk); ISBN: 978-1-118-17750-1 (ebk); ISBN: 978-1-118-17751-8 (ebk); ISBN: 978-1-118-17752-5 (ebk)

Manufactured in the United States of America

10 9 8 7 6 5 4 3 2 1

About the Author

With more than one million books in print, **David D. Busch** is one of the best-selling authors of digital camera guides, digital photography, and imaging technology. As a roving photojournalist for more than 20 years, he illustrated his books, magazine articles, and newspaper reports with award-winning images. He has operated his own commercial studio, suffocated in formal dress while shooting weddings-for-hire, and shot sports for a daily newspaper and upstate New York college. His photos and articles have been published in magazines as diverse as *Popular Photography & Imaging, The Rangefinder, The Professional Photographer,* and hundreds of other publications. He has also reviewed dozens of digital cameras for CNet and Computer Shopper.

When About.com first named its top five books on Beginning Digital Photography, debuting at the #1 and #2 slots were Busch's *Digital Photography All-in-One For Dummies* (John Wiley & Sons, Inc.) and *Mastering Digital Photography* (Course Technology PTR). His 140 other books published since 1983 include seven *Digital Field Guides* for John Wiley & Sons, Inc. Busch is a member of the Cleveland Photographic Society (www.clevelandphoto. org), which has operated continuously since 1887. Visit his website at http://www.dslrguides.com/blog.

Dedication

For Cathy

Author's Acknowledgments

Thanks as always to Executive Editor Steve Hayes at Wiley, who was the first to see that a book about digital SLR cameras should cover both the cameras and photography in depth. Special thanks, as both author and avid consumer of *For Dummies* books, go out to Wiley for publishing books like this one in full color at a price anyone can afford. Technical editor Mike Sullivan, as usual, provided his sage advice from the viewpoint of one of the pioneers of digital SLRs, dating back more than 20 years. Mike was also quick to come up with useful photos to illustrate particular points when my own portfolio came up short.

More thanks to Project Editor Pat O'Brien and Copy Editor Debbye Butler for keeping this book looking sharp. Working behind the scenes was my agent, Carole Jelen.

Publisher's Acknowledgments

We're proud of this book; please send us your comments at http://dummies.custhelp.com. For other comments, please contact our Customer Care Department within the U.S. at 877-762-2974, outside the U.S. at 317-572-3993, or fax 317-572-4002.

Some of the people who helped bring this book to market include the following:

Acquisitions, Editorial, and Vertical Website	es Composition Services
---	-------------------------

Project Editor: Pat O'Brien (Previous Edition: Nicole Sholly)
Executive Editor: Steve Hayes
Copy Editor: Debbye Butler
Technical Editor: Michael Sullivan Project Coordinator: Kristie Rees
Layout and Graphics: Claudia Bell, Carl Byers, Corrie Socolovitch
Proofreaders: Melissa Cossell, Penny L. Stuart
Indexer: Christine Karpeles

Editorial Manager: Kevin Kirschner Editorial Assistant: Amanda Graham

Sr. Editorial Assistant: Cherie Case

Cover Photo: © iStockphoto.com / Cary Westfall

Cartoons: Rich Tennant (www.the5thwave.com)

Publishing and Editorial for Technology Dummies

Richard Swadley, Vice President and Executive Group Publisher

Andy Cummings, Vice President and Publisher

Mary Bednarek, Executive Acquisitions Director

Mary C. Corder, Editorial Director

Publishing for Consumer Dummies

Kathleen Nebenhaus, Vice President and Executive Publisher

Composition Services

Debbie Stailey, Director of Composition Services

Contents at a Glance

Introduction 1
Part 1: Digital SLRs and You 5
Chapter 1: The Digital SLR Difference7
Chapter 2: Safari Inside a dSLR
Chapter 3: Chapter Tracking the Ideal dSLR55
Chapter 4: Saving and Archiving Your Photos73
Chapter 5: Accessorizing Your dSLR
Part 11: Oh, Shoot!
Chapter 6: Taking Control of Your dSLR103
Chapter 7: Mastering the Multi-Lens Reflex
Chapter 8: Movies and Special Features of dSLRs143
Part 111: Beyond the Basics 159
Chapter 9: Working with RAW and Other Formats161
Chapter 10: Action, Flash, and Other Challenges
Chapter 11: Composition and dSLRs201
Part 1V: Fine-Tuning Your Output 223
Chapter 12: Fixing Up Your Images
Chapter 13: Combining and Reorganizing Your Images
Chapter 14: Hard Copies Aren't Hard
Part V: The Part of Tens 293
Chapter 15: Ten Ways to Improve Your dSLR Photography295
Chapter 16: Ten Things You Never Thought of Doing with Your Digital SLR 309
Chapter 17: Ten Online Resources for Digital SLR Photography
Chapter 18: Ten (or More) Confusing Concepts Clarified
Index

Table of Contents

Introduction	1
About This Book Foolish Assumptions How This Book Is Organized Part I: Digital SLRs and You Part II: Oh, Shoot! Part III: Beyond the Basics Part IV: Fine-Tuning Your Output Part V: The Part of Tens	2 3 3 3 3 3 3
Icons Used in This Book	4
Part 1: Digital SLRs and You	5
Chapter 1: The Digital SLR Difference	.7
dSLR: dNext Great Digital Camera Resolution: Peak or plateau? Full frame: Is it for you?	10
Improving Your Photography with a dSLR Composing shots with a more accurate viewfinder Flexing the powerful sensor	10 11 12
Reducing noise in your photos Reclaiming depth-of-field control Taking photos faster	. 16 . 17
A dSLR works like a camera Getting more lens flexibility Freeing yourself from image editors	. 21 . 22
Where Did All Those Downsides Go? Lack or expense of superwide lenses: Vanquished! Fending off dirt and dust: Automatic!	. 23 . 25
LCD preview: Live, and in person! Carrying that weight: Heft not mandatory! Budding Spielbergs no longer out of luck: HD movies are here! In-camera editing!	. 27 . 28
Chapter 2: Safari Inside a dSLR	
Megapixels and Why dSLRs Have More of Them Pixelementary, my dear Watson How many pixels does your camera need? 14 to 24MP and beyond!	.31

Digital SLR Cameras & Photography For Dummies _____

Matching pixels to print sizes and printers	33
Nothing's super about superfluous pixels	
Touring through a Digital SLR	
Sensorship	
The bits that control exposure	
Taking time out for viewing	
Through the looking glass	
Storage	
Dual memory cards	
Overcoming Quirks of the dSLR	
Out, out damned spot: New trends in self-cleaning sensors	
Multiplication fables: Working around the crop factor	52
Chapter 3: Tracking the Ideal dSLR	55
Features for Now and the Future	56
Breadcrumbs on the Upgrade Path	
Cameras of Today and Tomorrow	
Basic dSLR cameras	
Enthusiast dSLRs	
Advanced amateur/semi-pro dSLRs	63
Professional dSLR models	63
Rebirth of mirrorless and EVF alternatives	65
Checking Out Key Features	67
Lenses	
Sensors and image processors	
Exposure systems	69
Focusing systems	69
Special features	70
Chapter 4: Saving and Archiving Your Photos	.73
Memory Cards in a Flash	
The right write speed	
Finding the key to the (capa)city	
Perfect pairs	
Storing Your Images	
Exploring options for backup media	
Longer-term storage	
It's a RAID: Attack of the cheap data robots	81
Chapter 5: Accessorizing Your dSLR	.83
Filtering Factors	
The Tripod: Your Visible Means of Support	
Putting a tripod to good use	
Choosing a tripod	
encount a arboa	00

_____ Table of Contents

Electronic Flash in the Pan	
Perusing different types of flash units	
Tools for triggering the flash	
New Tools for the Connected	
Smart phone apps	
Tablet/iPad apps	
Oh my, Wi-Fi	
Gee, P.S.	
Other Must-Have (Or Maybe-Have) Gear	
A second camera	
Sensor-cleaning kit	
Close-up equipment	

(art 11. VII. SIIVE:	Part	11:	Oh.	Shoot!	10)]	1
-----------------------	------	-----	-----	--------	----	----	---

Dideo i di ing the beer ete of Lipeoure initiation	
Understanding why exposure is tricky	
Getting exposure right with the histogram	
Fine-Tuning Exposure with the Metering System	
Metering works how?	
Choosing a metering scheme	
More versatility with metering options	
The Many Ways to Choose Exposure	
Adjusting exposure the easy way	
Giving up control (in Program mode)	
Taking control	
Exotic ISO settings become mundane	
Focus Pocus	
Focusing manually	119
Oughta autofocus	
Chapter 7: Mastering the Multi-Lens Reflex	
Optical Delusions	
Shooting in low light	
Improving your shutter speed	
Producing sharper images	
Taking a step back	
Getting closer	
Focusing closer	
Choosing Your Prime Lens — or Zoom	128

Digital SLR Cameras & Photography For Dummies _____

Lens Concepts	
Different strokes	
Going for bokeh	
Using Lenses Creatively	
Creative use of wide angles	
Creative use of telephotos	
Lens Compatibility with Earlier Cameras	
Babying Your Camera with Special Effects	141
Chapter 8: Movies and Special Features of dSLRs	143
Making Movies	144
Resolution and Frame Rates	145
In-camera movies	145
Using Video OUT in the age of HDTV	146
Feel the Noize at Night	146
A fast lens or not?	146
Taking night shots at short shutter speeds	147
Noise Reduction Made Easy	147
Shake, Shake, Shake	149
Leaving camera-shake myths behind	150
Testing for tremors	151
Everyday solutions for shakiness	152
Image stabilization: The ready-steady-shoot technology	
Time Waits for Someone: Creating Time-Lapse Sequences	
Better Infrared than Dead	157
Dust Off	158
Part 111, Round the Reside	150
Part III: Beyond the Basics	139
Chapter 9: Working with RAW and Other Formats	161
So Many Formats, So Little Time	161
Worth the Fuss: Understanding the Main Formats	
Don't get TIFFed	
JPEG o' my heart	
The RAW deal	
Choosing a File Format	
TIFF enuff	
JPEG junkies unite!	
JPEG+RAW	
Working RAW	
Using RAW Files as Digital Negatives	
Salvaging images from RAW files	
Archiving RAW files	175

xii

_____ Table of Contents

Chapter 10: Action, Flash, and Other Challenges	181
Kind of a Lag	
Comparing point-and-shoot cameras to dSLRs	
Understanding the sources of lag	
Minimizing shutter lag	
Minimizing first-shot delays	
Minimizing shot-to-shot delays	
Minimizing flash delays	
Shooting in Sequences	
Stopping Action in Its Tracks	
Going with the flow (or panning)	
Catching peak action	193
Zapping action with flash	
Flash in the Pan: Other Keys to Good Flash Photography	194
Understanding flash at different distances	195
That sync-ing feeling: Coordinating flash and shutter	
Getting the right exposure	
Yo, Trigger! Setting Off an External Flash	
Chapter 11: Composition and dSLRs	201
Composing a Photo: The Basics	
Composing for message and intent	
Applying the Rule of Thirds	
Posers and Poseurs	
Shooting individual portraits	
Shooting group photos	
Tips for Publicity and PR Photography	
Capturing Architecture	
Reeg, your perspective is out of control!	
Charge of the lighting brigade	
You've been framed!	
Designing Your Landscape Photos	
Compositional Ideas That Travel Well	219
Part 1V: Fine-Tuning Your Output	223
Chapter 12: Fixing Up Your Images	225
Editor-ial Comments: Choosing an Image Editor	
Adobe Photoshop CS5	
Adobe Photoshop Elements 9.0	
Alternative image editors	

Digital SLR Cameras & Photography For Dummies

	Fixing Your Photos	
	Cropping	
	Fixing murky or contrasty photos	
	Correcting those colors	
	Spot removers	
	Look sharp, be sharp	254
	Blurring for effect	254
	Fixing with filters	
Cha	pter 13: Combining and Reorganizing Your Images	
	Making Selective Modifications	
	What is a selection?	
	Performing everyday changes with selections	
	Making Basic Selections	
	Making rectangles, squares, ovals, and circles	
	Selecting odd shapes	
	Selecting pixels	
	Painting selections	
	Fiddling with your selections	
	Adding to and Subtracting from Your Pictures	
	Evicting your ex-brother-in-law	
	Bringing a family closer together	
	Adding New Backgrounds	274
	Combining Several dSLR Photos into One	
	The pitfalls of compositing images	
	Getting creative with compositing	
Cha	pter 14: Hard Copies Aren't Hard	
	Prints? What Prints?	
	You Pays Your Money, You Takes Your Choice	
	Doing it yourself	
	Online output outsourcing options	
	Live and in person!	
	Choosing a Printer	
Part V:	The Part of Tens	293
Cha	pter 15: Ten Ways to Improve Your dSLR Photography .	
	Does Lighting Ever Strike Twice?	
	Choosing a Righteous Resolution and Other Settings	
	Changing environments	
	Living with limited memory card space	

xiv

Table of Contents

Shooting for a low-resolution destination	
Hurrying along	
Stop! What's That Sound?	
Working the Right F-Stop	
Focus Is a Selective Service	
Playing the Angles	
Through a Glass Brightly Feel the Noize	
Editing, Retouching, and Compositing Images	
Reading the Funny Manual (RTFM)	
Chapter 16: Ten Things You Never Thought of	
Doing with Your Digital SLR.	309
•	
Capturing the Unseen with Infrared Photography	
Lighting for All in Tents and Purposes Turning Your dSLR into a Pinhole Camera	
Warping Time with Time-Lapse Photography	
Expanding Your Creativity with Slow Shutter Speeds	
Capturing an Instant in Time with Fast Shutter Speeds	
Making Your Own Effects Filters	
Shooting the Works!	
Going for Baroque	
Going Crazy with Your Image Editor	
Chapter 17: Ten Online Resources for Digital SLR Photograph	y325
About Facebook	-
Online Editing with Photoshop.com	
All Your PBase Are Belong to Us	
Digital Photography Viewed and Reviewed	
For the Shutterbug in You	
Pop Goes the Photo!	
Landscapes Can Be Luminous	
Cult of Personality	
Rob Galbraith	
Charmin' Miranda	
Don't Miss eBay	
Chapter 18: Ten (or More) Confusing Concepts Clarified	339
Ambient Lighting/Available Lighting	
Anti-Aliasing	
Bracketing	
Chromatic Aberration	
Dodging/Burning	343
Fill Flash	

xv

Digital SLR Cameras & Photography For Dummies _____

Hyperfocal Distance	344
Lossy/Lossless Compression	344
Moiré	346
Saturation	
Threshold	
Tolerance	
Unsharp Masking	
Chisharp Masking	0.0

Index	5	1
-------	---	---

xvi

Introduction

he digital single lens reflex (dSLR) is the great step upward for photographers who want to expand their creative horizons — or simply just get better pictures. Whether you want to become a serious photo hobbyist, have a hankering to turn pro, or want to take advantage of the improved control that digital SLRs give you over your photography, discovering how to use this tool should be high on your priorities list.

The latest digital SLRs have features that no one had even dreamed of back when I wrote the first edition of this book, including full high-definition moviemaking, and the capability to use accessories that embed global positioning service (GPS) data in your images, or upload your shots to your computer or sites like Facebook as you shoot.

All the major bugs of the earliest dSLRs have been magically transformed into killer features in the latest models. Today, you can preview your images by using Live View features before you snap the shutter. Dust that collects on the sensor causes much less of a problem thanks to built-in sensor-cleaning features. You get better image quality than in earlier models, thanks to higher resolutions (you can commonly get 15 megapixels and up, even in low-cost dSLRs), super-sensitive sensors that can capture images in near darkness, and inexpensive but effective anti-shake technology built into cameras or lenses.

Most recently, the only remaining drawback of digital SLRs — the fact that you couldn't shoot movies (long a common feature in point-and-shoot cameras) — was swept aside with the introduction of new models that grab HDTV-quality video with monaural or stereo sound.

Best of all, all these capabilities are eminently affordable. Digital SLRs in the \$500-to-\$1,000 range today can outshoot the \$5,000 professional models of five years ago and are light-years ahead of even the best point-and-shoot models. The dSLR provides more control over what portions of your image you want in sharp focus, boasts lower levels of the annoying grain effect called *noise*, and operates fast enough to capture the most fleeting action. If that isn't enough, you can change lenses, too, adding superwide perspectives or the huge magnification possibilities of long, long telephoto lenses to your repertoire.

Almost all the other advantages of digital photography come with your digital SLR camera, too. You can review your image immediately, upload the photo to your computer, make adjustments, and print a sparkling full-color print within minutes. You never need to buy film. You decide which images to print and how large to make them. You can proudly display your digital photographic work framed on your wall or over your fireplace. You can even make wallet-sized photos, send copies to friends in e-mail, or create an online gallery that relatives and colleagues can view over the web.

About This Book

Technology and techniques — you find both in this book. Understanding exactly how a digital SLR works can help you use its capabilities more fully. By mastering the technology, you're better equipped to understand how to use interchangeable lenses, set up speedy continuous-shooting burst modes, apply selective focus, and shoot under the lowest light levels. Understanding how a point-and-shoot digital camera works offers you little advantage because such entry-level cameras don't give you the creative control that a dSLR does.

You don't need to understand internal combustion to drive a Porsche, but it helps if you know a little about double-clutching and limited-slip differentials. Technology also provides the grounding you need to work with advanced photographic techniques, such as the ones I discuss in this book. I fill these pages with basic information and tips that you can use to hone your skills while you grow as a digital SLR photographer.

Foolish Assumptions

This book is written for both experienced and budding photographers who have a good grasp of using their computers and navigating the operating system, as well as at least a cursory knowledge of the operation of their digital SLR cameras. You needn't be an expert photographer; all you need is a desire to improve your skills and knowledge.

Because dSLRs are a more-advanced type of digital camera, you might be making the upgrade from a conventional film SLR. At the very least, I assume that you aren't new to photography and have some knowledge of conventional photography. If so, this book helps you fine-tune your abilities.

Although most of the emphasis in this book is on picture-taking, I offer a couple of chapters on image-editing, too. You can get the most from those chapters if you have some familiarity with an image editor, such as Corel PaintShop Pro, Adobe Photoshop, or Adobe Photoshop Elements.

How This Book Is Organized

Organization is your friend! All the chapters in this book are grouped together into parts that address a broad, general area of interest. If you're especially keen to know more about a particular topic, such as how to select the perfect dSLR or its accessories, turn to the part of the book that includes that material. You don't have to read this book in any particular order. You can absorb each part and chapter on its own. (If I explore a certain topic, such as shutter lag or infrared photography, in more detail elsewhere in the book, I give you a cross-reference pointing to the relevant section in case you want more information.) Skim through and study the photo examples or examine only the odd-numbered pages, if you prefer. It's your choice. I hope that eventually you wade through the whole thing, but my top priority is delivering the information that you need right now to take better photographs.

Part 1: Digital SLRs and You

Find out all the advantages of digital SLRs and why they beat the pants off both film and digital point-and-shoot cameras. Take a safari through the innards of a typical dSLR to track down the most-needed and most-desired features. Then, choose the accessories that can take your dSLR to the next level.

Part 11: Oh, Shoot!

Digital SLRs bristle with controls and components that give you absolute sovereignty over virtually every feature and function. In this part, you work with those controls, master the mysteries of interchangeable lenses, and discover special features, such as image stabilization.

Part 111: Beyond the Basics

It's time to take the next step and improve your photography by using more advanced features, such as the RAW format and your dSLR's action, sequence shooting, and flash capabilities. Apply these advanced features to get better compositions in a variety of settings.

Part 1V: Fine-Tuning Your Output

Your creative possibilities don't end when the shutter snaps. After you transfer the photo to your computer, you can further enhance and refine your picture by using image-editing software. Then, make hard-copy prints that you can show off, hang on the wall, or display on your mantel. This part shows you some of the things that you can do with your prize (and prize-winning) photos.

Part V: The Part of Tens

Four (not ten) chapters are in The Part of Tens, and each provides a-dozenminus-two interesting things that you can do to enjoy your digital SLR even more. You can discover the ten best ways to improve your photography *right now*, ten fascinating things you probably never thought of doing with your dSLR, and ten online resources that have useful information and showcases for your digital dexterity. I also provide you with clarifications for ten (or more) of the most confusing terms applied to digital photography and image editing.

Icons Used in This Book

I use the following icons throughout the book:

The Tip icon marks tips (what a surprise!) and shortcuts that you can use to more easily work with your digital SLR.

Remember icons mark information that's especially important to know. To siphon off the most important information in each chapter, skim through these icons.

The Technical Stuff icon marks information of a more technical nature that you can normally skip over, unless you have a special interest in the background info I discuss.

The Warning icon tells you to watch out! It marks important information that might save you headaches, heartaches, and even cash-aches — especially when your dSLR starts acting in unexpected ways or won't do exactly what you want it to do.

Part I Digital SLRs and You

he digital SLR difference is significant, as you can discover in this part. I tell you exactly why dSLRs produce better results faster than other cameras, and you can master the technology behind these advanced cameras. You can also discover how to select the best digital SLR for your needs and which accessories can help you do a better job.

Chapter 1 explains the advantages of dSLRs and outlines a few of the disadvantages of old that have been conquered in recent years. Chapter 2 takes you into the darkest recesses of your digital SLR camera so that you can understand the sensors, shutters, and how exposure works. In Chapter 3, you can find a list of the features you need, want, and wish you had. Chapter 4 explains the best methods for storing and archiving your photos. Chapter 5 tells you about the accessories that any dSLR photographer must have.

The Digital SLR Difference

G

In This Chapter

- Discovering why digital SLRs are a big deal
- Exploring dSLR advantages
- Looking at downsides? What downsides?

ow that you can buy a fully featured digital SLR (or dSLR) for five Benjamins or less, virtually everyone (including your grandmother) probably knows that SLR stands for *single lens reflex*. However, your Nana or you, for that matter — might not know precisely what single lens reflex means. *SLR* is a camera (either film or digital) that uses a marvelous system of mirrors or prisms to provide bright, clear optical viewing of the image that you're about to take — through the same lens that the camera uses to take the picture. The very latest dSLRs offer an even more interesting option: the capability to bypass the optical viewfinder and preview your image right on the LCD (liquid crystal display) on the back of the camera (which also uses the same lens that the camera uses to take the picture).

But the key thing to know about dSLRs is that they're very cool tools that you can use to take photos electronically.

Welcome to the chapter that tells you exactly how smart you were when you decided to upgrade from whatever you were using previously to a digital single lens reflex camera. In this chapter, you find out how a digital SLR transforms the way you take and make pictures, why you may find the strengths of the dSLR important, and how even the very few downsides of previous digital SLRs have been vanquished in recent years. Now that digital SLRs have become a big deal, you can get in on the action.

dSLR: dNext Great Digital Camera

Digital SLRs are now available to suit every budget. They range from surprisingly capable entry-level models that barely nudge above the \$500 price point, to robust intermediate models built for avid amateurs with \$1,000 to spend, on up to semi-pro and pro models for \$2,000 and up. So, almost anyone who wants more picture-taking flexibility than their cell phone or point-and-shoot snapshooter can provide can afford to make the jump to a digital SLR. If you already have, you've discovered that the dSLR lets you take pictures the way they're *meant* to be taken.

It's easy to see why enthusiast photographers interested in taking professional-looking photos embrace these features of a digital SLR:

- ✓ You can view a big, bright image that represents (almost) exactly what you see in the final picture. No peering through a tiny window at a miniature version of your subject with a tiny viewfinder window, or squinting at the LCD of your cell phone or point-and-shoot camera. Digital SLRs have big and bright viewfinders that show virtually the entire image, so you don't have to wonder whether you chopped off the top of someone's head. Using the optical viewfinder, which comes as standard equipment on every dSLR, means that you don't have to squint to compose your image at arm's length on an LCD (liquid crystal display) viewfinder that washes out in bright sunlight. However, if lighting conditions permit, all newer digital SLRs also enable you to preview your picture on the back-panel LCD using *Live View*, (just like a point-and-shoot camera), giving you the best of both viewing worlds.
- ✓ A dSLR responds to an itchy trigger finger almost instantly. Forget about pressing the shutter release and then waiting a second (or agonizing fraction thereof) before the camera decides to snap the shot. Although newer point-and-shoot cameras are more responsive than older versions, few can match the capability of dSLRs to crank out shots as fast as you can press the button. Even fewer point-and-shoot cameras are capable of the four-to-nine-frames-per-second continuous shooting rates available with some of the digital SLRs aimed at more advanced photographers.
- ✓ You have the freedom to switch among lenses. Yes, there are some non-dSLR cameras (so-called *mirrorless* models) with interchangeable lenses. But none of them can match the selection of optics available for the typical dSLR camera, even when you use an adapter that allows fitting lenses from other camera models. You can switch among an all-purpose zoom lens, a superwide-angle lens, an extra-long telephoto lens, a close-up lens, or other specialized optics quicker than you can say 170-500mm F/5-6.3 APO Aspherical AutoFocus Telephoto Zoomexpialidocious.

Chapter 1: The Digital SLR Difference

(Best of all, you don't even have to know what that tonguetwister of a name means!)

Just be prepared to succumb to *lens lust*, a strange malady that strikes all owners of dSLRs sooner or later. Before you know it, you find yourself convinced that you *must* have optical goodies, such as the lens shown in Figure 1-1 — a telephoto lens that's absolutely essential (you think) for taking photos of wildlife from enough of a distance to avoid scaring away the timid creatures.

✓ If you're a movie nut, you can shoot the best movies of your life. The latest dSLRs are truly all-in-one cameras, capable of capturing razor-sharp stills and either 720p or 1080p highdefinition movies with equal aplomb. They produce better-

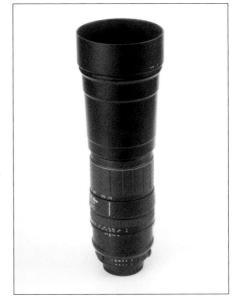

Figure 1-1: Playing with lenses, lenses, and more lenses is one of the inevitable joys of working with a dSLR.

looking movies than most point-and-shoot cameras, and even exceed the capabilities and quality of the average dedicated camcorder, too. There's an old saying that "The best camera is the one you have with you." It's equally true that the best movie camera is the one you're already holding in your hands when a video opportunity pops up unexpectedly.

If you're ready to say *sayonara* to film, *adiós* to poorly exposed and poorly composed pictures, and *auf Wiedersehen* to cameras that have sluggardly performance, it's time to get started.

The sections that follow (as well as other chapters in this part) introduce you to the technical advantages of the digital SLR and how you can use the dSLR features to their fullest. When you're ready to expand your photographic horizons even further, Parts II, III, and IV help you master the basics of digital photography, go beyond the basics to conquer the mysteries of photo arenas (such as action, flash, and portrait photography), and then discover how you can fine-tune your images, organizing them for sharing and printing.

Part I: Digital SLRs and You

Resolution: Peak or plateau?

Only a few years ago, it was common to buy a digital camera based only on the number of pixels — measured in millions of pixels or *megapixels* because a camera with 15 gazillion pixels obviously must be superior to one with only 13.14159625 gazillion pixels, right? Then photographers discovered that one vendor's 12MP camera produced much better images than another vendor's 15MP camera, especially in terms of image quality characteristics unrelated to resolution (say, visual noise or color accuracy.)

In recent years, digital SLRs have continued to boast more and more pixels, but those other image qualities have gained equal stature in terms of importance. Photographers are looking at the overall picture, in other words. As I write this, resolution seems to be averaging around 20 megapixels, with 14–18MP at the low end for entry-level and intermediate models, and 21–24MP for more advanced cameras. Because additional resolution isn't as important as reduced visual noise and other image quality factors, I expect resolution to plateau or peak at no more than 32MP during the life of this book.

Full frame: 1s it for you?

So-called full-frame cameras have become more affordable, with some models available for less than \$2,000. Equipped with sensors the same size as a 35mm film frame — 24 x 36mm — these cameras enjoy the double benefit of offering "true" (non-cropped) fields of view and improved low-light/ visual noise characteristics thanks to their larger, light-hungry pixels. Wide-angle lenses of a given focal length have a wider field of view when mounted on a full-frame camera, and conversely, longer lenses don't have the same "cropped" telephoto "reach" as they do on a camera with a smaller sensor. Because full-frame cameras are generally more expensive, larger, and may force you to buy a whole new complement of lenses that can bathe their larger sensors with light, whether one of these models might be for you will depend on what features you need, and how much you want to pay for them. I explain the advantages and disadvantages of full-frame cameras in more detail in this chapter.

Improving Your Photography with a dSLR

The differences between digital SLRs and the camera that you used before you saw the (digital SLR) light depends on where you're coming from. If your most recent camera was a point-and-shoot digital model, you know the advantages of being able to review your photos on an LCD screen an instant after you take them. And, if you're serious about photography, you also understand the benefits of fine-tuning your photos in an image editor. If you're one of the few remaining holdouts only now making the long-delayed switch to a digital SLR from a film SLR, you're likely a photo enthusiast already and well aware that a single lens reflex offers you extra control over framing, using focus creatively, and choosing lenses to produce the best perspective. And, if you're making the huge leap from a point-and-shoot non-SLR film camera to a digital SLR, you're in for some *real* revelations.

A digital SLR has all the good stuff available in a lesser digital camera, with some significant advantages that enable you to take your photo endeavors to a new, more glorious level of excellence. Certainly, you can take close-ups or sports photos by using any good-quality digital camera. Low-light photography, travel pictures, or portraits are all within the capabilities of any camera. But digital SLRs let you capture these kinds of images more quickly, more flexibly, and with more creativity at your fingertips. Best of all (at least, for Photoshop slaves), a digital SLR can solve problems that previously required you to work long hours over a hot keyboard.

Despite the comparisons you can make to other cameras, a digital SLR isn't just a simple upgrade from another type of camera. In the sections that follow, I introduce you to the advanced features and inner workings of a dSLR so that you can begin getting the most out of your camera.

Composing shots with a more accurate viewfinder

When you use non-SLR cameras, what you see isn't always what you get.

Theoretically, the LCD on the back of a digital camera *should* show exactly what you get in the finished picture — and many of these LCDs do just that, offering a 100-percent view of the image you end up with. After all, the same sensor that actually captures the photo produces the LCD image. In practice, you might find the back panel LCD difficult to view under bright light. It also appears so small when you hold the camera at the requisite arm's length that you may feel like you're trying to judge your image by looking at a postage stamp that's gone through the wash a few times.

You probably find the view through a non-SLR digital camera's optical viewfinder — if it even has one — even worse than the camera's LCD screen: diminutive, inaccurate enough to make chopping off heads alarmingly easy, and offering no information about what's in focus and what isn't.

More advanced cameras might use an electronic viewfinder (EVF), which is a second, internal LCD that the user views through a window. You can find this kind of viewfinder in many so-called *superzoom* cameras that have a

Part I: Digital SLRs and You

fixed lens with a versatile, relatively long zoom range. The mirrorless cameras I mention earlier (including the various Sony NEX interchangeable lens models) also may have an optional supplementary EVF-style viewfinder that you clip onto the top of the camera. EVFs provide a larger image that's formed by the actual light falling on the sensor, and you can use an EVF in full sunlight without the viewfinder washing out. However, EVFs might not have enough pixels to accurately portray your subject, and they tend to degenerate into blurred, ghosted images if the camera or subject moves during framing. They also don't work as well in low light levels. An EVF is a good compromise, but you can't preview an image as easily using this kind of camera as you can by using a dSLR.

A digital SLR's optical viewfinder, in contrast, closely duplicates what the sensor sees, even though the image is formed optically and not generated by the sensor itself. It's all done with mirrors (and other reflective surfaces) that bounce the light from the lens to your viewfinder, sampling only a little of the light to measure exposure, color, and focus. As a result, the viewfinder image is usually bigger and brighter — from 75 percent to 95 percent (or more) of life size by using a dSLR normal lens or zoom position, compared with 25 percent or smaller with a point-and-shoot camera's optical or LCD viewfinder.

Check out Figure 1-2 and decide which view of your subject you'd rather work with. You may find the 3-inch LCD on the mirrorless interchangeable lens model (in the upper-left corner of Figure 1-2) difficult to view in bright light; the electronic viewfinder (in the upper-right corner of the figure) can give you fuzzy images, making it hard for you to judge focus. The digital SLR's big, bright viewfinder (at the bottom of Figure 1-2) is, as Goldilocks would say, just right.

A dSLR's optical viewfinder shows you approximately what's in sharp focus and what isn't (the *depth-of-field*), either in general terms (all the time) or more precisely when you press a handy button called the *depth-of-field preview*, which many dSLRs have. You probably find your dSLR viewing experience more pleasant, more accurate, and better suited for your creative endeavors. If you switch to a camera's Live View mode (if your camera includes that mode) to preview the image on the back-panel LCD, you can often perceive depth-of-field. However, under high light levels, the LCD can be just as difficult to see as on a point-and-shoot camera.

Flexing the powerful sensor

With very few exceptions, digital SLR sensors are *much* bigger than their point-and-shoot camera counterparts. This size gives them a larger area that can capture light and, potentially, great sensitivity to lower light levels, along with improvements in the ability to make larger prints or crop tightly. (Some non-SLR cameras give up compactness to provide somewhat larger sensors, but they're still fairly rare.)

12

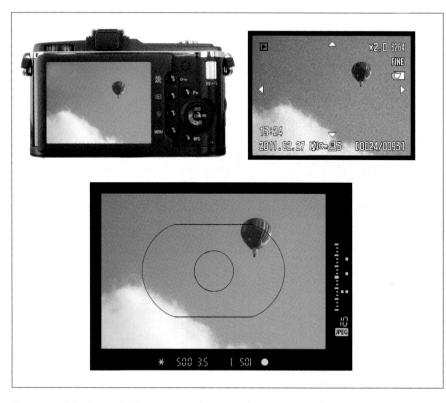

Figure 1-2: A back panel LCD viewfinder (upper-left) or an EVF LCD (upper-right) is no match for a dSLR's optical system (bottom).

A dSLR's extra sensitivity pays off when you want to

- Take pictures in dim light.
- Freeze action by using shorter exposure times.
- Use smaller lens openings to increase the amount of subject matter that's in sharp focus.

Within the Canon digital camera line alone, you find digital SLRs that have 22.2mm x 14.8mm to 24mm x 36mm sensors (the size of a 35mm film frame). By comparison, some of Canon's digital point-and-shoot cameras use a sensor that measures only 7.8mm x 5.32mm. Put in terms that make sense to humans, the dSLR sensors have 8 to 20 times more area than their Lilliputian point-and-shoot sensor-mates. Figure 1-3 gives you a better idea of the relative sizes.

Part I: Digital SLRs and You

If you think of a sensor as a rectangular bucket and the light falling on it as a soft drizzle of rain, the large buckets (or sensors) can collect more drops (or the particles of light called *photons*) more quickly than the small ones. Because a certain minimum number of photons is required to register a picture, a large sensor can collect the required amount more quickly, making it more sensitive than a smaller sensor under the same conditions.

In photography, the sensitivity to light is measured by using a yardstick called ISO (International Organization for Standardization). Most point-and-shoot digital cameras

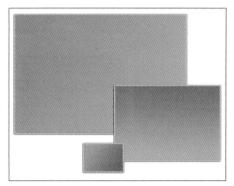

Figure 1-3: These images represent the comparative size of a dSLR's 24mm x 36mm sensor (upper left) and 22.2mm x 14.8mm sensor (center), and a point-and-shoot digital camera's 7.8mm x 5.32mm sensor (bottom).

have a sensitivity range of about ISO 50 to ISO 100 (at the low end), up to a maximum of ISO 800 to ISO 3200 (at the high end). Some point-and-shoot models have even higher sensitivity settings, but it remains to be seen how useful these ultra-high ISO non-SLR models are. Indeed, many models that have high ISO settings generally don't do a very good job in terms of image quality, because their pixels are smaller and can't capture light as efficiently.

In contrast, digital SLRs — which have more sensitive sensors and larger light-gathering pixels — commonly have usable ISO settings of up to at least ISO 1600 or ISO 3200. Many are capable of ISO 6400 or may range up to a lofty ISO 25600 (and up!) This extra speed does have a downside, as you can see in the following section. But, in general, the added sensitivity allows people to shoot photos in dim light, take action pictures, or stretch the amount of depth-of-field available.

Reducing noise in your photos

Visual noise (or just *noise*) is that grainy look that digital photos sometimes get, usually noticeable as multicolored speckles most visible in the dark or shadow areas of an image. Although you can sometimes use noise as a creative effect, it generally destroys detail in your image and might limit how much you can enlarge a photo before the graininess becomes obtrusive.

The most common types of noise are produced at higher sensitivity settings. Cameras achieve the loftier ISO numbers by amplifying the original electronic signal, and any background noise present in the signal is multiplied along with the image information. Figure 1-4 shows an image with a relatively low ISO value of 200 that's virtually free of noise and an image with a sensitivity of ISO 6400. The ISO 6400 sensitivity produces a lot more noise than the ISO 200 — even though someone took both pictures by using a digital SLR.

Point-and-shoot digicams often don't have ISO settings beyond ISO 3200 because the noise becomes excessive at higher ratings, sometimes even worse than you see in the bottom example in Figure 1-4. However, you can boost the information that the big dSLR sensors capture to high ISO settings with relatively low overall noise. I've used digital SLRs that had less noise at ISO 1600 than some poor-performing point-and-shoots displayed at ISO 400. Obviously, the large sensors in dSLRs score a slam-dunk in the noise department and make high ISO ratings feasible when you really, really need them.

Figure 1-4: A noise-free photo shot at ISO 200 (top); a noisy photo shot at ISO 6400 (bottom).

Noise doesn't always result simply from using high ISO settings: Long exposures can cause another kind of noise. Although some techniques can reduce the amount of noise present in a photo (as you can discover in Chapter 2), by and large, digital SLR cameras are far superior to their non-SLR counterparts when it comes to smooth, noise-free images.

Thanks to the disparity in size alone, all sensors of a particular resolution are *not* created equal, and sensors that have fewer megapixels might actually be superior to high-resolution pixel-grabbers. For example, older 12-megapixel dSLRs may produce superior results to some of the newer 14-megapixel non-SLR digicams. So, no matter how many megapixels a point-and-shoot camera's sensor can hoard, that sensor generally isn't as big as a dSLR's. And when it comes to reducing noise, the size of the sensor is one of the most important factors.

Reclaiming depth-of-field control

Depth-of-field is the range over which components of your image are acceptably sharp. In general, you want to be able to control the amount of depthof-field because having more or less depth-of-field gives you creative control over what's sharp and what isn't in your photos. You might prefer to zero in on a specific subject and let everything else remain blurry. Or you might want to have everything in your frame as sharp as possible.

To understand how dSLR cameras give you more control over depth-of-field, you need to understand the three factors that control this range, which I outline in Table 1-1.

Table 1-1 Factor	How Depth-of-Field Affects Photos
	How It Affects a Photo
The distance between the camera and the subject	The closer your subject is to the camera, the greater the tendency for the objects in front or behind the subject to blur in the photo.
The size of the lens opening (the <i>f-stop</i> or <i>aperture</i>) used to take the picture	Larger f-stops (smaller numbers), such as f/2 or f/4, produce less depth-of-field than smaller f-stops (larger numbers), such as f/11 or f/16. Remember : The size of the numbers are reversed because aper- tures are actually the denominators of fractions, so $\frac{1}{2}$ and $\frac{1}{4}$ are <i>larger</i> than $\frac{1}{10}$ or $\frac{1}{16}$.
The magnification (or <i>focal length</i>) of the lens	The shorter the focal length of the lens (say, 18mm of 20mm), the more depth-of-field is present. When the focal length grows longer (say, to 70mm or 100mm), depth-of-field shrinks.

Point-and-shoot digital cameras offer very little control over depth-of-field because unless you're shooting an extreme close-up, virtually everything is in sharp focus. The prodigious depth-of-field also makes it difficult to plan and visualize the range of focus as you view the image prior to exposure. This condition (which you may not like if you're trying to use focus selectively) occurs because non-SLR digital cameras that use tiny sensors also must have lenses of a much shorter true focal length. Smaller sensors require a shorter focal length to produce the same field of view.

So, a point-and-shoot digital camera might have a 7.5mm-to-22.5mm 3X zoom lens that provides a slightly-wide-angle-to-slightly-telephoto field of view. A digital SLR with the largest (24mm x 36mm) sensor might need a 35mm-to-105mm zoom to provide the same perspective.

Yet, depth-of-field is dependent on the *actual* focal length, not the equivalent. So, that point-and-shoot camera's lens, even at its longest telephoto position (22.5mm), provides more depth-of-field than the dSLR's same-perspective zoom at its widest angle. So much is in focus with a non-SLR digital camera that, in practice, you have very little control over depth-of-field, except when shooting close-up pictures from very short distances.

You can see the effect of using a large maximum aperture in Figure 1-5, which was shot at f/5.6 with a 200mm lens. Creative use of depth-of-field can isolate a subject effectively. In Chapter 7, I explain depth-of-field in more detail.

Taking photos faster

Everything about a digital SLR seems to work more quickly and responsively. You may find that speed important when you want to make a grab shot on the spur of the moment or expect the camera to take an action photo *right now* when you press the shutter release at the peak moment. Many point-and-shoot digital cameras are downright sluggardly compared to dSLRs when it comes to performance (although vendors have worked very hard to close the gap, and it's much less than it was in years past). You can find improved speed in three key areas, which I explain in the following sections.

Wake-up time

You can have a relatively fast non-SLR digicam powered up and ready to snap its first photo in as little as 2 seconds. Many of these cameras take even longer to emerge from their slumber. Worse, because they consume so much power (thanks to the rear-panel LCD), these cameras may go into stand-by mode or shut off completely if you don't take a picture for 30 to 60 seconds.

Part I: Digital SLRs and You $_$

Figure 1-5: Using a large f-stop, you can easily isolate a subject with a creative application of blur.

When you flip the power switch of a dSLR, the camera is usually ready to take the picture before you can move the viewfinder up to your eye. Some dSLRs are ready to go in 0.2 of a second! Digital SLRs don't need to go to sleep, either, because they consume so little power when not in active use. I've left dSLRs switched on for days at a time with little perceptible draining

of the battery (but not in Live View mode, of course). Certainly, the autofocus and auto-exposure mechanisms go on standby a few seconds after you move your finger from the shutter release, but you can have them available again instantly by giving a quick tap to the button.

Shot-to-shot time

Conventional digital cameras have limits on how quickly you can take pictures in succession. Unless you're using the motor-drive-like burst mode, one shot every second or two is about all you can expect. Even in burst mode, you're lucky to get much more than one to three frames per second for 5 to 11 shots, max. Some point-and-shoot cameras do allow you to fire off shots continuously for longer periods (in some cases, until the memory card is full!), but you don't find such speediness in the average entry-level digital snapshot camera.

But all digital SLRs have relatively large amounts of built-in memory that temporarily store each photo that you snap before the camera transfers it to your memory card at high speed. You can probably take pictures in singleshot mode as quickly as you can press the shutter release, and for at least eight to ten shots before a slight pause kicks in. If you use a fast dSLR that has some quality level settings, you can often keep taking pictures for as long as your finger (or memory card) holds out.

A dSLR's burst mode can typically capture 3 to 11 frames per second for 12 to 30 shots or more, depending on the speed of the camera, speed of the memory card, and the quality level you choose. Low quality (high compression) settings produce smaller images that the camera can write to the memory card quickly (see Figure 1-6). No common point-and-shoot camera comes anywhere close to that level of performance at full resolution, even though a few can shoot at sustained frame rates that allow you to produce movielike effects with your still images. Sony produces near-dSLR models that use a semi-transparent mirror instead of a flip-up mirror, which allows them to fire off shots at a 10 frames per second (fps) clip. However, these "SLT" (single lens translucent) cameras have an EVF (electronic viewfinder) rather than optical SLR viewfinder, so they are not true dSLRs.

Shutter lag

In years past, the number one question I got from new digital photographers was "What can I do about shutter lag!?!" Digicam owners seem to really dislike their camera's *shutter lag* — the pause between the moment you click the shutter button and the moment the sensor captures a slightly different image. Some snapshot cameras are worse than others, of course, but you can still find many models available that produce an annoying lag between pressing the button and taking the picture.

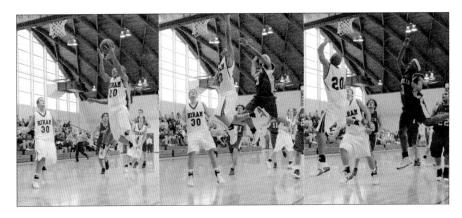

Figure 1-6: Digital SLRs make shooting high-speed action sequences easy.

Technically, digital SLRs also experience shutter lag, but it's likely so brief — on the order of 0.1 to 0.2 of a second — that you never notice it. Of course, dSLRs have little shutter lag only *most* of the time. Point your lens at a difficult-to-focus subject, such as the sky, or try to take a photo under low light, and your speedy autofocus lens might hunt back and forth while you gnash your teeth in frustration. (You can discover some ways around this problem in Chapter 10.)

A dSLR works like a camera

Another reason why digital SLRs have improved performance is that they're easier to use, so you, as the photographer, can work quickly while you shoot. The manufacturers configure most non-dSLR cameras for consumers who simply want to grab a quick snapshot, instead of investing some artistry in creating a photograph.

Moreover, point-and-shoot cameras tend to be designed by an engineer who did a really, really good job adding photo capabilities to the vendor's cell-phone line last year, and who obviously *must* be the best choice to cobble together a full-fledged digital camera. Indeed, the line between cell-phone cameras and digital snapshot cameras is blurring all the time. (Now that iPhone, Android, and other smart phones are commonly furnished with *two* cameras — one front-facing and one rear-facing — it's likely that one day you'll be able to get only a few categories of cameras: cell-phone-integrated point-and-shoot models and interchangeable lens cameras such as digital SLRs and mirrorless LCD/EVF models.)

Like cell phones, non-SLR digital cameras tend to have most of the controls tucked away out of sight in the menu system, where the average consumer never has to see them and where the photo enthusiast has to hunt for them. Digital SLRs, on the other hand, are always designed by a team of engineers who have extensive photographic experience. They know which controls a photographer absolutely needs and which controls they can bury away in the menus because you access those controls only when setting up the camera and maybe once a month (if that) thereafter.

Digital SLR designers know that you don't want to go three levels deep into a menu to set the ISO sensitivity or adjust white (color) balance for the type of illumination that you're using. You want to press an ISO or a WB (white balance) key and dial in the setting without giving it much thought. Or, perhaps, you can press a "quick control" button to produce a screen of all the available settings. You don't want to wade through a tedious on-screen display to set frequently used controls like shutter speed or aperture. You want to adjust each with a dial or two. Nature intended that you zoom and manually focus your camera by twisting a ring on the lens, not by pressing a little lever and letting a motor adjust the lens at its own pace.

Simply having a camera that operates like a camera, rather than like a DVD player, makes your picture-taking much easier and faster.

Getting more lens flexibility

When you work with a non-SLR, you use the lens mounted on the camera. In the past, some models had add-on telephoto and wide-angle attachments. You can still find such accessories, but they tend to subtract a bit of sharp-ness, even while they change the camera's viewpoint.

So, point-and-shoot camera owners must decide at the time they buy the camera what kind of pictures they intend to shoot. If they want to take a lot of photos indoors or of architecture outdoors, they might need cameras that have the equivalent of an ultrawide-angle lens, which is still fairly rare among non-dSLR models. Perhaps a photographer wants to shoot sports, so he or she needs a very long lens. You can find those lenses available, especially with superzoom models, but not generally with cameras that also have wide-angle capabilities.

Digital SLR camera owners have fewer limitations. I own a 10mm-to-24mm zoom that's the equivalent of a 15mm-to-36mm wide-angle lens on a dSLR that has a sensor of less than full-frame size. (You can find out more about full-frame sensors and why lenses are measured in equivalents in Chapter 2.) Other lenses that I own cover every single focal length, up to 500mm (750mm equivalent). I have two lenses designed especially for close-up photography and others that have fast f/1.4 apertures, which are perfect for low-light sports shooting, concerts, parties indoors, and other subjects. I haven't come close to exhausting the possibilities, either: You can find longer and wider lenses than what I own, along with specialized optics that do tasks such as canceling sharpness-robbing vibration caused by a photographer's unsteady hand.

Part I: Digital SLRs and You

Owners of dSLR cameras don't have to mortgage their homes to buy these lenses, either. Camera vendors offer some very sharp-fixed focal length lenses (*prime* lenses) for around \$100. You can find inexpensive 70mm-to-210mm zoom lenses for as little as \$150 to \$200. A versatile 28mm-to-200mm zoom that I bought a few years ago cost only \$300. Because dSLRs can often use lenses designed for their film camera counterparts, you can find hundreds of inexpensive used lenses, too. If you have a non-dSLR, you frequently have to buy a new camera to expand your lens horizons. You can find out more about selecting lenses in Chapter 7.

Freeing yourself from image editors

Digital SLRs do more than change how you *take* pictures. They change how you *make* pictures, as well. Perhaps you're a seasoned image editor, accustomed to cropping images in Photoshop or Photoshop Elements to mimic the extreme telephoto perspective that your previous camera couldn't duplicate. You might have used an image editor's Zoom Blur feature because your digicam's zoom lens didn't zoom fast enough to allow you to create that effect in the camera, as shown in Figure 1-7. You've faked fish-eye lens effects because your camera didn't have a fish-eye lens, or you've manually added lens flare instead of trying to create the real thing.

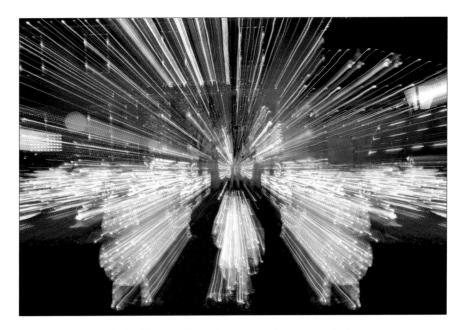

Figure 1-7: Don't settle for fake zoom blur when you can have the real thing.

Maybe you had to blur the background of your images in an image editor because your digital point-and-shoot camera always brought *everything* into sharp focus (an excellent trait when you *want* everything in focus, but not so great when you want to focus selectively for creative effects).

By using a dSLR, those limitations might be behind you now. A digital SLR can do a lot of tricks that you had to fake in Photoshop in the past. Image editors are still helpful for some tweaks, as you can find out in Chapters 12 and 13.

Where Did All Those Downsides Go?

Of course, the digital SLR isn't perfect — but it's getting close. In previous editions of this book, I had to include a section that explains, in detail, several downsides to using these *Wundermaschinen*, which ranged from the annoying to the almost irrelevant. Today, each of those downsides has been virtually vanquished. I address them in decreasing order of concern (at least, for most photographers) in the following sections.

Lack or expense of superwide lenses: Vanquished!

Many high-end digital SLRs have sensors that are the same size as the 35mm film frame, so you don't have to calculate equivalency factors. A 200mm lens provides the same magnification on a full-frame dSLR as it did on a film camera. More importantly, a 16mm or 14mm superwide-angle lens retains the same wide field of view.

But more affordable digital SLRs have smaller-than-full-frame sensors (I talk more about the sensor-size issue in Chapter 2), so the sensor crops the field of view of any lens that you mount on the camera to match the smaller sensor size. The crop factor ranges from 1.3 to about 2.0 for the current, er, crop of digital SLRs. Therefore, in practice, a 100mm telephoto lens mounted on one of these cameras has the same field of view as a longer 130mm-to-160mm telephoto lens on a 35mm film camera. Because you figure the effective field of view by multiplying the actual focal length by the crop factor, the figure is also sometimes called a *magnification factor*, and where all the mentions of "equivalency" come in when comparing lenses. But magnification factor isn't an accurate term because no magnification takes place. The camera simply crops out part of what the lens sees. Your 100mm lens might *look* like it's been magically transformed into a longer 160mm optic, but the depth-of-field and other characteristics remain the same as the 100mm lens it really is.

Part I: Digital SLRs and You .

Photographers who shoot sports and distant subjects often love the crop factor, even though it gives them nothing they can't achieve just by cropping a full-size frame. The crop factor *seems* to provide a longer telephoto lens for the same money. The good news turns bad, however, when they mount 28mm wide-angle lenses on their beloved dSLRs and find that they have the same field of view as a 45mm standard (normal) lens, or that their favorite 18mm superwide lenses are now 29mm ordinary wide-angle optics. (I use a 1.6 crop factor, typical of Canon cameras, in all these examples.) In this case, you get a less wide view from a particular lens.

Fortunately, you can find plenty of true wide-angle lenses available for digital SLRs. Since the last edition of this book, those lenses also have become inexpensive enough that any serious photographer can afford them. Three different vendors offer 12mm-to-24mm or 10mm-to-24mm superwide zooms for my favorite dSLR, making it possible to shoot expansive shots, such as the one shown in Figure 1-8. You can get focal lengths down to 8mm. If you want to shoot wide and have a dSLR that has a crop factor, you can find lenses that provide you with the wide-angle view you crave.

Figure 1-8: You can take panorama-like shots by using an ultrawide-angle lens.

And remember, most of these lenses are *considerably* wider than the (current) widest-angle optics available for point-and-shoot cameras, which seem to get no wider than the equivalent of 24mm with a traditional film camera.

Fending off dirt and dust: Automatic!

For some dSLR owners, the worst of the camera's downsides is the plethora of dust bunnies and odd particles of matter that seem to attach themselves to the camera's sensor at every opportunity. Fortunately, virtually every digital SLR introduced in the last few years includes a sensor-shaking device that vibrates when the camera is powered up, turned off, or whenever you specify to remove these artifacts before they can show up in your photos. Some vendors apply anti-static coatings to keep the dust from sticking to your sensor and include a sticky-strip in the sensor chamber to capture the dust that's dislodged by the cleaning process.

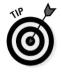

Even so, take extra care when changing lenses to keep dust from wending its way back to the sensor area (which is fully exposed only when you're taking a picture, anyway). Also, find out how to manually clean this dust off your sensor, a process that's much easier to do than it is to describe. I go into the details of sensor cleaning in Chapter 5.

Some photographers have problems with dust seemingly on a weekly basis. Others go months without any infiltrations. If your camera has a sensorcleaning feature, dirt and dust and digital SLRs might be a very small problem for you. But this problem might loom large, depending on your working habits, cleanliness, and willingness to stomp out a few artifacts from time to time in your image editor.

LCD preview: Live, and in person!

Non-SLR digital cameras have always been able to offer a live preview of the image, as seen by the sensor, prior to exposure. At one time, almost all dSLRs couldn't offer such a preview because the mirror that provides the optical view of the subject, which flips up just prior to exposure, is in the viewing path. However, virtually all current digital SLR cameras use various technologies to provide a Live View preview.

Use a digital SLR's larger optical viewfinder if you want to judge composition, depth-of-field, and frame fast-moving action, and use the Live View when it suits you and the LCD screen isn't washed out from bright sunlight. The following sections cover the key applications that *do* benefit from an LCD preview.

Live histograms in real time

A *histogram* is a graph that displays the tonal range of an image. You can use a histogram to judge whether a photograph is or will be under- or overexposed. The trained eye can also see whether an image is likely to have excessive contrast or look particularly flat, based on the distribution of tones in a histogram.

Part I: Digital SLRs and You .

You can make adjustments to lighting and exposure to improve the rendition of a shot. Prior to Live View, you could view dSLR histograms only after the fact, when you reviewed the photo you already took. The digital SLR owner who has live histogram capabilities can make adjustments before taking the next picture. You can find more about the use of histograms in Chapter 6.

Déjà view with extended eye-points

The *eye-point* is the distance that you can move your eye away from the viewfinder and still see the entire image for framing. An extended eye-point is useful for sports and other applications where you want to keep an eye on what's happening outside the camera's viewfinder.

A live LCD preview lets you keep the camera a few inches from your face, or even at arm's length, and still see what the camera will capture. Point-andshoot digital cameras and many dSLRs from Nikon, Canon, Sony, and other vendors (including the model shown in Figure 1-9), put the LCD on a swiveling mount so that you can use it for framing while you hold the camera at waist level, overhead, or, with some models, even facing you for a self-portrait.

Figure 1-9: Live View and a swiveling LCD are a perfect combination for framing shots from any angle.

Infrared imagery not up to your imagination

Infrared photos call for a filter that blocks visible light. All you see through the optical viewfinder is a vast expanse of black, which makes framing your photo difficult. A live LCD preview gives you *some* type of image, at least.

Although this problem is annoying, you can work around it. Most people don't shoot infrared photos at all. A few dedicated souls convert an extra dSLR for full-time infrared use, so they don't need a visible-light-blocking infrared filter. Those photographers who do shoot infrared with their unmodified cameras find that exposures are so long, they need a tripod. If you fall into this camp, you have two options:

- Set up your camera on a tripod, frame your picture, and *then* mount the infrared filter.
- ✓ Frame the photo as best you can (by using Live View, if available), take a shot, and then use the after-shot LCD review to make adjustments.

Carrying that weight: Heft not mandatory!

Many digital SLRs are much bigger, heavier, and clunkier than pocket-sized point-and-shoot digital cameras. Fortunately, camera manufacturers have recognized the appeal of smaller dSLRs, so you can find relatively small models from Nikon, Olympus, Canon, Sony, Pentax/Samsung, and others. If all you want is an interchangeable lens camera and don't need a dSLR, you can go even smaller with mirrorless models from Sony, Olympus, and Panasonic.

Of course, the more money you spend on a dSLR, the bigger it likely is because vendors offer magnesium alloy bodies, rather than the composite plastic used for entry-level digital SLRs. Tack on extra battery packs and special grips that let you shoot more comfortably in a vertical position, and the camera becomes even larger.

This size problem is an annoyance only to someone who needs to travel light. For most photographers, the whole point of upgrading to a digital SLR is to gain access to the extra lenses and accessories that these cameras can use. The extra heft is part of the cost of the greater versatility. Many dSLR owners also purchase small point-and-shoot cameras to carry when weight and size are important to them.

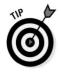

In my case, I often use a compact version of my "big" dSLR as a backup when I'm traveling. I fully intend to take all my photos by using my hefty main camera, but I'd hate to be without any camera at all in case of a mishap. So, the compact dSLR goes in the bag, too, as backup.

Budding Spielbergs no longer out of luck: HD movies are here!

Most point-and-shoot digital cameras can capture motion-picture clips with monaural sound. Some of these cameras offer only poor-quality clips at, say, a herky-jerky 10 or 15 frames per second (fps), rather than the standard 30 fps, and these clips have resolutions as low as 320 x 240 or 160 x 120 pixels. You might be limited to 30- or 60-second clips, tops. High-end, non-SLR digital cameras might give you high-definition TV-quality at 1280 x 720 or 1920 x 1024 pixels, often with your choice of 24 or 30 fps, with decent sound and recording times for as long as the available capacity of your memory card holds out. You can even find in-camera trimming and editing facilities.

Because a dSLR's mirror can't flip up and down 30 times a second (the current fastest burst capability tops out at around 11 fps), you don't find motionpicture capabilities on any dSLR when you use the optical viewfinder. However, cameras that have Live View capabilities can shoot HDTV images while providing views of the image on the LCD. Now, when you want to shoot digital movies, you no longer have to tote along a digital video (DV) camcorder.

In-camera editing!

Newer digital SLRs now give you the ability to do some simple editing right in the camera by using a Retouch menu or other facility. Here are some of the benefits of this capability:

- ✓ Correct your images without a computer. Correct colors, change tonal values to improve the brightness or darkness of your image, fix red-eye, straighten crooked shots all in the camera and without the need of a computer. You may find this capability handy when you want to fix your shots and then e-mail them while you're on the run.
- ✓ Create small copies for web display or e-mailing. You don't want to send a 16-megapixel (or larger) file home while you're traveling. Such an image might over-tax your connection when you're on the road and could cause trouble for the person trying to view it. The latest dSLRs let you trim, crop, and output a lower-resolution version of your best shots for easier Internet distribution.
- Apply special effects. Convert your image to black-and-white. Add filter effects. Combine two shots by using overlay techniques. Add or remove distorting effects. Create a fish-eye shot without the need for a fish-eye lens. Produce those cute "miniature/shift-tilt" effects. You can find these capabilities in several different dSLR models.

Safari Inside a dSLR

6 SA

In This Chapter

- > Understanding megapixels and dSLRs
- > Taking a guided tour through dSLR-land
- Working out the quirks and kinks of the dSLR

f digital photography is the greatest thing since sliced bread, the digital SLR (dSLR) is the toaster — a no-nonsense device that anyone can use to create tasty results. Even so, you get better results if you know a little about how your favorite gadget works. You don't need to understand Ohm's Law to make breakfast, but it is a good idea to understand a little about a toaster's innards before you poke a fork inside. In the same vein, understanding pixels, lenses, and sensors helps you get better results from your photographic appliance.

SON

GGØ

ac580

This chapter takes you on a safari through the darkest recesses of the digital SLR to give you a little knowledge about how it works before you decide to poke a figurative fork inside.

Megapixels and Why dSLRs Have More of Them

If you've been working with digital images for a while, you know that pixels are your pals. They are the basic building blocks that make up an image. The term *pixel* is a *portmanteau*, which was Lewis Carroll's term for a new word created by combining two old words, such as slimy and lithe to create *slithy*. In this case, pixel stands for *picture element* and came into vogue when computer imaging became popular. You have seen pixel-like components outside the digital realm, in pointillist paintings, such as the illustrations Georges Seurat created for the Broadway musical *Sunday in the Park with George*. You also see pixel-like components in newspaper halftone photos. All these images are made up of tiny dots that you can see vividly up close, but those dots blend to create continuous tones and colors when you view them from a distance, as you can see in Figure 2-1. The difference between these picture elements and those used to represent digital photos is that the digital pixels are all the same size and shape. Digital pixels vary only in brightness and hue.

In digital images, the *pixels* — tiny squares that you can see individually only under magnification — are arranged in rows and columns like a checkerboard that happens to measure hundreds of squares on a side. Among current digital SLRs, this array is a minimum of 4,288 pixels wide and 2,848 pixels tall, for a total of 12 million pixels. The latest digital SLR cameras for consumers actually offer many more pixels than that, up to 4,928 x 3,264 (16 million) pixels or more for the majority of current digital SLRs. Of course, pro and advanced amateur cameras go up to 6,048 x 4,032 (24.5 million) pixels. That's a lot of pixels!

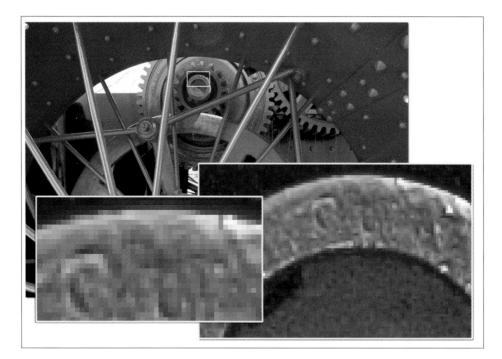

Figure 2-1: Every digital picture is made up of thousands (or millions) of pixels.

Those pixel counts represent the number of light-sensitive areas in the digital camera's sensor. The total is usually expressed in terms of *megapixels* (millions of pixels), and abbreviated MP. The precise dimensions vary, depending on the sensor used.

Pixelementary, my dear Watson

Pixels, represented by individual light-sensitive areas in a sensor called photosites, capture the detail in your image. In general terms, the more megapixels, the better. That's because when you add pixels, the sensor's capability to capture detail improves and its effective *resolution* rises.

It's like dividing a foot-long ruler into 1,200 increments rather than 120. In the former case, the ruler could measure things with 1/100-inch accuracy; in the latter, you could use the rulings only in 1/10-inch chunks. In the same vein, a sensor of a particular size that has 24MP can show much finer detail than one the same size that has only 12MP.

As you can see in Figure 2-2, when the size of the pixels decreases. more of them can fit on a sensor to capture tiny details of the original image. However, image quality involves more than resolution. Many 12MP dSLRs produce sharper and more noise-free results than 15MP non-dSLRs simply because the 12MP dSLR's sensors are physically larger, and each individual pixel is better than one produced on a non-dSLR's sensor. Some dSLRs even outperform other dSLRs that have more resolution because of the quality of the sensors, lenses, or electronic circuitry in the outperforming dSLR. For example, I have a 12MP pro dSLR that consistently produces better results than a 14MP entry-level model

Figure 2-2: More pixels typically mean sharper images.

from another vendor, particularly under lower light levels. The raw number of megapixels gives you only a guideline, even though the more pixels, quite often the better your images look.

How many pixels does your camera need? 14 to 24MP and beyond!

People contemplating the purchase of a digital SLR often agonize over how many megapixels they should buy. (Other factors, such as ease of operation and the kind and quality of lenses available for a particular dSLR, may be considerably more important in the long run.) To a certain extent, vendors have (at least temporarily) alleviated this agony. In the past year or two, a surprising number of vendors have settled on 14 to 18MP as a basic benchmark number.

Although more pixels usually render more resolution and more detail in your pictures, the number of pixels you actually need depends on several factors:

- How you plan to use the photo: An image that you place on a website or display in presentations doesn't need to have the same resolution as one that you use professionally (for example, as a product advertisement or a magazine illustration).
- ✓ How much manipulating and cropping you plan to do: If you want to give your images quite a workout in Photoshop or you often crop small sections out of images to create new perspectives, you want all the spare pixels that you can muster. High-resolution images can withstand more extensive editing without losing quality than low-resolution images can.
- ✓ How much you plan to enlarge the image: Many people view most of their images on a computer display or in 4-x-6-inch to 5-x-7-inch prints. Any dSLR has enough megapixels for those modest applications. If you're looking to make blowups bigger than 8 x 10 inches (for example, to make posters or prints that you display on the wall), you need a plethora of pixels.
- ✓ The resolution of your printer: Most digital images are printed on inkjet devices that have their own resolution specifications, usually from 300 dpi (dots per inch) to 1,440 dpi and beyond. Printers work best with images that more closely match their own capability to print detail.

If you primarily want to create prints, the following section can help you gauge which capabilities you need in your camera and printer so that you can get the best output possible.

Matching pixels to print sizes and printers

If nice-looking prints are important to you, pay as much attention to your printer as the number of pixels in your digital SLR. In truth, printers that have low resolution don't benefit much from digital shots that have high megapixel counts. Those printers might produce *worse* results because they have to discard a lot of that precious detail to squeeze the picture information into their available output pixels. You need a printer that has a lot of resolution to do the best job printing a high-resolution photo.

Calculating the appropriate resolution for a particular printer/image size combination is easy. Just follow these steps:

1. Multiply the printer resolution by the desired width of your image.

This calculation gives you the number of pixels that you need for a wide image. For example, if I have a 300 dpi printer and want an 8-x-10-inch print, $300 \times 8 = 2,400$ pixels.

2. Multiply the printer resolution by the desired height of your image.

So, in my example, $300 \times 10 = 3,000$ pixels.

3. Multiply the width in pixels by the height.

You get the number of pixels that you need. Keeping with my example, $2,400 \times 3,000 = 7,200,000$.

4. Divide the total number of pixels by 1 million.

This step calculates the number of megapixels that your camera needs to collect for the print.

Technically, in my example, I end up with 7.2MP, but a ballpark figure of 8MP or more will do. Virtually all digital SLRs these days exceed this figure, with resolution to spare.

Using an image of the same resolution as in the preceding list (2,400 x 3,000 pixels), you can print in other sizes, of course. Your printer or the software that drives it, however, must drop or add pixels by using a process called *interpolation*, or *resampling*, which applies intricate computer calculations to come up with a reasonably good-looking representation of your original image at a different size:

Adding pixels (or upsampling): Figure 2-3 shows a highly simplified example of how new pixels are calculated from existing pixels during interpolation. In this case, upsampling is taking place; the two original pixels, one black and one white, are used to interpolate intermediate gray pixels. In sophisticated interpolation schemes, the density values of pixels in the rows above and below the original pixels, as well as the actual colors of the pixels, are also taken into account. Dropping pixels (or downsampling): Downsampling is basically the same process as upsampling, but in reverse. Based on calculations by the software, some pixels are deleted to create the smaller image size.

Table 2-1 shows the nominal print sizes without the need for interpolation, for various camera resolutions at three common print resolutions. Of course, 6 to 8MP cameras are virtually extinct these days, but you

Figure 2-3: Software sees a black pixel and a white pixel and guesses that it should add gray pixels between them.

can see they were good enough for decent print sizes.

Table 2-1	Print Sizes at Various Resolutions				
Resolution	at 200 dpi at 300		Print Size at 300 dpi (Inches)	o dpi at 600 dp	
3,008 x 2,000	6MP	15.0 x 10.0	10.0 x 6.7	5.0 x 3.3	
3,456 x 2,304	8MP	17.3 x 11.5	11.5 x 7.7	5.8 x 3.8	
4,256 x 2,848	12.1MP	21.3 x 14.2	14.2 x 9.5	7.1 x 4.7	
4,536 x 3,024	13.7MP	22.7 x 15.1	15.1 x 10.1	7.6 x 5.0	
4,992 x 3,328	16.6MP	25.0 x 16.6	16.6 x 11.0	8.3 x 5.5	
5,782 x 3,946	22.8MP	28.9 x 19.7	19.3 x 13.2	9.7 x 6.6	

These native print sizes represent only the dimensions that you can get without using interpolation. In practice, digital SLR cameras can produce much larger prints that have little noticeable loss of quality. A 6MP-to-8MP camera should give you 11-x-14- to 16-x-20-inch prints that look great; a 12MP-to-16MP camera should create good-quality 20-x-30-inch enlargements and beyond.

Nothing's super about superfluous pixels

If you think you can never be too rich, too thin, or have too many megapixels, think again. Megapixels have a dark side, too, Luke. Unnecessary pixels lead to bigger image files — useful when you actually need all those pixels, but they're a potential nuisance if you don't. Few people have the problem of being able to afford a camera that has a resolution significantly higher than they really need, but if you're in that elite class, consider these caveats:

- Excess megapixels eat up your memory cards. All dSLRs store images on solid-state memory cards. I own three cards for my 16MP camera, each of which can store about 300 pictures in the best high-resolution shooting mode. Most of the time, I have plenty of digital memory for any day's shooting, and I can always drop to a lower resolution mode to stretch my memory cards further. However, if I use the same vendor's top-of-the-line 24.5MP dSLR, each card could hold fewer than 200 images at the top quality setting. I'd have to own more memory cards to do the same amount of work!
- Extra resolution taxes your computer. Fat photo files take a long time to transfer to your computer. Your image editor needs fast processing speeds and a lot of memory to manipulate those files, too. Plus, that high-end digital camera that you're lusting after might call for a high-end computer.
- More pixels need more storage. Very high-resolution files can be several times larger than run-of-the-mill high-resolution image files. If you want to keep a lot of these files available on your computer, you need one with a large hard drive. You also probably need a lot of extra CDs, DVDs, or external hard drives on which you can archive them for permanent storage. I discuss storage options in Chapter 5.

Touring through a Digital SLR

The following sections explore the innards of your digital SLR so that you can better understand how to use all its nifty features. At best, these sections give you a better handle on why, sometimes, the results you get when you press the shutter release aren't exactly what you expect. At worst, you can find more convincing excuses to give when you goof.

In some ways, the basics of a dSLR have a lot in common with the conventional film SLR, or indeed, any film camera. All these picture-grabbers share some fundamental components, which I list in the general order of their arrangement inside your camera, as shown in Figure 2-4.

- Lens: Consists of one or more optical components made of glass, plastic, or ceramic; captures light and gathers it to a point of focus inside the camera.
- Viewing system (including flip-up mirror): Lets you see what the camera sees so that you can compose your image and perform other functions, such as evaluating depth-of-field.

Part I: Digital SLRs and You

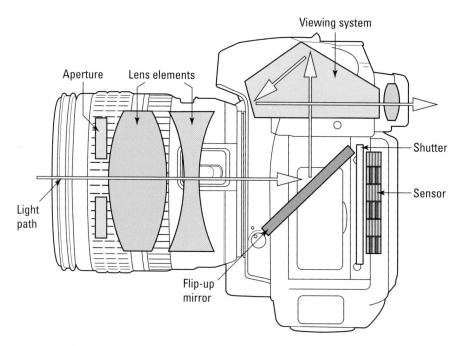

Figure 2-4: The components of a digital SLR.

- Aperture: An opening inside the lens that you can (usually) adjust in size so that more or less light sneaks through into the camera.
- Shutter or other mechanism: Controls how long the light passing through the lens can expose the film or sensor.
- ✓ Light-sensitive component: Whether it is film or with digital cameras, the sensor, captures the illumination admitted through the lens by the aperture for the time duration allowed by the shutter.
- Medium for storing the captured image: The camera needs a way to store the image until you remove it. With a film camera, that medium is the film itself. For a digital camera, the storage is a solid-state film card.

Some of these components, especially lenses, are similar for film and digital cameras. Indeed, many digital SLRs can use the same lenses built for their film counterparts. So, in the guided tour of the dSLR in the following sections, I concentrate on the pieces and parts that film and digital cameras *don't* have in common.

Sensorship

After a night on the town, you might find in the morning that you are extra sensitive to light. Well, a digital SLR's sensor is like that all the time. When exposed to an incoming stream of light-bits (*photons*), a solid-state sensor scoops those light-bits up into little buckets, with one bucket for each pixel.

If each bucket, or *photosite*, collects enough photons to partially fill it to an imaginary line (or *threshold*), which appears as a line on the side of the bucket in Figure 2-5, that pixel registers something other than black. While more and more photons accumulate, the pixel's value gets lighter and lighter until, when the bucket is full, the image-processing software deems the pixel completely white. The intermediate tones register as grays or, in color pic-

tures, as darker or lighter shades of a particular color.

If too many photons are dumped into the bucket, no further tonal changes happen to that pixel, but the excess light-bits can actually overflow to adjoining pixels, causing an unpleasant flaring effect called blooming. After the camera completes the exposure, the bucket full of sloshing photons converts to ice cubes. Well, not actually, but it might help to think of the process of analog (water) to digital (ice cubes) conversion that way. Your computer's bits and bytes can handle a discrete number of ice cubes (expressed in 1s and 0s) a lot more easily than it can work with an amorphous quantity of H_20 .

The camera processes the bits and then transfers them to a memory card, making your camera ready to take another picture. This entire process can happen in $\frac{1}{2}$ to $\frac{1}{3}$ of a second or less (which explains why digital SLRs can take two to ten or more pictures per second).

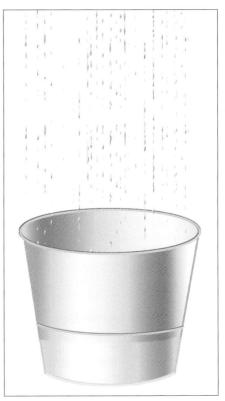

Figure 2-5: A photosite is like a bucket that collects photons.

Two (count 'em), two types of sensors

Today's dSLRs use two main types of sensors: CCD (charge coupled device) and CMOS (complementary metal-oxide semiconductor) imagers. Although each type of sensor uses different technology to capture images, they don't have any inherent quality difference. In any case, CCD sensors have more or less died out, with virtually all digital SLRs today using some form of CMOS digitizing chip.

Both CCD and CMOS imagers use metal-oxide semiconductors (although, apparently, the CMOS type is more complementary), and they have about the same degree of sensitivity to light. The main difference is in what each type of sensor does with the light after capturing it:

- The CCD sensor is dumb. It simply captures photons as electrical charges in each photosite/pixel. After exposure, the charges are swept off the chip to an amplifier located in one corner of the sensor. External circuitry converts the analog signal to digital form and handles storing it on your memory card.
- ✓ A CMOS sensor, theoretically, is a lot more complicated than its CCD counterpart. It includes solid-state circuitry at each and every photosite and can manipulate the data for each pixel right in the sensor. That's pretty cool because it gives the CMOS sensor the capability to respond to lighting conditions in ways that a CCD can't. Sweeping all the photon information off a CMOS chip isn't necessary; every photosite can be accessed individually.

Piling on the components

You get some interesting components piled on top of both sensor types. These components include

- Color filters: Give the colorblind CCD and CMOS chips the capability to respond to various colors of light.
- ✓ Teensy microlenses: Focus the incoming light onto the photosensitive area in each photosite. These components are especially important when you use wide-angle lenses because the photons may approach the sensor from too sharp an angle for the photosites to capture them properly. Although film is flat and can grab light from virtually any angle, the photosites in digital sensors are recessed below the surface, and capture photons best when these minuscule lenses steer those photons toward the light-sensitive areas.
- ✓ A protective transparent layer: Contains a special filter (an *anti-aliasing filter*) that smoothes out the incoming light signal by eliminating certain frequencies of light before they can clash with each other. This layer

also includes an *infrared cutoff filter*. This filter removes most of the infrared (IR) light component from the illumination that reaches the sensor (so-called IR contamination can affect image quality and produce off-color colors). Some also include an antistatic, dust-repelling layer.

✓ A sensor-moving mechanism: Rattles the sensor to shake off dust when it accumulates on the protective layer. Some dSLRs, from vendors other than Canon and Nikon, also include a more sophisticated sensor adjustment feature that shifts the position of the sensor in response to camera shake. The result: It cancels out vibration and provides *image stabilization*. Canon and Nikon build an anti-shake feature into specific lenses, rather than into the camera body (which Sony, Pentax, Olympus, Samsung, and others do).

The average photographer probably finds the color filter layer of most interest because these filters make color photography possible. The sensors in dSLRs do a fairly good job of registering the brightness in a scene. However, these pixel grabbers are totally colorblind on their own.

So, a tiny color filter overlays each individual photosite, as shown in Figure 2-6, that renders it sensitive *only* to a single primary color of light: red, green, or blue. These colors can combine to produce all the intermediate hues, such as yellow (red + green), cyan (green + blue), or magenta (blue + red). All three colors (red, green, and blue) added together produce white. Your TV set and computer display use the same color system to show colors, and any image editor can manipulate them, which a digital photographer can find highly convenient.

The (now) color-sensitive pixels are arranged in a matrix of alternate rows of red-green-red-green-red-green photosites and blue-green-blue-green-blue-green photosites. Green gets twice as many pixels as each of the other two colors because of the way our eyes perceive color. (Humans are most sensitive to green light.) This arrangement is called a *Bayer pattern* (see Figure 2-7), after Dr. Bryce Bayer, the Kodak scientist who developed the process.

A green, red, or blue pixel might not be lucky enough to receive light that's colored its designated hue. So, the camera takes all the information and uses the color of surrounding pixels to calculate (or *interpolate* — that word again!) the most likely true color of a particular picture element. With at least 12 million pixels to work with, this interpolation (called *demosaicing*, for terminology nerds) generally provides a good representation of the actual colors in a scene.

Figure 2-6: The parts of a sensor.

An exception to this scheme is the Foveon sensor. The exotic (and somewhat rare) Sigma dSLRs use this sensor, and it employs a special kind of CMOS imager that doesn't use the Bayer filter pattern at all. Instead, it has three separate photosensitive layers, one each for blue, green, and red (stacked in that order, from top to bottom). During exposure, each pixel absorbs the

blue light first (if present), then green, and finally red while the photons work their way through the layers. The camera doesn't need to do any interpolation, and each and every pixel can detect each color of light. Although Foveon technology sounds pretty cool (and it is!), the company still needs to work out some kinks — the sensor hasn't seen wide use to date.

()())	11111	目目
/////		11

Figure 2-7: Part of a Bayer filter array.

Understanding noise and sensitivity

Imagine that you are driving along in your convertible with the top down, wind whistling in your ears, and the satellite radio playing some cool tunes. This situation is pretty great, but it would be even better if you could *hear* the sounds coming from the radio. So, you crank up the volume — but you really can't hear the music much better. Welcome to the wonderful world of background noise. Unfortunately, digital photography has its own equivalent background noise.

In the digital camera realm, *visual noise* is what you get when you crank up the sensitivity of a sensor so that it can capture the sparse population of photons that exist under dim lighting conditions. This sensitivity is measured in ISO settings, with ISO 800 being twice as sensitive as ISO 400, and ISO 400 having double the sensitivity of ISO 200.

When you amplify the signal created by actual photons striking the sensor, you also multiply the noise produced by random electrical charges generated in the sensor. At low ISO settings, the sensor simply waits until it captures a certain level of photons, and that number overpowers the small number of random noise pixels.

In a digital camera, noise is worse at high ISO settings, at long exposures (because long exposures provide more time for random pixels to be generated on their own), and if the camera has small pixels. I rhapsodize in Chapter 1 about how brilliantly digital SLRs can ignore noise, chiefly because of their large pixels. Still, remember that any digital camera is subject to this curse when you raise the ISO enough or take pictures with a long-enough exposure.

Digital cameras can remove much of the noise caused by long exposures by taking a second, blank frame after exposing the first picture, and then comparing the two. The camera can see which pixels appear in both versions and remove those pixels that appear to be noise. Figure 2-8 shows a long exposure plagued with noise (left) and another photo in which the noise has been silenced with the dSLR's noise-reduction feature (right).

You can find more about noise reduction in Chapter 12.

Figure 2-8: Too much noise (left) and a much quieter photo (right).

The bits that control exposure

You need to understand the controls that adjust the exposure. What's exposure, you ask? A picture's *exposure* is nothing more than the amount of photons available for capture by the sensor. A good exposure requires that the sensor capture exactly the right number of photons. Too few photons, and the image doesn't register at all. Too many photons, and the photo is overexposed.

If a lot of light is bouncing around a scene, a large number of photons can illuminate the sensor in a very brief time. If the light is dim, you might have to wait longer for enough photons to reach the sensor. The important detail to remember is that for any given scene, an ideal exposure exists — one that provides just the right number of photons to capture the image.

Your digital SLR's exposure system is designed to improve your chances of getting that ideal exposure, either by adjusting the length of time the sensor is allowed to suck up photons or by modifying the number of photons that reach the sensor in any particular instant. Make these adjustments by using the camera's shutter speed and lens opening/aperture controls, which I describe in the following sections.

Your exposure time machine

Of course, in a digital SLR, the sensor isn't exposed to incoming light all the time. Instead, it sees photons for a brief interval, dubbed the *exposure time*, usually measured in fractions of a second. The exposure time can extend for many seconds in the case of a *time exposure*.

The gatekeeper that controls these time slices, a sort of exposure-time machine, is the *shutter*. The shutter can be a mechanical device (usually a curtain in front of the sensor that opens and closes very quickly) or an electronic mechanism that activates the sensor for a specific instant of time. Digital SLRs might have both, using a mechanical shutter for exposures measured in seconds from about $\frac{1}{180}$ to $\frac{1}{200}$ of a second and an electronic shutter for exposures in the $\frac{1}{200}$ of a second range.

Longer shutter speeds let in more light but can produce blurring if the subject or camera moves during the exposure. Shorter shutter speeds cut down the amount of light admitted, but they also reduce the chance that movement causes blurriness.

An aperture is a lens opening is an f-stop

You can control photons by using the lens aperture (or the *f-stop*). The *aperture* is the size of the opening through which the photons pass. Think of an f-stop as a pipe: Larger pipes let more light flow in a given period of time,

and smaller pipes restrict the amount of light that can pass. The aperture is a clever little adjustable mechanism that uses a sliding set of overlapping metal leaves to create an opening of the desired size, as shown in Figure 2-9.

To get the right amount of light for an exposure, you need to choose the right f-stop. To choose the correct f-stop, you need to understand three confusing facts about f-stops:

F-stops seem to be named wrong. That is, f/2 is larger

wrong. That is, f/2 is larger than f/4, which is larger than f/8. When the numbers get larger, the

amount of light an aperture can admit gets smaller.

- F-stops don't seem to be properly proportioned. An f/2 opening lets in four times as much light as f/4, and f/4 admits four times as much as f/8. You'd think numbers like 2, 4, and 8 would represent double (or half) as much not four times.
- ✓ F-stops use all these weird intermediate numbers that *do* represent halving and doubling the amount of light passed by the aperture. For example, between f/2 and f/4 is f/2.8, which is exactly twice as large as f/4 and half the size of f/2. The actual sequence of f-stops, each half the size of the preceding aperture, is

f/2, f/2.8, f/4, f/5.6, f/8, f/11, f/16, f/22, f/32

What's going on here? Everything becomes clear when you realize that f-numbers are actually denominators of fractions that represent the size of the aperture opening, just as $\frac{1}{2}$, $\frac{1}{4}$, $\frac{1}{8}$, or $\frac{1}{16}$ represent ever-smaller quantities. So, f/11 allows your camera's sensor to collect more light than f/16 because $\frac{1}{16}$ is a bigger number than $\frac{1}{16}$.

Two of one, half a dozen of the other

As far as the camera is concerned, f-stops and shutter speeds are equivalent. Cutting the shutter speed in half produces the same effect on exposure as using an f-stop that cuts the size of the lens opening in half. You get the same image results if you take two pictures, one that has the exposure twice as long and the other by using an f-stop that's twice as large.

So, if your camera's exposure system suggests an exposure of $\frac{1}{100}$ of a second at f/11, you could reduce the exposure to $\frac{1}{1000}$ of a second (half as long) at f/8, or get the exact same exposure at $\frac{1}{100}$ of a second at f/11 (with the aperture half as wide).

Similarly, various combinations of f-stops and shutter speeds can produce the same exposure value. An exposure of $\frac{1}{500}$ of a second at f/8 is the same as $\frac{1}{1000}$ of a second at f/5.6 (halving the shutter speed, but doubling the size of the lens opening), whereas $\frac{1}{250}$ of a second at f/11 (twice the shutter speed, but half the size of the lens opening) is the same, too. Although these reciprocal relationships might be confusing at first, they become second-nature after a few weeks using your camera.

Taking time out for viewing

Strictly speaking, your camera's viewfinder isn't part of the exposure process. It does have an important role, however: The dSLR's viewing system is one of the reasons (along with lens interchangeability) why people lust after these cameras in the first place.

Non-SLR digital cameras generally use an LCD on the back panel to provide a real-time image of what the sensor sees. This LCD view is often (but not always) coupled with an optical viewfinder window that you can also use to frame the image. That's particularly handy under bright lighting conditions when the back-panel LCD is washed out. Some cameras, called EVF (electronic viewfinder) models (which might physically resemble dSLRs, even though you can't change their lenses), have a second LCD inside, which you can view through a window. This EVF is easier to see in bright light. Mirrorless cameras, like those from Sony, Panasonic, and Olympus, often can use add-on EVFs that clip onto the top of the camera and connect with it electronically to receive a signal from the sensor.

With digital SLR cameras, the default viewing mechanism is through an optical viewfinder that uses the same lens that takes the picture (rather than a separate viewing window). The lens admits light, and a system of mirrors or prisms bounces that light to a viewfinder window, making it possible for you to see exactly what the sensor sees. When you're ready to take the picture, the mirror in a typical dSLR swings out of the way, blanking the viewfinder for a fraction of a second while the light is directed to the sensor to make the exposure.

Compared to the tiny LCD or optical view offered by non-SLRs, you can more easily use the big, bright optical display of a dSLR to compose, evaluate focus, and judge how much of the image is actually sharp, as shown in Figure 2-10.

Figure 2-10: Digital SLR optical viewfinders show a lot of information, along with the big, bright view of your subject.

As I mention in Chapter 1, current dSLRs have an additional feature called Live View, which allows the camera to display the actual image that the lens sees on the back-panel color LCD before exposure. Here are the key considerations of Live View:

✓ What you see may be what you get — mostly. Live View does show you the image that the sensor captures, with a couple of caveats. Although some LCDs show the full sensor coverage, depending on the model, the display may not show 100 percent of the image that the camera will capture (usually true of a dSLR's optical viewfinder, which typically shows 90 percent to 95 percent of the frame). Moreover, the camera usually increases or reduces the LCD image's brightness for easiest viewing under a variety of ambient lighting conditions. So, Live View may not provide a true indicator of whether your exposure is correct. Some

dSLRs have an Exposure Preview mode that brightens or darkens the image while the exposure (that you or the camera sets) changes, giving you valuable feedback. (If you don't have this feature, you can still judge exposure by viewing the image's histogram, as described in Chapter 6.)

- ✓ One or more focus systems. In normal, non-Live View mode, your dSLR's autofocus system uses a special sensor in the optical viewfinder to achieve automatic focus. It does so by using a process called *phase detection*. *Phase detection* works very much like the rangefinders used in surveying and rangefinder-type cameras (natch): It lines up vertical and/or horizontal lines. When using Live View, the mirror is flipped up, so the camera can't do phase detection. Therefore, cameras that have Live View focus either by evaluating the relative sharpness of the sensor image (called *contrast detection*) or by quickly flipping up the mirror for an instant prior to exposure so that the normal phase detection system can operate. (Or by using both methods, at your option.)
- Cluttered screen. Unlike the optical viewfinder display, in which most information appears below the picture array, most Live View previews have much of the data overlaid on the picture area. (See Figure 2-11.) However, you can usually specify how much information you want the camera to provide, so you can trade off less data for a cleaner-looking LCD screen.

Figure 2-11: Live View preview screens sometimes seem cluttered.

✓ Tripod mounting works best. Live View is great for contemplative photography, particularly close-ups or landscape shots, when you want to carefully compose the image on the LCD. You probably want to use a tripod because a secure mount keeps your camera steady while you lock in your composition. It also simplifies the autofocus process. In fact, some vendors call their two Live View autofocus modes Hand-Held Mode and Tripod Mode.

Through the looking glass

All cameras form their images by grabbing light through a *lens*, a series of precision-made elements of glass, plastic, or ceramic. The components are arranged to gather the light and focus it onto the film or sensor at a certain distance, called the *focal length*. Fixed focal length lenses, or *prime* lenses, always produce the same magnification. Other lenses have elements that can shift around in particular ways to change the magnification over a certain range. These lenses are called *zoom* lenses. One of the coolest things about dSLRs is that you can remove a particular lens and replace it with one that provides a different zoom range or has other useful capabilities, such as the capability to focus extra close.

Inside the lens is a diaphragm that can dilate or contract, much like the iris of the eye, to change the size of the aperture. These f-stops not only control the amount of light reaching the sensor, but also affect the amount of an image that's in focus:

- Small f-stops provide large areas of focus (called *depth-of-field*).
- Large f-stops offer a small, sharp focus range (which allows you to throw the foreground or background out of focus and artistically isolate your subject).

The distance of the lens elements from the sensor also controls the overall focus of the picture. You can adjust focus manually by twisting a ring on the barrel of the lens itself or automatically by using tiny motors inside the lens. Some lenses have additional motors that move the elements in response to camera shake or movement, producing a useful vibration-reduction or image-stabilization effect. I explain more special lens features in Chapter 7.

Storage

The very first electronic cameras of 30 years ago stored images on tape recorders! Fifteen years later, the \$30,000 digital cameras that a few daring professional photographers used stored their photos on a bulky hard drive that had to be tethered to the camera by a cable. Today, you're much better

off than those digital-camera pioneers. You can use tiny solid-state devices called *flash memory* to store your photos until you can transfer them to a computer for permanent archiving. A dSLR's storage has two components:

✓ The buffer: Your digital SLR takes the bits siphoned out of the sensor and conducts them to a special high-speed type of internal memory called a *buffer*. Thanks to the buffer, you can continue taking photos while the camera deals with transferring the most recent pictures to the film card.

The size and speed of the buffer determine how many pictures you can take in a row. Digital cameras generally let you take 5 to 30 shots consecutively, and have continuous shot *(burst)* modes good for 2.5 to 10 frames per second for as long as the buffer holds out. A fast, large buffer is better.

✓ Memory card: Memory cards have their own writing speed, which determines how quickly the card can accept images from the buffer. No one has created a standard measurement for this speed, so you can find CompactFlash memory cards (the larger kind used in many intermediate and advanced dSLRs) labeled 40X, 80X, 120X, 133X, 333X, up to 666X (which is close to the theoretical limit in speed), as well as with descriptive terms such as Ultra or Extreme. The smaller Secure Digital memory cards used in many intermediate and midrange dSLRs are marked Class 4, Class 6, Class 10, and so forth, which represents their transfer rates of 4, 6, or 10 megabytes per second.

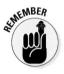

Most of the time, card speed limits your shooting only if you're photographing sports and want to take many pictures in a row. The rest of the time, your dSLR is probably a lot faster than your trigger finger. However, movie-shooting, especially if your camera offers full high-definition (1080p) capture, can also benefit from faster memory cards.

Digital SLRs today generally use either CompactFlash (CF) or Secure Digital/ Secure Digital High Capacity/Secure Digital Extended Capacity (SD/SDHC/ SDXC) memory cards, as shown in Figure 2-12. They're mostly equivalent in speed, cost, and capacity, although SD cards are physically smaller than their CF counterparts. Because of the size, SD cards have found a home in entrylevel and enthusiast dSLR models, while CompactFlash cards are a mainstay among professional models.

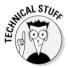

Some earlier and now little-used form factors include miniature hard drives with the CompactFlash form factor, xD cards, or (with an adapter) Sony Memory Stick Pro Duo cards — although manufacturers have generally phased these out, and cameras that use them have become rather rare.

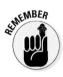

Figure 2-12: Memory cards come in a variety of capacities.

In recent months, the cost of flash memory has plummeted, which digitalcamera users can benefit from because the reduction in cost came at the same time that the basic resolution specifications for digital SLRs increased from 12MP to 16 or 18MP and beyond. More megapixels bring a need for large-capacity memory cards. Today, you can purchase a 16GB memory card for less than *half* what an 8GB card cost a year or more ago, even if you purchase one of the upscale, speedy models that has faster write speeds.

If your dSLR is an older model that uses Secure Digital (SD) memory, check out any cards that have capacities of 2GB or larger to make sure that they're compatible with your camera and your memory card readers. Some older cameras and other devices don't accept 2GB or larger cards at all. To alleviate the problem, a new format, SDHC (Secure Digital High Capacity), has been developed for capacities of 4GB to 32GB, but SDHC works only with products that are explicitly SDHC compatible. SDXC capacities are already available in 64GB and 128GB sizes. All recent dSLRs that use SD-type memory include support for the newer SDHC type of memory, and a growing number support SDXC as well. If you're unsure, check your owner's manual to find out which card your camera accepts. A qualified service rep or technician at your local photography shop may also be a great source.

Dual memory cards

One useful innovation in the dSLR world has been the introduction of cameras with two memory cards, as shown in Figure 2-13. Canon, Nikon, and Sony each offer cameras that tuck a duo of different form factor cards inside (pairing either a CompactFlash card with an SD card, or a CompactFlash or SD card with a Sony Memory stick.) Nikon also has models that have two of the same type of card inside (in several cases. a pair of CF cards; in others, two SD cards). Dual cards offer several cool advantages, which vary depending on whether a particular camera model offers all of them:

Instant backup: You can elect to copy each image shot to both memory cards simultaneously, giving you an instant exact backup. Or, you may be able to opt to copy your JPEG version to

one card and the alternate, RAW

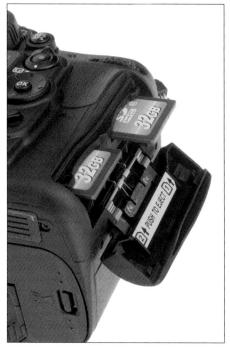

Figure 2-13: Dual memory cards can double your pleasure and offer failsafe protection.

version to the other card, giving you two slightly different backups.

Easy copying: Cameras with two memory card slots may allow you to copy images back and forth between them. At the end of a long shooting day, you can produce copies of your memory cards for backup, or to distribute to your shooting companion/colleague.

Shoot everything with your faster memory card, then copy the images over to a larger memory card for backup or longer-term storage after you reformat the original card.

Movie double feature: Some cameras allow you to specify which of the two memory cards are used to store your movies.

Because of the demands of movies streaming from your camera onto the card, you should select the faster card as the destination for your epics. Or, you simply might want to save movies on one card and stills on the other.

✓ Overflow: Photojournalists, especially, end up swapping out nearly full cards sooner than they have to, in order to avoid losing potential shots at ill-timed exchanges. With two memory cards and the camera set to

overflow operation, you can keep on shooting; the camera will switch over to the second card as soon as the first one becomes full. You can then replace the filled-up card at an opportune moment, if need be.

Overcoming Quirks of the dSLR

If you're entering the digital SLR world from the realm of non-SLR digital photography (or, even, belatedly, from the film world), you may note some significant differences between digital SLRs and other types, which can only be called quirks. They're idiosyncrasies of the dSLR that you must compensate for or grudgingly put up with. Some might even drive you crazy. The following sections offer advice for contending with these quirks.

Out, out damned spot: New trends in self-cleaning sensors

Every time you remove your dSLR's lens to replace it with another, you could be admitting tiny specks of dust that might find their way past the shutter when it opens for an exposure, and get onto the sensor. It may take a few weeks or a few months, but eventually, you end up with artifacts on your sensor. The automatic sensor-cleaning mechanisms built into virtually all common digital SLRs do a pretty good job of shaking off the dust. They include tiny mechanisms that vibrate the sensor at ultrasonic speeds, casting off the dust with blinding speed. The latest models may include a sticky strip at the floor of the sensor chamber to capture dust, coat the sensor overlay with a repellant surface, and use carefully designed airflow within the camera to urge artifacts to settle someplace else.

However, these miracle cleaners are not always 100-percent effective. So, even with automatic cleaning, you can still end up with dust on your sensor. You might not even notice this dust because it's most apparent when you use small f-stops that produce the largest range of sharp focus. (I explain why in the section "The bits that control exposure," earlier in this chapter.) If you take most of your pictures at f/8, f/5.6, or larger, any dust on your sensor might appear blurry and almost invisible in your photographs. In addition, if the dark dust spots happen to fall into dark areas of your image, the darkness masks them.

So, if you own a digital SLR, clean your sensor manually from time to time. You may have to clean your sensor only once or twice a year (with your camera's sensor shaker taking care of the job most of the time). Manual cleaning isn't particularly difficult, and you can find cleaning kits at camera stores and online. Some tips to remember include

- Point your camera downward when you change lenses so that you reduce the amount of dust that infiltrates.
- ✓ If possible, change lenses only in relatively clean, calm environments.

- Don't attempt to clean your sensor with canned air, compressed air blowers, lens-cleaning liquids, or other methods that seem to make sense. The reality is that they can damage your sensor. Use only bulb blowers and swabs intended expressly for sensor cleaning.
- ✓ If you have any doubts about your ability to clean your sensor yourself, let your local camera shop or the manufacturer do it.

Multiplication fables: Working around the crop factor

As I mention in the section "Sensorship," earlier in this chapter, many digital SLR cameras use a sensor that's smaller than the traditional 35mm film frame, even though they typically can use lenses that were originally designed for full-frame cameras. The smaller sensor, in effect, crops out part of the image, so you're using only about 75 percent of the area produced, as shown in Figure 2-14. For example, when you use a 100mm lens, a small sensor images only the center area, capturing an image that has the same field of view as a 150mm lens.

This effect is sometimes called, inaccurately, a *multiplication factor* or lens *multiplier* because you can represent the equivalent field of view by multiplying the focal length of the lens by the factor. In truth, no multiplication is involved. A 100mm f/2.8 lens that you use on a camera that has a 1.5 multiplier is still a 100mm f/2.8 lens and provides the exact same image. The camera just crops the image to a smaller rectangle. The preferred terminology is *crop factor*, although that isn't 100 percent accurate, either. The assumption is that a 24 x 36mm frame is "full," when, in fact, there are other digital cameras with even larger full-frame sensors (measuring as much as 48 x 36mm in the "medium format" world). Common crop factors in today's dSLRs are 1.3X, 1.5X, 1.6X, and 2X. A camera that provides a full-frame image, with no cropping at all, is sometimes said to have a 1X crop factor.

The crop factor affects your picture-taking in two ways:

✓ Your telephoto lenses seem to be magically converted to much longer focal lengths. A 200mm telephoto lens becomes a 300mm telephoto lens; a 400mm-long lens is transformed into a 600mm super-telephoto lens. Of course, you get identical results by taking the same picture with a full-frame camera and cropping the image, but it's a convenient fable, even so. ✓ The view of wide-angle lenses is cropped so that they no longer take in as much of your surroundings as they would on a full-frame camera. A nice, superwide 20mm lens on a camera that has a 1.6X crop factor has the same field of view as an ordinary 32mm wide-angle lens. A useful 35mm wide-angle lens view, such as the one shown in the upperleft in Figure 2-14, becomes the mundane 56mm normal lens perspective, as shown at lower-right. The crop factor means that, to get a true wideangle view, you have to purchase expensive, ridiculously wide lenses, such as the popular 12mm-to-24mm lenses offered by Sigma, Tamron, and Tokina, and previously by other vendors, including Nikon.

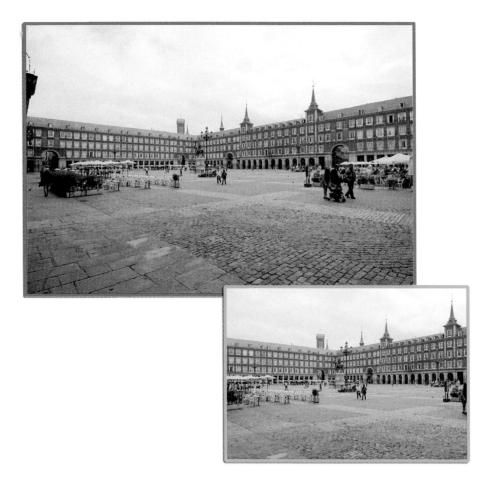

Figure 2-14: A wide-angle shot (upper-left) loses its wide perspective because of the typical 1.5X crop factor (lower-right).

Part I: Digital SLRs and You .

Most affordable digital SLRs (up to the \$1,500 price level) use small sensors that provide this crop factor. Nikon, Sony, and Pentax offer entry-level and intermediate cameras that have a 1.5X crop factor. Canon's non-pro offerings all use a 1.6X crop factor, and Olympus and Panasonic lead the way among the Micro Four Thirds troops with 2X crop factor.

However, so-called *full-frame*, or 1X-crop-factor cameras, have become more affordable in recent years. Although Nikon and Canon still ask megabucks for their full-frame pro cameras, several 1X cameras from Nikon, Canon, and Sony are each priced in the \$2,000 to \$3,000 range, with resolutions ranging from 12MP up to 25MP. Of course, full-frame cameras require lenses made specifically for the large sensors (although these lenses are also compatible with cropped-sensor cameras). I discuss this factor in detail in Chapter 7.

Tracking the Ideal dSLR

In This Chapter

- > Factoring in future features and your future needs
- > Looking at camera types and your photography requirements
- Choosing among key features

hen you upgrade from your first digital camera to a digital SLR, the stakes increase dramatically. A dSLR generally costs quite a bit more than the average point-and-shoot digital camera, so you want to make the right purchase the first time. You also want to buy into a camera product line that has all the accessories you may want to buy in the future. Owning a very cool digital single lens reflex camera is little comfort if you can't find that special external electronic flash that you need or an underwater housing that you absolutely must have.

The high stakes extend into the future, too. The dSLR that you buy now will grow when you add lenses and other accessories, and you want to be able to use those same add-ons with whatever camera eventually replaces your current pride and joy. SLR camera buyers have known for years that you can easily get locked into a particular camera system, so selecting the right camera today is a little like choosing a spouse. If the photographic marriage doesn't last forever, it can be full of heartache. And starting over with a new mate can be expensive.

This chapter helps you choose your ideal dSLR now to ensure your future happiness.

Part I: Digital SLRs and You .

Features for Now and the Future

Some have said that once, in the 1950s, a world-famous photographer was preparing to shoot a portrait of an important business executive. The captain of industry watched him set up and made conversation by observing proudly, "I see you use a Leica. So do I." Cracking a faint smile, the famed lensman replied, "I see your secretary uses a Royal typewriter. So does Hemingway."

The best camera in the world can produce mediocre pictures in the hands of a clumsy photographer. Conversely, a creative mind can produce stunning images when armed with the simplest of cameras. Figure 3-1 is far from a stunning photograph, but I took it with a \$200 point-and-shoot camera and a pair of \$10 high-intensity desk lamps for illumination. I didn't use any fancy close-up or macro lenses. You don't need an expensive camera to take good pictures.

Figure 3-1: A \$200 camera took this photo; you don't need an expensive camera for creative photography.

Of course, you don't have to tie one hand behind your back to make sure that you concentrate on composition and capture the decisive moment. So, consider the full range of available features when choosing your camera, recognizing that you might not be able to justify them all right now. Divide the features you're considering into these three categories:

- ✓ Features you need: These are the capabilities you really must have for the kind of photography that you do. Perhaps you shoot in low light levels and require a fast lens that lets you grab images without flash. Or you specialize in sports photography and must have a dSLR with a 3-to-4-frames-per-second (fps) shooting rate or better. If you plan to shoot a lot of time-lapse photography, you probably want a camera that can take pictures while powered by AC current and tethered to a laptop computer, either through a cable or by a Wi-Fi link. Make a list of your must-have features and keep them in mind when searching for your ideal camera.
- ✓ Features you want: These features aren't absolutely essential for the majority of your photography, but they might come in handy or expand your picture-taking opportunities. You probably consider how much extra you have to pay to get these features. You might want to take wild-life photos without a tripod, so you want the availability of long lenses with built-in image stabilization features. Still, if you can't afford such a lens, you can probably get by almost as well with a good tripod (despite the extra weight to lug around). Your nice-to-have features aren't deal-breakers, but they can tilt your preferences from one camera line to another.
- ✓ Features you want to get, but can't (yet): A few capabilities are totally out of your reach either because they're too expensive or not available for the camera models you're considering. Deposit these features in the What Ifs category. These features just might filter down to you someday (perhaps more quickly than you think). Perhaps you want image stabilization built into the camera itself so that just about every lens you own gains anti-shake capabilities. If that's what you want, you can find it in an increasing number of cameras, including Sony Alpha, Olympus, and Pentax models.

Breadcrumbs on the Upgrade Path

You may find the capability to upgrade your dSLR in the future tempting, like alluring breadcrumbs sprinkled on the path through the dark woods of the future. Plan now to make sure these crumbs haven't been gobbled up by the time you choose to add to your dSLR system.

Part I: Digital SLRs and You _____

The following tips can help you choose a camera that has great upgrade potential:

Look at how particular vendors have handled the evolution of their lens systems when they've added features.

- The Pentax line of dSLRs is capable of using KA and K mount lenses, older Pentax screw-mount lenses dating back decades, and even some lenses intended for medium-format cameras if you have the proper adapter.
- The latest Nikon dSLRs (except for the company's most basic entry-level models like the D3100) can use virtually any Nikkor lens dating back to 1959, although some lenses require slight modifications. (The entry-level models can autofocus only with lenses that have built-in focusing motors.)

Of course, automatic metering and focusing aren't possible in all cases for very old lenses built before these features were invented!

- Although all Canon EF-series lenses work fine with any EOS camera (film or digital), you can use the company's EF-S-series lenses only on the latest consumer-oriented dSLR Canon models, such as the entire digital Rebel line, such as the T3i, as well as the EOS 20D/30D/40D/50D/60D, plus the 7D.
- ✓ Explore how well a vendor supports its older model cameras and flash units. Vendors are continually improving their dedicated electronic flash units. As a result, the latest speedlights might not be compatible with newer or future cameras. Some flashes might not function with full through-the-lens metering, but you can operate them in semi-automatic modes that have exposure-measuring cells built into the flash itself. You may not be able to use others in wireless mode without special adapters. For details on using electronic flash, see Chapter 10.
- ✓ Figure out which filter size fits the most lenses. Especially before making an investment in polarizers, infrared filters, and close-up lenses that can be fairly expensive. A film SLR that I worked with for many years used the same size filter on nearly all its lenses, so I could safely buy as many of these screw-on accessories as I wanted. I knew they wouldn't become obsolete when I added a new lens. Today, vendors might offer lenses that use a bunch of different-size filters. You might own one lens that takes 62mm filters, another that calls for 67mm add-ons, and a third that takes 72mm accessories. You might find that the clearest upgrade path is to buy the largest filters and then adapt them to other lenses by using step-down rings, as shown in Figure 3-2.

Figure 3-2: You might be able to use one set of filters on several different lenses by using adapter rings.

Cameras of Today and Tomorrow

Only a few years ago, dSLR cameras came in only one category — expensive. You could expect to spend at least \$5,000 for a digital SLR from Canon, Nikon, or Kodak, and be thankful that the camera was that affordable. After all, it wasn't long ago that digital SLRs cost upwards of \$30,000, used a tethered 200MB hard drive, and gave you 1.3-megapixel photos!

Of course, dSLRs of the late 20th century were built on rugged professional camera bodies, and they housed very expensive sensors. The Kodak DCS 460 of more than a decade ago was basically a common Nikon F90 body with a very, very costly 6MP imager built in. Although some digital SLRs that cost as little as \$2,000 (for the body alone) made an appearance, it wasn't until the original Canon Digital Rebel was introduced in 2003 at less than \$1,000 (with lens) that the new category of basic consumer dSLR was born.

Although the distinct camera categories that I cover in the following sections have some overlap, these categories are still aimed at particular classes of buyers.

Basic dSLR cameras

The basic dSLR is the newest type of digital camera that has interchangeable lenses. These cameras are stripped-down versions of more advanced digital SLRs, aimed specifically at photographers who are looking to step up from point-and-shoot models but don't necessarily want full-fledged systems that include all the bells and whistles. Typical cameras in this class include the entry-level Nikon, Canon, Pentax/Samsung, and Olympus. A typical compact basic dSLR is shown in Figure 3-3.

Figure 3-3: Basic dSLR models boast very low price tags but a lot of useful features.

Priced at around \$500 to \$600 (with lens), basic dSLRs compete directly with the more expensive point-and-shoot, non-dSLR cameras in the same price and megapixel range, as well as the mirrorless models in the Sony NEX, Olympus PEN, and Panasonic DMC-GF line. The point-and-shoot cameras might have non-interchangeable zoom lenses that have a longer range (12:1 or more) while offering a smaller, lighter, more portable package. Mirrorless models are light, too, but can use interchangeable lenses.

I avoid calling basic dSLRs entry-level models because that implies a tendency to move up and beyond the original dSLR to more advanced cameras, lenses, and accessories. In practice, a surprising number of people who buy these cameras are perfectly happy with the capabilities they have and may stick with their new dSLRs for years. Many of them never buy another lens. They get great results with their basic dSLR and its kit lens, and they have no interest in upgrading. It's terrific that vendors have recognized this important type of snapshooter and have provided affordable cameras with the features casual photographers need. Indeed, I was surprised to find that a very inexpensive Pentax model dSLR that I purchased had sophisticated weather sealing and advanced features that I would have expected in a much more costly camera.

The advantage of an entry-level dSLR over a comparably priced point-andshoot camera is usually faster operation and better image quality (even when matched in the megapixel department), plus the capability to exchange lenses. Compared to the mirrorless models, even the most modest entry-level dSLR has a more convenient optical viewfinder.

Those who never plan to buy additional lenses find the quality of the pointand-shoot non-SLR adequate. And people who don't shoot demanding subjects, such as sports, are happy with the point-and-shoot models, especially the models that offer a bit of manual control. Both groups prize the pocket size of point-and-shoot cameras and will actually pay *more* for an extra-tiny shooter. But more serious photographers take a basic dSLR at the same price every time.

Of course, these basic dSLR models lack a few features that their more advanced brethren have — but, boy, are they affordable! You might be happy with one of these as your main camera or as a second camera body, particularly if your budget is tight.

What do you give up? Most of the most basic dSLRs sacrifice a few features that you might never or rarely use. These may include depth-of-field preview, shutter speeds faster than ¼000 of a second, or the speediest continuous-shooting bursts. Some of the cost-saving measures add some inconvenience: Your basic dSLR might have only one command dial, so you need to press a button to switch between setting the shutter speed and aperture. Many skip the traditional top-panel monochrome LCD (liquid crystal display) status display and show all shooting information on the color LCD on the back of the camera.

Still, what you give up to save several hundred dollars might be insignificant if it means you can get behind the wheel of an honest-to-gosh dSLR today.

Part I: Digital SLRs and You $_$

Enthusiast dSLRs

What I think of as *enthusiast* dSLRs are a step up from the most basic models and provide a true launching point for avid photographers who need to get into digital SLR shooting at minimal cost, but insist on plenty of opportunities for enhancing their capabilities later with new lenses, flash units, and accessories.

These dSLRs start at about \$800 (often including a basic zoom lens) and range to about \$1,200. These models are available from Nikon, Canon (as shown in Figure 3-4), Pentax, Sony, and other vendors.

Figure 3-4: True entry-level enthusiast dSLRs start at less than \$1,000 and have a full set of features.

These cameras don't sacrifice many features; the corners are cut in ways that probably don't affect the typical photo enthusiast. For example, many cameras in this class (but not all) are built around rugged polycarbonate bodies rather than the almost-indestructible magnesium camera bodies found in upscale cameras. The viewfinder systems might use pentamirrors that are a little dimmer than the pentaprisms found in pro cameras, and magnification through the viewing system might be lower. It's common for these dSLRs to have much less sprightly continuous shooting modes, too.

For anyone who could never justify spending \$1,800 or more on a dSLR, these models offer just about every needed feature with enough megapixels to produce high-quality pictures, indeed. They form an excellent foundation for building an arsenal of lenses and other accessories that remain useful even when the photo enthusiast upgrades to a newer model in the future.

Advanced amateur/semi-pro dSLRs

The next step up from enthusiast dSLRs are the *advanced amateur/semipro* models. These cameras are intended for more-experienced, advanced amateur photographers, but outfitted with enough features to make them attractive to professionals as a second camera body. Indeed, some pros who have light-duty shooting requirements (perhaps because their work is more contemplative and they don't fire off thousands of shots a day) use them as primary cameras. In truth, of course, no hard-and-fast set of features makes a particular camera a pro camera. Professionals can get excellent photos from any model that they care to use.

These dSLRs start at about \$1,200 (for the body only). These models are available from Canon, Nikon, Sony, Olympus, and others.

Like entry-level enthusiast cameras, these cameras trim a few features to achieve their affordable cost and may use plastic bodies rather than the almost-indestructible magnesium camera bodies found in the pro cameras. They might lack built-in vertical camera grips and easy plug-in remote controls that professionals require. They typically fire off fewer shots in burst mode, typically from 3 to 5 fps, whereas pro models usually have 8-to-11-fps capabilities.

Professional dSLR models

Although some models are priced in the \$3,000 range, most professional dSLRs set you back a bit more — up to five to eight grand. (See Figure 3-5.) If you're selling your work, the camera is well worth the cost. Cameras in this class include the Sony Alpha DSLR-A850; Nikon D3s, and D3x; Canon EOS-1D

Part I: Digital SLRs and You _

Mark III, EOS-1Ds Mark IV, and EOS 5D Mark II. These models take you all the way from 12MP up to a lofty 25MP (or beyond) and can, arguably, meet or exceed the image quality of the best film cameras.

Figure 3-5: Many of the leading professional dSLRs have full-frame (1X crop) sensors, such as this model.

What do you get for thousands and thousands of extra dollars? Here's a quick checklist of what your extra cash buys:

Tanklike reliability: Okay, I really have no experience with how reliable tanks are, but they must be pretty good if being built like a tank is a positive. Pro dSLRs have metal bodies, excellent sealing against the elements, and rugged controls and components, such as shutters that can operate thousands of times without failing. A typical professional might

shoot more pictures in a day than an amateur photographer takes in a year. I know one canine photographer (he isn't a dog; he photographs Pomeranians) who recently passed the 500,000 exposure mark with his pro camera and its original shutter. Professionals can't afford to have a camera wimp out at the worst possible moment. So, professionals often purchase these cameras for the cameras' ruggedness alone. Even then, pros commonly buy multiple bodies in order to have a backup (or two or three).

- ✓ Faster operation: Pro cameras generally have the most advanced autofocus systems available from a vendor, so they can take pictures *right now* without delay or shutter lag. They have large internal memory buffers that suck up exposures as fast as you can take them. And the speedy digital image chips process the bits and bytes, and then write them to your memory card. Exposure systems, too, are top-notch, both in accuracy and speed. Professional dSLRs are veritable speed demons.
- ✓ Faster burst modes: Whereas prosumer dSLRs are considered speedy if they can capture continuous-mode pictures at 3 fps, pro cameras typically can grab 4 to 11 fps without sweating. Those big memory buffers (to store images until they can be written to the memory card) and digital signal processing chips make this speed possible.
- ✓ More options: Pro cameras let you set up multiple sets of shooting parameters and recall them at the press of a button, so you can tailor your camera's operation to particular environments. You might find other choices not available to lesser cameras, such as the capability to save images in either compressed or uncompressed RAW format, TIFF, and multiple levels of JPEG quality. (Find out more about file formats in Chapter 9.)
- Bigger sensors: Some pro cameras offer larger, full-frame sensors, which can be an advantage to pro shooters. These sizeable, non-cropped sensors are available from Sony, Nikon, and Canon, and a few so-called medium-format dSLRs, such as those from Mamiya and Hasselblad. (Chapter 2 explains lens crop in detail.)

Rebirth of mirrorless and EVF alternatives

A strange thing happened after the first low-cost digital SLR cameras emerged onto the market. The cameras positioned at the former high end of the amateur/photo-enthusiast market were suddenly described as SLR-like. These cameras happened to be priced about the same as the new dSLRs but, originally, didn't have interchangeable lenses. They did have a form of throughthe-lens viewing that lesser point-and-shoot cameras lacked, so they became SLR-like, and now you sometimes hear them called *bridge* or *transitional* cameras. Many of them have packed the most zoom range possible into their optics and are referred to as superzoom cameras. What's the story here?

In their time, cameras sporting *internal electronic viewfinders* (a miniature LCD inside the camera) were the next best thing and were all that serious photographers who had limited bank accounts could afford. Their viewing systems were far superior to the optical viewfinder windows that supplemented rear-panel LCDs in point-and-shoot cameras. You could use these electronic viewfinders (EVFs) to compose your shots accurately, even in bright sunlight, and with luck, monitor depth-of-field. Many of them were designed with real controls, including zoom rings, rather than the motorized gadgets and buttons the point-and-shoot cameras used.

Although justifying non-SLR cameras' existence in these days of \$500-neighborhood dSLRs is tough, new wrinkles have made them a viable alternative again. Some EVF cameras manage to live on by providing features that you can't get in cameras that have interchangeable lenses, such as a fixed 18X zoom (the equivalent of 28mm to 504mm.) Sony's SLT (single lens translucent) camera line uses the same interchangeable lenses as its true dSLR Alpha models, but has a transparent mirror that diverts 30 percent of the illumination to the autofocus system, and 70 percent to the sensor. These cameras use an internal EVF or the traditional back-panel LCD for viewing and composing images, but, without the need to flip a mirror up and down for each shot, are able to snap off pictures at a 10 fps clip.

Another new category includes the mirrorless models. These cameras, such as the one seen in Figure 3-6, *do* have interchangeable lenses, using either a lens mount called *Micro Four Thirds* (from vendors such as Olympus and Panasonic), or a proprietary lens mount (from Sony and others.) Although only a relatively small number of lenses may be available for mirrorless cameras, they can be mated with very tiny and compact bodies. That makes them perfect for people who want to be able to swap lenses, but don't want to tote around a larger dSLR. However, if you don't want to compose your images on the back-panel LCD, you need to purchase an optional clip-on EVF for these mirrorless cameras.

If you're reading this book (and obviously, you are, thank you very much), you probably are irreconcilably biased toward a digital SLR. However, an EVF/superzoom/mirrorless camera can make a good vacation camera when you're traveling extra-light, or be useful as a spare camera or a fall-back camera for when you can't or don't want to take your dSLR.

Figure 3-6: Mirrorless interchangeable lens models are ultra-compact.

Checking Out Key Features

When you approach your final purchase decision, look at the individual features of the cameras that you're considering and how those features affect you. I cover most of the main topics in the following sections in more detail in Chapter 2. (Chapter 8 has information on special features.) The following sections summarize what you need to know.

Make a list of features and divide it into three categories, as I explain in the section "Features for Now and the Future," earlier in this chapter. This list can help you decide which camera best suits your needs.

Lenses

The capability to swap optics is the reason why the word *lens* is so important in the abbreviation SLR. Some factors to consider when choosing a camera include

Lens quality: Are the lenses of a particular vendor known for their quality, both optically and mechanically (what's known as *build quality*)? Does this vendor offer multiple lens lines that include economy lenses, which might be a little less rugged but affordably priced, as well as pro-style lenses that have the ultimate in sharpness and ruggedness? Depending on the type of photography you do, trading off a little weight and replacing a few metal parts with tough plastic might be important. Or, you might require lenses that can take punishment and still deliver sparkling results.

Part I: Digital SLRs and You

- ✓ Focal length ranges: Some vendors are stronger in the telephoto lens department and weaker when it comes to providing wide-angle lenses. Canon, for example, sells an amazing array of long lenses, many with built-in image stabilization, and offered at amazing prices. Nikon has some exquisite wide-angle lenses. Some vendors do a better job with certain kinds of zooms than others. Make sure that the vendor of the camera you're contemplating offers lenses in the focal lengths and maximum apertures that you require. If not, see whether you can fill in the lenses you require from third-party vendors, such as Tokina, Tamron, and Sigma. These manufacturers' optical offerings might be completely satisfactory or they might not. See whether the lenses you need are readily available at a price that you can afford.
- ✓ Special features: Focal lengths, zoom ranges, and maximum aperture aren't the only features that you want in a lens. You might need close focusing, fast autofocus (which is partially dependent on the design of the lens), or the ability to control the out-of-focus areas of an image. (Nikon, for example, has a line of DC lenses that are great for portraiture because you can control how the defocused areas look.) So-called *tilt-shift* lenses are also becoming popular because of their capability to change the orientation of the lens elements to match the perspective of your subject to extend depth-of-field (or, when used in the opposite way, to create the popular tilt-shift/miniature effect).

Sensors and image processors

The sensor and digital signal processor have as much effect on your final image as the lens does, so be sure to check out the qualities of your dream camera's imager very carefully. In particular, look into the following. You'll find comparison information about various dSLR cameras at review sites like DPReview (www.dpreview.com):

- ✓ The amount of noise it generates at low ISO settings (ISO 100 or ISO 200) and at high ISO settings (ISO 1200 and above): Some photographers like the low noise produced by the prosumer Canon digital cameras, compared to that of competing Nikon dSLRs. Others find the Canon images so smooth that they look plasticky, and those people prefer the extra sharpness and texture of the Nikon sensor. Chapter 12 tells you more about noise.
- The sensor's dynamic range: Do your photos have detail in both shadows and highlights? Does the camera produce accurate colors? Do the images look sharp? If you answered no to any of these questions, you probably need to keep looking for the right camera.

CMOS (complementary metal-oxide semiconductor) and CCD (charge coupled device) sensors show little difference in quality these days, but significant differences exist among sensors from different vendors. Do some comparisons now so that you can be happy with your camera later.

Exposure systems

Exposure systems range from simple spot metering, to center weighted, to complex evaluative systems that examine a huge matrix of points to arrive at the correct settings. Often, all three systems dwell in harmony together in one camera. To better understand exposure systems and how they can affect your work, check out Chapter 6 before you select your camera.

Focusing systems

The focusing system of a dSLR partially depends on two factors:

- Mechanisms: Built into the lens; move the lens elements to the proper position at the camera's direction
- Electronics: In the camera; evaluate the image to decide exactly where the correct focus point is

That's complicated stuff! Yet, if your image is out of focus, odds are that your picture is totally ruined. You can often partially or fully correct for improper exposure. Color-correction tools in an image editor can fix bad white balance. You can crop your photos to remove extraneous subject matter. But if your image is badly out of focus, you should end its suffering by pressing Delete.

You definitely want a camera that has an efficient autofocus system and one that focuses accurately, both when you're using the optical viewfinder and when you're working in Live View mode to preview your image on the LCD. You sometimes need to specify what point the camera should use as the point of focus, especially when your main subject is *not* in the center of the viewfinder. Find out whether the camera locks focus when you press the shutter release halfway down or whether it can continue to seek a focus point for moving subjects right until the instant of exposure.

You might appreciate a camera that can predict where the focus point *will* be when a moving object is racing toward or away from the camera.

Part I: Digital SLRs and You

You might want the capability to switch quickly to manual focus by using a switch — either on the lens or on the camera body — as shown in Figure 3-7. Some kinds of photography, particularly macro (closeup) photography, work best when the photographer has complete control over focus

Special features

Digital SLRs are rife with special features, such as the capability to shoot movies. You can find enough of these special features, in fact, that I devote Chapter 8 to describing features such Figure 3-7: A convenient switch on the camera as movie-shooting, extra-fast burst

modes, anti-dust features (which literally shake the debris off your

or lens enables you to quickly change from automatic focus to manual focus.

sensor before it can appear in your images), image stabilization, time-lapse photography, and so forth.

If you have specialized needs, you might have special requirements. For instance, if you like to photograph the progress of blossoming flowers or construction, you might require the capability to connect to a computer by using a USB connector and capture time-lapse images. Or maybe you want to shoot movies by using your dSLR and need an HDMI port to connect to your HDTV. Both types of ports are shown at right in Figure 3-8. Perhaps you've discovered that the vibration of the flip-up mirror in an SLR spoils your critical close-up or telephoto shots, so you want a camera that has pre-shot mirror lockup. Maybe you want to be able to instantly transmit your photos wirelessly to a laptop computer for immediate review by an assistant. If infrared photography is your most important application, you need a camera that's especially sensitive to infrared illumination.

If you do have specialized camera needs, pay particular attention to how well your potential new digital camera fills them. Nothing is more frustrating than having a hard-to-fulfill requirement while owning a camera that's just a little less than what you require in that department.

The special features to consider when buying a camera are covered in more detail Chapter 8. They include:

Chapter 3: Tracking the Ideal dSLR

- ✓ Built-in HDR: Cameras from Sony, Nikon, and others have the capability to take several shots of the same scene at different exposures, and combine them to produce a single image with an extended, high dynamic range (HDR.) This feature makes it possible to get good pictures under very bright, contrasty conditions.
- Sweep panorama: Sony has pioneered the ability to rotate the camera during a series of exposures to produce a final image that provides a sweeping panoramic view. Great for landscapes!
- ✓ 3D photography: Sony again has come up with an innovative feature that produces threedimensional images, although, lacking special display hardware to view them, you may enjoy the 3D effect only when reviewing the images on your camera's LCD.

Figure 3-8: A USB port (top socket at right) and HDMI port (bottom right) allow you to connect your camera directly to a laptop computer or HDTV, respectively.

- ✓ Wi-Fi: Although some point-and shoot cameras have the capability to transmit images directly to a computer over a wireless link (and upscale dSLRs have been able to do this with expensive add-ons in the past), today just about anyone using a camera with an SD card slot can insert an Eye-Fi memory card. Then, after a few minutes' setup, they can beam their photos to their computers, smart phones, and social networking sites like Facebook and Flickr.
- Burst modes: Burst, or continuous shooting modes let you shoot many pictures consecutively at relatively high speeds, from 2.5 frames per second on up. You don't need to be a sports photographer to use this feature — if you have fast-moving children or pets in your sights, it's a shot-saver.
- Anti-Dust: Virtually all dSLRs have this dust-busting feature, which shakes artifacts off your sensor before they can appear in your photos.

Part I: Digital SLRs and You _____

- Anti-Shake: Built into the lens or camera body, vibration reduction gives you sharper pictures by reducing camera motion during exposure.
- ✓ Movie-shooting: The Nikon D90 was the first dSLR to include moviemaking capabilities. Now virtually all models have it, and the trend is toward full HD capabilities at 1920 x 1080 pixels, and, in some cameras, the capability to shoot stereo sound.

Saving and Archiving Your Photos

In This Chapter

- Adding memory storage
- Considering your backup storage options

ne of the best things about dSLR cameras is that they're almost infinitely expandable. Hundreds of lenses are available, of course, but that's another whole level of accessorizing. I'm talking about add-ons that let you focus closer, operate your camera more efficiently, hold your camera steady for long exposures, or do things that you otherwise couldn't do at all.

I'm sure you already know about some of the accessories in this chapter and the next one. Some are a bit more obscure, though. Only a few of them, such as memory cards, are absolutely essential for taking photos. However, you might take comfort in knowing that you can find so many tools available if you want them, especially in the memory card arena.

Memory Cards in a Flash

Most digital SLRs are furnished without any memory card at all, so you need to buy one as soon as you get your camera. Of course, even entry-level point-and-shoot digicams frequently come without a card or are furnished with a useless small-capacity card, so this omission comes as no surprise.

Whereas low-end cameras come with no card to save costs, more sophisticated cameras (such as a dSLR) lack a memory card because the vendor likely doesn't know exactly what kind of card you prefer. By not including any memory card at all, your camera vendor is upholding your right to choose the card that exactly suits your needs. So, when choosing a memory card for your digital SLR, consider the following key factors:

- Write speed: Perhaps you shoot a lot of sports and want to use only high-speed memory cards that can suck up bursts of shots as quickly as vou can take them.
- Capacity: With most dSLRs, a 4GB card is almost useless because of its low capacity. You might not want to bother carrying around any card smaller than 8GB. With resolution on the increase, many dSLR owners have standardized on larger cards of 32GB (or even more) capacity, as shown in Figure 4-1. Actual capacity of a card varies widely, depending on camera resolution, whether you're shooting RAW. JPEG, or both. the type of subject you're photographing (the level of detail in subjects determine how "squeezable" or compressible they are.) If you're shooting movies, your camera may have four or five different movie resolution options, as well. A 16GB memory card may hold as few as 300 shots. or as many as 3,000, and have room for an hour's worth of movies - or many hours of clips. Your camera's owner manual will have a table or chart that will help you roughly estimate the capacity of a given memory

card for your model in both still photography and movie modes.

Form factor: You usually don't need to consider the physical form factor of the memory card - unless vou have a camera that accepts more than one type of media. Maybe vour digital SLR accepts both CompactFlash (CF) and Secure Digital (SD) memory cards. A few do, and at least one camera accepts both SD cards and xD Picture Cards. Sony dSLRs have traditionally accommodated both CompactFlash or SD cards Figure 4-1: A 32GB memory card provides and Sony Memory Stick Pro Duo plenty of capacity. cards.

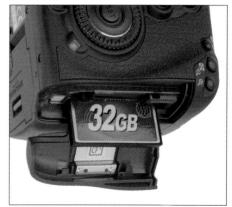

In the following sections, I explain the three main considerations in more detail.

The right write speed

Memory cards operate a little bit like hard drives in the sense that some of them can write data faster than others. Although cards don't have the rotating platters that hard drives have, they do have electrical properties that limit the speed with which they can accept and store information.

Real-world write speeds typically range from about 3MB per second to about 30MB per second, and they depend greatly on the speed of your digital camera. You might be able to use a particular card at 3MB per second in one camera and at 8MB per second in another that does a better job of writing information quickly. However, the speeds are proportional: A card rated as a better performer works faster in all the dSLRs that you use it with, regardless of the actual speed and regardless of the type and size of the file being written:

- CompactFlash cards are typically rated by speed factors such as 40X, 133X, 400X, and so forth.
- Secure Digital (SD) cards are assigned Class labels, such as Class 4, Class 6, Class 10, and so forth, which represent the typical writing speed in megabytes per second (4MB, 6MB, 10MB per second, and so forth).

Fast memory cards can help if your digital SLR has a small buffer that can hold only a few shots. The faster your card can accept images, the more quickly you can resume shooting. Some digital single lens reflex cameras can't shoot and write at the same time, so this can be critical. For more info about memory cards, check out memory card guru Rob Galbraith's website (www.robgalbraith.com), which I describe in Chapter 16.

Finding the key to the (capa)city

You must weigh technical, cost, and practical considerations when choosing memory card capacity:

✓ Technical: Cameras that use CompactFlash cards can typically use any CF card available. That isn't true of Secure Digital cards, which exist in the original SD (2GB or less), SDHC (Secure Digital High Capacity; 32GB or less), and SDXC (Secure Digital Extended Capacity; currently available in sizes up to 128GB). Some older dSLRs can't use memory cards that exceed their built-in limitations. They may not be able to use SDHC or SDXC cards (and are thus limited to 2GB or smaller cards); even many newer dSLRs aren't compatible with SDXC, and thus must use cards with 32GB or less capacity.

Check with your vendor in case a firmware update can fix this limitation.

Cost: If a 16GB card costs more than twice as much as an 8GB card, it isn't an economical buy — unless you really need a 16GB memory card. Usually, a significant price disparity will happen only when a card with a newer, higher capacity is introduced. Within months, you'll find that larger cards are almost always less costly than purchasing the equivalent GB capacity in two smaller cards. ✓ Practical: Some photographers are nervous about putting all their photo eggs in one basket. They fear having a card failure or, more commonly, losing the card altogether. Using a smaller number of higher-capacity media does put you at risk of losing a chunk of — or even all — your vacation to Paris if something bad happens. Only you can weigh the risks. However, as you can see in the following section, you can take steps to minimize picture loss.

Perfect pairs

Now that a growing number of digital SLRs are available with dual memory card slots, you may wonder how to select your perfect pair. I explain in Chapter 2 the four key benefits of using two memory cards simultaneously (instant backup, easy copying, dedicating a "fast" card to movies or sports, and overflow capacity.)

The eggs/basket myth

Memory card capacity doubles and prices drop by half with amazing regularity. Any time digital photographers start to make the transition from one common size to the next-larger size, doomsayers come out of the woodwork warning against putting all your photo eggs in one basket. The same folks who are saying it's foolish to use a single 8GB memory card, rather than two 4GB cards (or even four 2GB cards), were panicking over the thought of storing their images on one of those newfangled 1GB memory cards, rather than the 256MB versions common only a few years ago.

The fact is, unless you're using a camera that accepts more than one memory card at the same time and you write each picture to both cards, you're *always* storing your pictures in a single basket until you choose to back it up. The chief variables are how many pictures you're putting at risk and the nature of the peril. If you use more memory cards, you increase your chances of accidentally formatting one or damaging another. With CompactFlash cards, it's actually more common to damage the camera through over-frequent insertions and removals than to lose images to a faulty card. Nor do memory cards work perfectly until they're full, and then mysteriously fail. It's just as likely that a 4GB card becomes corrupt after, say, 2GB of photos as it is for an 8GB card to flake out after 2GB of images have been stored. Your risk is identical in either case.

Would you insist that your family drive in two cars to each destination? How many people are riding in each car? How likely is a traffic accident in your location? Obviously, the risks are impossible to assess. Each photographer should realize that malfunctioning memory cards are also exceedingly rare, and each must decide for him- or herself how many images he or she can comfortably expose to such a minuscule risk.

In my day-to-day shooting, I use the largest memory cards I have (at present, 32GB cards) to avoid needless swaps (which would cause me to lose pictures that I couldn't take during the switch-over). When I travel or shoot any kind of once-in-a-lifetime event (such as a wedding), I back up my photos on the spot — to *two* backup devices. I don't care how many baskets I must use, as long as I take good care of those baskets. Keep those applications in mind when choosing which pair of memory cards to install in your dual-card camera.

- Identical cards: If you like, and your camera accepts two cards of the same type, you can select identical cards, using them virtually interchangeably. That might be the best approach if you have no special reason (like those described below) to favor a different type as your second card.
- ✓ Fast card/slow card: Of course, buying two identical cards can be expensive, especially if you want the fastest cards available.

It's often more economical to pay a little extra for a super-fast card, and save some money on your second card with one that's somewhat slower. Or, you can buy a fast card with a lower capacity, and use a slower, larger card when storage capacity rather than speed is your primary concern. Put the preferred card in Slot #1 (whether it's fast, or large) and the other card in Slot #2.

Some digital SLRs allow you to specify a particular card to use for demanding applications, such as movies, but it's often easier to just swap the cards manually as needed.

- Extra capacity: Your dual memory cards don't need to match in capacity. That's especially true if you're in backup mode and have specified that RAW files are saved to one card, and JPEG files to the other card. Because RAW files are typically much larger than their JPEG versions, you can get by with a smaller card as the JPEG destination.
- Recycling older cards: I like memory cards that are both fast and high in capacity, so that's typically the type of card I put in my #1 slot. Unless I'm traveling or working on an important job where constant backup is necessary, I often use the second slot just as overflow when my main card fills. That's a great opportunity to use older memory cards that no longer are suitable for the "first chair." My 32GB Class 10 SD card may capture most of my photos, with an old 4GB Class 4 SD card in reserve in the overflow slot.

Storing Your Images

Don't keep your images stored on your flash memory cards (which I discuss in the preceding sections) for very long. The first chance you get, copy them to your computer's hard drive for reviewing, editing, and printing. The second chance you get, copy them to more permanent storage for archiving. So, backup media is high on your list of accessories for your dSLR.

Part I: Digital SLRs and You

Exploring options for backup media

In the past, the most common way to store images has been on CDs or DVDs. All commercial computers built today, even laptops, have some sort of CD/ DVD-burning capability. The exception might be super-compact netbooks, such as the Acer Aspire that I use, or my MacBook Air. However, I can still attach a DVD burner to either one by using its USB port. Unfortunately, in these days of 16MP (and up) cameras, it's too easy to fill up a CD or DVD with only a fraction of the images of a single memory card. You'd need nearly eight DVDs to back up a 32GB CF or SD card, and two dozen CDs!

You can also purchase stand-alone battery-operated burners and hard drives (dubbed *personal storage devices*, or *PSDs*) that have 20GB to 500GB (or more) of storage that you can use to offload your images while you're traveling. Some photographers prefer the portable DVD burners to the PSDs because the hard-drive solutions are subject to the same potential problems that any hard drive can suffer. Non-rewriteable optical media that's verified when originally written should remain readable for at least long enough to copy it to additional backup discs when you return. I like the PSDs (see Figure 4-2) because they're much more compact than DVD burners and have proven reliable enough for my needs. (When I'm being especially careful, I take along two PSDs, or a laptop and a PSD, and then back up to both.)

If you own an Apple iPod, consider buying one of the card-reader adapters available from several vendors. The Camera Connection kit for the iPad series allows plugging in an SD card reader. You can use these adapters to copy your images to your iPod or iPad. Then, you can transfer those images to your computer later. The only problem with this solution is that transfer is relatively slow and uses up a lot of your

Figure 4-2: Personal storage devices (PSDs) are stand-alone hard drive backup units.

MP3 player or tablet computer's power in a very short time.

Another increasingly attractive option for medium-term (or long-term) storage is an external hard drive. Because I have memory cards that hold two to four times as much information as a standard DVD, external hard-drive storage has become a mainstay for me.

When I travel with a full-fledged computer (laptop, netbook, or MacBook Air), I usually tote along a 1TB Seagate FreeAgent drive, as shown attached to my MacBook in Figure 4-3. I can plug it into one USB port on the computer, and

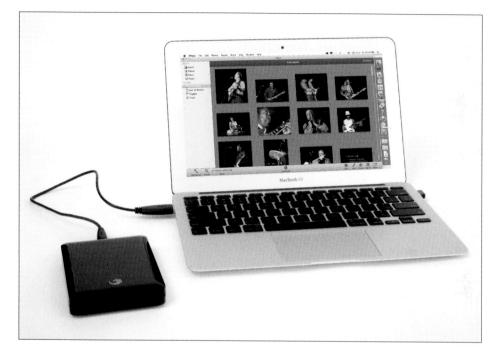

transfer images from a card reader directly to the external hard drive. (My Windows-based laptop and netbook have built-in SD card readers, and can use an external CF card reader.) In that case, the PSDs can stay at home.

Figure 4-3: An external hard drive can be a portable solution.

Longer-term storage

It's great to be able to come home from a trip with multiple backups, burned to a DVD, copied onto an external hard drive, mirrored on my iPad (see Figure 4-4), or duplicated on extra memory cards I have for my dual-card dSLR.

But, for longer-term storage, it's usually necessary to resort to other means. Conventional DVDs don't have the capacity for backing up large quantities of large image files anymore, and even Blu-Ray discs (at up to 25GB to 50GB, depending on the format and number of layers) are not ideal. I now keep all my current backup files on hard drives. And, since hard drives are known to (or guaranteed to) fail eventually, my backup method relies on multiple copies. Prices for magnetic media have fallen so significantly that this method is eminently practical. You can buy a 2TB hard drive for a lot less than \$100 these days.

Part I: Digital SLRs and You .

Figure 4-4: Copy images from a memory card to your iPad.

Indeed, I have four 2TB hard drives built into my computer, and all my most recent photographs are stored on them. None are actually "permanently" installed; they are mounted in slide-out mobile racks, so I can swap out any of the drives at any time. Once a week, I extract each drive and pop it into a hard-drive duplicator and make an exact copy. I have two sets of backup drives that I rotate between, so at any given time I have *three* exact copies of each of my hard drives: the one currently residing in a rack in my main computer, last week's copy, and the copy I made the week before that (which I store off-site, as protection against a fire or natural disaster).

It gets worse. As a past victim of a motherboard explosion, I also have an identical backup computer with the same set of racks. So, if my main computer fails, I can install my most current set of hard drives in that, and resume working without losing a step.

It's a RAID: Attack of the cheap data robots

Of course, weekly backups aren't really sufficient. I have two more backup systems, one real-time, and one that runs daily. The real-time system consists of a pair of 32GB thumb drives. A program called Allway Sync (www.allway sync.com) monitors the folders with the files I am working with on any given day, and backs them up to both thumb drives simultaneously. Each evening, another backup program (mine is TrueImage Home from Acronis, www. acronis.com) copies all new and modified files from internal hard drives to a pair of fault-tolerant hard disk arrays. Available from Data Robotics, Inc. (www.drobo.com), these arrays are called Drobos. They consist of external cases that each have four 2TB drives arranged in what's called a RAID (Redundant Array of Inexpensive Disks) setup. If one of the four individual drives in the Drobo fails, I can simply replace it with a new one, and the data that the damaged disk contained is restored to the new one automatically. (Note: This process can take several days to complete.) You'll find that many companies offer RAID (or, as in the case of Drobo, RAID-like) solutions that don't really cost that much. You can buy a Drobo for around \$400 and fill it with old hard drives you've outgrown, or buy at the current \$50 or so perterabyte prices.

If you're *really* cautious, you can have multiple Drobos (or other hard disk storage devices) and keep at least one copy of your files off-site, perhaps at a friend's house. In terms of off-site storage, I don't recommend online services like Carbonite or "cloud" solutions. Even assuming that Internet storage is secure, while it's fine for data files, it's quite useless for image files. I once computed that it would take two years to upload all the image files I already have, and a minimum of two weeks to upload all the image files I shoot in an average week. You might be able to get away with storing a few favorite images online, but as an image-archiving option, the cloud is not practical.

As you can guess, I don't lay awake at night worrying about losing my photographs. You may not be as paranoid about losing images as I am, so DVDs, CDs, and simple external hard drives may be sufficient for your needs. Just remember to make multiple copies to be absolutely safe!

Part I: Digital SLRs and You _____

82

5

Accessorizing Your dSLR

In This Chapter

- Sifting through filtration considerations
- ▶ Gaining support from tripods
- Understanding electronic flash
- Choosing connectivity options
- Adding additional add-ons

Remember how cool it was to pick out your school supplies every August before classes began? You got to choose the exact notebook and paper that you wanted. You likely selected your pencils and book covers with the greatest of care. If you're younger than I am, you probably spent a lot of time deliberating over which Trapper Keeper to get. If you're my age, the big decision was which quill pen to buy. If you own a digital SLR, you can experience the same joy of buying school supplies — but all year 'round!

This chapter is a quick introduction to the most useful accessories you can add to your camera arsenal.

Filtering Factors

Filters are those glass or gelatin disks or squares that are affixed to the front of your camera's lens, changing the light that passes through the lens in some way. Filters were *really* popular before the advent of digital photography because some of the effects that you could get with them weren't possible (or easy) to achieve in the darkroom. I own dozens of them, including a complete set of decamired color-correction filters, which many of today's photographers have never heard of.

Part I: Digital SLRs and You .

84

Things to do with ND filters

You can do a lot of amazing things by using a neutral density (ND) filter, including rendering objects invisible! All ND filters decrease the amount of light that reaches the sensor, so you need to use a longer exposure than you would without the filter (or let your camera adjust the exposure for you automatically). Here are the key applications that you can take advantage of:

- ✓ Use the large f-stop you prefer. Sometimes, the scene has too much light to use the large f-stop that you want to work with (in order to reduce depth-of-field). Some dSLRs have ISO settings no lower than ISO 200, so in bright sunlight, even a ¼∞∞ of a second shutter speed means that the largest f-stop that you can use is about f/4. Add an ND2 or ND4 filter to make f/2.8 or f/2 available to you.
- ✓ Use the slow shutter speed you want. Perhaps you want to get the classic blurrywater effect when photographing a flowing stream at a slow shutter speed while the camera's mounted on a tripod. At ISO 200, using f/22 gives you a shutter speed of ⅓∞ of a second under bright sunlight. If, as is likely, your mountain stream isn't in bright sunlight, you still probably can't use

a shutter speed any longer than about $\frac{1}{10}$ to $\frac{1}{10}$ of a second. An ND filter can give you the half-second to several-second exposures you need for truly cool-looking water effects, such as the one shown in the following figure, which I further enhanced in Photoshop.

- Make moving objects vanish. The moving cars and people in your scene distract from the image of the building you're trying to capture. No problem. Use an ND8 or heftier neutral density filter (stack several filters, if you need to), mount the camera on a tripod, and shoot an exposure of 30 seconds or even longer. Unless a traffic light halts traffic, likely no individual person or vehicle is in the image long enough to register. If you have enough ND filter power at your disposal, this trick works in full daylight, so you can create your own ghost town.
- Balance the sky and foreground. In most scenes, the sky is much brighter than the foreground. A split ND filter, with the dark portion positioned so that it's on top, can even out the exposure for the two halves, making those washed-out clouds visible again.

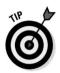

Glass and gelatin filters are less used today among casual photographers because you can achieve many of the effects they provide within Photoshop. Yet, you can't create all filtration effects in the digital darkroom. Here's a description of the most essential filter add-ons:

- ✓ Infrared: Many digital SLRs are capable of taking photographs by using only infrared illumination, which produces a spectacular effect outdoors. You can get dark skies, vivid clouds, and ghostly white trees in your landscape shots and strange, pale complexions with your photographs of humans. However, you must buy an infrared filter that blocks visible light and be prepared to shoot at slow shutter speeds (because very little light is left for the exposure). Also, you can't preview your shot. An SLR viewfinder turns black when an infrared filter is mounted, and Live View doesn't always offer a clear look at your composition, either. (For more on infrared photography, see Chapters 8 and 16.)
- ✓ Polarizers: Polarizing filters, like the one shown in Figure 5-1, can reduce the glare bouncing off shiny surfaces in your photos. Simply attach the filter and rotate it until the glare disappears. These filters can also help deepen the contrast of the sky from certain angles.

Be certain to buy a circular polarizer, rather than a linear polarizer, for your dSLR. (All polarizers are round; *circular* refers to the way in which the filter handles light.) Circular polarizers don't interfere with the autoexposure mechanism of your camera in the way that linear polarizers can. You should also take care when using any type of polarizer with wide-angle lenses; the wide perspective can produce dark areas that are polarized to a different degree across the frame.

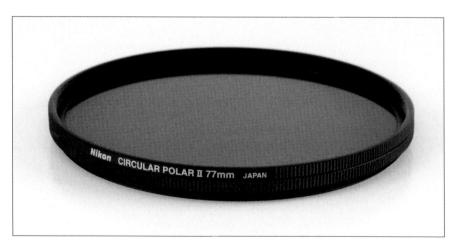

Figure 5-1: Polarizing filters reduce glare in many situations.

Part I: Digital SLRs and You

- ✓ Neutral density: The third kind of filter that every digital SLR photographer should own is a neutral density (ND) filter, so called because it blocks light but is neutral in color. ND filters come with various assigned filter factors, such as ND2 (reduces the light by 1 f-stop), ND4 (reduces light 2 f-stops), and ND8 (cuts down 3 f-stops). Like with most filters, they can be stacked to combine the effects of more than one, as long as the additional filters in the pack aren't so thick that they become visible in the image, thereby cutting off corners. (This is called *vignetting*.) Neutral density filters also come in a split variety — the top half (or bottom half or one side, if you rotate it) has neutral density, and the other half is clear.
- Special effects: A lot of different filters produce special effects, including starlike points on highlights, prisms, special colors, and so forth. All the leading filter vendors offer these effects, but the 140 spectacular filters offered by Cokin (www.cokin.com) are in a class by themselves. Check them out. If you're interested in making your own filters, flip to Chapter 16.

The Tripod: Your Visible Means of Support

One way to tell the casual photographer from the serious photographer is the size of the tripod he or she uses. (Snapshooters don't have any tripod at all and are probably none the worse for it.) Casual photographers rarely shoot the longer exposures that need help from a tripod, and the lenses of their digicams aren't long enough to require a tripod's steadying influence. That's all for the better because photographers who aren't serious photo enthusiasts are likely to purchase flimsy tripods that don't do what they're supposed to, in any case.

When a shooter evolves into a photo enthusiast, the real value of a tripod becomes evident. The first step is to spend \$100 on a "really good" tripod, which will turn out to be not so really good, after all. However, the money isn't totally wasted because experience with inadequate tripods provides a valuable education that comes in handy when it's time to buy the real thing.

You know you've met a serious photographer when he or she unfolds a beautiful work of art made of carbon-fiber or magnesium alloy, or maybe even volcanic basalt with titanium trimmings, topped with a quick-release grip-ball head that allows pivoting the camera in any direction in seconds. Such a tripod is likely to be larger and steadier than the amateur jobs (which frequently have telltale leg braces because they *need* them) but still weigh a lot less, thanks to the exotic materials used in its construction. Although a really good tripod can cost \$500 (don't gasp; I wanted to say \$800 but didn't think you'd believe me), it can be a once-in-a-lifetime investment. I bought my first tripod when I was in college, and it served me ably for many years. It would still be in everyday use if I hadn't started traveling more and had to upgrade to lightweight carbon fiber models, including one \$550 gem that fits in my carry-on luggage.

Putting a tripod to good use

A tripod is much more than a three-legged camera stand. A tripod can do a lot for you and let you take pictures that you couldn't get otherwise. Its key uses are

- ✓ Holding the camera steady: If you need a long shutter speed for a picture in dim light, a tripod reduces the loss in sharpness from camera shake. Notice that I said reduces. You might still have camera shake when using a tripod if the tripod itself is unsteady or gets jiggled during the exposure. A steady camera is essential when shooting long exposures in dim light or when using a telephoto lens, which magnifies vibrations along with your image. Few people can hand-hold a camera for ½₀ of a second or slower with a normal or wide-angle lens. Fewer can get good shots at a shutter speed slower than the reciprocal of the effective lens focal length for example, ½₀₀ of a second with the equivalent of a 300mm lens (which might actually be a 200mm lens before a 1.5X crop factor).
- Serving as a camera stand: Perhaps you want to get in the picture, too, or do something else besides stand behind the camera while it takes the photo. Even if the shutter speed is high enough that you don't need the tripod's steadying influence, the tripod fixes the camera in one place long enough for you to take the picture with a self-timer, cable release, or remote control device.
- Providing precise, stable positioning: A tripod lets you frame a shot exactly and then take several pictures with the same framing. You may find this capability useful for landscapes, portraits, or any other shot that you want to repeat. Stability is almost essential for close-up pictures when precise depth-of-field or focus considerations come into play.
- ✓ Keeping the camera level for multiple shots in a panorama series: You can fit some tripods with a panorama head that can help you provide the precise positioning and proper overlap for these photos.
- ✓ Providing a platform for HDR photography: HDR (or high dynamic range) photography is a current fad that landscape photographers, especially, are embracing. With HDR imaging, you need to take three or more photos, exposed one f-stop apart. The images are later combined in an image editor or special HDR utility software program to produce a stunning image that has a lot of detail in the deepest shadows and brightest highlights. (Such a long tonal range is otherwise beyond the capabilities of the typical dSLR sensor.) I call HDR a fad because I hope it'll eventually become unnecessary when camera vendors offer extended range sensors that do the same thing. Also, we're seeing a remarkable lack of

Part I: Digital SLRs and You

imagination in the typical HDR photo, which is usually a vertically composed landscape that has water at the bottom and sky at the top, taken with an ultrawide-angle lens that shows a lot of both. Still, a tripod offers a solid platform for taking that batch of HDR photos.

The chief disadvantage of tripods is that you have to carry them along when you need them, and sturdy-but-lightweight tripods can be expensive. An alternative is to use a tripod substitute, which can vary from a simple clamplike device, to beanbags, to monopods.

I always, without fail, carry my Joby (www.joby.com) Gorillapod (see Figure 5-2) in my bag, and find it useful with lighter-weight camera/ lens combinations when there is a secure place to use it. Most of the time, I carry along a monopod, too. I have a 170mm-to-500mm zoom lens that I like very much, but I find that it's virtually impossible to use without, at the very least, a monopod. At 500mm (750mm after applying the crop factor), I've detected visible camera shake in my photos, even when I use a 1/2000 of a second shutter speed. Who wants to jump up to ISO 1600 to be able to get a decent aperture while freezing camera motion when a tripod or monopod lets you do the same thing at ISO 400 or ISO 800?

MANANA AND A REAL PROPERTY OF A

Choosing a tripod

Figure 5-2: A portable support like the Gorillapod allows you to use any handy stationary object as a camera rest.

All tripods have three legs (if they have only one leg, they're *mono*-

pods). Some tripods can also have only two legs, but that's because you can remove their third leg and use it as a monopod. Ordinarily, you find either tripods or monopods because a bipod has very little practical use. Here are some considerations for you to think about when choosing a tripod:

What you see and what you get. Tripods always look nice in the catalog, but what's shown might include several optional components that you don't get unless you order them with your tripod. For example, high-end tripods tend to come as a set of legs only, with a center column that cranks up or down to extend the height of the tripod beyond what you get from extracting the legs. If you want a tripod head to attach your camera to, you might have to pay \$100 extra (don't wince; I wanted to say \$300–\$400, but I held back for your sake). Other necessary parts, including quick-release plates that help you mount and dismount your camera speedily, might be available, but they cost more.

- ✓ Leg style. The legs might be cylindrical, cylindrical but flat on one side, open-channel, or some other shape. They might open from two to five different sections. The more sections, the more compact the tripod is when you fold it up, but the smaller the inner sections have to be to fit inside the others. The legs need to be as sturdy as possible when extended. They shouldn't bend or flex, and the extended tripod shouldn't sway in the breeze.
- ✓ Leg height. Your tripod should extend to at least eye-level without the need to crank up the center column (which you should really use only for minor height adjustments, when you require the absolute maximum height, or if the column swivels to vary the shooting angle). My own studio tripod goes up much higher than that, so I need to stand on a ladder or stool to use it at its maximum height. That's great for shooting photos from a higher vantage point. At the other end of the scale, you want some way of shooting from low angles, too, which you can accomplish by retracting the legs of a tripod with multiple sections or by swiveling or reversing the center post.
- Leg lock and positioning. Check out the method used for locking and unlocking the legs, and note the range of movement available. The best

designs let you lock or unlock all the sections of a particular leg simultaneously, rather than one at a time, and they allow you to position the legs at independent angles so that you can use your tripod on uneven ground.

✓ Use your head. The *head* is the part to which you attach your camera. The most common type is the pan/tilt head that allows you to pan the camera on one axis and tilt it on another. Fluid heads have a long handle that you can twist to release the head so that you can pan and tilt simultaneously. Increasingly popular are joystick and ball heads, such as the Photo Clam model shown in Figure 5-3, which let you tilt the camera at any angle.

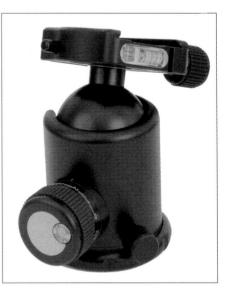

Figure 5-3: A well-designed ball head allows tilting the camera at any angle quickly.

✓ Fast release. Some heads come with quick-release plates, or you can fit them with quick-release plates. One part of the plate fastens to the tripod socket of your camera. The other part attaches to the tripod. Instead of screwing and unscrewing the camera from the tripod each time, you press a control and slide it off.

Electronic Flash in the Pan

With only a few exceptions, digital SLRs that cost around \$2,000 or less — for the body only — generally have a built-in electronic flash, or *speedlight*.

More expensive, "pro" cameras usually don't have an internal flash, because advanced shooters prefer to use an external flash.

Professional photographers probably wouldn't use a built-in speedlight on their high-end cameras, usually because such units aren't powerful enough for anything other than fill flash and provide the kind of direct lighting that pros abhor. I've been paid for my photos and seen them used on the covers and inside magazines, but not every picture I take is destined for the cover of *National Geographic* magazine (okay, *none* of them are). Like you, I find it quite handy to be able to pop up my dSLR's internal flash when I want to take a quick shot and/or don't have my fully laden shoulder bag handy. I *like* having a flash built-in and always available.

However, like you, I'm serious about photography, and I'm glad I have my more powerful and flexible external flash units available to provide additional and supplemental lighting. In the following sections, I offer tips on the types of flashes you may find useful. I also explain different ways external flash units work with your camera, and I cover any pros and cons that you should know about. In Chapter 10, I explain using a flash for various effects.

Perusing different types of flash units

Flash units come in several types. I have a whole bunch of them. You can probably use any of these types of flash with your dSLR:

✓ A fancy sort of flash. My \$350 super-sophisticated unit can communicate with my camera and do fancy tricks, such as zooming its coverage to match the camera lens's zoom setting. It also reports to the camera the exact color temperature it uses, which results in more accurate hues, and adjusts its exposure by reading the light that actually goes through the lens. In wireless mode, I can use it off-camera with no connecting cable.

- ✓ Do the mashed potato. I have a big monster of a potato-masher flash that has massive output, which I sometimes use for sports photography. I work with this beast when I want to, say, illuminate a fullback on the opposite sideline. It attaches to an external battery power pack, so the flash's power lasts longer, and I never ask it to do anything fancy. Although it has an automatic mode, I don't use that all the time because I often want to get the maximum output. The only zoom coverage available is through built-in wide-angle and tele-filters that modify the light.
- Studio flash dance. I probably get the most use out of my studio flash, though, which consists of a pair of large *monolights* (AC-powered flash units that have the power source built into the flash head) and two smaller electronic flash units that I can use as background and hair lights.

Tools for triggering the flash

To use an external flash, your camera needs to have some way of triggering the supplemental flash unit. You can do this in five ways:

- ✓ Slave operation: Perhaps you can set the external flash to function as a *slave unit*, which means it has a photocell that detects the firing of the camera's main flash, and the external flash triggers in response. In this mode, you can use any slave-compatible external flashes, including those that have an add-on trigger. The problem with using slave flash is that you might not want both the built-in flash and the external flash to illuminate your scene. If you can cut the power of the internal flash, you might be able to reduce its impact on the photo, relegating it to a fill-flash effect.
- ✓ Wireless mode Part 1: Some dSLRs can communicate with the same vendor's electronic flash units in wireless mode. You might expect something called wireless to involve radio waves or, at the very least, some sort of infrared signal, but it can be much simpler than that. For example, Nikon and Canon external flash units "talk" to compatible Nikon dSLRs by using almost imperceptible pre-flashes that take place an instant before the flash fires. In the case of Nikon dSLRs and newer Canon cameras with built-in "wireless" capabilities, the camera's own flash tells the external flash details, such as the zoom setting of the lens, the correct exposure to use, and (most importantly) when to fire. The external flash, in turn, responds with information, such as the color temperature of the illumination it provides. This data exchange can take place when the two flashes aren't connected, or even without the built-in flash providing part of the main exposure.
- Wireless mode Part 2: You'll find an increasing number of remote triggers available from third parties, such as Pocket Wizard (www.pocket wizard.com) and Radio Popper (www.radiopopper.com), that can

Part I: Digital SLRs and You

be used to control flash units, your camera, or both. Some can control the output of an off-camera flash from the camera position, using a dial on the trigger that's connected to your dSLR. These units are especially useful in the studio (your home "studio" counts), but are great for location shooting when you want to use multiple flash, too.

- Hardwired PC connection: You can find some dSLRs that have a standard PC connection for attaching standard electronic flash units. (PC stands for Prontor-Compur, pioneering shutter manufacturers, rather than personal computer.) So, you can plug in studio flash and speedlights made by other vendors, assuming that the triggering voltage of the flash units isn't high enough to fry the circuits of your dSLR. (A Wein Safe-Sync add-on device isolates your camera from the flash's voltage. I use one to connect my studio flash to my digital cameras.) A PC connection, if you have one, works only with non-dedicated flash units that can't communicate with the camera. The only signal that's exchanged between the camera and the flash is the trigger that fires the external unit.
- ✓ Hot-shoe connection: Modern cameras, including dSLRs, tend to use sophisticated dedicated flash units that require full communication between the camera and speedlight. These units require special connectors, usually in the form of a flash accessory hot shoe on top of the camera, such as the one shown in Figure 5-4. The shoe has multiple contacts. You can plug in a flash unit designed to work with these contacts or use a hot-shoe adapter that allows you to connect a flash by using a cable instead.

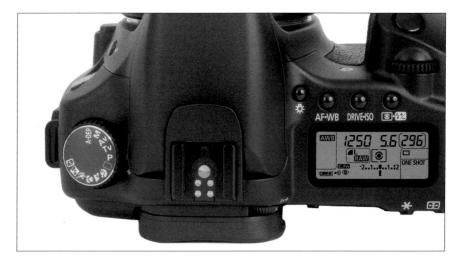

Figure 5-4: Dedicated electronic flash units use flash accessory hot-shoe connections.

New Tools for the Connected

It's fitting that in an age of ubiquitous connectivity (whether you have a cell phone, a tablet computer, or tote around a laptop/netbook), cameras are becoming connected, too. Some capabilities we only dreamed of a few years ago are must-haves for the savvy photographer these days. Here are some of my favorites.

Smart phone apps

With landlines going the way of the dinosaur, every photographer I know has a cell phone that accompanies them *everywhere*, and threatens to make the most basic point-and-shoot cameras (and even the wristwatch) obsolete. But smart phones and their built-in snapshooters have a long way to go before they make a dent in the usefulness of interchangeable lens dSLRs. Instead, they've become useful tools that help you get more from your "real" camera.

Hundreds of photography apps exist for the iPhone's iOS and the Android operating systems. They range from widgets that turn your cell phone into a fill light, to image-editing programs, to apps that suck images right off your camera's memory card (using Wi-Fi technology I discuss later in this section) for transmission to social media sites like Facebook. I've even converted some of my camera-specific guidebooks to apps, making it possible to carry my shooting advice with you everywhere on your smart phone.

Tablet/iPad apps

Many smart phone apps run on tablet computers like the iPad, too, but there are even more sophisticated versions specifically for tablets that do a lot more than you can accomplish with a phone application.

One of my favorite tools is the Apple Camera Connection Kit for the iPad (seen in in Chapter 4), which accepts an SD card and allows me to transfer pictures I've taken to my tablet for viewing on a large screen, display in a slide show, backing up, or e-mailing to the folks back home when I'm on a trip.

Oh my, Wi-Fi

Thanks to a company called Eye-Fi (www.eye.fi), just about any dSLR that accepts an SD card can beam photos directly from the camera to your computer and/or social networking sites like Facebook or Flickr. The magic is made possible by a series of conventional-looking SD cards like the one shown in Figure 5-5, that have built-in Wi-Fi transmitters. The Eye-Fi cards are available in 4GB to 8GB capacities.

Part I: Digital SLRs and You _

Figure 5-5: An Eye-Fi card adds Wi-Fi capabilities to cameras that accept SD cards.

After you set up your camera (many newer dSLRs have an Eye-Fi entry in their menus) and "programmed" the SD card to do your bidding, you can do the following things:

Upload to your computer: An Eye-Fi card can upload to your desktop computer or laptop as you shoot over your home or office network. That's great for shooting around the house, or your studio. Your photos are available for viewing quickly, and, as a bonus, are backed up as you shoot. ✓ Upload to the web: Whether you're connected to your home network, or out and about with Wi-Fi access through your favorite restaurant, coffee shop, hotel, or other access point, the Eye-Fi card can upload to destinations on the web, including Facebook, Flickr, and other sites. You can designate upload to public areas viewable by all your friends, or private albums online, where they'll wait for you to share them when you like. You can choose to upload either all photos you shoot, or only those you've marked with your digital SLR's Protect feature. (The same choice is available for uploading to your computer over your home/office Wi-Fi network, too.) Program your card using your computer, through the Eye-Fi Center application, shown in Figure 5-6.

Figure 5-6: Upload your photos directly to your computer or to a website.

Part I: Digital SLRs and You

- ✓ Upload through your smart phone/tablet: Eye-Fi offers apps for iOS and Android operating systems that let you upload the pictures you specify to your smart phone for immediate (or eventual) sharing through your tablet/phone's connectivity. I have an app called Shuttersnitch (www. shuttersnitch.com) that lets me upload directly from my camera to my phone/tablet, providing near-real-time display on my phone or tablet's screen.
- Work tethered: My iPhone has the portable hotspot feature found on many smart phones. This allows me to set up a Wi-Fi access point anywhere I happen to be, giving my Eye-Fi cards access to a local area network anywhere.

Gee, P.S.

Sony has introduced several dSLR or dSLR-like cameras (starting with its SLT lineup) that have Global Positioning System (GPS) capabilities built in. However, you can also purchase GPS add-on devices for many cameras from third parties. Some Eye-Fi cards provide a type of GPS, and Nikon even offers a unit that works with most of the cameras in its line (see Figure 5-7.)

Figure 5-7: GPS tracks your pictures so you don't have to.

GPS, in traditional form, works only outdoors where the device can capture signals from the global satellite system. When active, GPS embeds positioning information right in your digital camera files that can be read by many image editors, and, even a variety of social networking sites. For example, if you upload an image with GPS data included to Flickr, the site can display where the picture was taken.

Although traditional GPS systems work best, Eye-Fi cards can add GPS data using information from cell phone towers around you when you're working in the field in an area with Wi-Fi connectivity.

If you've ever had a "Where in the heck did I shoot this picture?" moment, you'll find GPS capabilities invaluable.

Other Must-Have (Or Maybe-Have) Gear

After you collect the most essential accessories that your digital SLR needs, if you have any money left over, you might want to consider some of the addons I discuss in the following sections.

A second camera

I've gone to Europe on vacation and taken along only a single camera and lens. (I was planning on shooting movies most of the time). But now that I think about it, that wasn't a smart thing to do. When people are paying me money to take pictures, I *always* have one or two spare camera bodies, extra lenses, multiple flash units — duplicates of any essential piece of equipment. I discovered early in my career that "Sorry, my camera broke!" is *not* an excuse that clients find acceptable. So, why was I so dumb to go overseas and risk arriving with no way to take photos? Umm . . . I wanted to travel light?

Sooner or later, you discover that a second camera body makes sense for you, too. Even if you aren't 3,000 miles from home, can you really stop taking photos for a few weeks while your dSLR is in the shop? Haven't you been in situations where you wanted to alternate between taking photos with a wide-angle or wide-angle zoom and a long telephoto or telephoto-zoom lens? Having an extra body, one for each lens, can be just what you need.

You don't have to break the bank to buy your second camera body. Your existing lenses fit just fine if you buy another model from the same vendor, but you don't need an identical camera. You can purchase an entry-level camera from the same vendor to supplement more expensive bodies from the same manufacturer. Or you might find yourself with an extra camera body when your favorite vendor comes out with a new model and you decide to buy it and keep your old camera as a spare/second camera.

Part I: Digital SLRs and You

Sensor-cleaning kit

Like it or not, if you remove the lens from your dSLR, sooner or later, vou're going to have to clean dust and grime off the sensor that the sensor-cleaning capability of your camera didn't remove. Available gear to do this sensor cleanup includes brushes, swabs, and special liquids. But all you may need for most cleanings is a blower bulb, such as those bulbs shown in Figure 5-8. You may find taking that first swipe at your sensor terrifying, but you actually can clean your camera's sensor simply and relatively safely. The bulbs are also useful for blowing dust off lenses and external filters.

Close-up equipment

A lot of available add-ons can help you focus close, including filterlike

Figure 5-8: Keep your sensor clean with an air blower.

close-up attachments that screw onto the front of the lens, as well as bellows accessories that fit between the camera and lens.

Extension tubes, such as those shown in Figure 5-9, provide an inexpensive and versatile solution. You install these tubes between the camera and lens, and they provide the additional distance needed to focus closer. Single tubes are available for as little as \$50, but you can pay \$150 or more for a complete set of fully automatic tubes in multiple lengths. Close-up gear is great for photographing tiny bugs, details of flowers, coins, and stamps, and other subjects.

If you want extension tubes that you can easily use, go for ones that couple with the camera's automatic focus and exposure mechanisms.

Chapter 5: Accessorizing Your dSLR

Figure 5-9: Extension tubes let you focus closely.

100 Part I: Digital SLRs and You _____

Part II Oh, Shoot!

Il those controls! What do you do with them? Digital SLRs give you great control over every camera feature and function. In this part, you can find out how to work with those controls, master the use of interchangeable lenses, and work with special features, such as Live View and image stabilization.

In Chapter 6, I explain Shutter Priority and Aperture Priority modes, various programmed exposure features, how to adjust your exposures by using histograms, and the mysteries of autofocus. Chapter 7 tells you everything you need to know about choosing and using lenses, including special-purpose optics, such as macro lenses. Chapter 8 explores special features that most digital SLRs have, such as Live View, moviemaking, and a few more exotic capabilities.

Taking Control of Your dSLR

In This Chapter

- Unveiling the secrets of foolproof exposure
- Metering for fun and profit
- Finding the advantages of self-exposure
- Getting focused

n terms of buttons, dials, and controls, comparing a typical point-andshoot camera with a digital SLR is like comparing a hang glider to a Boeing 787 cockpit. Certainly, the more sophisticated option has more controls, but most people find it easier to flip a switch and shift a control than to yank on a lever, lean to the right, and pray.

Because you can do so many different things with a dSLR, the learning curve is a bit steep. Fortunately, your digital 787 has an autopilot — programmed modes — that can fly your photographic aircraft for you until you can ease into navigating solo. But you may find all those controls daunting at first. You might have four or five exposure modes to choose from; a half-dozen different ways to focus; and the capability to fine-tune details, such as white balance, sharpness, contrast, and color. Because you're a more serious photographer, those options are probably the reason you bought a digital SLR in the first place.

Okay, champ. You have this incredibly versatile gadget in your hands. How can you make it work? This chapter helps get you started with the toughest of the tough: exposure and focus.

Part II: Oh, Shoot!

Discovering the Secrets of Exposure

If you're lazy or not up to using your brain on any given day, you can set up your digital SLR to operate much like a glorified point-and-shoot camera. Turn on autofocus, set the exposure control to Auto, and fire away. When you press the shutter release, your camera tries to guess which subject in the frame is most important, and it focuses on that. The camera attempts to ascertain what kind of picture you're shooting (landscape, portrait, or closeup, for example), and it chooses an exposure that's probably fairly close.

Clever little algorithms choose a shutter speed that eliminates subject- or camera-related blur (most of the time) and an f-stop that provides a decent compromise between depth-of-field (the range that's in sharp focus) and proper exposure. In short, your \$800 dSLR then produces pictures just as good as a \$200 snapshot camera.

But you didn't buy your digital SLR to take snapshot pictures. You use the Auto mode when you hand your camera to your fumble-fingered brother-inlaw and ask him to take a picture of you and your kids. You'd rather maintain control over your exposures so that you can apply f-stops, shutter speeds, and other options creatively.

Understanding why exposure is tricky

In a perfect world, your dSLR's sensor could capture all the photons that reach it from your subjects. Dark areas would be represented by *photosites* (the individual picture elements) that received few photons, and light areas would be registered by photosites that captured a whole lot of photons. All the intermediate tones would fall somewhere in between.

But it doesn't work quite that way. Some dark areas might produce too few photons to produce an image at all; some very light areas might be represented by so many photons that excess light overflows from one pixel into adjacent pixels, causing a light smear known as *blooming*. (I introduce blooming in Chapter 2, where I explain how sensors work in more detail.)

Proper exposure helps ensure that the sensor receives enough light to capture detail in the dark areas of an image, but not so much that light areas are washed out. Figure 6-1 shows some of the choices you might have to make. Exposing for the shadows provides a lot of detail in the top version (the original version of this image), but the highlights are completely washed out. The bottom version uses improved exposure to trade off some of the brightness in the shadows for more highlight detail. (Actually, I played with the exposure by using an image editor on the RAW version of the file, but these images represent real-life choices, nonetheless. You can find more information on using RAW files in Chapter 8.)

Try to preserve highlight details; you can't retrieve them if they get washed out. You can much more easily brighten dark shadows than retrieve lost highlights.

Achieving an ideal exposure can be tricky because sensors have a fixed *dynamic range*, meaning the range over which the sensor can capture detail in both light and dark areas. No sensor's dynamic range covers the full gamut of illumination levels that you're likely to encounter in everyday photography, so finding the right exposure likely involves making a series of compromises.

The first compromise comes when the continuous range of brightness and darkness in an image is converted from that analog form into digital bits and bytes. During the conversion, an infinite gradation of tones is sliced up into a limited number of different shades - 256 different shades per color, in the case of the 24-bit full color you probably work with in your image editor. Your digital SLR might capture more tones than that — as many as 16,384 variations per color (red, green, and blue), or 281 trillion potential variations, if your camera captures 14 bits

per color channel — but you still end up with a measly 256 tones for

Figure 6-1: Expose an image so that highlights don't wash out; you can never retrieve them.

each color in Photoshop. (That is, unless you're working with an HDR, high dynamic range, image that has more than 8 bits per channel.)

Your mission, if you choose to accept it, is to make sure that the available tones are the *right* tones to represent your image. You don't have many to spare. Perhaps you're shooting a night scene and have a lot of detail in the shadows that you want to preserve, but you also want to keep some details in highlights illuminated by a street lamp. How can you even guess how the camera captures each of these details? Let the histogram be your guide.

Part II: Oh, Shoot!

Getting exposure right with the histogram

Many digital SLRs include a *histogram*, which is a chart shown on your LCD (liquid crystal display) that displays the number of tones being captured at any brightness level. The number of pixels at each brightness level is shown on the histogram as a vertical bar, and there are 256 of these bars represented. (Your camera's LCD might not have enough resolution to display all 256 bars individually, but it does show the shape of the curve that those bars produce.) The far-left position represents the darkest tones in your image, and the far-right slot shows the tones in the very lightest parts of your image.

Typically, a histogram looks something like a mountain, as shown in Figure 6-2. Most of the tones are clustered in the middle of the image because the average image has most of its detail in those middle tones. The bars are shorter at the dark or light ends of the scale because most images have less detail in the shadows and highlights. However, images that have a great deal of detail in the dark or light portions can have histograms that look very different, reflecting that particular distribution of tones.

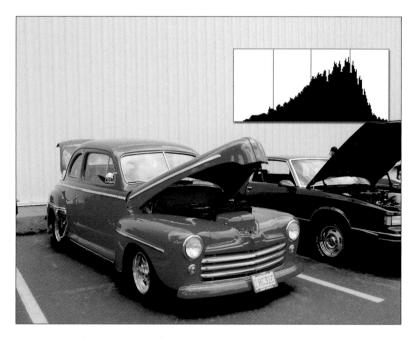

Figure 6-2: With a well-exposed image, the histogram looks sort of like a mountain.

You can't really do much to manipulate the *shape* of the histogram in your camera, other than increasing or decreasing your dSLR's contrast setting. To make significant changes to the tonal value relationships, you need to use an image editor. But dSLR owners *can* use a histogram display to judge whether the current exposure is correct for the image. Follow these steps:

1. Take your picture or view your camera's live histogram.

Some cameras can display a live histogram preview before you take the shot, using the Live View feature. With others, you need to take a picture of the scene first in order to see a histogram that you can use to make adjustments before shooting the real photo.

2. Examine the histogram with your picture review function.

• If an image is *overexposed*, the graph is shifted toward the right side of the histogram, with some of the pixels representing lighter tones clipped off entirely, as shown in Figure 6-3.

Figure 6-3: An overexposed image clusters all the information at the right side of the graph.

108 Part II: Oh, Shoot! _

• An underexposed image has the opposite look: The tones are crowded at the left side, and some of the shadow detail is clipped off, as shown in Figure 6-4.

Figure 6-4: An underexposed image moves all the picture information to the left side of the histogram.

3. If you see either condition, compensate by changing the f-stop, shutter speed, or exposure value (EV) to correct the exposure error.

Most of the time, experienced photographers try to keep the important details from running off the right side of the graph, where thanks to overexposure, they're lost forever.

If you're shooting RAW (see Chapter 9 for more about that format), you might be able to adjust exposure and contrast when importing the image into your image editor. However, most of the time, you want to get the exposure correct in the camera.

I spend the rest of this chapter showing how you can change the f-stop, shutter speed, and EV to control the exposure.

Fine-Tuning Exposure with the Metering System

Your camera's exposure metering system is a tireless friend that keeps plugging away, calculating its reckoning of the correct exposure (based on parameters that you set), regardless of whether you choose to pay attention. You can use it whether you're setting exposure manually or using one of the programmed or priority modes. You can't really turn off the exposure meter completely when the camera is on, although it might go to sleep after a few seconds of inactivity. Even then, as soon as you tap the shutter release button, a sleeping meter wakes up, looks at the current view through the lens, and reports its findings.

Like any true friend, your metering system is on its best behavior when you're around. It responds with the metering mode that you prefer and calculates exposure based on your particular guidelines. What more could you ask for?

In the following sections, you can find out how metering works, and you get a tour of all the main metering options on your dSLR to help you choose the optimum setting for the type of picture that you want to take.

Metering works how?

Digital SLR exposure meters are so accurate because they interpret the actual light passing through the lens, which the mirror flips upward toward the viewfinder (or sideways, in the case of some cameras in the older Olympus E series). The camera uses a portion of the light for viewing the image and some for measuring the exposure. If you zoom the lens (which often changes the amount of light passing through) or place a gadget (such as a filter) in front of the lens to modify the light, the meter sees the results and takes them into account. The metering system is also linked to the shutter speed and aperture controls, so the metering system understands the effects of both shutter speed and aperture on the recommended exposure.

Choosing a metering scheme

Your camera has a separate sensor (distinct from the imaging sensor used to capture the image) dedicated to measuring exposure when viewing the image through the optical viewfinder. Usually, the sensor is located in the penta-prism/pentamirror housing on top of the camera, Metering schemes on your dSLR enable you to configure the photosensitive elements of the exposure system's sensor (which can number from a dozen or so to thousands of individual exposure-measuring elements) so that the exposure system interprets the incoming light in a specific way. Table 6-1 explains how photographers typically use the most popular schemes.

110 Part II: Oh, Shoot! _____

Table 6-1	Metering Schemes	
Scheme	What It Does	Best Used for
Center weighting	This system looks at the entire frame but tends to emphasize the portion of the image in the center, assigning a center weighting determined by the vendor, but which usually amounts to about 80 percent for the center and 20 percent for the rest of the image.	Scenes in which the most important subjects are in the center of the frame. Perhaps you're shooting portraits or close-ups of flowers and, naturally, want to center your subject. Center weighting zeroes in on those subjects and isn't influenced by very bright or very dark areas out- side the center.
Spot metering	This method makes its expo- sure recommendations based only on a center spot shown in the viewfinder that might measure 3mm to 12mm. Illumination outside the spot is ignored. Your dSLR might allow you to choose the size of the center spot.	Subjects that don't domi- nate the frame, and which are surrounded by areas of misleading brightness or darkness. If you were at a Bruce Springsteen concert and wanted to capture him during a spot-lit acoustic set, you could use spot metering to collect exposure informa- tion from the Boss alone. Figure 6-5 shows the relative areas used by typical spot and center-weighted meter- ing schemes. (Sorry, I don't have any photos of Bruce Springsteen.)
Multipoint/ evaluative/ matrix metering	This mode is the default meter- ing mode for most dSLRs. It col- lects exposure data from many points on the screen (usually not shown in the viewfinder) and uses sophisticated algo- rithms to decide which points to use in calculating the correct exposure.	Any scenes that don't require the special treatment provided by the other two methods. In other words, you use multi- point metering almost all the time.

Figure 6-5: A spot metering area (center of the image) and a center-weighted zone (the larger oval area).

More versatility with metering options

Your digital SLR has several options that can increase your exposure versatility:

- ✓ Lock in settings with exposure-lock control. When you press the button, the current exposure (or focus or both) is locked until you press the button again or take a photo. This lock gives you the freedom to set exposure and then reframe the photo any way that you like without worrying about the preferred settings changing. This option is different from the normal system of locking exposure and/or focus when you press the shutter release partially because you don't have to keep your finger on the release button. Exposure-lock control is sometimes combined with a focus-lock adjustment.
- ✓ Shoot a series of photos at different exposures by setting your dSLR's bracketing system. The camera takes the first picture at the metered exposure, and then it takes the second and third at, say, one-third stop less exposure and one-third stop more exposure. You can set the exact increment, choosing to *bracket* by half or full stops, if you want. You can also bracket parameters other than exposure, such as white balance and flash. Your camera might allow you to bracket more than one of these settings in the order you choose.

Adjust the shutter speed and/or aperture combination in use without changing the exposure at all. If the camera chooses ¹/₂₅₀ of a second at f/8, spinning the command dial to the right might switch to $\frac{1}{500}$ of a second at f/5.6, or to the left to change to $\frac{1}{125}$ of a second at f/11. All these exposures are the same, but they provide different useful combinations of shutter speeds and f-stop sizes. Use this capability when you want the same exposure, but would prefer a faster shutter speed to stop action/ increase blur, or need a different f/stop to increase/decrease depth-offield. To actually change exposure, use the following EV setting method.

The Many Ways to Choose Exposure

If you want to get the best results, you must use the available exposure options — automated, manual, and semiautomatic — in an intelligent way. Whether you're choosing Auto, Programmed, Aperture Priority, Shutter Priority, Manual, or one of the programmed Scene modes, give some thought to what you want to accomplish and choose the mode that's best suited for vour planned picture-taking session.

The following sections offer tips for selecting the right mode.

Adjusting exposure the easy way

Digital SLRs include a simple way of bumping exposure up or down through EV (exposure value) adjustments. You can use EV as a way of referring to equivalent shutter speed and aperture settings that produce the same exposure. For example, if the correct exposure for a scene is $\frac{1}{250}$ of a second at f/11 exactly, equivalent exposures would include $\frac{1}{200}$ of a second at f/8 (a shutter speed half as long, but an aperture twice as large) and $\frac{1}{125}$ of a second at f/16 (a shutter speed twice as long, but an aperture half as large). All three exposures would have the same EV.

Increasing or decreasing the EV adjustment adds or subtracts to the basic exposure. If you bumped up exposure by one EV, you could change the shutter speed to $\frac{1}{125}$ of a second while keeping the f-stop at f/11, or you could use the equivalent exposure of 1/250 of a second at f/8. Reducing exposure by one EV works in the opposite direction: You can shorten the shutter speed or make the aperture smaller. It doesn't matter. EV is a quick way to add or subtract exposure without fiddling with the shutter speed or aperture controls directly.

Your digital SLR has an EV button somewhere, usually on the top surface of the camera near the shutter release button. Press it and use the corresponding EV control (usually a command dial or cursor pad button) to adjust the

EV up or down one increment. This adjustment overrides your camera's auto-exposure setting. In effect, you're giving your image more or less exposure than the exposure meter indicates when you change the EV.

Whether the camera adjusts the aperture or shutter speed is determined by your current shooting mode:

- A programmed exposure mode: The camera might adjust either value. It's that simple.
- Aperture Priority mode: In this mode, you set the f-stop and let the camera determine the shutter speed, making an EV change bump the shutter speed up or down.
- Shutter Priority mode: In this mode, you set the shutter speed and the meter sets the f-stop, so an EV adjustment makes the aperture larger or smaller.
- Auto mode: The camera sets both shutter speed and aperture with no input from you (and often without the ability to make exposure or EV changes).

In the following sections, I discuss these modes (Program, Aperture Priority, and Shutter Priority) in more detail.

Giving up control (in Program mode)

If you don't want absolute control over your exposure, you have an alternative to the dreaded Auto setting. It should suit you to a P — as in, programmed exposure — and that's where you can usually find this option on the mode dial. It's an automated exposure system but, unlike Auto, the Program setting lets you fine-tune the exposure settings that it selects. Auto generally locks you out of most useful adjustments completely.

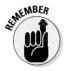

Program mode is smarter than Auto. Most dSLR cameras have a built-in database of tens of thousands of photos that have been analyzed and reduced to numbers that characterize their optimum exposures. In Program mode, your camera can look at the image in your viewfinder, compare it with this database, and come up with an image that probably is a pretty good match. It can then apply the exposure parameters to your picture.

For example, the camera decides that it has a landscape picture on its hands and attempts to maximize depth-of-field. Or, the camera determines that it's working with a portrait and, therefore, *less* depth-of-field might be in order to concentrate sharpness on the face of the subject, while allowing the background to blur. The algorithms might dictate that high shutter speeds are needed to counter camera shake or subject motion, and the program switches to lower shutter speeds only when the camera deems the aperture too small for the correct exposure at the current speed.

Part II: Oh, Shoot!

Carried to the extreme, programmed exposures can include settings that are optimized *only* for a specific type of picture, such as portraits, night photography, beach or snow photos, sports, or macro (close-up) photography. These *Scene* modes are useful when you want to take a particular kind of picture and want to inform the camera of what you're doing, but don't have the time to set up the camera yourself. Scene modes can include more than exposure settings, too. They might adjust saturation to give you more vivid land-scapes or decrease contrast to cope with bright snow scenes.

Figure 6-6 shows an image that benefited from the photographer using the Sports Scene mode. The default shutter speed selected by the camera produced a good exposure, with a shutter speed that stopped most of the action but still allowed a little blur, which prevented the picture from looking posed. (The photographer also could have used Shutter Priority, which I discuss in the section "Getting your aperture and shutter priorities straight," later in this chapter.)

Both Program and Scene modes are useful shortcuts for photographers in a hurry. However, most of the serious photographers I know use the options discussed in the following section — Aperture Priority, Shutter Priority, and Manual Exposure modes — almost exclusively.

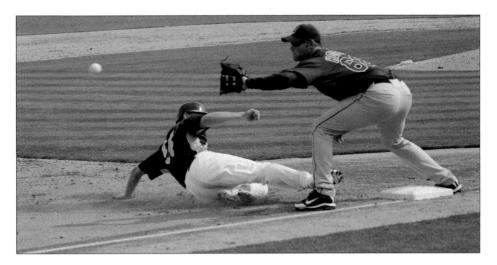

Figure 6-6: The Sports setting improved this action photo by freezing runner, third baseman, and the incoming ball, but with just enough blur remaining to add a feeling of motion.

Taking control

One of the joys of gaining expertise with your dSLR is knowing what's best for a particular type of photo and making the necessary choices, even if you let the camera's electronics do most of the work. That's why digital SLR owners love Aperture Priority, Shutter Priority, and even Manual Exposure modes.

Here's how to choose among them.

Getting your aperture and shutter priorities straight

Your camera doesn't know you're taking photographs of a soccer game, but you do. You know that you sometimes want to use $\frac{1}{1000}$ of a second to freeze the action, but other times, you'd prefer to use $\frac{1}{125}$ of a second to introduce a little blur into the mix.

When you use *Shutter Priority mode*, usually represented by an S or Tv (for Time Value) on the mode dial, you get to choose the shutter speed. After you select the shutter speed, the camera locks it in. The auto-exposure system varies *only* the aperture.

You can see the selected aperture in the viewfinder so that you, the all-knowing photographer, can decide when, say, the f-stop is getting a little too large for comfort and you want to accept a slower shutter speed to gain a smaller aperture. If light conditions change enough that your selected shutter speed doesn't produce a correct exposure with the available f-stops, a LO or HI indicator in the viewfinder or, perhaps, a flashing light emitting diode (LED) alerts you.

Aperture Priority mode, represented by an A or Av (for Aperture Value) on the mode dial, is the flip side of Shutter Priority mode. (Don't confuse A with Auto, which is another setting entirely.) Perhaps you want a small aperture to maximize depth-of-field or a large f-stop to minimize it. It's your choice. You set the aperture you want, and the metering system sets the matching shutter speed. Again, if you notice that the shutter speed is too slow or high, you can opt to adjust the f-stop that you've dialed in to one that's larger or smaller.

Some cameras include an ISO Auto option that also can change the sensitivity (to a higher ISO setting) if the camera's programming determines that the aperture you select doesn't allow the camera to use a shutter speed fast enough to counter camera shake, particularly vibration that can't be offset by the built-in vibration reduction system that is built into many camera bodies or lenses.

Part II: Oh, Shoot!

The Shutter and Aperture Priority modes let you use your photo smarts to set a basic parameter suitable for the photo that you have in mind, and then the camera takes over to intelligently make the other adjustments.

Doing exposure yourself

Sometimes, if you want something done right, you have to do it yourself. Manual Exposure mode allows you to set both the shutter speed and aperture while using the camera's built-in meter for guidance. After you switch to Manual mode, the dSLR doesn't touch either setting, but it continues to evaluate the scene for the correct exposure and provide information in the viewfinder, which shows you that you're over, under, or right on its recommendation. You can then follow the camera's recommendation, or make adjustments based on your own judgement.

I'm no technological Luddite, but I did resist exposure automation for an interminable period. Why did I resist? Well, Manual Exposure mode has some distinct advantages:

- ✓ Special effects: Suppose that you want to create a silhouette effect, as in Figure 6-7, or underexpose a sunset to cloak your image in deep shadows. Maybe you want to overexpose a bit to wash out unwanted detail. Any automatic exposure mode stubbornly tries to correct for the lighting, effectively blocking you from applying your special effect. You can usually just switch to Manual Exposure mode and make the settings yourself much faster than trying to override your camera's auto-exposure mechanism.
- Balancing lighting: You have a subject that's illuminated by several different light sources say, two or more studio lights or, outdoors, by sunshine and fill light from your flash or a reflector. Manual Exposure mode lets you control exactly how the camera sets exposure for these multiple light sources.
- ✓ Older optics: You might have an older lens that doesn't couple with your dSLR's auto-exposure system. In that case, setting the exposure manually might be your only option.
- ✓ Non-compatible flash: I use Manual Exposure mode quite frequently when I connect my dSLR to some studio flash units. The camera can't control the flash, and it has no way of adjusting exposure automatically. So, I use a flash meter and set the f-stop manually. If you're using a flash that isn't built specifically for your dSLR, or you want to use the flash in Manual mode (say, to make sure that it always uses its full power), setting the exposure manually can work for you. Chapter 10 covers working with flash in more detail.

Chapter 6: Taking Control of Your dSLR

Figure 6-7: Manual settings let you use creative exposure for special effects, such as this silhouette at the Bastille in Paris.

Exotic 150 settings become mundane

In recent years, digital SLRs have gained a bit of flexibility in the exposure arena as vendors have upped the ISO ante to (potentially) stratospheric heights. I'm able to shoot basketball games in the typical college gymnasium at $\frac{1}{300}$ second at f/5.6, whereas, when I began photographing these games in the dark ages with a product called "film" at an ASA (later ISO) rating of 400, $\frac{1}{25}$ second at f/2.8 was the norm.

118 Part II: Oh, Shoot!

Even in modern times, it wasn't so long ago that using an ISO 1600 sensitivity setting was considered adventurous, and venturing into the ISO 3200 territory was a slippery slope toward grainy images with abundant visual noise. Then, vendors began developing sensors with more photon-hungry photosites, and some cameras had ISO 6400 settings that were entirely practical (particularly full-frame models with large sensors and correspondingly larger pixels that could gather more light).

Today, settings of ISO 12800 to ISO 102400 are available with some cameras. Even with the best performing cameras, I find that ISO 12800 is still the highest ISO you can use for any images you might find acceptable, and ISO 102400 is just for showing off. Yet, the best thing about these newer, loftier sensitivity settings is that formerly exotic ISO ranges, up to ISO 6400, have become almost mundane.

Focus Pocus

Focusing your image correctly is arguably the most important technical aspect of taking pictures because even a small focus error might ruin an image beyond redemption. You can often correct exposure problems or fix bad color balance in an image editor. You might be able to fix clumsy framing with some judicious cropping. You can even retouch images to remove particularly ugly subject matter. But if an image is badly focused, you can sharpen it a little, but most likely not enough to bring a blurry shot back from the dead.

Oddly enough, focus is both a benefit and bane of the dSLR. Focus isn't usually much of a worry for point-and-shoot photographers, except when taking close-up pictures. Nor is selective focus (placing parts of an image out of focus to emphasize other portions) much of a creative tool. The very short focal lengths required by the tiny sensors in those cameras put virtually everything in sharp focus, regardless of zoom position, f-stop, or distances (other than close-ups). Even a telephoto shot taken with a point-and-shoot camera's lens wide open is likely to be sharp, all the way from a few feet to infinity.

But dSLRs and their lenses don't necessarily have such extensive depth-offield. You can throw parts of your scene, such as the background in a portrait shot, out of focus to emphasize your subject. Unfortunately, you can also accidentally throw your subject out of focus if you aren't careful, producing unintended results.

Digital SLRs offer two ways of achieving focus: manual and automatic. Each method has its advantages and disadvantages.

Focusing manually

Manual focusing sounds easy, but it's more difficult than it sounds. You just need to twist a ring on the front of the lens, and the image pops into sharp focus, right? If only it were that simple! Manual focus is, unfortunately, rather slow when compared to the automatic focus features of digital SLRs. It works well when you're doing thoughtful work, such as *macro* (close-up) photography, where your subject (if a nonliving object or, perhaps, a particularly mellow insect) sits there patiently while you fiddle with the camera, often locked down on a tripod, and focus until you get everything exactly right.

Manual focus isn't so good when you're photographing fast-moving sports or if you're shooting in a rush for any reason. The big problem is that humans' brains have a very poor memory for sharpness. You don't really know for sure that you've achieved sharp focus until you pass it and your image starts to blur again. Then, you have to jog back and forth until you're convinced the image is sharply focused. This jostling takes time, and you might not have that much time to waste.

Focusing an image becomes more difficult when your scene is dark or low in contrast — for both you and the camera's autofocus mechanism. But at least when the camera's doing the job, you don't have to fret in frustration.

Still, manual focus might work for you in several situations:

- Zeroing in on one subject: When you want to focus on a particular object that the autofocus system doesn't readily lock in on, focus manually. Perhaps you want to concentrate attention on the fleet fingers of the bass player, shown in Figure 6-8. You can aim most autofocus systems, but you might simply be able to do the focusing yourself more quickly.
- ✓ Shooting action pictures: Autofocus systems can work fast, but in some action situations, they might focus at lightning speed on the wrong subject. Sports photographers can sometimes use Manual mode to focus ahead of time where they know the action will be, dispensing with the uncertainty.
- Avoiding total confusion: Autofocus systems are totally confused by some kinds of situations, such as subjects posed against plain backgrounds. For example, I find that when photographing seagulls in flight, I often have to focus manually unless I'm lucky enough to have a bird blunder into one of my camera's autofocus zones.
- Photographing through glass: Sometimes, an autofocus system fixates on the glass itself, rather than the subject behind it, so you might need to focus manually.

120 Part II: Oh, Shoot! _____

Figure 6-8: You might more easily focus on the bass player's hand manually.

Oughta autofocus

Digital SLRs focus automatically by selecting the focus point at which the image contrast is highest. When a subject is out of focus, it looks blurry and lower in contrast. When the subject's in focus, the lack of blur translates into higher contrast that the focus system can see.

Of course, a low-contrast subject or one that's poorly illuminated can give an autofocus system fits. (I recommend manual focus in such cases.) Sometimes, a *focus assist lamp* built into the camera or a series of pre-flashes from a dedicated flash unit can put a little light on the focus problem.

One nagging problem with autofocus is how the system decides what to focus on. Most digital cameras have five to nine (or more) focus sensors grouped around the viewfinder screen, and the cameras evaluate the contrast of the image in each of them to select the zone on which to base focus. To gain a little more control over the focal point of a shot, you might have the following options:

- ✓ Switching zones manually: You might be able to switch from one zone to another manually by using your camera's cursor pad or other control. You may find this technique useful if your subject isn't smack in the center of the frame but still lies within one of the other focus zones. The zone you select is highlighted in the viewfinder and remains in that position until you move to another zone.
- ✓ Switching zones under camera control: If you don't choose a focus zone yourself, your camera does it for you by using a scheme, such as *dynamic focus area* (the zone switches around when the camera detects subject motion) or *nearest subject* (the zone is locked into what the system determines is the closest object to the camera). You might be able to allow the autofocus system to set the focus point for you, yet still override its decision without resorting to full manual focus.
- Locking out focus ranges: You can also lock out certain focus ranges, such as extreme close-up or distant focus, so that your autofocus system doesn't hunt over the full range when seeking correct focus.

Most of the time, you can let your camera focus for you, choosing among the three common primary focus modes:

✓ Continuous autofocus: After you press the shutter release halfway, the camera sets the focus but continues to look for movement within the frame. If the camera detects motion, the lens refocuses on the new position. Use this option for action photography or other subjects that are likely to be in motion. Remember that if your subject moves faster than the autofocus system can keep up, you might take an out-of-focus picture. Taking an out-of-focus picture isn't as bad as it sounds, though: Sometimes, you'd rather capture a picture — any picture, even if it's slightly out of focus — than miss the shot entirely.

122 Part II: Oh, Shoot! _____

- Single autofocus: Press the shutter release halfway to set focus. The focus remains at that setting until you take the photo or release the button. Use this mode for subject matter that isn't likely to move after the camera brings it into sharp focus. However, you can't take a photo at all until focus is locked in, so you end up either with a sharp photo or none at all.
- Automatic autofocus: Press the shutter release halfway to set focus, like in single autofocus. But, if the subject starts to move, the camera switches to continuous autofocus and refocuses as required. Use this mode when you aren't certain that your subject will remain stationary.

Mastering the Multi-Lens Reflex

In This Chapter

- Deciding on add-on lenses
- Choosing prime lenses or zooms
- Understanding key lens concepts
- Using wide angles and telephotos creatively

n one sense, the term *single lens reflex* is a misnomer. Even in these days of 18mm-to-270mm lenses that cover the range from wide-angle to medium telephoto (or 50mm–500mm superzooms that extend from short telephoto to really, really long telephoto), few dSLR owners try to operate with only a single lens. In fact, buying extra optics for one of these cameras is more than a reflex (pardon my pun) — it's a passion! Additional lenses are probably the most popular accessory for digital SLRs. They're the single component that can provide the biggest boost to your photographic repertoire.

Of course, you probably know that the term SLR actually refers to a camera design. An SLR camera uses the same lens to take the picture as it uses for *reflex viewing* (viewing by reflection, using mirrors or a prism), as opposed to a *twin-lens reflex*, which pairs two lenses of the same focal length for separate viewing and snapshooting. These days, however, dSLR owners are more likely to be single-minded about acquiring accessory lenses.

This chapter helps you choose which lenses to add to your collection, based on your needs — both real and imagined — and shows you how to use them effectively.

Optical Delusions

Unless you happened to purchase a compact 12mm-to-400mm f/1.4 zoom lens (they don't exist) with your dSLR, you're deluding yourself if you think you

Part II: Oh, Shoot!

can't use an accessory lens to improve your photography. Lenses don't make you a better photographer, of course, but they do increase your opportunities and let you take pictures that you simply can't grab with the lens that comes with your camera.

The following sections list some of the things that an accessory lens can do for you.

Shooting in low light

The do-everything zoom lenses furnished with dSLRs often have maximum apertures of f/3.5 to f/4.5. The entry-level Canon, Nikon, Sony, and Pentax models are all furnished in kit form with 18mm-to-55mm f/3.5-to-f/5.6 zooms. (I'm sensing a trend here.)

You can't compare the focal-length ranges directly, of course, because these popularly priced dSLRs have different crop factors (which I describe in Chapter 2), ranging from 1.5X (for Nikon, Sony, and Pentax) to 2X (for the Olympus line). But you can compare maximum apertures, and f/3.5 or slower is common among every vendor's starter lenses.

Although zooms that have large maximum apertures are expensive (and for a zoom lens, f/2.8 is a large maximum aperture), you can find fast fixed focal length (*prime*) lenses that cost very little. For example, a 50mm f/1.8 lens from a major camera manufacturer may cost less than \$100, even though it is two f-stops faster than an f/3.5 lens and three stops better than an f/4.5 optic.

If you're willing to spend a little more, you can buy 28mm, 35mm, 50mm, or 85mm f/1.4 lenses from the larger lens companies and speedy third-party lenses, such as the Sigma 30mm f/1.4 and Sigma 20mm f/1.8. Those extra notches on the aperture ring let you take hand-held pictures in dark environments (especially when the camera or lens uses image stabilization, which I discuss in Chapter 8), as shown in Figure 7-1, without resorting to detail-robbing high ISO ratings. An indoor concert that calls for a $\frac{1}{3}$ -second exposure at f/4 and ISO 100 may work just fine at $\frac{1}{25}$ of a second at f/1.4.

The fastest lenses are generally designed to produce good results when wide open, too, so you needn't fear using f/1.4 with a prime lens, even though you get poor results with your zoom at f/4.5.

Improving your shutter speed

That wide aperture also pays dividends in the shutter-speed department. The difference between f/1.4 at $\frac{1}{25}$ of a second and $\frac{1}{5}$ of a second at f/4 can be quite dramatic from a sharpness perspective, as you can discover in Chapter 5. You can find out more about making the most of slow shutter speeds by using image stabilization technology in Chapter 8.

124

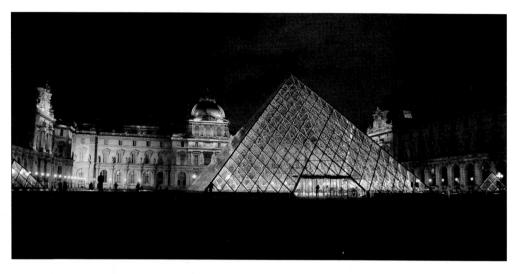

Producing sharper images

You may be able to get sharper images by switching lenses, too. That isn't to say that the lens you purchased with your camera is not sharp. However, your do-all lens is built on a foundation of compromises that don't necessarily produce the best results at all zoom positions and all apertures. Other lenses that you add to your collection may provide better results at specific focal lengths or f-stops. For example, that 50mm f/1.8 lens that you pick up for less than a single Benjamin just might be the sharpest lens you own. Or you might buy a close-up lens that is optimized for macro photography and produces especially sharp images at distances of a few inches or so.

Your current lens is probably very good, but that doesn't mean you can't get sharper pictures with another set of optics, particularly when you're swapping a general-purpose zoom lens for a fixed focal length prime lens designed for exactly the kind of photo project that you're working on at the moment.

Taking a step back

Wide-angle lenses let you take in a wide field of view — in effect, stepping back from your subject, even in situations where you really don't have room to move farther away. The lens that you bought with your camera likely provides a field of view no wider than that of a 28mm lens on a full-frame film SLR, which really isn't very wide. You can get interesting perspectives by using ultra-wide lenses, including the 10.5mm fish-eye view provided by one Nikkor lens, particularly because Nikon offers a utility that can defish the curved image to produce a more *rectilinear* (straight line) version. Your particular dSLR may have wide angles available with the equivalent of a superwide 18mm lens or better.

Part II: Oh, Shoot!

Third-party vendors also offer some interesting wide-angle choices, such as the Sigma 10mm-to-20mm f/4-to-f/5.6 optic that offers the equivalent of a 15mm-to-30mm zoom on a dSLR that has a 1.5X crop factor. I have a great deal of fun with a Tokina fish-eye zoom lens (used for Figure 7-2), which allows you to choose your degree of distortion over a 10mm-to-17mm range.

If you've been lusting after longer and longer lenses, I understand — particularly if you shoot wildlife or sports. And if you haven't worked extensively with wide-angle lenses, I urge you to give them a try. It's a whole new world.

Figure 7-2: Extreme wide-angle lenses, such as the fish-eye used for this shot, provide a new perspective.

126

Chapter 7: Mastering the Multi-Lens Reflex

Getting closer

The inverse of a wide-angle lens is the telephoto lens, and the telephoto lens's long focal lengths let you bring distant objects much closer to your camera. The lens that came with your camera probably provides only a moderate telephoto effect, perhaps around 70mm, which with a 1.5 crop factor, is the equivalent of a 105mm short tele-lens on a full-frame 35mm film camera.

You can easily find long lenses, and they usually don't cost much, simply because telephoto prime lenses and telephoto zooms are generally simpler to design than their tricky wide-angle counterparts. You can find 70mm-to-300mm zooms for many dSLRs for only a few hundred dollars. You can find prime lenses for even less. I picked up an ancient non-automatic (focus, exposure, and aperture) 400mm lens for about \$79. I use it for great wildlife shooting, as shown in Figure 7-3, especially if I can mount the camera or lens on a tripod.

Figure 7-3: Bring wildlife up close — if you have a long-enough telephoto lens.

Focusing closer

Your optional lens may be able to focus much more closely than the lens that came with your camera, making it a macro lens. If you're new to close-up photography, you'll soon find that the *magnification* of the image is more important than the close-focusing distance.

You can get the same size image with a 200mm lens at 8 inches as you get with a 50mm lens at 2 inches, and you may even be better off with the 200mm lens. The closer you get, the harder it may be to get good lighting on your subject. You simply don't have a lot of room to apply effective lighting when you have a gap of only a couple of inches between the front of the lens and that tree frog you're snapping. Worse, the tree frog may get skittish at the proximity of your camera and you, making that 200mm lens and the extra distance it provides an even better idea.

Choosing Your Prime Lens — or Zoom

In the olden days, photographers used only fixed focal length prime lenses most of the time. Zoom lenses were slow, often expensive, and had limited zoom ranges. In the 1960s and 1970s, photographers used zoom lenses only when they absolutely couldn't swap lenses to get the focal lengths they needed. Even then, they were more likely to tote around three or four camera bodies, each mounted with a prime lens of a different focal length. Zooms could do special tricks, such as the infamous zoom-during-exposure effect. In 1966, Nikon introduced one of the first decent zooms that had a practical zoom range and acceptable sharpness, a 50mm-to-300mm f/4.5 that seems fairly tame today, but which was revolutionary and horrendously expensive at the time.

Today, zooms are sharper, smaller, faster, and less expensive. The 28mm-to-200mm zoom that I have mounted on my dSLR right now costs around \$300, measures about 2.7 x 2.8 inches, weighs 13 ounces, and focuses down to 1.3 feet at 200mm. It's truly an all-purpose lens. You can find other zooms that meet your needs or, perhaps, fill out your arsenal with a few prime lenses.

Prime time

Prime lenses can be faster (both in aperture and autofocusing speed), sharper, and much lighter in weight than zoom lenses. If you're looking for the ultimate in image quality, a good prime lens or two may be exactly what you want. In all cases in the following list, when referring to recommended focal lengths, I use the actual focal length. I also assume that your camera has about a 1.5X crop factor. That number works for the majority of consumerpriced dSLRs on the market, and isn't too far off for cameras that have 1.3X to 1.6X crop factors.

Here's a list of some common applications and the prime lenses that you might find especially suitable for them:

✓ Architecture: Wide-angle lenses in the 12mm-to-28mm range (depending on how much of the wide view your system's crop factor clips off). Most of the time, you're shooting with a relatively small aperture to gain depth-of-field, so an f/2 or f/1.4 maximum aperture isn't as important, even when shooting indoors under low light levels. A tripod serves you better. If you shoot a great deal of architecture, you can purchase a *perspective control* lens that compensates for the falling-back effect that results when you tilt the camera back to capture the upper reaches of a

tall structure. You can find out more about perspective problems in Chapter 11.

- Indoor sports: You want a lens that has a moderately wide angle of roughly 30mm focal length for indoor sports, such as basketball or volleyball, as well as long lenses for shooting from up in the stands. You can use large apertures for available-light sports, but only if you can focus or pre-focus carefully on a single subject or two because depth-of-field is limited. (See Figure 7-4.) Autofocus may not accurately focus exactly where you need to when using a very large aperture.
- ✓ Outdoor sports: Longer lenses are useful, and primes in telephoto focal lengths often offer an excellent combination of reach and speed. You'll find 100mm-to-200mm lenses, or longer, great for capturing football, baseball, soccer, and other outdoor sports. Apertures of f/2.8 to f/4 let you use faster

Figure 7-4: When shooting indoor sports, focus carefully because you don't get much depthof-field at wide apertures.

shutter speeds to freeze the action (again, assuming that you or your camera's autofocus system makes the most of the available depth-of-field).

- ✓ Portraits: If you're taking head-and-shoulders shots, a 50mm-to-70mm prime lens offers the same flattering perspective as the traditional 75mm-to-105mm portrait lenses used with 35mm full-frame cameras (with a 1.5X crop factor on the dSLR). Such prime lenses usually come with f/1.8 or faster maximum apertures, which you can use to limit depth-of-field when you want to concentrate on your portrait subject's face. Longer focal lengths can produce a flattening effect on the features, and shorter focal lengths can make ears look too small while enlarging noses if you use those focal lengths up close.
- Macro photography: Prime lenses, such as the ever-popular 50mm f/1.8, although not intended for close-up work, can still do a great job. You may have to purchase extension tubes or other accessories to focus close enough to fill the frame with very small subjects.
- Landscapes: Wide-angle primes (12mm-24mm) can give you landscape photos that are sharp enough to blow up to 16 x 20 inches or larger, making framed pictures to grace your walls.

Of course, the only problem with using prime lenses is that you must be willing to swap lenses when you decide to shoot something else or need a different perspective that you can't get by stepping closer or farther away. Digital SLRs have one additional consideration: If you're working in a dusty environment, you may not *want* to change lenses a lot because each time you take off a lens, dirt invades the camera body and, possibly, ends up on the sensor. Read more about sensors and dust in Chapter 2.

Zoom, zoom, zoom

Zooms are good, too. Honest. I may be a little biased because most of my lenses have always been primes, with only a lone zoom that I didn't use much. Today, I do most of my work by using 12mm-to-24mm, 28mm-to-70mm, 28mm-to-200mm, and 170mm-to-500mm zooms, so you can see that I'm no optical Luddite. But I still get a lot of use from my new 60mm and 105mm macro lenses, as well as older prime lenses that I own, including a 16mm fish-eye that functions as a quirky 24mm lens that has a heck of a lot of barrel distortion (even after the crop factor has trimmed the image). I also regularly use my prime 50mm f/1.4, 85mm f/1.8, 105mm f/2.5, and 200mm f/4 lenses when I want a little extra sharpness or aperture speed.

- ✓ Wide-angle: These are designed strictly for wide-angle perspectives, and, if designed for digital SLRs, may include ranges such as 10mm to 20mm or 12mm to 24mm. You can find wide-angle lenses originally created for full-frame 35mm cameras, too, that have ranges such as 17mm to 35mm. On a camera that has a crop factor, such lenses are actually close to wide-to-normal in range, but they likely produce very sharp images (and sometimes cost quite a bit). Before purchasing a wide zoom for your dSLR, check it out carefully because the widest of the wide often have serious distortion and aberrations.
- ✓ Mid-range: The lens furnished with your camera is likely a midrange zoom that has a focal length at the wide end of about 17mm to 18mm, extending out to 55mm to 70mm at the telephoto end. Such lenses are not very fast but reasonable in cost. You can also find some upscale versions in the same focal lengths that have greater sharpness and larger maximum apertures. These lenses were usually designed for finicky full-frame 35mm film camera users. They may be worth the extra expense. They often have a fixed maximum aperture throughout the zoom range, meaning a 17mm-to-55mm f/2.8 lens has a constant f/2.8 aperture and doesn't vary between, say, f/2.8 at the wide-angle position and f/4 at the telephoto position, which commonly happens with less expensive models (such as the one that came with your camera).
- ✓ Short-tele to telephoto: These lenses may start out at 50mm to 70mm and extend out to 200mm to 300mm or more. One vendor's 50mm-to-500mm zoom is especially popular because it provides such a huge range of focal lengths in one lens. Of course, it's also possibly the largest and heaviest 50mm lens on the planet, so you want to own such a beast only if you plan on actually needing its 10X zoom reach.
- ✓ Telephoto: These lenses start long and go longer. My 170mm-to-500mm zoom falls into this category and can *really* reach out and touch some-one, as shown in Figure 7-5. You can also find 200mm-to-400mm zooms or even longer lenses from various vendors. Like with any lens of more than about 200mm, seriously consider using these optics either with the camera mounted on a tripod or, better yet, with the lens attached to the tripod using a special collar that has a tripod socket. Many long lenses are sold with such removable collars.
- Macro: Several vendors offer lenses that have zoom ranges in the medium telephoto range (out to about 200mm) that also offer macro focusing. Wildlife photographers who photograph big beasts and small find these lenses especially useful.

Figure 7-5: Capture subjects that you can't get close to easily with a long lens, such as the 170mm-to-500mm zoom used to capture this shot.

Special (lens) delivery

I touch on special-purpose lenses in this chapter and describe them in more detail in other chapters in this book. Just to make things neat and tidy, I list the special kinds of lenses you may encounter (or want to acquire). They include

- ✓ Optical image stabilization: I discuss image stabilization in Chapter 8. These lenses counter camera or photographer shake by shifting lens elements around just before exposure. They give you the power to shoot at shutter speeds about 4 times as long without producing camera-induced blur. Sony, Olympus, and Pentax build the anti-shake feature into the camera itself, so, with only a couple of exceptions, you can use image stabilization with *all* your lenses.
- Perspective control: These optics shift to provide improved perspective when you photograph buildings or other subjects that converge in the distance.
- ✓ Macro: Prime or zoom lenses designed especially for close-up photography, offering extended focusing; better sharpness; and often, extra-small apertures (such as f/32 or f/45) to maximize depth-of-field.
- Focus control portrait: Nikon offers a series of DC lenses that have defocus control, which lets you adjust how the out-of-focus background appears in portraits or similar kinds of single-subject pictures.

132

UV: If you're a scientist photographing subjects by using ultraviolet (UV) light, you probably want to scrounge around for one of these rare, expensive optics that don't filter out UV in the same way that lenses built of conventional glass elements do.

Lens Concepts

Ideally, lenses used on dSLRs should be designed to meet the special needs of digital cameras. But that isn't always possible. Most digital SLRs use lenses that were originally designed for film cameras, which might not work as well on a digital camera. Some vendors, such as Pentax, Nikon, and Olympus, offer lenses that work exclusively with their digital cameras. That's a better solution, in my book.

Sensors aren't what engineers might describe as *plug compatible* with film. You can't rip out the film transport mechanism and substitute a digital sensor and expect the same results (even though that's exactly how some of the original dSLRs were designed).

Different strokes

Sensors for many dSLRs are smaller than film frames, introducing the infamous crop factor that I'm forced to drag into about half the shooting discussions in this book. Only part of the image formed by a lens designed for a full-frame sensor is captured by a sensor that's smaller than 24mm x 36mm (like most dSLR sensors today are). The crop factor may be 1.3X, 1.5X, 1.6X, or even 2.0X. This crop factor can be (seemingly) good for telephoto pictures, but it doesn't create such a great effect if you really wanted a wide-angle view. A 100mm lens may have the field of view of a 150mm lens, but a 20mm superwide-angle lens ends up with the viewpoint of a mundane 30mm lens.

Because the image uses only a smaller portion of the lens coverage area, the smaller sensor crops the edges and corners of the image, where aberrations and other defects traditionally hide. You just might be using the best part of your lens if it was originally designed for a film camera.

Of course, vendors are producing lenses designed expressly for smaller sensors, which means that their reduced coverage area must be extraordinarily even in terms of sharpness and light distribution.

But wait, there's more! Sensors don't respond to light the same way that film does. Film grains absorb light in roughly the same manner, regardless of its angle of approach to the film surface. A sensor's *photosites*, on the other

hand, are little pixel-nabbing wells that collect photons best when they drop directly into the bucket, instead of coming in from a steep angle. When you use lenses designed for film on a dSLR, some of the light can hit the side of the well or spill over into adjacent pixels. Unwanted patterns and light fall-off can result, along with flare that happens when photons bounce off the shiny sensor surface, hit the equally shiny rear lens elements, and then reflect back onto the sensor. Ugh!

Although camera and lens designers have found ways to counter these problems with equipment designed expressly for digital photography, optics created for film cameras might not produce the same uniformly good results. Image quality can vary from lens to lens, based on how well the design meets the needs of digital imaging.

A camera that has an image cropped by the camera's small sensor gives you more telephoto reach than simply cutting the center out of a full-frame image because of *pixel density*. A 12MP crop-factor camera and a 12MP full-frame camera have the same number of pixels, but the cropped camera packs them all more densely into the area of a smaller sensor. Put a 500mm lens on a 12MP camera with a 1.5X crop factor, and all 12 megapixels give you the equivalent field of view of a 750mm lens on a full-frame camera. When you mount that same lens on a full-frame camera, such as the 12MP Nikon D700, cropping out the center portion yields the same field of view, but only 5 megapixels' worth of the full-frame camera's less dense pixels are used to form the image. The camera with the 1.5X crop factor gives you an image that has more resolution and sharpness.

Going for bokeh

Obsessing over the quality of the out-of-focus areas of an image that a lens produces (the lens's so-called *bokeh*) has become a subspecialty fixation of its own in recent years. Some lenses are prized for their wonderful bokeh, whereas others are reviled because their bokeh stinks. You can find endless discussion of this topic in the photographic forums online. So, what does it all mean?

The word *boke* means "blur" in Japanese, I'm told. English speakers insisted on rhyming it with "broke," so the silent "h" was added to the Western spelling of the term to help ensure that the language-challenged among us would properly pronounce it to rhyme with "polka."

Bokeh describes the points of light in the background that become fuzzy disks when rendered out of focus by inadequate depth-of-field. Various lenses render these disks in different ways. Some create uniformly illuminated disks. Others generate disks that are dark in the center and lighter at the edges,

134

which make them stand out like a sore thumb — or, actually, a frosted doughnut. When you have the reverse effect, a nicely illuminated center that fades to a darker edge, the disks tend to blend into each other, which gives you the ideal representation. Lenses that have the very best bokeh characteristics display almost no disk shapes at all.

If you shoot close-ups, portraits, or long telephoto shots that have out-offocus backgrounds, carefully examine the bokeh characteristics of any lens that you're considering. You might not even be aware of the deleterious effects of bad bokeh (except when you use a so-called *mirror* or *catadioptric* telephoto lens, which generates the mother of all doughnuts around each point of light). But you eventually notice that some out-of-focus backgrounds are more harmonious than others or, in the worst case, your bokeh-aware photographer friends make fun of you. Figure 7-6 shows examples of both good and bad bokeh.

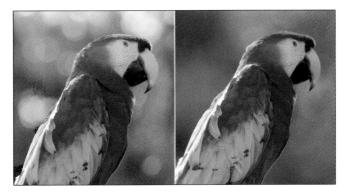

Figure 7-6: When bokeh goes bad (left), out-of-focus points of light produce obvious disks that are darker in the center than at the edges. With good bokeh, the points blend together to produce a smooth out-of-focus background (right).

Using Lenses Creatively

You need to know more about working with a lens than simply adjusting to its greater or lesser field of view. A wide-angle lens is much more than just a wider perspective, in the same way that a telephoto lens has a lot more going for it than the capability to pull objects closer to your camera. The following sections show you some things that you need to know to work with wideangle and telephoto lenses creatively.

Creative use of wide angles

Wide-angle lenses have some special characteristics that can hold pitfalls to avoid, but those characteristics offer some creative advantages if you use them properly.

You can use those wide-angle-lens qualities in your photography in these ways:

- ✓ Increase depth-of-field. Sometimes, you want what cinematographers call *deep focus*. Akira Kurosawa was a master of the technique of having both subjects very close to the camera as well as those that are more distant all in sharp focus. You can do it, too. At any given aperture, wide-angle lenses provide more depth-of-field than a telephoto lens, allowing you to picture a larger range of subject matter without distracting blurriness of objects in the foreground, background, or both.
- **Emphasize the foreground.** If you want to put extra emphasis on subjects in the foreground, such as a lake or meadow, while de-emphasizing the mountains in the background, use a wide-angle lens.
- Distort the foreground. Although wide-angle lenses tend to exaggerate the size of objects closest to the lens, you can effectively use this form of perspective distortion to create an interesting viewpoint in your picture.
- ✓ Add a unique angle. When you get down low and shoot up with a wide angle, you can creatively use the combination of perspective distortion and the unusual angle, and, in some cases, a less cluttered background, as shown in Figure 7-7. The same is true when shooting down from high angles.
- ✓ Use slow shutter speeds. Although telephoto lenses magnify camera shake, wide-angle lenses tend to minimize it. If you can hand-hold your camera with a normal lens (or zoom setting) at ½₀ of a second, you might be able to pull off ½₀-second exposures, or longer, with a wide-angle lens.
- ✓ Show more stuff. Indoors or outdoors in tight quarters, you can show more of your scene by using a wide-angle lens. You can fit most of a building or all of a room in the picture, but you can also use this expansive view when photographing people in their environment.

Don't be lulled by the creative opportunities that wide angles offer. Here are some pitfalls:

Avoid skewed horizontal and vertical lines. Watch those horizons and the vertical lines of buildings so that they don't look skewed in your photos. Keep the camera level as much as possible.

136

Chapter 7: Mastering the Multi-Lens Reflex

Figure 7-7: Shooting from a low angle with a wide-angle lens is a dual-edged sword. The perspective is interesting, but you run the danger of having tall structures appear to be falling backward.

Watch proportions. Because wide angles exaggerate the relative size of objects that are close to the camera, you can end up with weird proportions in your photos. You don't want your spouse's nose to appear twice its normal size (even button noses don't benefit from optical plastic surgery), so keep the possibility of distortion in mind when framing your photos.

- ✓ Don't let lens defects ruin your photos. Wide-angle lenses may distort an image, changing the shape of vertical and horizontal lines at the edges of the photo. Or such lenses may have chromatic aberrations that add purple or cyan glows around backlit subjects.
- Avoid vignetting. Filters, lens hoods, and other add-ons may actually intrude into the picture area when you use wide-angle lenses. Use thin filters, avoid stacking too many of them together, and use only lens hoods designed for a particular lens.
- ✓ Watch that flash. Your digital SLR's built-in electronic flash might not spread wide enough to cover the full frame of a wide-angle lens. Use a diffuser or wide-angle adapter over your flash. Some dedicated flash units actually zoom their coverage to match your lens's zoom position. Also, make sure that your lens or lens hood doesn't cast a shadow when you shoot close-up subjects with flash.

Creative use of telephotos

Telephoto lenses have their own set of creative strengths and dangerous pitfalls. Keep these tempting applications in mind when working with longer lenses and tele-zooms:

Compression: Telephoto lenses compress the apparent distance between objects, making that row of fence posts look like each post is only a foot or two distant from the next.

Moviemakers use this effect all the time to make it look like the hero is bravely racing between speeding cars while crossing the street, when actually none of the vehicles come closer to him than 5 or 10 feet.

- Isolation: The reduced depth-of-field of tele-lenses lets you apply selective focus when you want to isolate your subjects from the foreground or background.
- ✓ Sports action: A telephoto lens brings you into the middle of the huddle, right in the center of the action around the goal, and a lot closer than you ever wanted to get to the periphery of a scrum.
- ✓ Nature's bounty: A telephoto can take you closer to your photographic prey, including animals of all shapes and sizes, while letting you stay far enough away that you don't become prey yourself, as shown in Figure 7-8.
- Macro photos: You might not need a macro lens to shoot macro photos. You may only need a telephoto lens that has enough reach and focuses reasonably close.

Figure 7-8: Don't get too close! Use a telephoto lens and live to shoot another day.

Telephoto lenses don't have an unusual number of pitfalls, but be aware of them, nevertheless. Here are the crucial things to watch out for:

✓ Flash coverage: Like wide-angle lenses, telephotos have some potential problems with electronic flash coverage, except that the problem is depth, rather than width. The electronic flash built into most dSLRs isn't powerful enough to reach more than 10 to 20 feet, so if you're photographing a running back who's 50 feet away, you end up with a very underexposed photo.

If you do a lot of sports photography, consider buying a powerful external flash that can provide the extra light you need.

Too-slow shutter speeds: Because longer lenses magnify the shakiness of lightweight cameras or lightweight photographers, use a shutter speed that's high enough to counter the vibration.

If you can't use a higher shutter speed, use a tripod or monopod.

Reduced depth-of-field: Telephotos have less depth-of-field at a given aperture.

If you need the maximum amount of depth-of-field, use a small f-stop.

Atmospheric conditions: Even when smog doesn't fill the sky, the air is full of enough haze or fog to reduce the contrast of your long telephoto shots enough to affect your pictures.

Although digital sensors don't "see" much UV, sometimes a skylight or haze filter can help, or you can boost the contrast and color saturation in your camera or image editor.

Flare: Telephoto lenses have a narrow field of view, so bright light outside your image area can easily affect your image with flare, which reduces contrast. Use your lens hood without fail.

Lens Compatibility with Earlier Cameras

One of the things you might have considered when purchasing your current dSLR is whether your new camera was compatible with any lenses you might already own. Perhaps you were migrating from a Canon film camera to a Canon digital SLR, or owned a Konica Minolta dSLR and wanted to upgrade to a new Sony Alpha model. Here are some things you need to know.

- ✓ Nikon compatibility: Virtually all Nikon lenses produced after 1977 will fit on any Nikon digital SLR. Many earlier lenses (called "non-AI" because they lack Automatic Indexing) can be modified so they can be safely used on modern cameras. Most of Nikon's entry-level cameras (starting with the Nikon D40 and including the D5100) can autofocus only with lenses having a built-in autofocus motor. (They're given an AF-S designation.) If you're using a very old Nikon lens (generally a manual focus model), automatic exposure is possible only with Nikon's midlevel and top-of-the-line cameras (from the Nikon D7000 on up.)
- Canon compatibility: Canon's entry and midlevel cameras (the Rebels and models like the EOS 7D) can use any lens with the EF or EF-S (Electronic Focus, Electronic Focus/Short Backfocus) designation. These cameras all have the 1.6X crop factor. Canon's 1.3X crop factor and full-frame cameras can be used only with EF-model lenses. Earlier lenses with an FD mount (or earlier) can't be used with full functionality, although you might be able to find an adapter that allows some specialized uses.
- Minolta/Konica Minolta/Sony Alpha compatibility: Sony purchased Konica Minolta's technology, and most older Minolta autofocus lenses with the Minolta A mount will work just fine on Alpha cameras. Manual focus Minolta MC/MD/SR mount lenses can't be used directly, but you may be able to find an adapter.

- ✓ Olympus compatibility: Olympus OM-mount film lenses can't be used directly with the company's new E-mount cameras, which use the Four Thirds mounting system (nor with the company's mirrorless non-SLR models that use the Micro Four Thirds mount). You may be able to find an adapter to use these lenses, although it's common for them to operate only with a limited range of f-stops on Olympus digital cameras. Many Four Thirds lenses can be used on the mirrorless models from Olympus and Panasonic with full functionality using an adapter.
- Pentax compatibility: Many older Pentax lenses with a K in their mount name (K, KF, KA, KAF, and so forth) can be used on virtually any Pentax dSLR, although sometimes with some limitations in f-stop or other features. You can find adapters for earlier Pentax lens mounts, too.

Babying Your Camera with Special Effects

You can modify the way your camera lens sees the world by attaching special effects filters and other add-ons to the front of the lens. These can take the form of prisms, diffraction gratings, blur filters, and other fanciful image distorters that do things that are either impossible or time-consuming to duplicate in an image editor. The king of all special effects attachments has to be the Lensbaby, a lens-substitute that has evolved over the years from a simple semiblurry lens (like that found in "plastic" cameras like the Lomo or Diana), but with a movable "sweet spot" to a whole system. Figure 7-9 shows the kind of results you can get.

Each Lensbaby consists of a simple lens system that mounts on your camera like any other lens, but with a bellows or ball and socket that allows shifting the front of the lens off axis to move the area of sharpest focus from the center to anywhere you'd like within the image. The Lensbaby can be focused, and the amount of depth-of-field adjusted using either interchangeable iris discs, or, in some latest models, an actual functioning diaphragm. The resulting pictures have lots of interesting blur, augmented by the kind of flare and distortion you wouldn't wish on anybody, except when you're using it intentionally as a special effect.

Lensbabies are available in mounts for Canon, Nikon, Minolta/Sony, Pentax, and Olympus cameras, in one of the four current models:

- Muse (the lowest-cost Lensbaby with the traditional push-pull focus point adjustment)
- Composer/Composer Pro (an "advanced" design with a rigid, but adjustable ball-and-socket barrel)

142 Part II: Oh, Shoot! _____

- Control Freak (with positioning locks and manual focus fine-tune)
- Scout (a fish-eye lens)

The company also offers an Optic Swap system with more than a half-dozen interchangeable components that can be used to develop special fish-eye, soft focus, super soft focus, and "pinhole camera" effects.

Figure 7-9: Choose your center of focus with a Lensbaby accessory.

Movies and Special Features of dSLRs

In This Chapter

- Shooting movies
- Reducing noise
- Canceling camera shake
- Understanding time-lapse photography
- Shooting infrared photos
- Taking care of dust

Everyone loves watching movies on DVD more than on videotape, premium cable, or maybe even in a theater. Why? Because of those special features! It's a kick to press a button and hear the director's commentary, watch hilarious outtakes, or listen to Ben Stiller and Owen Wilson banter in French or Japanese. Okay, maybe a minority like the image quality that DVD provides, but for me, special features are the attraction. In the latest dSLRs, *movies* are one of the special features, too!

The special features built into your digital SLR are cool. These functions come built into some dSLRs, but not all. They let you do some very interesting things, such as take pictures in virtual darkness or shoot the unfolding of flowers through time-lapse photography.

This chapter describes what you can do with some of these special features. No movie stars are chattering in a foreign language among these options, but if you have your heart set on gibberish, your dSLR probably has a setting for switching your menus to any language you like. While you're looking for that setting, I explore some of the more useful features of digital cameras.

Making Movies

As Live View picture preview features became standard in digital SLRs, the capability to capture that real-time view in the form of movies couldn't be far behind. In August 2008, Nikon introduced its D90 model, the first digital SLR with the capability of shooting high-definition (HD) movies, albeit only in "standard" 1280-x-720-pixel mode. The floodgates opened, and within months there were dozens of dSLR models, many with Full HD (1920-x-1080-pixel) resolution.

Moviemaking capabilities are among the most prized features in today's digital SLRs. Professional still photographers are adding video to their services, especially for gigs like weddings. The opening sequences of *Saturday Night Live* are filmed using Canon dSLRs, and when Nikon introduced its D5100 model, it produced several of the commercials for the camera using that model's built-in video features. Normal folks like you and me are just thrilled that we don't have to take along a still camera *and* a camcorder on vacations anymore. Figure 8-1 shows a typical LCD screen during video capture.

Figure 8-1: You can leave your camcorder at home when your dSLR has movie-making capabilities.

144

Video capabilities in dSLRs are remarkably easy to use. With the newest cameras, all you need to do is press a button to start filming, and press the same button again to stop. You can set exposure and focus before you start or, with some cameras, continue to use autofocus during video capture.

Resolution and Frame Rates

There are only a few decisions to make when shooting movies with your dSLR. Choose a resolution and number of frames per second that the video captures.

If your camera has both Full HD and Standard HD, don't automatically select 1920 x 1080 resolution (Full HD.) That option will eat up memory card storage space at an alarming rate (around 5 megabytes *per second.*) That's great if you plan to show your movie on a large-screen HDTV, and have a large, fast memory card (16GB–32GB.) If your needs are more modest, you'll find that Standard HD, at 1280 x 720, looks just fine. In fact, it may seem excellent on your 26-inch or smaller TV or computer monitor. If your video is destined for Internet display on a web page or YouTube, many dSLRs have a 640 x 424 option that will work great.

Your camera may offer both 30 fps and 24 fps frame rates (with 25 fps and 60 fps sometimes an option). The 24 fps rate is the same standard used for motion pictures ("film"). That rate gives your production a film look, with plenty of fine detail, and is especially good if your subjects don't move around a lot. However, when you pan the camera or your subject moves, a jerky effect called "judder" can creep into your movies. The 30/60 fps setting (and 25 fps in Europe and other countries that don't use the NTSC system that's standard in the U.S.) is a video rate and gives your movie a "video" look, and better rendition of moving subjects. Video-editing software, listed in this chapter, can handle all these, so you might want to experiment with each to see which works best for your productions.

In-camera movies

Shooting movies in your still camera has many advantages. You have superior low-light capabilities and control over selective focus, compared to most camcorders. The typical dSLR has in-camera editing, so you can trim unwanted seconds from the beginning or end of each clip. Some newer cameras have a "video snapshot" feature that combines fixed length clips (say, each 10 seconds long) into a video album. When Nikon introduced the D5100, it included a feature that allows you to apply some special effects to your movies as you shoot.

Using Video OUT in the age of HDTV

After you capture a movie, you can play it back on your camera's LCD screen, or, optionally, on an HDTV screen. You'll probably have to purchase a separate HDMI cable for your camera, as few vendors include one in the box.

Make sure you get one designed for your camera; the HDMI connector that plugs into your TV is standard, but there are several types of connectors at the camera end.

You can always transfer your movies to your computer, and edit them with an application like iMovie, Windows Movie Maker, or Adobe Premiere Elements. Add narration or music, cut sequences from several shoots in and out, and burn your film to a DVD for playback on any DVD player or computer with a DVD drive. Hollywood, here you come!

Feel the Noize at Night

There have been lots of improvements in dSLRs beyond those in the moviemaking realm. For example, all digital SLRs can take fine pictures at night. However, some do a better job than others, thanks to special features built into them to handle long exposures and noise (or, as Quiet Riot and Slade fans call it, *noize*). The following sections describe the key components that you need to work with so that your night shots are sparklingly clear.

A fast lens . . . or not?

As you can discover in Chapter 7, a lens that has a large maximum aperture (generally, anything faster than f/2.8) is a must only if you're hand-holding (that is, shooting without a tripod) your night photos or, perhaps, if you want to shoot with flash and need your speedlight's illumination to reach as far as possible. An f/2 or f/1.4 lens might let you take some night pictures at $\frac{1}{30}$ of a second hand-held or, with image stabilization (which I discuss in the section "Shake, Shake, Shake," later in this chapter), at slightly slower shutter speeds.

The more sane shooters take night photographs with the camera securely mounted on a tripod. That practice enables them to use virtually any lens at any desired f-stop and still get a clear photo. Correct exposure in such cases is simply a matter of using a sufficiently long shutter speed. That said, using a long shutter speed isn't always an option, as I discuss in the following section.

Taking night shots at short shutter speeds

You might want to avoid very long shutter speeds and prefer the shorter shutter intervals a higher sensitivity (higher ISO setting) affords for any number of valid reasons:

- Perhaps you don't want to spend 30 seconds or more making a single exposure because of time constraints or physical conditions (rain, muggers, an episode of *Desperate Housewives* that you don't want to miss, and so forth).
- Vou might want to take as many photos as possible in available darkness.
- ✓ You want to avoid the light streaks from moving cars or other illuminated objects that a long exposure likely produces.

Bumping up the ISO can let you take your night photos with a reasonably short exposure. Some dSLRs have ISO settings no higher than ISO 1600, but others go up to ISO 3200, or as much as ISO 102400! A few cameras top out at a specific ISO notch but include push settings that have names such as H1 or H2. Those settings in a pinch, but expect some quality loss when you do. You can also adjust your camera's exposure value (EV) compensation controls to underexpose an image (effectively providing a higher ISO setting) and then try to salvage the photo in your image editor.

Of course, high ISO settings tend to amplify nonimage signals in an image, producing extra noise. Your camera's noise reduction feature can cut down on the annoying speckles that appear at those high ISO settings. See the following section for more about using noise reduction.

Noise Reduction Made Easy

Consider using noise reduction anytime you take photos at night using long exposures or high sensitivity settings because the objectionable texture overlays unprocessed images.

Noise comes from several sources. One might be the amplification of the weak signal that the sensor produces under low light conditions. The sensor itself also produces noise while it inevitably heats up during a long exposure, and the sensor mistakes some of that heat for incoming photons. Some digital cameras exhibit an *amp glow* or *amp noise* phenomenon, which is a reddish or purple glow in the corners and edges of very long exposure images (usually several minutes or more) caused not by heat, but by electroluminescence of electrons in the readout amplifier of the camera's sensor. You don't

need to be a rocket scientist to understand that; the actual specialty you need is astronomy (astronomers experience amp glow when they take astro-photographs).

The bottom line is that your camera's sensor can generate noise at high ISOs with exposures of any length and at relatively low ISO settings with long exposures.

To cancel some of those noisy speckles, digital SLRs include internal noise reduction circuitry. This circuitry works by making *two* exposures: an actual picture of your subject, and a blank or dark exposure for the same length of time. This second picture contains only noise of the same type that appears in the real picture. The camera's noise reduction circuitry compares the two and zaps the pixels that are common to both (the *noise*). This solution is along the order of the sculptor who starts with a block of marble and removes everything that doesn't look like a statue.

Figure 8-2 shows two versions of an image taken in the early evening, using a relatively short exposure (¼ of a second), but with the ISO setting cranked up all the way to ISO 1600. The upper version includes a lot of noise. (The upper version is actually a little exaggerated to make it visible on the printed page.) The lower version is the same shot, but it has noise reduction applied. You can see the quite dramatic difference.

Because the noise reduction feature works by taking two shots, any photos that you take with the noise reduction feature turned on take twice as long. You scarcely notice the delay with shutter speeds of about 1 second or shorter, but when you're snapping off 30-second exposures, you definitely notice the extra half-minute pause during this dark-frame-subtraction process. If you're in a hurry or forget to switch on the noise reduction, you can also

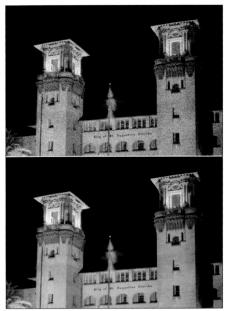

Figure 8-2: The upper version badly needs noise reduction. You can see the results in the lower version.

perform some post-shot noise reduction by using an image editor, such as Photoshop (as shown in Figure 8-3), or with a third-party application, such as Neat Image (www.neatimage.com) or Noise Ninja (www.picturecode.com).

Figure 8-3: Photoshop and Photoshop Elements have a noise reduction filter built in.

The Reduce Noise filter in Photoshop and Photoshop Elements lets you control the strength of the noise reduction, how much detail you want to preserve, whether you want to eliminate color noise, and how much sharpening of the remaining detail you want to apply. The Adobe Camera Raw plug-in supplied with both programs also includes noise reduction features that you can apply to RAW files. For an introduction to image editors and image editing, see Chapters 12 and 13.

Shake, Shake, Shake

Whenever photographers get together, one of the inevitable topics of conversation is each shooter's prowess at hand-holding a camera for incredibly long exposures. Oddly enough, these same photographers might swear by an emerging camera-steadying technology known as *image stabilization*.

"I get razor-sharp images at $\frac{1}{30}$ of a second, even with telephoto lenses!" one boasts. "I can squeeze off shots at $\frac{1}{4}$ of a second with no problem!" another counters. "I have a special technique for bracing my arms that lets me take

time exposures of up to 2 seconds without a tripod!" a third asserts, leaving the others to wonder whether he's joking or just filled with braggadocio.

No matter how experienced a photographer you are, and whether you apply arcane breath-control and body-steadying practices to your techniques, you only *think* you're steady enough to shoot long exposures with short lenses, and reasonably long exposures with telephotos.

The following sections point out some of the common myths about camera shake, identify the point where you *really* need to switch from hand-held shots to a tripod, diagnose shake-related problems in your photos, and discover ways to fix those problems.

Leaving camera-shake myths behind

In camera-shake lore, you might have come across two misleading assumptions:

- ✓ If you don't see the shake, it isn't there. The slowest shutter speed at which you *think* you can reliably shoot sharp images is probably the speed at which you can't detect the blurriness that appears at normal levels of enlargement. Crop a small section out of the center or make a huge enlargement, and you can probably see the difference. You can likely make a surprising number of your shots sharper if you use a tripod.
- ✓ Use a shutter speed that's the reciprocal of the lens's focal length. For example, ½50 of a second with a 250mm lens. This advice is more of a rough guideline than a rule because it doesn't take into account the crop factor that some dSLRs produce. Your 250mm lens is effectively a 400mm lens if your camera has a 1.6X crop factor. No, you *aren't* multiplying the focal length of the lens (as I emphasize over and over), but you *are* filling the frame with less subject area, magnifying any camera shake, just like if you made an 8-x-10-inch print rather than a 4-x-6-inch print.

Some people are shakier than others, so a 1/400 of a second shutter speed that one photographer can use successfully might be woefully inadequate for another photographer. To figure out the point where you personally need to switch from hand-held shots to using a tripod, see the following section.

It goes without saying, of course, that this discussion deals with blurriness caused *only* by camera/photographer shake. Blurs derived from moving objects is another issue entirely — although you can fix them, too, by using higher shutter speeds.

Testing for tremors

Before looking at the latest technological cure for shaky hands, try this exercise to see just how bad you have the "affliction." (If you've inherited, as I have, a mild case of essential tremor condition, you can remove the quotation marks.) Follow these steps:

- 1. Find a scene that contains sharp pinpoints of light, preferably at night so that you have a dark background, such as a scene with streetlights.
- 2. Switch your camera to Manual mode so that you can vary both the shutter speed and f-stop independently.
- 3. Take several pictures at a fixed f-stop but vary the shutter speed for each picture.

Use various shutter speeds that you think are test-worthy. For example, $\rlap{k_0}, \rlap{k_0}, \rlap{k_0}, .$ or \rlap{k} of a second.

4. Calculate your exposure by using your digital camera's metering system.

You don't need the exposure to be precise, as long as you vary only the shutter speed during the tests. If you change f-stop or focus, you can change the size of the points of light, although the greatest effect appears on any out-of-focus points.

If you're shooting over a great range, change the ISO setting of your camera so that you can maintain the same aperture while varying the shutter speed.

5. Open your shots in your image editor and examine the camera shake by enlarging the light points enough that you can study their shape.

The appearance of the round disks of light in your images let you judge fairly accurately how steadily you held the camera during the tests:

• *If the disks are perfectly round:* Like the red stoplights at right in Figure 8-4. You used a shutter speed that's fast enough to stop action at that focal length.

Keep in mind that if you zoom in to a longer focal length, you need a higher shutter speed. Telephotos *magnify* the effects of camera shake.

- *If the disks are elongated vertically:* You shook the camera up or down (or both) when taking the picture.
- If the disks are elongated in a diagonal direction (usually a diagonal pointing from upper-left to lower-right): You jerked the camera, probably by punching the shutter release button too aggressively. Why that particular direction? You tend to press down and to the right,

152 Part II: Oh, Shoot! ____

not the other way around. But remember, your sensor records an image upside-down, so the direction of any camera movement is reversed.

- If the disks are elongated from side to side: Your camera shake formed some panning-style blur. Again, the direction of the blur is reversed, so if you jerked the camera slightly to the left, the blur appears to the right in your final image.
- If you're really shaking, you might find the blurs create a streaky pattern: Like the one shown in Figure 8-5. That shutter speed is way too low for hand-held exposures.

Figure 8-4: The stoplights and other round sources of illumination are sharp; the shutter speed used for this photo was fast enough to stop camera shake.

Everyday solutions for shakiness

After you determine your minimum practical shutter speed for hand-holding (keeping in mind that this speed can vary because of lens focal length and other factors), you can attempt to sharpen your photos. To cease the shakes, try using

- Higher shutter speeds
- Better shooting ergonomics (meaning brace yourself)
- Aids, such as tripods, monopods, or beanbags (see Chapter 5)
- Image stabilization

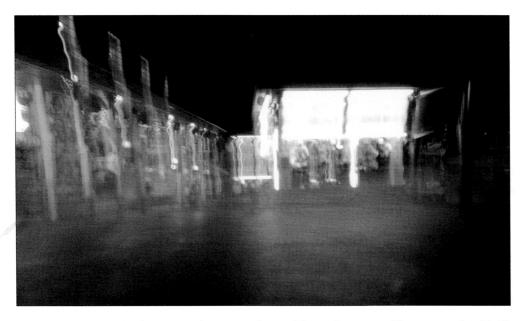

Figure 8-5: Really streaky photos mean that you need a *much* faster shutter speed if you want to hand-hold your camera.

Image stabilization: The ready-steady-shoot technology

Antivibration technology has gained a lot of attention because several of the most popular low-priced cameras from Olympus, Sony, Panasonic, and Pentax/Samsung include the feature right in the camera body. Translation: You can now get this technology in modestly priced entry-level cameras.

Leave it to the techno-wonks to come up with stunning new technologies just because they can. Camera-steadying technology has been around since 1976 in the motion picture industry, when the Steadicam was introduced. This device produces gyroscope-like stability through an exquisite application of gimbaling and balance. By 1995, Canon had introduced an electronic form of image stabilization (IS), which Nikon, Sony, and Pentax/Samsung now offer, and you can find others under names such as Vibration Reduction or Anti-Shake.

Nikon and Canon build IS into individual lenses; Sony, Pentax/Samsung, and Olympus (the only other vendors offering the technology for digital SLRs) incorporate image stabilization into the cameras. They all operate by using

ATMEMBER

similar principles: The device (the lens or camera) senses motion and then shifts components (which are elements of either the lens or the sensor) in the opposite direction(s) to compensate. You can turn off the vibration-reduction feature when you don't need it. You can see an antishake on/off switch in the lower-right corner of Figure 8-6.

The mechanics of image stabilization work very quickly, although not quickly enough to avoid slowing down camera operation a tad. So, you can best use IS to counter camera shake when you're taking pictures of relatively slow-moving

Figure 8-6: Turn off anti-shake technology when you don't need it.

subjects, when you're using longer exposures, or for shooting with telephoto lenses without a tripod. Although many photographers use IS for sports photography, you may find the small delays it introduces annoying — the dSLR equivalent of shutter lag.

IS allows you to hand-hold your camera at shutter speeds roughly four times longer than you could manage without image stabilization. If you can hold your camera steady at $\frac{1}{100}$ of a second, you can get the same results with IS at $\frac{1}{100}$ of a second. Those extra two stops of exposure might mean the difference between not being able to take the picture at all and getting a well-exposed shot at a decent aperture.

The following scenarios offer a close-up look at how image stabilization works in different circumstances:

✓ You're shooting a poorly lit subject and you need an exposure of ¼₀₀ of a second at f/2. Oops! Your zoom lens has a maximum aperture of f/5.6. With image stabilization activated, you can go ahead and shoot at the equivalent exposure of ¼₅ of a second at f/5.6 and expect the same amount of sharpness, from a camera-steadiness perspective.

Of course, if your subject is moving too much for capture at a slow shutter speed, that's another story. I took photos of my son's high school stage performance by using the $\frac{1}{15}$ of a second and f/5.6 combination. I ended up capturing razor-sharp scenery, but I often lost the expressive hands, arms, and mouths of the actors in blur!

✓ You're using long lenses and shutter speeds that are high, but not quite high enough. For example, you're shooting wildlife (or even sports, if you can put up with the slight delay). In this case, IS can offer extra steadiness to compensate for the shake that long lenses can introduce. For example, you might find that shooting at ½∞ of a second at f/16 and ISO 400 with a 500mm lens is correct from an exposure standpoint, but your front-heavy lens causes enough wobble to blur photos, even at that shutter speed. By using IS, you can retain the ½∞-second shutter speed and the depth-of-field provided by the f/16 aperture, but with enough steadiness to make your image tack sharp. Figure 8-7 shows a pair of images shot with a 400mm lens at ½∞ of a second, both with and without image stabilization. Tracking this bird in flight made holding the camera steady difficult at ½∞ of a second (top), but I got a sharp image of the same bird a few minutes later at the same speed with image stabilization turned on (bottom).

Figure 8-7: Image stabilization made it possible to shoot this bird handheld with a long lens.

Time Waits for Someone: Creating Time-Lapse Sequences

Walt Disney didn't invent time-lapse photography, but some of the most memorable nature sequences ever filmed were early Disney films of flowers blossoming or the sun marching across the sky in the Painted Desert. Today, time-lapse imaging is so easy that people use it for transitions and segues in television shows. Just set up a motion picture or video camera, pop off a frame every minute or hour or day, project the sequence at the normal 24 or 30 frames per second (fps), and you have a time-lapse movie.

Your digital SLR can easily produce the same kind of sequences. You can snap off pictures at preset intervals to document a flower opening, a butterfly emerging from its chrysalis, or the construction project across the street. You just need a willingness to tie up your camera for the necessary period of time and some means of tripping the shutter at the proper times. Of course, you can trip the shutter manually, if you have the patience.

Some non-SLR digital cameras have built-in timers that trip the shutter for you. When people use digital SLRs to shoot time-lapse sequences, however, if their camera does not have that feature built in, they usually tether the camera to a computer by using a USB cable and allow computer software to take the exposures. This method makes sense for several reasons:

- ✓ Time-lapse photography uses a lot of juice. Consequently, you want to keep the camera close to a computer and an AC power source. If your sequence takes more than an hour or two, your camera's battery probably can't supply the power that the camera needs to take the photos. So, connect your camera to an AC adapter that's plugged into the same power that keeps the attached computer running.
- Long sequences tax your camera's internal storage. If you want to use the maximum resolution that your dSLR offers, a single memory card might fill up before the camera finishes your sequence. Systems that tether the camera to a computer save the images directly onto the computer's hard drive.
- Computer-driven time-lapse photography can be more sophisticated. Most of the software programs used for this kind of work can automatically assemble your finished shots into a movie.

Today, though, you have options beyond the tethered-camera setup. For example, if you can outfit your camera with an Eye-Fi wireless SD card, you can transmit images directly from the camera to your notebook or desktop computer network without using a USB tether. Some vendors make self-timer/time-lapse cables that you can set up to make exposures over a period of time without any computer intervention. (These cables are often fairly expensive, with some units in the \$150 range.) However, time-lapse photography still takes a lot of juice, so still connect your camera to AC power during a long sequence. Experiment with time-lapse photos to see your world from an entirely different perspective. It's fun!

Better Infrared than Dead

Feel like your creativity is on its last leg? Looking for a real challenge? Do a little research and see whether your particular dSLR can handle one of the unexplored frontiers of digital photography — infrared imaging. It's dark territory (quite literally — you have to shoot blind).

Infrared (IR) photos have a particular, other-worldly look. Skies are dark, clouds stand out in sharp relief, and foliage appears ghostly white, as you can see in Figure 8-8. Human faces are pale and lack texture. The pictures are grainy and sometimes seem to glow with an inner light. You either love or hate these effects after you take the time to explore them for yourself.

Some digital SLRs are better suited to IR photography than others. Most models include an IR-blocking filter called a *hot mirror* that filters out most of the longer wavelengths of

Figure 8-8: Infrared images look other-worldly.

light, which encompass the infrared band. As luck would have it, digital sensors are quite sensitive to infrared, but that sensitivity leads to poor photographs in visible light. Thus, cameras come with an IR-blocking filter built in.

Luckily for photographers interested in infrared imaging, some of these filters do a worse job than others in blocking the IR illumination. Your own dSLR might be one of those capable of taking infrared pictures. You can quickly tell whether your camera can take infrared pictures by pointing a remote control at your lens and snapping a picture in a dark room while you press a button

on the remote. If you can see the glow of the remote control's IR burst in the image, you're in business.

In addition to the hot mirror, watch for infrared blockers on your lens, too. A few lenses from Canon and other vendors have an anti-IR coating that can produce a bright spot in the center of your IR image. If you have this problem, switch to a different lens or try to correct the spot in your image editor.

To start taking infrared photos, you just need an IR filter and some patience:

- The filter blocks visible light but lets infrared light through. Don't confuse this infrared filter with the hot mirror.
- Patience is essential because even the most IR-worthy dSLRs still filter out most of the infrared light. Enough infrared light remains to take a picture, but you have to use long exposures for best results. I've taken IR photos at ¹/₃₀ of a second with my lens wide open and ISO set to 1600, but those pictures were fuzzy and lacked depth-of-field.

✓ For better results, use normal ISO settings and mount your camera on a tripod. The tripod helps because you're shooting blind. Any IR filter that you use removes virtually all visible light, so the view through your viewfinder is totally black. If your camera has Live View, you may be able to discern an image on the LCD, but don't count on it.

In Chapter 16, you can find details about choosing a filter and steps that walk you through taking infrared photos.

Dust Off

Another feature found in most dSLRs these days is a built-in automatic dust removal system (as opposed to the non-built-in *manual* dust removal procedures that I outline in Chapter 2). These systems often work like the system found in the Olympus, Pentax/Samsung, and Sony: The same sensor-shifting technology used to provide anti-shake features produces a little vibration (usually when you have the camera turned off) that bounces any dust or other particles on the sensor off the filter that covers the sensor and onto a flypaper-like sticky-strip at the bottom of the chamber. Cameras from Canon and Nikon that don't have in-camera image stabilization use a sensor-shaking mechanism.

Part III Beyond the Basics

oving on up ... taking your digital imagery to the next level by putting your digital SLR's advanced features to work. In this part, you can find out how to work with the RAW format and marshal your dSLR's action, sequence shooting, and flash features. I show you how important composition is, too.

Chapter 9 explains the fuss over formats and shows you how shooting RAW can give you extra flexibility when you want to manipulate your images. Chapter 10 offers a solid grounding in action and flash photography — because the two often work hand-in-hand. In Chapter 11, you can discover how to arrange all the elements in your photo in pleasing ways by using compositional rules that were meant to be broken (after you understand exactly how they work).

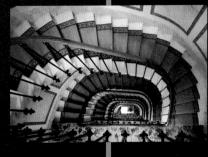

Working with RAW and Other Formats

In This Chapter

All Photographs Quick Collection

- Discovering all those formats
- Understanding dSLR format options
- Choosing the right file format
- Using RAW as a digital negative

ou can find many bones of contention in the digital SLR world, but the choice of file format is one of the boniest. Some photographers swear by RAW, a misnamed "unprocessed" format (RAW isn't really unprocessed) that supposedly retains all the information the sensor captures (it doesn't). Others scoff at RAW, feeling that the JPEG format is the key to taking pictures most efficiently, with a minimum of after-shot processing required. Old-school photographers might insist that the TIFF format is the only way to go, despite the fact that few digital SLRs support that format these days.

This chapter removes the mystery surrounding RAW and other formats, and helps you choose which one is right for you in any particular situation. Should you shoot RAW, JPEG, or both at the same time? In this chapter, I explain what you need to know to make that call.

So Many Formats, So Little Time

The proliferation of file formats started with image-editing software. Dozens of different schemes exist for saving image files, and most of the leading image editors are forced to support just about all of them.

Part III: Beyond the Basics

Unfortunately, digital cameras brought back the revenge of the format proliferators, and it helps to get the lay of the land before you venture out to do what should be so simple: Choose a format for saving an image.

Virtually all digital SLRs today support JPEG because that format lets you squeeze more images onto memory cards that have limited amounts of space. A few (chiefly high-end) dSLRs also let you capture images in TIFF format, which is great at retaining detail but not so great at compressing photos to a reasonable size. All dSLRs have the option for saving images in a proprietary RAW format that supposedly preserves all the image detail and parameters that the sensor captures.

But that claim isn't precisely true. The sensor data is processed quite thoroughly by algorithms that convert the image from analog to digital form. However, the resulting RAW data doesn't have all the settings that you dialed into your camera (white balance, sharpening, color, and so forth) set in concrete. When you import a RAW file into your image editor, you can go ahead and use those settings, if you like, or — by using the RAW converter software that does the conversion — you can specify new parameters, instead. That's where the "unprocessed" label gets hung on RAW files.

What!? Am I telling you that *each* digital camera vendor uses a different RAW format? If only it were that simple! As it turns out, some camera makers have created several different versions of their RAW format, each incompatible in some way with earlier versions, so rather than a dozen RAW variations, you have to deal with *several* dozen. Here are a few examples:

- The different RAW formats for Canon dSLRs include CRW and CR2.
- Nikon has some slightly different variations of its format, including a trick it unveiled a few years ago of *encrypting* the white balance information of its newest cameras so that third-party RAW tools can't interpret it. (After much consternation and reverse engineering by other vendors, Nikon ended up demystifying its encryption scheme.)
- Other vendors might use one RAW format for their dSLRs and another for their high-end point-and-shoot models.

This mess was Adobe's cue to get into the act, producing yet another format, DNG (digital negative), which purports to support all the features of all the other RAW versions, as a sort of standard. Adobe even provides a free Digital Negative Converter, shown in Figure 9-1, if you want to change all your current RAW files to the new format. To date, only one vendor, Pentax, allows you to choose whether to save your images in the camera by using either Pentax's proprietary RAW format or Adobe's DNG.

DNG	Converter			
R 🔇	dobe Digital Negative C	Converter		Adobe
O Selec	ct the images to convert			
()	Select Folder C:\Misc\Misc	4		
-	Include images contained within	n subfolders		
Selection	ct location to save converted image	IS		
69	Save in Same Location			
	Select Folder C:\Misc\Misc	4		
	Preserve subfolders	n 1		
Selection	ct name for converted images			
	Name example: MyDocument.dn	q		
	Document Name	v +		¥ +
		v +		~
	Begin numbering:	- Segundorgi L		hannesses and here an
	File extension: .dng			
O Prefe	rences			
	Compressed (lossless)	Change Prefere	ances	
	Preserve Raw Image			
	Don't embed original			
About	DNG Converter Extract		Convert	Exit

Figure 9-1: Adobe's free Digital Negative Converter transforms your current RAW files into the Adobe DNG format.

Things get even more interesting when you realize that no one has created a standard for naming the formats used within digital SLR cameras. Instead, the cameras use names such as Fine, Basic, Superfine, Good, Supergood, and so forth, providing no real clue about which format you're actually choosing. The Superfine option might represent TIFF on one camera and JPEG with minimal image loss on another. Choosing the right format is difficult, but the following sections help clear things up.

Part III: Beyond the Basics

Along came a proprietary format

Did you know that Photoshop gives you the option to save your images in almost two dozen different formats right out of the box? Do you know what RLE or PXR or TGA formats are, or what applications create or need them? Or why these formats exist at all?

I'm sure each of the various file formats must have seemed like a good idea at the time. The ostensible reason for creating a particular format is that the software vendor wanted to add special features (such as the layers in the Photoshop PSD format) that weren't possible in other formats. Presto! A new file format is born that includes support for the new feature.

Of course, back in the Dark Ages of computing, another reason for creating a proprietary format existed: It tied buyers to the particular application that relied on that particular format. If you liked PixelPaint (I'm not making the name up; it was a Macintosh program that flourished in the early 1990s, and I used it extensively), you used the PixelPaint format — and after you accumulated a few thousand images in that format, you were pretty well locked into that program . . . until a new, spiffier application came along, offering support for the PixelPaint format and negating the advantages of the proprietary feature.

Before long, most of the non-compatible formats fell into disuse (although they remain as shadowy wraiths in many Save As menus). Virtually all image editors support the Photoshop PSD format, plus JPEG (created to provide extrasmall file sizes), and TIFF (the closest thing to a standard high-quality format that isn't tied to one vendor). Image editors still have their own proprietary formats, but users of those programs are more likely to archive processed images as PSD or TIFF.

Worth the Fuss: Understanding the Main Formats

I ignore the file formats used only within image editors and for applications outside the realm of digital cameras, such as web pages. These formats include GIF, PNG, PICT, PDF, and BMP. Nice formats. Not relevant. B-b-bye!

When you're trying to decide what format to shoot with, you need to look at only TIFF, JPEG, and RAW and the variants, such as "Small" or "Medium" resolution RAW – sRAW or mRAW, found in some models. Digital cameras work with only those formats (other than some Pentax models that can save in DNG format). Each of these formats has its advantages and disadvantages, and that's what you really need to know about to make a wise selection.

Don't get TIFFed

The TIFF format originated in 1987 with a company called Aldus, which developed pioneering graphics and layout programs such as Freehand and PageMaker. Intended as a standard file format for images, TIFF (Tagged Image

164

File Format) incorporates descriptors called *tags*, which you can use to provide parameters for any special features included in the file. Theoretically, an application could include any kind of information it liked in a TIFF file — such as layers, objects, special color information, and selections — and tell any other application attempting to read that TIFF file how to retrieve the special data.

In practice, the TIFF format's versatility ends up making it possible to create "standard" files that not all the applications that have to work with them can read, which isn't an advantage at all. TIFF files run the gamut (ha!) from RGB (red, green, blue), CMYK (cyan, magenta, yellow, black), and L*a*b color models to black-and-white and grayscale images. It supports both 24-bit and 48-bit (high dynamic range) color depths, and it can be squeezed down without losing any picture information by using optional Huffman encoding, LZW, or PackBits. (If you don't know what some of these formats are, consider yourself lucky; they aren't important for day-to-day shooting.) Adobe acquired Aldus in 1994, and today, Adobe offers options for saving Photoshop layers and selections right in a TIFF file.

To make things even more interesting, some of the RAW formats that I discuss in the section "The RAW deal," later in this chapter, are actually TIFF files that have some headers which transform them from standard TIFF into a vendor-specific format that requires special software to read.

Keep in mind these two important TIFF-file facts:

TIFF files are *lossless*. They don't discard any of your image information.

TIFF files are much larger than JPEG and RAW files. The larger size

can increase the time it takes for your camera to store them on a memory card. In my tests, files that take only a few seconds to write to a memory card in RAW format can take 20 seconds or more as TIFF files

The third most important thing to keep in mind is that fewer dSLRs offer a TIFF option these days; most that do are professional-level cameras, such as the Nikon D3, as shown in Figure 9-2, which shows both TIFF and NEF (Nikon's version of RAW).

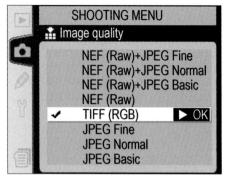

Figure 9-2: Pro-level dSLRs still offer TIFF file options, as shown in this camera menu.

JPEG o' my heart

Virtually every dSLR currently on the market can create JPEG (Joint Photographic Experts Group) files. About 20 years ago, a consortium of the same name created this format. (The consortium originally consisted mostly of vendors such as Eastman Kodak Company, but an international standards body now oversees it.) The goal of devising the JPEG format was to create files that are significantly smaller than you can produce by using formats such as TIFF, which compresses files somewhat without discarding image information, and to make those files readable by a wide variety of applications in a standard way.

The first JPEG-capable applications reduced the time needed to transmit images by telecommunications links. The Internet wasn't in wide use by the public at that time. So, newspaper photographers had to plug their unwieldy portable computers (laptops of that era needed several laps to support them) into devices called modems to beam their photographs back to the editorial office over telephone lines. I am not making that up.

JPEG can reduce files by a factor of 20 or more by throwing away some of your hard-won image data in a series of processes that are intended to reduce the size of the file by eliminating excess or redundant information.

JPEG compression first divides your image into *luminance* (brightness) values and *chrominance* (color) information, on the theory that human eyes are less fussy about color than they are about brightness. (If you see a stop sign that's a slightly odd shade of red, you notice that color less than if the same sign appeared darker or lighter than you expect.) The excess color information is discarded.

The process slices your image into cells, say 8 x 8 pixels on a side, and then the process looks at each of the 64 pixels in the resulting chunk individually. Using mathematical trickery called Discrete Cosine Transformation (DCT), the compression process discards pixels that have the same value as the pixels around them. (You don't have to remember terms such as *Discrete Cosine Transformation* unless you're trying to impress someone at a party.) Next, quantization occurs, during which pixels that are nearly the same color are converted to a common hue, and the picture information that's left is transformed into a series of numbers, which is more compact than the original information. (It's a bit like writing *1,500* rather than *one thousand five hundred.*) If everything is done properly, the process compresses the image by 5 to 20 times or more, depending on what compression level you select when you save the file.

Because JPEG doesn't keep all the image information, it's referred to as a *lossy* format. Each time you load a JPEG image, make changes, and then save it again, you run the danger of losing a noticeable amount of information

because the JPEG process occurs all over again — every time you save. The loss might be very slight at first, but it can accumulate, as you see in Figure 9-3, which shows a photograph that has lost sharpness after repeated savings in JPEG format.

Figure 9-3: Repeatedly saving JPEG images can introduce artifacts into your photos.

What's cool about JPEG is that you can dial in the amount of compression you want, using a lot of compression to produce very small file sizes (with an attendant loss in quality), or very little compression to preserve quality at the cost of larger files. What *isn't* cool is that no one has come up with a standard way of referring to the *amount* of compression. Digital cameras tend to use discrete steps with names such as Superfine, Fine, Normal, Good, and Basic. Image editors might let you choose a continuous compression/quality range from, say, 0 to 15 or 0 to 20. (The Nigel Tufnel in you might wish that your editors offered an all-the-way-to-21 setting for when you need just that little bit of extra quality, but unfortunately, the designers of these applications apparently have never seen the movie *This Is Spinal Tap.*)

Instead, in-camera JPEG compression is a little like a box of chocolates: You never know what you're going to get.

The RAW deal

RAW isn't really a single file format. It's the broad term applied to all the proprietary formats created by each digital camera vendor for its particular product line. Every RAW format is different, which means that in order to access a RAW file, you must have one of two types of programs:

- Special software from your vendor designed especially for its RAW format
- A third-party utility, such as Adobe Camera RAW (furnished with Photoshop and Photoshop Elements), that's compatible with your particular camera's RAW format

Not all utilities support all RAW formats (not even the Adobe DNG converter), so you might have somewhat limited choices for reading these files. Support for a particular version of RAW commonly lags behind the introduction of the camera that produces it for a few weeks or months, leaving you at the mercy of the camera vendor's utilities until everyone else plays catch-up.

You can consider RAW files your digital negatives because they haven't been subjected to the usual manipulations that your camera settings mandate when the camera converts the raw image data to JPEG or TIFF. (See the section "Using RAW Files as Digital Negatives," later in this chapter, for more details.)

Choosing a File Format

So, your image-format choices boil down to TIFF, RAW, and JPEG (or, with some cameras, saving in RAW and JPEG simultaneously). Which do you select? Your decision might hinge on how you shoot and on what you plan to do with your files after you transfer them to your computer. Your available storage space might also figure into the equation.

If you get good results most of the time by using your camera settings, don't want to do a lot of processing in your image editor, and take a lot of pictures, you might opt for TIFF or JPEG. TIFF gets the nod if you want the best image quality (although, as I note in the section "Don't get TIFFed," earlier in this chapter, digital SLRs rarely offer TIFF as an option these days), but you might prefer JPEG if you're on a trip and want to make your memory cards stretch

as far as possible. You might find that RAW works best if you plan to do a lot of image tweaking. The following sections explore these options in a little more detail.

TIFF enuff

If your camera has a TIFF option, here are some factors to consider:

✓ Highest quality: Use TIFF if you want the highest-quality image in a standard file format. This lossless format produces image files that are theoretically and practically better than even the least compressed JPEG image. The most common use for TIFF is for stock photography or advertising, where the client demands images taken as TIFF files. I think the clients are a bit behind the times, but those who write the checks make the rules.

- Minimal post-processing: TIFF is theoretically a good choice when you're generating large numbers of images for distribution and want to apply a minimum of post-processing. Perhaps you're shooting a wedding or other event and don't want to laboriously apply individualized settings to each photo with your image editor. If you carefully select your camera settings so that your TIFF files already have the exposure, color balance, sharpness, and other attributes that you want to end up with, you can safely save your files in TIFF format and expect all or most of them to be good to go right out of the box. In practice, however, most photographers use JPEG in this situation because the camera can store the images on its flash memory more quickly.
- Limited editing: TIFF is fine for images that you plan to manipulate in Photoshop to make improvements that don't involve "unprocessed" RAW file attributes. For example, if you want to retouch portraits so that you can minimize facial flaws or composite several images into one, you really don't need to work from RAW images. TIFF serves just as well.
- ✓ Too slow for sports: TIFF might not be the best choice if you're shooting sports or doing continuous shooting because your dSLR takes a long time to save such files to your memory card. Most digital SLRs store JPEG and even RAW files much more quickly than they do TIFFs.
- ✓ Takes a lot of memory: TIFF is a poor choice if you have limited memorycard space. If you're on vacation and have only a few 1GB cards to use between opportunities to offload your images, TIFF files fill up the available media with alarming speed. (Your camera's best JPEG setting produces image quality that's almost as good while consuming perhaps 10 percent of the storage space.)

IPEG junkies unite!

JPEG is a highly popular alternative to TIFF (if your camera even offers TIFF as an option) and RAW. Some JPEG junkies use nothing else for their original photos. The format is compatible with virtually all applications, making it as much of a standard as TIFF and much more compatible than RAW formats.

Of course, JPEG has that nagging loss-of-quality issue. You have to decide for yourself how important that issue is to you. Ponder these points when considering JPEG:

- Really minimizes post-processing: Everything I say about TIFF as an option when large numbers of images are involved goes double for JPEG. I don't know a single wedding photographer who prefers to shoot and work with RAW images, simply because they can't afford to spend that much time post-processing hundreds of images. I don't shoot weddings anymore, but I do photograph sports, and I often fire off 1,000 to 1,200 shots at a single game (blame my dSLR's nine-frames-per-second burst mode for that). I spend a little time before the contest shooting test pictures and adjusting my color balance, sharpness, and exposure to suit the conditions. Then, I blast away, knowing that most of my photos will require little or no post-processing.
- ✓ Gives you ready-made photos for web display: JPEG is a good choice for display on web pages, such as the one shown in Figure 9-4. Or, if you want to distribute pictures in digital albums on CDs or DVDs, in online albums, or as prints up to 11 x 14 inches or larger, the least-compressed JPEG option that your dSLR offers should produce files that can easily take care of these tasks.

- ✓ Good-enough quality: If you do end up editing JPEG files, you probably find the quality good enough, as long as you remember to save your final version as a TIFF or Photoshop PSD file. Always save your JPEG files in one of those lossless formats after you make changes. By saving in one of those lossless formats, you avoid the quality loss that can result from repeatedly opening and *editing* JPEG files. (Just opening and closing such files, without making any changes, causes no quality loss.) If you still need a JPEG file (say, for display on a web page), create one and retain your new TIFF or PSD versions, in case the image requires more editing later on.
- ✓ More compatible with software: JPEG can be more compatible with some image-management/album-making software or online storage services than other formats, which may accept only JPEG files. The ancient application that I prefer (which predates the term *digital asset management* by about ten years) doesn't handle RAW files at all, so I always catalog a JPEG version of the file that my camera produces at the same time as the RAW file. (See the section "JPEG+RAW," later in this chapter.)

Chapter 9: Working with RAW and Other Formats

Figure 9-4: You can use JPEG files for web display without having to alter them.

- ✓ Writes to memory faster: Your digital SLR probably can write JPEG files to your memory card faster than any other type of file. This speed might not matter if you're taking only a couple of pictures at a time; the photos first go into the camera's high-speed memory buffer, which sucks up JPEG, TIFF, and RAW at similar speeds. However, writing these images to the memory card takes longer, and after the buffer fills, you can't take any more photos until some shots make their way out of the camera's internal memory onto the card. I've used dSLRs that are so fast at writing JPEG files to a high-speed 133X–300X (or faster) CompactFlash card that I can take sequence photos almost continuously for a dozen shots or more.
- Takes less room on cards: You can fit a lot more JPEG files on a memory card of a particular size. A 4GB card can store about 600 photos snapped with a 12-megapixel camera if you use the typical JPEG Fine setting, nearly 1,200 photos at a representative medium-quality setting, and as many as 2,200 shots at the highest compression setting. Only 360 RAW shots from the same camera might fill a 2GB card. My old 10-megapixel camera can fit 488 RAW images on an 8GB CompactFlash card, or more than 900 JPEG Fine images.

I don't usually recommend using card storage space as a criterion for choosing which file format to use. You can simply purchase enough memory cards, instead. However, in some situations (such as vacations), you have limited storage, and using the JPEG format (particularly the highest-quality setting) makes a good compromise.

JPEG+RAW

Most digital SLRs include an option to save a pair of files every time a picture is taken: one as a JPEG file and a second in the RAW format. Many cameras, including modestly priced models from Nikon and Canon, let you select the quality level for the JPEG version, so you choose between a high-quality JPEG and one that's more compressed and lower in quality.

Saving JPEG+RAW is a valuable capability. It lets you shoot JPEGs for cataloging, reviewing, and using in less-demanding applications (such as small prints, online auctions, and web display), while retaining RAW versions as digital negatives in case you need to do more extensive tweaking. Generally, the image pairs share filenames (only the file extension is different), so it's easy to match them up.

The storage-card space penalty is fairly low. Even a 21-megapixel dSLR can save almost 200 RAW shots per 8GB card, and 132 JPEG Fine+RAW image pairs. It's truly a case of getting the best of both worlds. I use this mode by default.

RAW in the raw

People often describe RAW files as "unprocessed" image files that contain all the information captured by the sensor. That's nonsense!

As I explain in Chapter 2, the sensor catches photons in little analog buckets (setting aside the wave/particle duality of light, as well I should!). The data collected is manipulated by your camera's digital signal processor, a special chip that converts the analog information into digital format. At the same time, the Bayerfiltered image data that mimics separate red-, green-, and blue-sensitive pixels is interpolated to create three different color channels of 12 to 16 bits each. That's a lot of processing right there! All that preprocessing can have a significant impact on the quality of your image, and that's before your camera settings are applied. You can't do a whole lot to RAW files to reverse the changes. But RAW does let you apply, after taking the photo, those settings that you normally make in the camera (such as white balance, sharpness improvements, color saturation, and to an extent, exposure). If you used a too-slow shutter speed and you have a blurry photo, you can't fix that. If you had a too-large f-stop and your photo doesn't have adequate depth-of-field, you can't fix that, either. You can apply a little sharpening, which might help somewhat in either case, but you have no way to undo serious errors that you made when you snapped the photo.

Chapter 9: Working with RAW and Other Formats

Working RAW

Save in RAW format if you frequently need to fine-tune your images. RAW lets you make changes to settings that normally you apply in the camera, either to individual files or batches of them. For example, if you take a whole series of shots under a particular lighting setup, such as fluorescent illumination, and save them as RAW files, then later decide on a single group of settings to apply to all of them, you can do that quickly with one batch process. Also, you can manipulate individual photos to your heart's content.

Using RAW Files as Digital Negatives

The more you shoot, the more you realize that it's always a good idea to have that (relatively) unprocessed image as a sort of digital negative that you can go back to at any time to work with anew. These files can be a treasure-trove of images that may prove invaluable at a later time, whether or not you think so now.

Salvaging images from RAW files

SEMEMBER

However adept you may be presently, your image-editing skills will improve. With an image saved in RAW format, you can salvage images that weren't usable before you gained new capabilities. Pictures that you didn't think you had any use for might turn out to be worthwhile with the passage of time.

For example, take the photo shown in Figure 9-5, which I sometimes use as an example of how to take photos in dim light without a tripod if you have a lens with a large maximum aperture. It's true that the original photo *was* taken at dusk, and the camera *wasn't* mounted on a tripod. It was taken with a fast lens, too, exactly as described. However, as they say, here's the rest of the story. (You don't always need to have the patience of Ansel Adams to take landscape photos.)

I took the picture one evening when I was out scouting locations for future shoots. I was driving across a causeway that crossed a lake a few miles from my home, and I decided the view was interesting. While driving at 45 miles per hour, I picked up my camera and shot the image shown in Figure 9-6 *through the open window of my minivan*. (Don't try this at home!) The ISO sensitivity was at 1250, the camera was in Shutter Priority mode with a shutter speed of $\frac{1}{1250}$ of a second preselected, and an aperture of f/2 — chosen by the metering system — let me capture a relatively unblurred image, despite my relatively high motoring speed. I know all this information because it was recorded in the EXIF data that accompanied the image file.

Figure 9-5: This picture wasn't carefully composed. It was a grab shot produced from a RAW file shot on the spur of the moment.

Figure 9-6: Here's the original RAW file before image editing.

This photo was a grab shot in every sense of the word. Yet, when I needed a photo taken in dim light with a large f-stop, this throwaway proved useful. Because I'd saved in RAW, I was able to manipulate the photo a bit to make it a little more interesting by cropping out the guardrail and portions of my vehicle.

Chapter 9: Working with RAW and Other Formats

Archiving RAW files

If you want to use RAW files as your digital negatives, you need to have a way to store them because they're sure to eat up your hard drive space quickly. I have virtually every image I've shot in RAW archived on my computer's hard drives, as well as on DVD or backup hard drives. My archives include shots of my feet taken when I tested an electronic flash, semiblank frames that are seriously underexposed, and all manner of out-of-focus and poorly composed pictures. As my example in the preceding section shows, you never know when you might find some use for a garbage shot.

Blank DVDs and external hard drives are so inexpensive these days that you have no excuse for not saving *all* your digital negatives. (Just don't forget to copy them to whatever format replaces the current formats in 10, or 5, or 2 years.) When you use most operating systems, you just need to archive files by dragging and dropping them to the DVD drive or external hard drive. Or use a backup program to perform the task automatically.

Finding RAW image-editing applications

Remember, to work with RAW files, you need an application that can read them. A variety of RAW converters are at your disposal. Your camera's vendor provides some of these converters, and as you might expect, those converters work only with the RAW files for that line of camera. Unless you own several different digital cameras from different manufacturers that can produce RAW files, these proprietary converters might be all you need — or you can check out third-party RAW applications, if you prefer. The following sections introduce some of the more popular proprietary and third-party applications.

Nikon Capture NX 2

Nikon offers the eponymous Nikon Capture NX, an extra-cost program (\$179.95, but available heavily discounted) that handles both older and the latest versions of RAW files that Nikon cameras create. Besides offering control over settings that you could have made in the camera, this utility provides some interesting additional capabilities. For example, it can defish images taken with Nikon fish-eye lenses, producing undistorted photos that have straight lines where straight lines ought to be. If you have Nikon Capture NX, you can get superwide-angle photos from your trusty fish-eye lense.

Nikon Capture NX, shown in Figure 9-7, has a separate lightness/chroma/hue palette for modifying these image attributes directly, along with post-shot noise-reduction features and vignette control to remove (or add) darkening/ lightening to the corners of photos. You may also find handy an image-dust-off feature that compares your shots with a dust reference photo made previously in the camera, and removes spots caused by dust on the sensor.

Figure 9-7: Nikon charges extra for Nikon Capture NX, but the additional features it offers are worth the cost.

EOS Utility/Digital Photo Professional

Canon provides the EOS Utility and Digital Photo Professional software utilities, which allow you to view and convert RAW images that you took with Canon cameras, as well as control the camera remotely. The EOS Utility is a bare-bones program; most dedicated Canon shooters prefer Digital Photo Professional, shown in Figure 9-8.

Digital Photo Professional offers much higher-speed processing of RAW images than was available with the late (not lamented), sluggardly File Viewer Utility formerly offered for Canon cameras. (Digital Photo Professional is as much as six times faster than the File Viewer Utility.) Canon says this utility rivals third-party stand-alone and plug-in RAW converters in speed and features. The program supports both Canon's original CRW format and the newer CR2 RAW format, along with TIFF and JPEG.

Chapter 9: Working with RAW and Other Formats

Figure 9-8: Digital Photo Professional is an advanced RAW file utility for Canon dSLRs.

You can save settings that include multiple adjustments and apply them to other images, and use the clever comparison mode to compare your original and edited versions of an image, either side by side or within a single split image. The utility allows easy adjustment of color channels, tone curves, exposure compensation, white balance, dynamic range, brightness, contrast, color saturation, ICC Profile embedding, and assignment of monitor profiles. A new feature gives you the option to continue editing images while batches of previously adjusted RAW files are rendered and saved in the background.

Third-party applications

Third-party RAW converters range from the very inexpensive to the paycheck chompers, as shown in Table 9-1.

Table 9-1	Some Third-Party RAW Applications		
Application	Cost	Platform	Website
IrfanView	Free	Windows	www.irfanview.com
GraphicConverter	\$40	Mac	www.lemkesoft.com
Bibble Pro	\$199	Windows, Mac OS X, and Linux	www.bibblelabs.com
Capture One Pro	\$399	Windows, Mac	www.phaseone.com
Adobe Camera Raw	Comes with Photoshop, Lightroom, or Elements	Windows, Mac	www.adobe.com

At this time, the most popular and widely used third-party RAW converter is probably Adobe Camera Raw (known commonly as ACR), which is supplied with Photoshop Elements 9.0, Adobe Lightroom 3, and Photoshop CS5 (see Figure 9-9). It works with a long list of RAW formats from vendors, including Canon, Nikon, Sony, Fuji, Olympus, Pentax, and Sigma. It does most of the general-purpose RAW conversion tasks that the vendors' own utilities handle, and it has the advantage of working transparently with a lot of different RAW formats, plus Adobe's DNG format.

Of the others, IrfanView, a Windows freeware program that you can download at www.irfanview.com, is at the low end of the price scale (it's free!) It can read many common RAW photo formats. It's a quick way to view RAW files (just drag and drop to the IrfanView window) and make fast changes to the unprocessed file. You can crop, rotate, or correct your image, and do some cool things such as swapping the colors around (red for blue, blue for green, and so forth) to create false-color pictures.

Phase One's Capture One Pro 6 (\$400, see Figure 9-10) is the gorilla at the high end of the price scale, and this premium Windows/Macintosh program for professionals does everything, does it well, and does it quickly. Phase One has taken pity on us mere mortals and also provides several budget "lite" versions that have limited feature sets and more affordable prices, including Capture One Express (\$129).

Chapter 9: Working with RAW and Other Formats

Figure 9-9: Adobe Camera Raw supports a wide range of RAW formats.

Figure 9-10: Capture One Pro from Phase One is a pro-quality RAW utility.

One of my favorites among third-party RAW converters is Bibble Pro, which also incorporates Noise Ninja noise-reduction technology. It supports one of the broadest ranges of RAW file formats available (which you may find handy if you need to convert a file from a friend's or colleague's camera). Available formats include NEF files from Nikon; CRW and CR2 files from Canon; ORF files from the Olympus product line; DCR files from discontinued Kodak dSLRs; RAF files from the Fujifilm dSLRs; PEF files from Pentax; and so on.

Bibble Pro is available for Windows, Mac OS X, and — believe it or not — Linux.

Action, Flash, and Other Challenges

In This Chapter

- Avoiding that lagging feeling
- Shooting in bursts
- Freezing action
- Flashing your subjects

he difference between a novice digital photographer and one with some solid experience is often apparent in how the shooter handles challenging photographic situations. Action photography, electronic flash photography, and situations that combine both electronic flash and available light seem to be the trickiest for photographers who are making the transition from neophyte to grizzled veteran. (Nobody really looks forward to being grizzled, but remaining a neophyte forever isn't a pleasant prospect, either.) These types of photography all offer challenges on both the technical and creative levels. If you can handle them, you can tackle anything.

This chapter looks at some of the technical stuff that you need to understand to make the transition, while taking top-notch action, flash, and sequence photos. Although you can find a bit of nuts and bolts here, stay calm and stick it out — my intent isn't to make you go nuts and bolt!

Kind of a Lag

Shutter lag, first-shot times, and those annoying pauses between photos do more than interrupt your photographic momentum — they can cause you to miss photos. Fortunately, of all digital cameras, dSLRs do the best job of reducing those awkward moments to a minimum. In the following sections, you can find out what causes this lag and what you can do about it.

Comparing point-and-shoot cameras to dSLRs

Users of non-dSLRs have traditionally felt the pain of shutter lag the worst. Of the dozens of point-and-shoot and electronic viewfinder cameras that I test each year, some of them lag as much as 0.6 to 0.9 of a second when shooting photos under high-contrast lighting (which makes it easy for the camera's autofocus system to lock in). In challenging low-contrast light, some cameras clock in 0.9-second lag times, and a few can take up to 1.9 seconds before completing the exposure. Fortunately, vendors have been improving the performance of P&S (point-and-shoot) cameras, and although they still can't match the rapid response of virtually all dSLRs, the newest models are somewhat better.

If you want to know how much a 1-second lag can affect a photo, check out Figure 10-1. If you press the shutter release when the pitcher unleashes the ball toward the first baseman (top), you get 1 second later the photo at the bottom, when the play's over and the action's just a memory. You'd probably prefer to get the shot shown in Figure 10-2, an instant before the ball hits the defender's glove and the base runner's hand brushes first base. Full disclosure: I didn't actually take any of these photos by using a point-and-shoot; I used a digital SLR that captured the beginning of the play, the ending, and all the action in between in a five-frame burst. But the individual images demonstrate what you can capture — or not capture — by using a point-and-shoot camera.

The photo in Figure 10-2 is the sort of picture that you can expect to take with a digital SLR. These cameras operate on a different plane of existence. Most of the time, such a camera seems to take the picture as soon as you press the shutter button. The actual elapsed time might be 0.2 of a second, at least three times faster than what you get with a typical point-and-shoot digital camera.

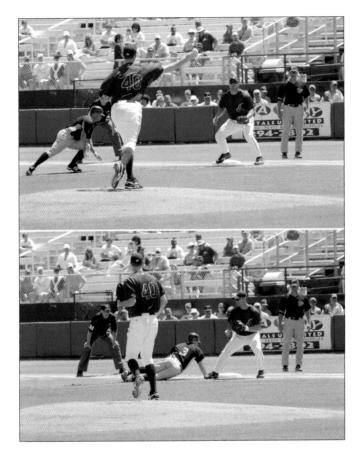

Figure 10-1: If you press the shutter release when the pitcher releases the ball (top), a point-and-shoot camera doesn't capture the image for as much as a full second later (bottom).

Shutter lag of any length can cause you to miss a photo, particularly if you're engaged in action photography or shots of children or animals, where the difference between capturing the decisive moment and capturing the notinteresting moment *after* the decisive one can be measured in milliseconds. Shutter lag can be a problem with portraits, too. You say, "Smile!" and your subject smiles, but then she frowns when nothing happens. Guess which expression you're most likely to capture?

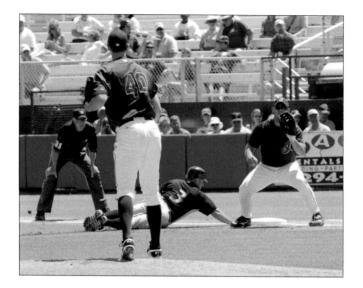

Figure 10-2: A digital SLR can give you a photo taken at the critical moment.

Understanding the sources of lag

Shutter lag is primarily caused by the camera's delay in locking in autofocus between the time you press the shutter release halfway and the time you fully depress it to take the picture. But this isn't the only factor you want to be aware of.

You can't blame a secondary kind of lag on a camera's pokey autofocus system. If you're taking a lot of photos in a row and your camera takes a long time to write them to the memory card (or your memory card is a slow one that can't accept data as quickly as your camera provides it), you can run into unfortunate delays. Your camera's buffer fills up, you press the shutter release, and nothing happens.

But wait! There's more! A third kind of delay can occur when you're shooting with electronic flash. It might take a second or two (or three or four) for your flash to recharge after you take a flash photo, so you either can't take a picture until the flash is ready or your camera goes ahead and takes the shot with incorrect exposure.

Fortunately, you can do things to counter all these shot-to-shot delays. Read on to find out how.

Minimizing shutter lag

Even the best-performing dSLR might not take a picture at the exact instant that you want to capture the shot. Hey, a 90-mph fastball travels 132 feet per second, so during a 0.2-second delay, the ball moves 26 feet. That's almost half the distance between the pitcher's mound and home plate!

Here are some ways to improve your results:

- Anticipate the action. It takes practice, but you can press the shutter release a fraction of a second before the action peaks. You can anticipate more easily if you understand the activity so that you know approximately when, say, a skier is about to leap over a mogul, or you can tell the difference between a pump fake and an actual forward pass. By shooting just prior to the decisive moment, like I did for Figure 10-3, you can improve your timing.
- ✓ Take a lot of photos. You end up missing that crucial moment quite a few times. If you take a lot of photos, you're bound to get some good ones, and the practice helps you improve your timing. The day before I sat down to write this chapter, I photographed a professional women's softball game and took nearly 400 pictures over six innings. But I didn't use a scattershot approach, attempting to get a good picture through dumb luck. I was trying to take a lot of good pictures in an attempt to get a few great ones.

Figure 10-3: Shoot just before the decisive moment to catch the action at the right time.

- ✓ Use your sequence capabilities. Your dSLR's continuous shooting mode can boost your odds by grabbing quick bursts of 3 to 5 shots per second (or even more; Nikon and Canon offer pro models that snap off 8 to 11 frames per second). However, all the pictures in a sequence may be taken just before, just after, or between the best moments, so burst mode isn't a panacea.
- Understand your camera's focus modes. You can help your dSLR lock in focus more quickly by understanding how the individual focus modes work. Single autofocus (AF-S or One Shot, depending on your camera brand) focuses the camera when you partially depress the shutter release. That mode's fast, but it may not result in a sharp picture if your subject's moving. (Some cameras can be set to lock the shutter release, preventing you from taking a picture if focus can't be achieved.) Continuous autofocus (AF-C or AF Servo) focuses the lens but continues to monitor the scene and then refocuses if the subject continues to move. AF-C is often the best mode for sports. Automatic autofocus (AF-A or AI Servo) starts in AF-S/One Shot mode, but it can switch automatically to AF-C/AF Servo if your subject begins moving. You also need to understand how your camera uses various areas of the screen, the focus zones, to select which subject to lock in on. You can set some cameras to focus on the nearest subject and ignore intervening objects that cross the field of view for a moment (such as when a referee passes in front of the camera while you're trying to photograph a running back).
- ✓ Switch to manual modes. Although digital SLR autofocus systems are remarkably speedy, they can be thrown off by rapidly moving subjects or a shift between the background and foreground while you frame your image. You might have better luck turning off the autofocus and manually pre-focusing on a particular point, such as first base, the goal line, or the position where an ice skater is expected to leap into a triple axel. Also, if you don't expect lighting conditions to change much, use manual exposure. Fewer automatic features can lead to a quicker response from your camera.
- ✓ Lock and load. When using auto modes, follow the action, and then lock in exposure and focus by using the lock control provided by your digital camera. When your camera is locked in for both exposure and focus (usually by pressing the shutter release halfway), pressing the shutter release the rest of the way takes your picture a bit more quickly.

Minimizing first-shot delays

Some digital SLRs take awhile to "warm up" before you can take a photo. The original Canon Digital Rebel back in 2003 was notorious for this delay, requiring up to three seconds from the time you turned it on until it reported for duty. Worse, the Digital Rebel tended to go to sleep as a power-saving measure while it was turned on, resulting in multiple 3-second delays during a shooting session.

This delay was largely eliminated in later Canon Rebel models, which turn on in less than half a second, a figure matched by most other digital SLRs on the market today.

You can virtually eliminate many first-shot delays with a simple technique: Don't turn off your dSLR! Point-and-shoot cameras typically turn themselves off after a few minutes because their LCDs drain so much juice. Digital SLRs use very little battery power when turned on, so you can safely leave them activated for hours (or days) at a time.

Digital SLRs are more power-efficient because the LCD is switched on only when you review pictures or navigate menus (or when you use the Live View feature, described in Chapter 2). The autofocus and exposure systems turn themselves off after a few seconds if you aren't actively taking a picture, but both revive almost instantly when you tap the shutter button. Only the builtin electronic flash and Live View use a significant amount of power.

If you get in the habit of turning on your camera at the beginning of a shooting session and not turning it off again until you're ready to pack up the camera and put it away, you avoid nearly all first-shot delays. Your flash needs to recharge from time to time, but that doesn't impact most of your photography.

Minimizing shot-to-shot delays

All cameras have an interval between shots that limits your ability to take a new photo immediately after taking the last one. Most of the time, this delay is negligible. That's because digital SLRs typically have a good complement of built-in super-fast memory called a *buffer*, which accepts photos as quickly as you take them, freeing the camera to take another picture. As long as the buffer retains enough room to accept new shots, you can take pictures as fast as you can press the shutter release. Many of the latest dSLRs, in fact, write images to your card so fast that you can take pictures one after another for an unlimited amount of time — until the memory card fills up, in fact.

Unfortunately, not all dSLRs have sufficient buffer memory for all the shots you might want to take, particularly if you're using the continuous sequence modes. When your camera fills up its buffer, delays can set in. Here are some things you can do to minimize those delays:

✓ Monitor the buffer. Keep an eye on the buffer indicator in your viewfinder. It might be a bar readout or numbers that show how many frames remain. If you think a more important moment may soon occur than the one you're shooting now, back off and let your buffer drain to make room.

- ✓ Get a faster memory card. As I note in Chapter 4, some memory cards are faster than others. With some digital cameras, a better-performing card can reduce shot-to-shot delays. When a camera feeds photos to the memory card faster than the card can accept the images, a bottleneck takes place and the buffer can fill. A faster card just might eliminate the problem. But a fast memory card doesn't necessarily cut down on delays with every dSLR. Some dSLRs have very large buffers and can often write even to standard memory cards at roughly the same speed while capturing new images. You might be able to shoot photos all day and not notice any delay except, perhaps, when shooting long bursts. A faster card gives the most benefit to dSLRs that have smaller buffers.
- ✓ Shoot at a lower resolution. I don't advocate shooting smaller image files (you never know when you can use the full resolution), but in a pinch, you can switch to a lower resolution to increase the number of shots that you can take in a row. If rapid-fire is more important than image quality, perhaps when shooting pets or active kids, go for it!
- Enlarge your buffer. Only a few cameras have this option, but I'm mentioning it for the sake of being complete. The factory can upgrade some digital SLRs with additional buffer memory for a reasonable cost. The effected models are generally older, high-priced professional cameras. Your digital SLR is unlikely to have this option.

Minimizing flash delays

Your camera's built-in electronic flash can cause delays when you're forced to wait for it to build up a full charge between shots. Some cameras have a useful option of locking the camera to prevent taking a photo before the flash is recharged, which blocks spoiled photos but obviously doesn't eliminate the annoying delays. Others let you fire away, risking an underexposed photo if the flash doesn't have enough charge.

Keep these tips in mind when you want to keep shooting flash pictures without pausing:

- Close-up shots use less power. If you're taking close-up photos, you can probably shoot more quickly and with fewer delays than if you're using up your flash's maximum power with every shot.
- Reduce flash power. A related technique that you can use for photos taken at closer distances is to reduce the power setting of your flash. You can set many built-in speedlights and external units to ½, ¼, ½ power (up to about ½28 power), or the device may reduce power for you automatically at closer distances. If that's all you need, use it and enjoy faster operation.
- ✓ Use an external flash. The flash built into your camera sucks juice from your camera's main battery and so has been designed to use the minimum amount of power necessary to do the job. This conservative

approach can mean slower recycling. External flash units that fit on your camera's hot shoe or use a connecting cable usually have beefier batteries and recycle much more quickly.

✓ Use an add-on battery pack/grip. You might be able to connect your external flash to an add-on battery pack/grip that offers *really* fast recycling, on the order of a second or less.

Shooting in Sequences

In the consumer marketplace, very cool features tend to filter down from higher-end products to the gear that we peons can afford. You used to find power seats and power windows only in pricey luxury cars, but now you'd have a hard time finding a vehicle without them. Speedy motor drives on cameras, which used to be the province of professional photographers, eventually made their way into the lowliest point-and-shoot film cameras. And now, because you can find burst mode, continuous advance, or sequence shooting on every digital camera, you can also produce a series of shots such as photos of a speeding train, as shown in Figure 10-4.

The chief differences between the continuous shooting mode that you can find in \$149 point-and-shoot cameras and the one that you find in your digital SLR are the speed, flexibility, and number of shots that you can capture in a sequence. Whereas a basic digicam owner is lucky to grab 2 to 3 frames per second (fps) for a half-dozen shots, digital SLRs typically can snap off from 6 to 24 pictures at rates of 3 up to 11 fps (with the pro models) without breaking a sweat. Your results vary, depending on the camera and format you use.

Figure 10-4: Continuous shooting lets you capture a sequence of shots.

As I mention in the section "Minimizing shutter lag," earlier in this chapter, sequence photography is no substitute for good timing. You still get better results by taking a picture at precisely the best moment than by capturing random frames in great bursts of exposures.

To use your digital camera's burst mode, you just need to activate it by choosing continous shooting mode, and then fire away, taking into account the need for good timing, the capacity of your camera's buffer, and all the other tips for minimizing delays, which I discuss in the section "Kind of a Lag," earlier in this chapter.

Stopping Action in Its Tracks

Freezing action isn't all it's cracked up to be. My recent foray into pro softball shooting had some strange results, as you can see from Figure 10-5. I was testing a long lens to see whether I could successfully hand-hold it, and I bumped up the shutter speed of my dSLR to ½500 of a second. That lofty speed did nullify any camera shake, but it had the additional effect of freezing a hardthrown softball in midair.

Without the added dimension of a little motion blur, you can't tell whether the ball is headed toward the player or away from her (she's actually just thrown it), and it really looks like the ball isn't moving at all — it seems to be suspended from overhead by a string. This shot wasn't destined to be a prize-winner anyway, but now, at best, it looks a little weird.

The lesson here is that stopping action completely might not be the

Figure 10-5: It looks like this softball is hanging from a string, not flying through the air.

best idea unless the image contains all the other elements of a good action shot so that it looks like a frozen moment rather than a staged setup. Instead of completely stopping all movement, you might want to incorporate at least a little blur into your shot to add excitement. For example, motor sports look more realistic if photographed with a shutter speed long enough to allow the wheels to blur. And anyone seeing a photograph of a helicopter with its rotors stopped would expect to see it crashing to Earth in the next moment.

The key to stopping action successfully (and believably) is to choose the correct shutter speed. Your shutter slices off little moments in time; the briefer the exposure, the smaller the slice and the less blur-causing subject movement. To make things interesting, your shutter sees motion at the same speed in different ways, depending on which way the subject is moving:

- Across the frame: Motion parallel to the width or height of the frame seems to move fastest to the sensor, and the subject blurs more easily. You need to use higher shutter speeds — from ½000 to ½000 of a second, in many cases — to stop this motion, compared to movement in other directions.
- ✓ Toward the camera: Motion moving toward you appears to have a much slower rate of speed, and such subjects blur the least. You can use a much slower shutter speed to freeze this kind of motion. For some kinds of subjects, shutter speeds of ½0 to ½50 of a second might work.
- ✓ Diagonal motion: This type of movement falls in between the preceding two. An automobile going from the upper-left to the lower-right is crossing the frame at the same time it's coming toward you, so you need an intermediate shutter speed, on the order of ½25 to ⅓00 of a second.
- Close up/distant: Subjects closer to the camera cross the frame more quickly than those farther away, and so those subjects require a higher shutter speed.
- Relative speed: If you move the camera in the same direction as the subject's motion, a *panning* technique, the relative speed difference is less, so you can use a lower shutter speed. The following section has some tips on panning.

Going with the flow (or panning)

The term *panning* comes from the word *panorama*, or "whole sight" if you happen to speak Ancient Greek in the home. It refers to an unbroken view of an area, such as the view a motion picture camera produces when rotated smoothly from side to side. Panning is always horizontal; *tilting* is the vertical equivalent.

In either case, because the swiveling motion of the camera (usually) follows the direction the subject is moving, the subject appears to the camera to be moving at a slower rate of speed, so you can capture it at a slower shutter speed. The result is shown in Figure 10-6, which was taken at ¼ second with the camera following the player attempting a layup. The static background, which isn't moving at all, appears to be blurry, and so do the other players who could be stopped, moving slower than the player in the center of the frame, or moving in another direction.

Figure 10-6: A shutter speed of 1/4 second and panning allowed the player in the center to appear sharper, adding a feeling of motion to this shot.

You can pan with a hand-held camera or with a camera mounted on a tripod that has a swiveling panorama (pan) head. If your camera's manual doesn't specifically say that your model supports image stabilization when panning, you should turn it off. (Some models/lenses have separate horizontal and vertical stabilization and can apply anti-shake when panning.) Here are some tricks to getting good panned shots:

Have the right attitude. To pan without using a tripod, position your body so that you're facing in the direction at the end of the pan. Then, twist to the start position and untwist while you follow the action smoothly, triggering the shutter when you want to snap a picture.

- Level your platform. To pan with a tripod, make sure the tripod and pan head are level with the direction of the movement so that when you rotate the camera, it follows the action smoothly.
- Practice, practice. Try out your pan a few times before you actually take a picture. When you practice, your technique improves.
- Move smoothly. Don't use jerky movements. Follow the movement of your subject closely.
- Keep your eye on the background. Avoid unintentional mergers and distractions.

Catching peak action

Many kinds of action culminate in a *peak* — the motion stops for a moment before resuming. You can capture at relatively slow shutter speeds a basketball player at the top of his or her leap before uncorking a jump shot, a ski jumper at the apex of a soaring flight down a slope, or a roller coaster poised at the top of a hill. Figure 10-7 shows a running back bursting through the offensive line while his teammates engage all but one of the opposing players. Most of the movement had stopped when the linemen butted heads, and the halfback was running toward the camera. So, a shutter speed of $\frac{1}{250}$ second was fast enough to stop this action.

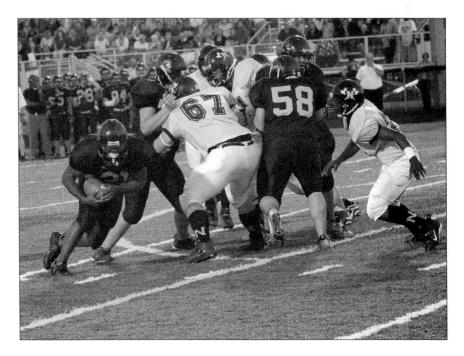

Figure 10-7: A shutter speed of 1/250 second was fast enough to stop this action.

You can find a lot of action peaks that don't involve sports, too. You can freeze your child on a swing for an instant at each end of the swing's arc. Birds in flight stop pumping their wings and ease into a lazy glide to ride thermal currents.

The magic bullet for catching peak action is patience and perseverance. Figure out just when the crucial moment is likely to occur and then time your shot accordingly.

Zapping action with flash

Electronic flash units are still sometimes called *strobes* after the stroboscopes used by Dr. Harold Edgerton at MIT to freeze shattering light bulbs and to stop bullets in flight. When flash is used as the only source of illumination in a photo, it can be very effective at stopping action because of its very brief duration.

Indeed, most electronic flashes built into digital SLRs have a *maximum* duration of about $\frac{1}{1000}$ of a second and might last only $\frac{1}{50000}$ of a second or less when used for close-up photography. The most effective way of controlling the exact output of a flash is to limit the length of time that the energy stored in the unit's electrical capacitors is emitted. To produce a small blip of light, the flash releases only a tiny amount of energy in a very short time. To produce more light, give the blip a longer duration.

If the shutter speed and f-stop you use to capture an image with the flash are such that the continuous or *ambient* illumination isn't strong enough to register, the image is produced by the flash alone, so your camera's actual shutter speed is irrelevant. For example, you might be shooting at $\frac{1}{250}$ of a second at $\frac{1}{8}$, but action is stopped by the electronic flash's $\frac{1}{2000}$ of a second duration.

You can find out more about flash in the following section.

Flash in the Pan: Other Keys to Good Flash Photography

Actually, you *can* use flash while panning (or when your subject is moving) to produce an interesting effect, which I talk about in the section "That sync-ing feeling: Coordinating flash and shutter," later in this chapter.

You need to understand a few concepts about using flash, whether you're applying this tool to action photography or other types of photography. In

the following sections, I help you understand how flash works at different distances, how to sync flash and the shutter to get the effect you want, as well as other techniques that can help you improve your flash photography in less than $\frac{1}{200}$ of a second.

Understanding flash at different distances

The most important flash fact to remember is that electronic flash differs from the continuous illumination you know as daylight in one important respect: Daylight appears to be relatively even at most working distances, but the brightness of flash diminishes rather quickly while the distance between the subject and the flash increases. You can step 10 or 20 feet away from your subject in daylight, and the exposure doesn't change. Move the same distance from your subject when using flash, and the illumination from the flash decreases dramatically.

Electronic flash, like all illumination, obeys the *inverse-square* law. Light diminishes relative to the inverse of the square of the distance. So, if you're photographing a subject that's 3 feet from your flash, you need four times as much light when the distance is doubled to 6 feet, not twice as much. That also means that if you photograph two subjects, one 3 feet from the camera and one 6 feet from the camera, the more distant subject is underexposed by 4X (two f-stops) if the closer subject is properly exposed. (See Figure 10-8.)

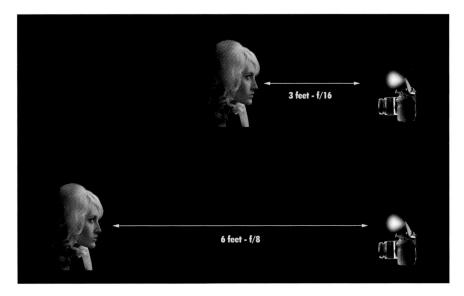

Figure 10-8: If the correct flash exposure at 3 feet is f/16, you must use f/8 when the subject is 6 feet away.

This pesky law applies to daylight, as well, but the distance between the light source and subject is so much greater that you can ignore the consequences — unless you plan on stepping back 93 million miles between shots.

In practice, your camera's built-in flash probably doesn't do a good job illuminating anything 24 feet from the camera (say, a quarterback stepping back to unleash a pass) unless you use a high ISO setting. Your flash has probably been optimized to shoot subjects around 12 feet from the camera at around f/8 or so, and it produces poor results at 24 feet, for which f/5.6 might be required. Those kinds of situations call for more powerful, external flash units.

In addition to the sharp fall-off in illumination, using flash has some other disadvantages:

- ✓ Flash photos can look harsh, with bright foregrounds and very dark backgrounds, thanks to that inverse-square nonsense.
- Flash photos can produce a ghost effect when the scene has enough ambient light to produce a blurry secondary image along with the flash exposure.
- 🛩 Electronic flash uses your camera's internal battery at a tidy clip.

You can see why proper use of flash is one of the more interesting challenges facing dSLR users.

That sync-ing feeling: Coordinating flash and shutter

Many new SLR owners become confused over the options for synchronizing electronic flash with their camera's shutters. This section clears up that confusion.

Digital SLRs can use a combination of electronic and mechanical shutters to control the length of time the sensor is exposed. An electronic shutter is just that: The sensor is controlled electronically to allow it to capture photons for a fixed period of time. The camera uses the electronic shutter for very brief exposures.

The mechanical shutter physically opens and closes to expose the sensor, and the camera uses it for longer exposures, from 30 seconds (or whatever your camera's maximum exposure happens to be) to a length of time that's known as the camera's flash maximum sync speed, which can range from $\frac{1}{180}$ to $\frac{1}{500}$ of a second, although most are in the $\frac{1}{200}$ to $\frac{1}{250}$ -second range. (Speeds slower than the maximum can be used, but will allow more of the existing, ambient light to reach the sensor in addition to the flash's illumination.) So, the *flash sync speed* is the *fastest* shutter speed that the camera can ordinarily use to take a picture with the electronic flash.

The mechanical shutter used in dSLRs travels in front of the sensor, just above the plane of sharp focus (and is called a *focal plane* shutter for that reason). The shutter consists of two curtains. The *front curtain* opens first, moving across the plane of the sensor until it's fully open. Then, after the sensor has been left exposed for the desired amount of time, the *rear curtain* begins to follow it, gradually covering the sensor until it's completely concealed. Because of the brief duration of the flash, the flash must be fired only when the sensor is entirely uncovered. Otherwise, your picture consists of a partial frame, showing only the portion of the sensor that happened to be uncovered when the flash went off.

You can synchronize the flash in two ways, each producing a slightly different effect:

✓ Front-curtain sync: This is the default mode used by cameras. The electronic flash is triggered as soon as the front curtain has reached the opposite side, recording a flash exposure of the subject. Then, the shutter is allowed to remain open for the rest of the exposure. If there's sufficient ambient light and the subject is moving, you end up with a streak in the direction of the subject movement, as if your subject was preceded by a ghost. Most often, you don't want to see that streak.

Rear-curtain sync: In this mode, the flash doesn't fire until the rear curtain begins to move at the *end* of the exposure. The ghost image, if any, registers first and terminates with a sharp image at your subject's end position. In this case, the ghost image trails the subject, like the cool streak that follows the Human Torch everywhere, as you can see in Figure 10-9. If you must have a ghost image (or want one), use rear-curtain sync.

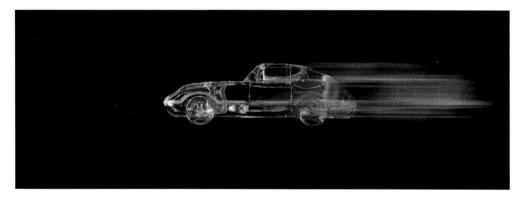

Figure 10-9: With rear-curtain-sync flash, the ghost image trails the sharp image of the subject.

What if you want no streak at all? In that case, try to use a shutter speed that's high enough that the ambient light doesn't register an image. The higher your camera's flash sync speed, the better your opportunity for using a shutter speed that's so brief you don't get a ghost image. Less is more: A ½00-second sync speed, such as the one on the Nikon D40, works better in that regard than slower speeds, such as the ½00-second sync speed of the Canon Digital Rebel XSi or Nikon D90, or the ½80-second sync speed of some Pentax cameras.

Don't confuse front- and rear-curtain sync with *slow-sync*, which is a digital SLR option in automated modes that sets the camera to choose slow shutter speeds to *deliberately* add exposures from ambient light to the flash image. Slow-sync doesn't work well with moving subjects; use it with the camera mounted on a tripod so the camera can record the background along with the flash exposure.

Another flash sync option found on some dSLRs is *high-speed sync*, which uses longer (but weaker) flash exposures to synchronize the flash at even higher shutter speeds than the camera's nominal flash sync speed. You can best apply this option to close-up photography, where the diminished flash output is sufficient for a good exposure.

Getting the right exposure

Your dSLR most likely uses a *dedicated* flash unit designed specifically for your camera, and it's built right into the camera, mounted on top in the hot shoe or connected to the camera with a cable or wireless triggering mechanism.

Dedicated flash units are commanded by the camera itself, which measures the amount of flash that reaches the sensor and tells the flash when to shut itself off. This is TTL, or *through-the-lens* metering, and is generally the most accurate type of flash exposure calculation. Communication between the flash and camera might also include information about which zoom setting (focal length) you are using the lens (so the flash can change its coverage to match) and what color temperature the flash emits (so the camera can compensate).

Flash exposure systems can also work with a preflash that's used to calculate the right exposure or integrate the distance data supplied by your camera's focus system to adjust flash output. There's also good old manual flash exposure, in which the flash pops at whatever power setting you specify (such as full, half, or quarter power), and you set the f-stop yourself by using a flash meter, guide-number estimates, or good old-fashioned guessing.

Yo, Trigger! Setting Off an External Flash

The mechanism used to set off your flash involves some considerations, too. Perhaps you want to separate an external flash from your camera by a distance that's too long for a connecting cable. In that case, you have a few options:

Slave device: This is an attachment to a remote flash that activates it when its sensor detects the light from your main unit.

It's important to use a slave trigger with a "digital" mode designed for digital cameras that typically fire a preflash before the main flash exposure. In that mode, the slave will wait for the main flash rather than firing as soon as the pre-exposure flash burst is detected.

✓ Slave units: These are separate electronic flash units with built-in slave triggers, and work well when you plan to use several electronic flash units together. You can end up with brighter overall illumination or use the position of the different flash units to provide specific lighting effects. Again, these slave units should have a mode that avoids triggering the unit from the preflash.

✓ Wireless trigger: This more sophisticated approach sets off your flash without the need for a main flash at all. The camera or a device attached to the camera provides the signal that trips the remote flash unit(s). These triggers often have a selection of four or more channels, which let you control flash units individually and also avoid conflicts with other photographers who happen to be using similar wireless devices at the same location. Wireless sync can operate by radio signals or low-power preflashes from the main camera that don't contribute to the exposure.

In addition to the type of trigger that you can use for your external flash, I have one more slightly important topic to discuss: how to avoid frying the electronics of your camera when using an external flash! Sounds like a good idea, right?

All digital SLRs that allow you to connect an external flash use a triggering circuit that closes a switch, which fires the flash. The triggering voltage from the flash that passes through this switch in your camera might vary from a few volts to 250 volts or more.

Modern digital cameras might not respond well to voltages of more than 10 to 15 volts, and some very bad things can happen to the camera's circuitry if more juice goes through than recommended.

Flash units built specifically for your camera or for digital cameras, in general, rarely cause difficulties. The problem seems to reside with older flash units and newer cameras. One solution is to determine from your flash vendor the exact triggering voltage. You can often find this figure on the Internet, and the information is usually as reliable as any guidelines you find on the Internet (which is to say, not very). My preference is to use a voltage isolation device, such as the Wein Safe-Sync (about \$50), which separates the camera from the actual voltage used

by the electronic flash.

The Safe-Sync, shown in Figure 10-10, receives the signal from your camera and passes the information along to your electronic flash. The flash fires, your camera isn't fried, and every-body's happy. You can mount the device in your camera's hot shoe and then slide the flash into the shoe on top of the Safe-Sync. Or you can link a flash by using a PC cord plugged into the connector on the side of the gadget.

Figure 10-10: A voltage isolation device can safely connect your dSLR to any flash unit.

Composition and dSLRs

In This Chapter

- Understanding composition basics
- Shooting portrait poses and other people shots
- Snapping publicity and PR photos
- > Photographing architecture and landscapes extraordinaire
- > Taking travel shots for gadabouts

n some respects, a digital SLR makes achieving good composition a tiny bit easier than with non-SLR cameras, even though the eye and skills of the photographer bear the final responsibility. Some photographers say, with justification, that good composition should be exactly the same, whether you're using a digital SLR or the least-expensive point-and-shoot camera. Other photographers say that those folks need to spend more time using a dSLR. Some significant differences exist between composing photos with a snapshooting camera and a digital SLR, the primary one being that you can do it.

Your basic non-SLR camera might rely on a tiny LCD (liquid crystal display) that's about 3 inches diagonally. This LCD is easily washed out in bright light, might be too dim to view under reduced illumination, and is grainy and subject to ghost images if the camera or subject moves. It might display only 85 percent or less of the actual subject matter (although most provide a 90- to 100-percent view these days), and it probably turns off after a minute or two because it hogs so much power. Other non-SLRs, the so-called *mirrorless* cameras like those available from Sony, Olympus, and Panasonic, supplement their back-panel LCD with a clip-on electronic viewfinder (EVF) that's an LCD-in-a-box. Still other non-SLR cameras include an internal LCD-based EVF. None of these are ideal, and that's the *good* news.

The bad news is that these cameras often have an alternate viewfinder that's even worse than the LCD or EVF. A *viewfinder* is a tiny optical window that not only shows just part of the actual image, but also shows the view uncentered. Depending on the location of the optical viewfinder, it can seduce you into cutting off the top of your subjects and maybe a little on the right side, as well. This paragon of technology doesn't show depth-of-field even as well as the LCD.

And it gets worse. The trend these days is to eliminate the optical viewfinder on non-SLR cameras entirely, so many snapshooters end up holding their camera at arms' length, so that they end up *aiming* the device in the general direction of the subject they want to shoot, rather than creating a thoughtful composition. Truman Capote once said of Jack Kerouac's work, "That's not writing — that's typing!" The photographic equivalent is, "That's framing not composing."

Think how much easier the typical dSLR makes your job of creating a photograph. Your camera's viewfinder probably shows 95 percent of the actual photo at a magnification of 0.75X to 0.95X life size at a normal focal length (roughly the equivalent of 45mm–50mm). You have a good idea of the depthof-field by default, and you can usually press a depth-of-field preview button to get a better representation of what's in focus and what isn't. A digital SLR's viewfinder is live all the time — even when the camera is turned off, and the view winks out for just a split second during exposure. You don't have to deal with ghosting. You're never in danger of cutting off your subjects' heads.

So, coming up with a good composition when shooting with a point-andshoot camera is more than problematic — it's an outright challenge. Given that a dSLR makes it easy for you to compose images in the first place, consider applying some of the tips listed in this chapter.

Composing a Photo: The Basics

Good composition is a little like good art. Even when people aren't consciously aware of all the components that go into great compositions, they still know what they like. The very essence of composition is to arrange subject matter in a way that both is pleasing and communicates the message the photographer is trying to get across.

That communication can be subtle. Once, I was watching one of my favorite films by Japanese master Akira Kurosawa with the DVD commentary turned on. The film scholar/commentator pointed out that when Kurosawa wanted to express tension in a scene, he frequently arranged the actors and their surroundings in triangular compositions. During calmer scenes, the composition was more open and squarelike.

When I knew what to look for, the late director's compositional legerdemain leapt off the screen, as obvious now as the methods were unnoticed before. I realized that good composition can strongly affect my feelings about an image, even if I am not consciously aware of the techniques being used.

I help you understand some of the rules for composing images — and understand when you can bend or break them. Composition is all about communicating messages in a pleasing way — or, conversely, in a disturbing way, if that's your intent.

Composing for message and intent

Before you can frame your image in the composition you desire, you need to know what your messages and intent are. You don't need to spend hours contemplating your photo before you shoot. Simply keep the following questions in mind while you bring your dSLR to your eye and compose your picture:

- ✓ What do I want to say here? Am I simply trying to portray my subject in a thoughtful or playful mood, or is my intent to show the anguish and hard life of a typical migrant mother? Am I looking to create a peaceful shot of a forest scene, or do I want to show the ravages humankind has wrought on the environment? Or is my goal to make my client's widget look tempting so that someone will buy it? Some good photos make statements; others convey images of quality or affordability. A few more attempt to evoke humor. If you know in advance what kind of message you want to convey and who your audience is, you're way ahead in the compositional game.
- ✓ What's my main subject? Wow! What a great lot of classic automobiles all lined up at the drive-in. Wouldn't that make a great picture? An array of these cars might make a memorable shot but it might not make a good composition. Instead of trying to cram six autos into one shot, choose one and let the others create an interesting background. Your photo should always have one main subject, even if that main subject is a group of people posing for a portrait.
- ✓ Where's the center of interest? Your main subject is generally your center of interest, and it probably shouldn't reside in the center of the photograph, except when you're shooting close-ups, portraits, and other subjects that are naturally centered. But, if not centered, your subject *should* be in a place that attracts the eye and encourages examination of the rest of the image. You'll learn the principles of placing your center of interest in the Rule of Thirds discussion that follows this section.
- ✓ Do I want a vertical or horizontal composition? Digital SLR shooters are much less likely to fall into the trap that the point-and-shoot set is subject to — composing all photos horizontally — simply because that's the way the camera was designed to be held. A dSLR easily pivots between vertical and horizontal orientations (some even have built-in or

add-on vertical grips that have auxiliary shutter releases and command dials). So, you can choose vertical compositions for tall buildings and NBA players, and you can use horizontal layouts for ranch homes and NFL quarterbacks who've just been flattened by a linebacker. Of course, you can always crop vour image from one orientation to the other within your image editor, but that editing wastes pixels. Figure 11-1 shows an image that quite logically falls into the vertical composition mold.

- Do I want to print this image in black-and-white? In that case, textures and contrasts can become a more important part of the composition.
- ✓ How should I arrange the subjects in my photo? Placement of the subjects within the frame is a key part of good composition. You might be able to move some objects or change your shooting angle to alter the composition. The arrangement

Figure 11-1: Some subjects are best suited for vertical compositions.

of your subjects determines how the viewer's eye roams around in the frame. There should be a smooth path to follow, starting with your main subject and progressing to the other interesting elements in the photo.

- ✓ Where should I stand? The distance from you to your subject and your angle can have a dramatic impact on your composition. A high angle provides a much different view than a low angle, and shooting at eye level is likely to be boring. Getting close emphasizes a subject in the foreground while potentially minimizing the importance of the background. Backing away can make the foreground appear to be more expansive. You have to change your shooting angle by physically moving, but you can achieve a specific distance by zooming, switching to a prime lens of a particular focal length, or simply taking some steps forward or back. And in a pinch, you can crop your photo in an image editor.
- What's in the background? Backgrounds can make or break a photo. Sometimes, you want a plain background to draw emphasis on the center of interest. Other times, the background is part of the composition and

adds interest. For example, the throngs of fans *not* in the stands on the visitor's side of the court in Figure 11-1 tells a story about lack of attendance at this road game. In other cases, a busy background could be a little distracting or, worse, form a merger with subjects in the foreground. You can find out more about mergers in the section "Compositional Ideas That Travel Well," later in this chapter.

Applying the Rule of Thirds

Every book on photography includes a blurb describing the infamous *Rule of Thirds,* which posits that the ideal locations for objects in a composition reside one third of the way from the top or bottom margins and one third of the distance from either side. For example, in Figure 11-2, Cathedral Rock at Sedona, Arizona, occupies one such node at the right side of the frame, and the horizon lines up roughly one third of the way from the bottom of the picture. Most of the books don't tell you exactly *why* dividing an image into thirds is such a good idea. After all, couldn't you follow the Rule of Quarters, the Rule of Fifths, or even the Rule of Six and Seven-Eighths?

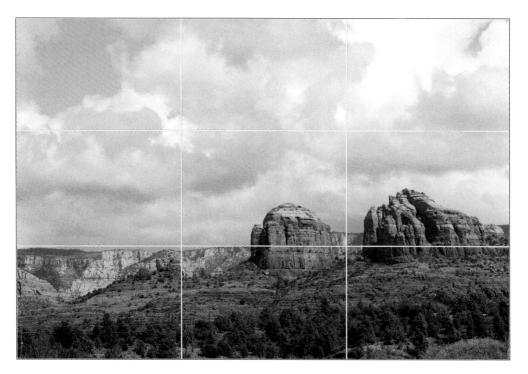

Figure 11-2: The Rule of Thirds offers guidelines for placing the horizon and other significant parts of an image within the frame.

The origins of the Rule of Thirds

In reality, the Rule of Thirds wasn't created by some all-knowing artist back in the dawn of time, nor was it created arbitrarily. The Rule of Thirds was created by Mother Nature herself. The ancient Greeks studied many of the most pleasing works of nature and discovered that most of them adhered to a specific proportion that could be described in a particularly harmonious mathematical way.

They deemed this particular proportion golden and used it to construct a Golden Rectangle, which, if its long side is defined as 1, the short side is 0.618 as long. Bisecting this Golden Rectangle produces Golden Triangles, and if you do it enough times you end up with four points that divide the original rectangle into thirds. Zazaam! With all that math and natural beauty driving it, the Rule of Thirds *has* to provide pleasing proportions. Of course, the typical digital film frame isn't necessarily a Golden Rectangle, but the Rule of Thirds can be applied, nevertheless.

Putting the Rule of Thirds to work

To use the Rule of Thirds, try to locate your subjects at one of the imaginary intersection points in the viewfinder. If your dSLR has optional grid lines, they probably *aren't* arranged to follow this rule. Also, know when to ignore the guideline. You can center your subject or locate it at the far right, top, or bottom if you have good reasons for doing so. Most close-up photos and many portraits, for example, place the subjects right in the middle of the frame, usually because no other compositional elements are in the photo that need to be arranged to provide balance.

Posers and Poseurs

People photography is one of the most enjoyable types of picture-taking, and digital SLRs are especially adept at it. Whether you're posing friends, family, and colleagues for casual or formal portraits, or attempting to catch the next rock star wannabe onstage, your dSLR has the features that you need to excel.

Compared to point-and-shoot digital cameras, digital SLRs provide more flexibility in choice of lenses, more control over depth-of-field (so you can throw a distracting background out of focus), and better image quality with the longer exposures sometimes necessary for people shots at night. Despite all you have going for you, keep the compositional tips in the following sections in mind while you snap away.

You can use thousands of good poses for individuals or groups, but you don't need to memorize dozens of options to get good portraits. If you're a beginner at people pictures, you might want to look at some poses that work in magazines and books. However, a few simple rules can help you build workable subject arrangements from scratch. Read on for details.

Shooting individual portraits

Composing portraits of individuals is theoretically easier than pictures of groups because you have only one subject to worry about. Of course, you have to please that subject with your results. Everyone wants to be portrayed in a flattering way, and the photographer needs to make a subject *look* the way that he or she imagines himself or herself — or better!

Here are some individual-portrait tips:

- ✓ Make sure that your subject is relaxed and comfortable. Sitting is better than standing for anything short of a full-length portrait, and a stool is often the best seat because no back or arms intrude into the photo and a perch on a stool discourages slouching. However, a picnic bench, handy rock, fence, or even the kitchen table can provide a place for your subjects to relax while you capture them for posterity.
- If your victim isn't facing the camera, have him or her look into the frame, rather than out of it. Otherwise, the viewer wonders what's going on outside the picture area that's so interesting.
- ✓ Choose a good angle that flatters your subject. As I discovered from my days photographing models, even the most attractive people can have hands and feet that are positively grotesque when photographed from their worst angles, which are the backs and palms of the hands and bottoms of the feet. Most of the time, you don't make bare feet a prominent element in your portraits, but if you photograph the edges of hands, they can become an expressive part of your photo. Exception: Baby hands and baby feet can be cute from any angle, particularly to the parents and close relatives. But be aware that some childless adults and a few other types are powerfully sick of adorable pictures of somebody else's kids, so this charm isn't necessarily universal.
- ✓ Compose your shot to de-emphasize problem areas. Bald heads aren't necessarily as problematic as they used to be because athletes, musicians, and those who aspire to coolness often shave their heads specifically to get the bare-pate look. If your subject is sensitive about involuntary baldness, or if his or her particular attempt at being cool is, um, a poor implementation, lower your camera slightly and elevate your subject's chin. If you're using external lights, avoid adding glare to the top of the head.

Long, large, or angular noses might be a badge of honor and personality for some, and perhaps a plus for thespians seeking character roles for their distinctive faces. For everyone else, try having subjects face directly into the camera.

Alfred E. Neuman, Dumbo, and H. Ross Perot just wouldn't look the same without their distinguishing ears. Less-famous folk sometimes appreciate it if you minimize their prominent ears in photographs or, at the very least, avoid making them the center of interest. Try shooting your subject in profile or arrange the lighting so that the ear nearest the camera is in shadow.

Diffuse lighting to diminish

defects. To minimize wrinkles or facial defects, such as scars or bad complexions, use softer, more diffuse lighting, as shown in Figure 11-3. Shooting in the shade or bouncing light off a reflector (which can be something as simple as a white shirt worn by an assistant or passerby) can provide a more flattering rendition. A diffusing filter on your lens or diffusion added in your image editor can help, too. You can also zoom out or take a step back to shoot your subject from the waist up. That approach reduces the relative size of the face in the final picture.

Avoid reflections off eyeglasses. Have your subject raise or lower the chin a bit so that the glasses don't bounce light directly into the lens. If you

Figure 11-3: Female subjects are often best pictured with soft lighting.

use a flash, position the flash at an angle. You can see many reflections through your SLR viewfinder, but for flash shots, review your picture and reshoot if reflections are a problem.

Shooting group photos

Group photography (two or more people) has all the potential pitfalls of individual portraits, multiplied by the number of people in the shot. However, the following special considerations are unique to photographing groups:

- ✓ Each group shot is also a portrait of all the individuals in the shot. The guidelines for creating flattering portrayals remain basically the same. (I list those guidelines in the preceding section.) Unfortunately, optimizing everyone's visage in a single shot can be tricky because you can't have one person in profile, another from a low angle, and a third with special lighting to minimize yet another kind of defect. Fortunately, though, because individual faces in a group shot are relatively small, these problems can take care of themselves, as long as you keep everyone relaxed and smiling.
- ✓ Watch the eyes! Make sure that everyone in the photo is looking in the same direction, which should generally be in the same direction that their noses are pointing. Check for blinkers and nodders, too. Try to take at least one photo for every person who's in the photo (for example, take at least six photos for a six-person pose) just so that you can get one in which everyone's eyes are open. Then double that number to be safe.
- Arrange your subjects into interesting patterns. Make sure that all the heads aren't in a single horizontal or vertical line, as shown in Figure 11-4.
- Triangular and diamond shapes work best for groups of three or four people. If you have more people than that in a shot, break them up into multiple triangles and diamonds. Copyright restrictions dating back to the year 1662 prevent me from including in this book Rembrandt's portrait we know as The Dutch Masters. but if you Google this picture (or simply buy yourself a box of cigars). vou can see that it contains a cunning arrangement of three triangles to represent just six people. The trio on the left make up one triangle, the three on the right make up a second, inverted triangle, and the same figures produce a third triangle if you look only at the three gentlemen in the center.

Figure 11-4: When shooting groups of two or more, keep their heads at different levels and angles to add some interest.

Tips for Publicity and PR Photography

I made my living taking publicity and public relations (PR) photographs for more years than I care to count, so you'd think I'd be competent at it by now. I know enough that I can summarize the difference between the two in a single sentence:

Publicity photography is intended to make someone or something famous; PR photography is designed to make someone or something likeable.

A typical publicity photo might show a rising 28-year-old TV/movie star out on a date with a 45-year-old thespian whose career has seen better days. If the picture captures the public interest, it's likely to boost the careers of both, regardless of whether it portrays the pair in a favorable light, or was taken by a paparazzo or supplied by a publicist.

A publicity photo can also picture an object, rather than a person. Perhaps a giant blow-up figure promoting a new movie has been stolen from the roof of a fast-food restaurant and now resides on the front lawn of a college fraternity. Everybody wins here: the restaurant, the movie producers, and the college students who gain 15 minutes of fame.

Photos intended to improve PR are almost always provided by the PR agency or publicist of the person or product that benefits. If the 28-year-old and 45-year-old stars happen to be arrested after crashing a sports car through the window of a jewelry store, you can bet that some PR photos will soon appear picturing those same personalities doling out dinner at a soup kitchen or entertaining the troops in some foreign country.

Of course, the approach isn't quite that cynical in the real world, and both publicity and PR photos can be used for quite serious and laudable purposes, I'm told.

Your job, if you choose to accept it, is to create pictures that do their intended job. As such, you must realize that publicity and PR photos don't revolve as much around a particular subject as they do a particular purpose. This category can include portraits, sports photos, landscape pictures, and even travel photography, so follow the guidelines for each of those kinds of pictures. But, in particular, keep these tips in mind:

These photos all have a particular message or two to convey. Your composition should revolve around that message, whether you hope to portray a particular person as a fine upstanding citizen, represent a product as a good value, highlight a premium-priced luxury item, or

show a technological breakthrough that'll save the world. Keep your message in mind at all times.

- Keep It Simple, Silly (KISS). Exclude everything from the photo that doesn't help convey the message. You don't want viewers of the picture to become interested in something other than your subject that they find more compelling.
- ✓ Look for unusual angles, subjects, and treatments. Your historical society had a Civil War buff give a presentation on a recent recreation that he participated in. Ho hum! If you want a newspaper in your area to run your PR shot, avoid a traditional head-shot photo. Instead, shoot an eye-catching picture of him in character, make it look like an old-time Civil War-era photograph, and watch the newspaper's editor sit up and take notice. (See Figure 11-5.)
- ✓ If you're shooting a PR picture, you must represent the person or product accurately, within reason. If your photo isn't accurate, your image loses credibility, and reputable news media will decline to run it. No adding marbles to a bowl of soup to make the vegetables rise to the top. Don't show your company's CEO running a marathon when the most exercise she gets in

Figure 11-5: Capture your subject in action for a more interesting PR shot.

real life is pounding on the boardroom table. That doesn't mean you're obligated to picture every defect and problem, only that you shouldn't deliberately use your photographs to mislead the audience.

✓ If you're shooting a photo for publicity, go ahead and ignore all the advice in the preceding paragraph. Nobody takes your efforts seriously, anyway. Your photos are desirable only if they're a bit over the top and perhaps more than a little sensational. A photo showing an Academy Award winner punching out one of his mates in a bar is a lot more salable than one of him mending a fence on his ranch. The latter is more likely to be a PR photo released when he's out on bail — and a much tougher sell.

Capturing Architecture

Architectural photographs frequently call for wide-angle lenses, which let you take in large expanses of a building and its surroundings without having to step back a mile or two. Indoors, the same wide-angle lens makes it possible to photograph interiors without having to step outside and shoot through an open window. Wide-angle lenses also allow you to include foreground detail, such as landscaping, which can be an important part of an architectural photo.

On the plus side, the interchangeable lenses available for digital SLRs generally have a much wider view than you can get with even the wide-zoom model point-and-shoot digitals. Several non-SLR cameras from Nikon, Olympus, and others have wide-angle lenses that are the equivalent of a 24mm lens on a 35mm film camera or a full-frame digital SLR. However, those are relatively scarce, and frequently, that isn't nearly wide enough. Only digital SLRs allow you to fit lenses as wide as 15mm for a true ultra-wide view.

Of course, the wide-angle perspective comes at a price, especially if you're using a digital SLR that has the crop factor that comes with the territory in cameras that have smaller than full-frame sensors. On a camera with a 1.5X crop factor, a 20mm extra-wide lens becomes an ordinary 30mm wide-angle lens, and an 16mm ultra-wide optic has a 24mm view. Although you can readily buy true ultra-wide lenses for your digital SLR — including zooms that take in the equivalent of an 18mm full-frame lens, at the wide end, and fish-eyes — these lenses can be expensive. My favorite fish-eye zoom lens, a 10mm-to-17mm Tokina optic (originally developed by Pentax but now available for Canon and Nikon lens mounts, too), costs almost \$600. Even so, if you want to shoot architecture frequently, spring for the pricey lenses that you need.

The following sections outline some of the details that you need to consider when shooting architecture, indoors or out.

Reeg, your perspective is out of control!

Whether it's a good thing, most people take photographs with the camera at eye-level and the back of the camera parallel to the plane of the subject, at right angles to the ground. I'm always harping about using interesting angles, both high and low, but most of the time, people take photos straight-on with little or no tilting in any direction.

Wouldn't you know it? Camera tilts commonly come into play when the shooter is taking architectural photos. Outdoors, tilting the camera up is often necessary to photograph tall structures, which seems like a good idea until you see that the building appears to be falling back in the final picture. That little bit of tilt, which causes the plane of the sensor to be not parallel with the plane of the subject, can make the picture look somewhat bizarre, as you can see in Figure 11-6, thanks to a syndrome called *perspective distortion*. Fortunately, when you're shooting interiors, unless you're inside a cathedral or domed stadium, you probably don't need to tilt the camera upward, so you can avoid the most common kinds of perspective distortion.

Figure 11-6: If you tilt your camera back, a tall structure appears to be falling away from you.

The most logical solutions for this distortion outdoors don't always work well. You can take a few steps back so that you don't need to tilt the camera (or tilt it as much), but that often means that intervening trees, fruit carts in the plaza, and other obstacles now intrude on your photo. A wider lens sometimes helps, although you waste a lot of pixels on foreground subjects that you end up cropping out of the picture.

If a handy building stands across the street, you might be able to ascend about halfway up, shoot out a window, and take in both the base and top of your target structure without tilting the camera at all, but you'll rarely be that lucky.

Your digital SLR might be compatible with any of the available *perspective control* lenses, which can move their optics off-center enough to take in more of a subject in any one direction without the need to tilt. However, perspective control lenses can cost a bundle, might not be available for your camera, and are tricky to use.

Your best bet might be to do the best you can and then use your image editor to correct the perspective distortion. Photoshop CS5 and Photoshop Elements 9 have a handy Lens Correction tool, as shown in Figure 11-7 (choose Filter Lens Correction to open this tool).

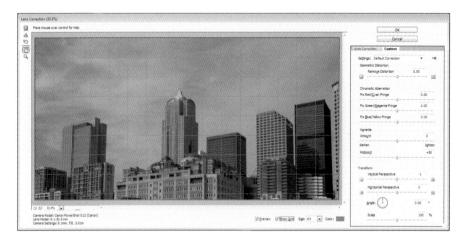

Figure 11-7: Photoshop's Lens Correction tool can help fix perspective distortion.

The Lens Correction tool can fix perspective distortion, correct chromatic aberrations (color focusing errors), and mend *pincushion distortion* and *barrel distortion* (the tendency to bow vertical and horizontal lines inward or outward, respectively). If you apply this corrective filter, you can end up with an image like the one shown in Figure 11-8.

Figure 11-8: The corrected tower looks like this.

Charge of the lighting brigade

Architectural photos, indoors or out, can suffer from lighting problems. Like with other types of photography, one of the main challenges for you, the photographer, is to make sure that the lighting helps render your subject in the most suitable way for the particular type of photograph you're taking.

Your first challenge is to make sure you have sufficient light to take the picture. Using a higher ISO setting, or mounting a lens with a faster maximum aperture (f3.5 to f/2.8 or larger), if available can help. But in many cases, the amount of the light available isn't the most vexing problem. Architectural photographers often encounter illumination that is "spotty" or uneven.

In Figure 11-9, for instance, I decided to let uneven lighting work for me. The bright area at the bottom of the spiraling staircase naturally leads the eye through the image. In most cases, though, you're not so lucky. But you can turn to Table 11-1 for solutions to many common lighting problems.

Figure 11-9: Sometimes, uneven lighting can work for you, concentrating attention on one part of the image.

216 Part III: Beyond the Basics _____

Table 11-1	Handling Co	ommon Lighting Problems
Problem		What to Do
Too little light: If you're shooting outdoors at night or indoors, you very likely don't have enough light to make a proper exposure with the camera hand-held.		Provide extra lighting (by using a flash, perhaps); mount your camera on a tripod to allow a longer exposure; or use a technique such as <i>painting with</i> <i>light</i> , in which you leave the shutter of a tripod-mounted camera open in a time exposure while you illuminate the subject with repeated electronic flash bursts, a flashlight, or another light source.
Too much light: Having to light is rarely a problem. A photography usually is fri bright (but not harshly lit) ments that allow you to u ter speeds and/or small a provide a lot of depth-of-1	Architectural endly toward environ- se short shut- pertures that	In very bright situations, you may need to use a neutral density filter to cut back on the amount of light.
Harsh lighting: You might in a situation that has gla trasty, and harsh light.		You may need to soften the lighting by intercepting direct illumination so that it bounces off reflectors.
Uneven lighting: Harsh lig be uneven, but uneven lig necessarily harsh. You sin find yourself with plenty o illumination in part of you not enough light in other p	hting isn't nply might of suitable r frame and	Break out the electronic flash or reflectors to cast a little light in the gloomy portions of your subject.
Mixed lighting: Indoors, y multiple light sources illur room. Space located near might be lit by outdoor lig bluish, compared to the w light. These mixed light so give you a fairly ugly phot modify them.	ninating your r windows ht that's quite varm interior purces can	Pros do things such as draping orange filterlike material over windows to give the sunlight coming through the same color as the interior light, or filtering their electronic flash so that it matches the room illumination. You might draw the blinds or turn off the interior lights and stick with the window light and perhaps a few supplemental electronic flash units that have the same white balance.

SEMEMBER

You've been framed!

Most kinds of photography benefit from building a visual frame around your subject, but architectural photos benefit more than most. If possible, frame your main subject by using doorways, windows, arches, the space between buildings, or the enveloping branches of trees as a pseudo border. Usually, these frames are in the foreground, which creates a feeling of depth, but if you're creative, you can find ways to use background objects to frame a composition.

Designing Your Landscape Photos

Landscape photography is another photographic pursuit that benefits from the dSLR's capability to use wide-angle lenses. Landscapes also happen to be, after portraits, one type of photography that people often blow up to huge sizes and display on the wall. As much as people love their loved ones, they're also fond of Mother Earth and enjoy sharing photographs of both.

Like architectural photography, landscapes lend themselves to contemplative shooting. Scenery changes slowly over long periods of time, so Ansel Adams–esque quests for the perfect angle, idyllic weather, and ideal conjunction of the stars and planets are understandable and not at all unreasonable. Given enough time to work with, you can use all the compositional suggestions that I mention in this chapter when you shoot landscapes.

Use curves, lines, and shapes, like those shown in Figure 11-10, to guide the viewer's eye. Fences, gracefully curving seashores, meandering roads, railroad tracks, and receding tree lines all can lead the viewer through your carefully crafted composition. Curved lines are gentle; straight lines and rigid geometric shapes are more forceful. Although you can't plan on moving things around helter-skelter to improve your composition (rocks, mountains, and streams pretty much must remain where you find them), you're free to change angles and viewpoints until your picture elements all fall into place.

Landscape photography also happens to be one of the more happily gadgetprone photographic pursuits. Gradient neutral density filters — dark on top and clear on bottom — can balance a brilliant sky with the less-bright foreground. Gradient color filters, which I describe in more detail in Chapter 16, can blend a warm orange color on one half with a rich blue on the other, producing an interesting split effect between sky and foreground.

Figure 11-10: Lines and shapes can guide your viewer through your photograph.

Tripods are a valuable tool for landscape photos because they steady the camera to help you take razor-sharp images that you can blow up to mammoth size. They're also handy as a camera stand that keeps your lens pointed in the right direction while you spend a lot of time thinking about your shot. Panorama heads work in conjunction with your tripod to allow leveling your camera while you crank off overlapping shots at the correct intervals.

When you're ready to shoot your landscape, keep some of these tips in mind:

✓ Avoid splitting your photo in half with the horizon. Remember that Rule of Thirds (which I talk about in the section "Applying the Rule of Thirds," earlier in this chapter)! Place the horizon one-third down from the top if you want to emphasize the foreground or one-third up from the bottom if the background and sky are your most favored subjects.

- ✓ You don't have to compose landscapes in landscape mode. Try shooting some verticals. If you incorporate strong vertical lines, such as trees, off to one side of the shot, your landscape photo can be naturally converted to a vertical orientation.
- Shoot a lot of sunsets (or sunrises if you're *that* kind of person). Sunsets and sunrises always look good because the light has a marvelous golden quality, and they're different each time — even if you shoot from the same location. Remember that the sun rises and sets in a slightly different place on the horizon each day of a given year.
- Manually focus, if you must. Autofocus systems sometimes have difficulty finding enough contrast for focusing automatically, especially if you have a lot of sky in the photo. When you take most landscapes, you focus at infinity, anyway.

Compositional Ideas That Travel Well

Travel shots are often a combination of architectural photography and landscape photography. While you roam around on vacation, you're bound to find interesting things to photograph within cities, as well as in the countryside. The chief difference between travel photography and architectural or landscape pictorials is that the travel shots invariably have one or more members of your party standing smack in the middle of the picture waving or pointing.

It doesn't have to be so. Oh, of course you want to prove you've been to the Eiffel Tower or Grand Canyon, so go ahead and take a few shots that show you or your companions mugging for the camera. But then shoo everybody out of the way and take a few well-composed photos that you can be proud of. After all, 20 years from now, most of your family members in the photos will be old and wrinkly. But the Eiffel Tower and Grand Canyon will be unaging parts of your vacation memories, if you take the time to capture some memorable photos while you're there.

Vacation photos are your chance to apply some of the basic compositional techniques that I discuss throughout this chapter. A few new principles to consider include

✓ Try to balance your compositions. Place interesting subject matter on both sides of the frame. I don't mean that you need to have two centers of interest, only that you don't want a lopsided photo. If you pose a person on one side of the frame, include a building or some foliage on the other side to create a balanced look. This trick encourages viewers to explore the image, rather than feel uneasy because they're wondering why all that empty space is on the other half of the photo.

✓ Avoid mergers. Mergers are the (usually) unintentional combinations of unrelated subjects spliced together in disturbing ways. The classic merger is usually a tree growing out of the top of someone's head (but you can do the same thing with the Eiffel Tower if you're careful — and tired of having your subjects just stand in front of it and wave).

Mergers can also happen when subjects seem to grow out of the edges of the picture. For example, if you have a tree branch drooping down into your image but you don't see a tree anywhere in the rest of the photo, the branch appears to have sprung from the edge of your picture. Examine your compositions carefully to spot and eliminate mergers before you capture them in pixel form.

✓ Don't be afraid to try some new subjects. Certain travel photos are almost obligatory. Return from Spain without a picture of a flamenco dance, or come back from Philadelphia lacking a shot of Independence Hall or the Liberty Bell, and your acquaintances might doubt whether you actually took that trip. But don't let those expectations limit you.

I like to photograph what I call the *Gettysburgs* of each location that I visit — the places that many people have heard of, but have rarely seen pictured. In the United States, that might be a view of the St. Louis arch taken from underneath the arch itself, rather than from the other side of the Mississippi River, or a close-up of the flaking paint on an old sculpture, such as the one shown in Figure 11-11. In Europe, you might want to photograph El Toboso, a village in Spain where Don Quixote's Dulcinea lived, rather than snap only the same-old-same-old photos at the Alhambra or the Costa del Sol.

With a little imagination, you can return from your trip with well-composed, interesting photos that capture the spirit of your vacation but don't look like you cribbed them from postcards.

Chapter 11: Composition and dSLRs

Figure 11-11: Look for unusual details, such as the flaking paint on this sculpture.

222 Part III: Beyond the Basics _____

Part IV Fine-Tuning Your Output

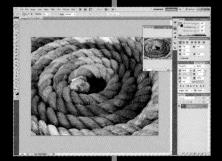

ou aren't done yet! Pressing the shutter simply takes the photo. Then, you might want to make the photo better by using the creative tools available with image-editing software. This part shows you some of the things that you can do with your image, including the joys of distributing them as hard-copy prints.

Chapter 12 helps you do basic retouching salvaging murky photos, correcting unacceptable colors, and removing annoying spots — with the image editor of your choice. Chapter 13 shows you simple techniques for combining one or more photos, removing backgrounds, and getting creative with selective modifications. Chapter 14 proves that making good hard copies doesn't have to be hard.

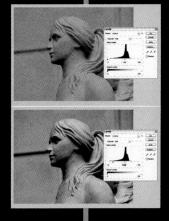

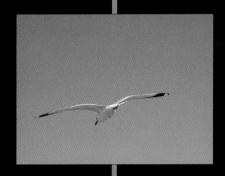

Fixing Up Your Images

In This Chapter

- Checking out available image editors
- Fixing up photographs

f you're really, really good at digital SLR photography, your images might not need any fixing at all, right? Dream on. *Nobody's* that good; even the most sharp-eyed shooter still uses image editing, or what the cognoscenti refer to as *post-processing*. (It'd take some major mojo for a photographer to perform *pre-processing* on images *before* they were taken!)

Thanks to the miracles of image editing, you can take that perfect composition and create an entirely new picture by judicious cropping. Perhaps you can modify your perfect exposure to produce a special high-contrast effect or a low-contrast moody look. You can creatively twist great color balance with oddball colors. You might even find that the perfect shot of the Eiffel Tower looks even better if you transplant the structure to a cornfield in Kansas.

Image editing is a skill anyone can master. One of the best things about digital photography is that your images are digital all the way. You don't need to scan film or a print or do any conversion. What you shot is what you got — a digital image full of pixels just waiting to be tweaked, fine-tuned, shifted around, and optimized. You can do a lot of that in your camera, but for even greater image enhancement, you need an editor, such as Adobe Photoshop Elements, Paint Shop Pro, or even the granddaddy itself, Photoshop CS5.

These are all things that you can do with an image editor. This chapter and Chapter 13 show you what you can do to fix up images or transform existing shots into entirely new ones.

Editor-ial Comments: Choosing an Image Editor

Which image editor should you use? It could be argued that Adobe Photoshop is the best image-editing software on the planet. It could also be argued that owning your own private jet is the best way to travel around the country. Not everyone can afford private jets or Photoshop, and not everyone wants to spend time figuring out how to pilot them. That's why so many alternatives to Adobe's flagship image editor have flourished.

Some image editors have every imaginable feature, but others take a barebones approach. Do you need to work in 3D or edit CMYK (cyan, magenta, yellow, black) image files while making color separations, or are you just looking to correct red-eye problems? Do you want absolute control over every parameter, or would you prefer that your image editor handles simple tasks with a wizardlike interface? Image editors differ both in the features they have and the approaches they take to image editing. The trick is to figure out which editor has the features you need and an approach that's compatible with your working style.

Because you're working with a digital SLR, I assume that your editing requirements are, potentially, a little on the ambitious side. Certainly, you want to adjust tones, fix color, or sharpen things a little. But you also might have a hankering to drop out backgrounds, remove an extra head from your brotherin-law from another planet, or combine several of your best shots into one. So, in this chapter, I assume that you want to go beyond the basics with your image editor and your image-editing activities. (In Chapter 13, I explain how to do so.)

For an ambitious soul such as yourself, the image-editing choices are numerous.

Adobe Photoshop CS5

Photoshop is a verb? With apologies to R. Buckminster "I Seem to Be a Verb" Fuller, Adobe Photoshop is well on the way to joining the English language as a process rather than just a product. The average person who has never used an image editor, when confronted with an obviously manipulated photograph, is likely to say, "That looks photoshopped!" Common misusage of its trademark might pain Adobe, but the company has to be pleased at how widely known and used the product is.

Since it appeared on the market in the early 1990s, Photoshop, including its latest incarnation, Photoshop CS5, has gained its number-one position over the years by virtue of a complex set of circumstances, many of which relate to how cool the product really is. Consider these points:

- Photoshop does everything any sane digital photographer or graphics worker would want to accomplish. Recent releases have filled a lot of holes, including the long-requested capability to curve text along a path. If you can't do it with Photoshop, you probably don't need to do it.
- Photoshop does not include (unlike, say, a certain Office suite) feature bloat in the form of capabilities that nobody wants or uses. You might not need every single Photoshop feature now, but someday you might. Adobe has wisely segregated some of the more advanced features, such as capabilities aimed at those who need sophisticated 3D and video production tools, into a special "professional" version, Photoshop Extended.
- Photoshop works identically with PCs and Macintoshes. With some minor interface differences, Photoshop works the same with both PCs and Macs.
- ✓ Understanding how to use Photoshop is a marketable skill. Certainly, it takes months to become a Photoshop master, but the knowledge you gain can help you not only with your current job but, potentially, your next one, as well. Employers don't take notice if you're a Paint Shop Proguru (unless the company happens to use that program) but might place a premium on Photoshop expertise.

Despite its cost and learning curve, Photoshop, as shown in Figure 12-1, is certainly not out of the reach of the average dSLR owner. Most computers built in the last couple of years are certainly powerful enough to run it, especially if you upgrade to 2GB of random access memory (RAM), which should cost less than \$100. If you're serious about photography, spend the time to master Photoshop.

Attractive upgrade offers let you purchase a full copy of Photoshop for a fraction of its original \$700 list price (or about \$1,000 for the CS5 Extended version). Thereafter, you can upgrade when Adobe comes out with a new release (on roughly an 18-month schedule) for about \$200. In the past, it was possible to skip a release (upgrading, say, from Photoshop CS3 to Photoshop CS5) if you don't need the very latest features. However, Adobe has begun the nasty practice of not supporting the latest version of its RAW software converter, Adobe Camera Raw, in previous editions of Photoshop. So, if you are using Photoshop CS4 and have just purchased a new camera, you might be forced to upgrade to CS5 if you want to use Adobe's RAW conversion software in place of the converter offered by your camera vendor.

8 Part IV: Fine-Tuning Your Output .

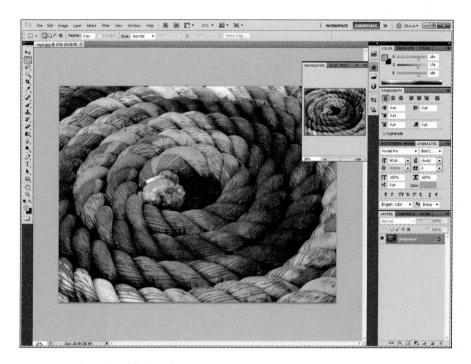

Figure 12-1: Photoshop CS5 in action.

The good news

Photoshop's strength is its complete feature set, with tools for doing retouching, compositing, complex color correction, and even web design. If you specialize in one type of image processing over another, Photoshop has everything you need in its well-organized tool set.

The most sensational feature of the latest version of Photoshop is the new Content Aware Fill capabilities. These "smart" filling and cloning tools make it easy to fill in unwanted areas of your image with appropriate content and textures derived from the surrounding area. Unlike plain old cloning, which just copies an area you select on top of another area, Content Aware tools do an excellent job of producing seamless camouflage, for much speedier retouching and compositing.

Photoshop CS5 also features a Puppet Warp tool. This tool is useful for creating simple animations by overlaying an image with a mesh where pivot points can be inserted at "joints." You can use the tool to swivel individual parts

independently, like a puppet (hence, the moniker). The artists among us will appreciate new Bristle Tips and Mixer Brush tools, and Macintosh users get a 64-bit version of Photoshop for the first time. Several changes have made applying lens corrections and high dynamic range adjustments easier for beginners.

The new version retains and refines some of the best capabilities introduced with CS4, including the Mask palette, which you can use to create selections by using pixel painting and line drawing; more natural-looking results when you use the revamped Dodge and Burn tools; and a killer feature called Vibrance adjustment, which lets you boost the saturation only of colors that aren't already fully saturated. No more blowing out your richest colors while you try to make other hues more vivid!

Photoshop is a nimble, cross-platform, cross-application tool. It can read, write, and manipulate all the industry-standard file formats, as well as many nonstandard file types. You can resample images to change the image size, resolution, and color depth. Photoshop excels at providing images that are optimized for specialized uses, such as commercial printing and web graphics. As part of the Adobe Creative Suite, Photoshop is also well-integrated with several leading page-layout programs and web-development programs, such as Illustrator, PageMaker, InDesign, and GoLive. Because Adobe acquired Macromedia, you can enjoy some integration with that subsidiary's products, as well.

Photoshop provides a rich set of tools for everything from simple image manipulation (cropping and color-balance adjustments, to name two) to selecting complex shapes from an image and applying sophisticated filters and effects to the selected area. Photoshop also includes a full set of painting tools that you can use to retouch your images or to create custom artwork.

Adobe designed Photoshop to accept filters and plug-in program extensions provided by third-party suppliers, such as Andromeda, Applied Science Fiction, Alien Skin, Auto FX, and Extensis. A robust aftermarket has evolved to supply a wide assortment of plug-ins that let you quickly and easily apply all manner of textures, edge treatments, special effects, and other image manipulations to the images you edit in Photoshop.

Photoshop integrates well with Adobe Lightroom 3 (see Figure 12-2) which, while it has some image editing tools, excels as a workflow management and image organizing application. You may want to do your heavy-duty editing in Photoshop, and developing library collections of your images, web galleries, and slide shows in Lightroom.

0 Part IV: Fine-Tuning Your Output

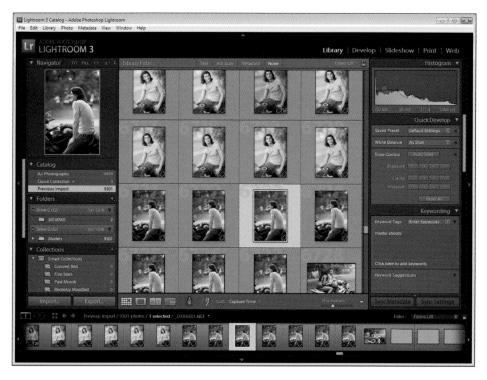

Figure 12-2: Photoshop CS5 integrates well with Lightroom 3.

The bad news

Photoshop still doesn't do natural media well; even with the Brush Tips capability, it has trouble mimicking various types and styles of brushes, charcoal, pens, and other tools needed to paint original images. To create original digital artwork, you need Corel Painter. In fact, many graphics pros own both applications: They use Photoshop for color correcting and retouching, and use Painter for creative brushwork.

Photoshop's \$700 list price has to go into the bad news column. Photoshop can also develop into a money pit. Serious Photoshop users have a thirst for plug-ins. Although Photoshop comes with more than 100 plug-ins, you can never be too rich, too thin, or have too many filters for your image editor.

Don't downplay your investment in time required to figure out how to use Photoshop. Although you can pick up the basics in a few weeks, if you really want to master every nuance and trick, be prepared to spend even more time. A search for Photoshop books on Amazon.com returns more than a thousand results for good reason. Hundreds of authors who had to figure out how to use this application are eager to share their knowledge with you. You probably need to buy two or three of the best books and read them thoroughly to master the basics and most common shortcuts.

One of the most comprehensive books on the market is *Photoshop CS5 All-in-One For Dummies*, by Barbara Obermeier (Wiley).

Finally, Photoshop definitely is not a program that you can use only once a month and become proficient. You can invest all that time figuring out how to use it and then forget half of what you know if you don't work with the application on a weekly basis. Photoshop is a commitment. For more information, visit Adobe at www.adobe.com.

Adobe Photoshop Elements 9.0

Adobe Photoshop Elements is a powerful junior version of the full Photoshop program. Elements has most of the functionality of Photoshop CS5, but it lacks some of the features that the average photographer might be able to get along without. At about \$100, it's more affordable, too. (Smart shoppers wait for a sale, when you can frequently find Elements 9.0 for \$70 or less.)

Elements, as shown in Figure 12-3, formerly shared much of the same user interface with Photoshop, but its look has been considerably streamlined in recent years. Today, Elements 9.0 doesn't bear much more than a family resemblance. Although it's missing a few features that Adobe deems professional, such as CMYK editing, Elements includes most of the basic image-editing tools that the typical digital photographer needs on a regular basis. Those tools include image-selection tools, retouching tools, painting tools, a generous assortment of filters, and the capability to expand those filters by accepting the same Photoshop plug-ins that its sibling program can.

The good news

A price tag of \$100 (or less) puts Elements within the reach of anyone, and its reduced feature set is a good match for the needs of the typical digital photographer. You can find most of the standard selection, retouching, and painting tools from Photoshop available in Elements. If your image-editing needs revolve around retouching and manipulating individual pictures one at a time, you probably will never miss the more advanced Photoshop features.

Elements has jumped two whole versions since the last edition of this book, which relied heavily on Version 7.0. Elements 8.0 (and now Version 9.0) introduced some interesting new features. These include significant upgrades in

the Organizer, such as automatic People Recognition, which helps you find photos of specific people. an Auto-Analyzer to help you locate your best photos and video clips, and the capability to edit photos in full-screen mode without leaving the Organizer.

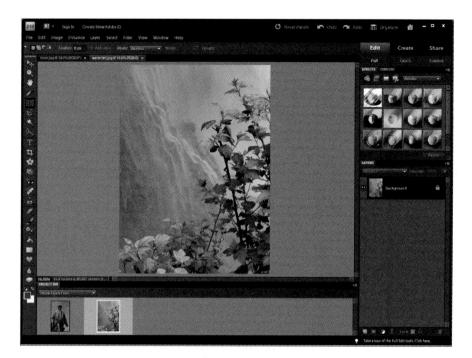

Figure 12-3: Photoshop Elements at work.

In Elements' editing module, the latest versions boast Photomerge technology for combining photos into broad panoramas, and adjustments previews you can use to judge effects before applying them. Elements 9.0 adds layer masks for applying changes to just portions of layers, new filters for pop art, Lomo (plastic camera) effects, and new portrait filters. The newest version is more tightly integrated with social media sites like Facebook and Adobe's own Photoshop.com, and has new templates for creating calendars, cards, and photo books on your home printer.

The automated commands on the Enhance menu make quick work of common image-editing tasks, such as adjusting backlighting or color cast. As a result, an occasional user working with Elements can complete those tasks faster and more accurately than a seasoned graphics pro working with Photoshop.

Elements also makes a good introduction to Photoshop for people who plan to upgrade someday. After you master Elements, you can transfer much of what you know directly to Photoshop. You use filters, most kinds of selections, and basic tonal and color corrections in much the same way in both applications.

The bad news

Compared to the most basic non-Adobe image editors, Elements can be a bit daunting. Elements today is as complex as Photoshop was five or ten years ago. The similarity to Photoshop works against you if you're a total imageediting neophyte. That's because, even with the revamped user interface, the menus and palettes still bear more similarity to Photoshop than they do to less ambitious programs. Even so, dSLR photographers probably wouldn't be happy with the simplest image editors, anyway, so the "easy, but not *that* easy" interface of Elements doesn't offer much of a downside.

The most vexing downside has been eliminated. In years past, Adobe's tendency was to introduce new features for Elements in its Windows version first, with the Macintosh upgrade following months later. Some features are available only in the Windows edition. In recent versions, Adobe has introduced new editions for both platforms simultaneously. You can find out more about Elements at www.adobe.com.

Alternative image editors

In the past few years, Corel Corporation has bought out and absorbed a host of alternative image editors (resistance is futile!), incorporating them as parts of its own varied product line. Other image editors from different vendors have either vanished entirely or are no longer promoted as heavily. Microsoft, for example, discontinued its Digital Imaging Suite products and incorporated some editing features into its latest operating systems, including Windows Vista and Windows 7. Corel's offerings include the following:

✓ Corel Photo-Paint X5: This image editing program is available only in the popular CorelDRAW Graphics Suite X5 (Windows only, about \$400 for the entire Suite). It is a full-featured photo-retouching and imageediting program that has much of the functionality of Photoshop Elements, including convenient automated commands for common tasks. Among them: red-eye removal, and Photo-Paint Image Adjustment Lab, which lets you correct the color and tone of photos with a single click. Photo-Paint also accepts Photoshop plug-ins to expand its assortment of filters and special effects. Its Cutout Lab is an improved selection tool.

- Corel PaintShop Photo Pro X3: This is a general-purpose image editor (Windows only) that has gained a reputation as the "poor man's Photoshop." It provides many of the advanced features of Photoshop at a bargain price. This editor has so many features that it isn't really that much easier to use than Photoshop, making its price the main benefit. However, it does bristle with more than 500 special effects, including infrared looks.
- ✓ Corel Painter 12: Corel is wisely not positioning this editor as a competitor to Photoshop (many graphics workers own both), but as a digital painting program that re-creates natural media effects. The only Corel editor available for both Windows and Mac OS (at about \$400 for either), Painter does an incredible job of mimicking artists' tools, such as charcoal, pastels, and various kinds of paint. You can define the color, size, and edge softness of the "brushes" you use, and also the texture of the paper or canvas, the thickness of the paint on the brush, and how the paint is absorbed into the paper. Everything from a watercolor wash on hot-press paper, oil on canvas, or pastels on a sanded board are at your disposal. Painter comes with a huge selection of pre-defined brushes and media, but you can create your own, as well.

Free image editors/albums

The latest wrinkle in the editing realm is the availability of free image editors associated with online services. The most popular include Microsoft Live Photo Gallery (from the Redmond, Washington, software behemoth), and Photoshop.com (a tool from Adobe):

- ✓ Windows Live Photo Gallery 2011: If you use any of the Windows Live services (I couldn't live without the online Windows Live Calendar), explore Live Photo Gallery. It's strictly an album service that allows you to upload, tag, and share your pictures. It's pretty cool because it works so well with the other Windows Live services. You can publish your photos through e-mail or in blog entries with a few clicks.
- ✓ Photoshop.com: This online album/image-editing service is perfect for those who use Photoshop Elements because it allows you to upload photos directly from the Elements desktop application by using your favorite browser. Its Photoshop Express editing features (shown in Figure 12-4) are simple, but effective. When you sign up for a free account, you receive 2GB of storage space (enough for hundreds of JPEG images) and the capability to add pictures to your album from anywhere in the world where you have access to a computer and the Internet.

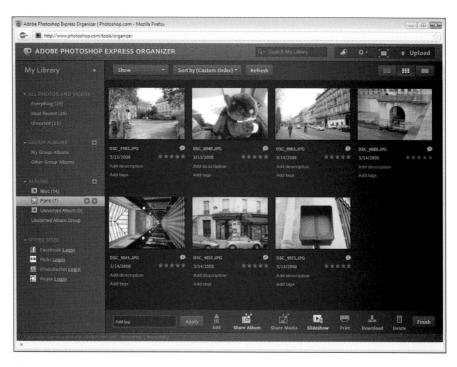

Figure 12-4: Photoshop.com is a free online album and image-editing service from Adobe.

Workflow Workarounds

Regardless of what image editor you end up with, as a digital SLR owner, you need to establish a mysterious set of protocols, or a workflow, before you get down to serious business. A *workflow* is nothing more than the order in which you perform all the various tasks associated with image editing under particular circumstances. You can easily have one workflow that you use for sports photography (because you're shooting tons of JPEG images at a healthy clip and don't want to waste a lot of time in post-processing) and another for landscape photography (which might require fine-tuning of RAW images to retain detail and subtle tones).

At the very least, *think* about your workflow and establish some guidelines for yourself, if only because all your photographer friends will be asking you what your workflow is in a given situation. If you don't have a good answer ready, you'll look like a (lowercase) dummy. A well-planned workflow can actually save you time because you aren't reinventing wheels every time you work on a photographic project that's similar to one you've already mastered. The key elements of a typical workflow proceed along these lines:

- Getting your photos from your camera to your computer: Will you be using a USB cable (fine for small numbers of photos) or a card reader (probably better for larger numbers of images)? Are your photos located on an external hard drive, such as a PSD (personal storage device), that you use for backing up images in the field or on vacations? Are you copying *all* the photos on your memory card or only some of them?
- ✓ Processing on-route: If you're using a photo transfer program, such as the one provided with Photoshop Elements, you can select from a few options for processing your images during the actual transfer to your computer. For example, you can rename the image files automatically (from, say, DSC_0488... to DisneyWorld0001... and so on). Some transfer programs can look for and remove red-eye effects automatically, as well.
- ✓ Destination location: Where do you put your photos on your hard drive? Do you separate them into folders that have chronological names and dates? Do they go into folders arranged by project? Are all your flower or football photos dumped into folders arranged by subject matter? This point in your workflow can help determine how easily you can locate a particular image at a later date.
- ✓ RAW conversion: If you shoot RAW files, do you run everything through a RAW converter, such as Adobe Camera Raw (see Figure 12-5), creating TIFF or JPEG files at the time that you transfer the photos from your camera to your image editor? Or do you just dump the RAW files and convert each when you're ready to edit a particular photo? Do you plan to convert files one at a time or in batches? Do you want to use (or need) preset settings to perform similar adjustments on images shot at the same time?
- Image editor workflow: You have a lot of options after you import a photo to your image editor. The order in which you crop photos, adjust color, make tonal changes, and apply sharpening can be important. Do you save a copy that still has all its layers before you flatten an image to produce the final version?
- Backing up your images: How and when do you create backup images? Do you back up everything, or just original and modified files? Do you copy images to a spare hard drive, a DVD, or some other media? How many DVD copies are enough for perfect safety? Where do you store your backups?

Figure 12-5: RAW conversion is an important part of your digital workflow.

Workflow considerations, inside and outside your image editor, can be quite complex and include many more factors than those I include in the preceding list. In any case, a little planning never hurts.

Fixing Your Photos

You can manipulate your photos in two ways: by fixing anything that you see as a defect without really changing the content extensively or by combining and reorganizing images in more drastic ways. I show you the basics of combining and reorganizing (which includes *compositing*, or melding several different images or parts of images) in Chapter 13. In the following sections, I stick with the techniques for making repairs and fixes.

The most common fixes for digital photos fall into five categories:

Cropping: As you discover in Chapter 11, you can often improve a photo just by removing items that don't belong or that distract from the composition. *Cropping* (adjusting the borders of an image) is the easiest way to remove things from a photo.

- ✓ Tonal adjustments: Your images might be too bright or too dark, or worse, include some parts that are too dark and others that are too light. Although your dSLR includes features that let you make some adjustments for tone (including specialized tonal settings called *custom curves*), frequently you can more easily make these adjustments by using an image editor.
- Color correction: If your colors are off, you can usually fix them in your image editor. If your colors are accurate, you might want to *make* them seem off as a creative effect. You can do both with your editor.
- ✓ Spot removal: Your dSLR shots might have a variety of different spots and artifacts that you need to remove. A dirty sensor can produce dust spots on pristine images. Perhaps birds in the sky off in the distance are too small to look like anything other than blotches. Your subject might have a small scratch or defect. You need an image editor to touch up these spots.
- Sharpening/blurring: You can change the emphasis within your composition by selectively sharpening or blurring parts of the picture. You can also salvage a shot that isn't quite sharp enough by using a little sharpening or smooth out rough texture by using blurring.

The following sections talk specifically about Photoshop; your image editor can perform the same tasks, but it might use different commands.

Cropping

If you know anything about composition, you know that you can often vastly improve images by doing some judicious trimming. Figure 12-6 shows what I mean. At first glance, it appears to be a photo of a powerful jet fighter climbing into the sky at dusk, possibly preparing to attack an enemy in a dogfight. When I show people this photo, they often ask whether I took it from the air or from the ground with a very long telephoto lens.

The answer lies in the uncropped version of the photo, as shown in Figure 12-7. (Please don't feel cheated by the mundane origins of this picture!) As you can see, it's a photo of an old jet mounted on concrete pylons on the front lawn of a high school in my area (nickname: Aviators). I loved the plane, but I found that it was difficult to get a good angle. So, I shot a picture anyway, darkened it a little to make the image look more dramatic, cropped the image tightly, and trimmed out some utility wires to produce a much more exciting view.

Figure 12-6: Cropping tightens a composition and adds drama.

Figure 12-7: The original shot is slightly less inspiring!

Photoshop gives you several ways to crop a picture. Here are some of the fastest and most versatile:

- ✓ Create a rectangular marquee around the part you want to crop to and then choose Image⇔Crop. Photoshop trims off everything outside the selection marquee.
- Draw around the area you want to crop with any line-oriented selection tool, including the Lasso, Polygonal Lasso, and Magnetic Lasso. The area specified doesn't even have to be remotely rectangular in shape. However, you end up with a cropped rectangle. Photoshop crops to the smallest rectangle that includes the entire image within your selection, as you can see in Figure 12-8. For details on using these Lasso tools, see Chapter 13.

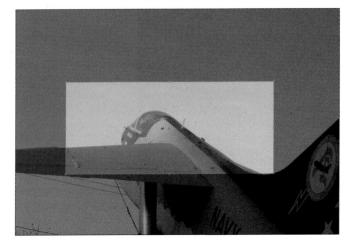

Figure 12-8: The Crop tool allows you to precisely specify the crop borders.

Perhaps the image you want to preserve is included inside a border that's roughly the same tone, such as a picture frame surrounding a photo hanging on a wall. You might be able to select that border with the Magic Wand, and then reverse the selection by pressing Ctrl+Shift+I (\mathfrak{H}+Shift+I on the Mac) and cropping to the image that's now selected.

✓ Use the Crop tool. It is probably the best choice because it allows you to adjust the borders of the selection individually before making the crop.

To use the Crop tool, follow these steps:

- **1.** Select the Crop tool (press C to make it active or select it from the Tool Palette).
- 2. Drag a selection that roughly includes the area in the cropped image.
- **3.** Grab the handles on the top, bottom, or side selection borders, and then move in or out to adjust the cropping exactly the way you want.

Notice that the area outside the crop selection darkens, making it easier for you to visualize the final picture, as shown in Figure 12-8.

4. Press Enter (Return on the Mac) to apply the crop to your image.

Fixing murky or contrasty photos

You probably often want to make tonal adjustments to your photos. Digital SLRs have the capability to capture a broad range of tones, called a *dynamic range*. That range lets you capture detail in dark shadows, as well as bright highlights. Unfortunately, many scenes have a dynamic range that's too long for even the best digital sensors. When that happens, you might end up with pictures that have a lot of detail in the shadow areas, but the highlights are washed out (or *blown* in digital parlance).

If an exposure captures highlight detail, your shadows might be murky. Indeed, some dSLRs are programmed to deliberately produce this murky effect, on the theory that you can more easily retrieve underexposed information in shadows that are dark, but not completely black, than regain detail in highlights that have gone completely white.

Some images might have a very limited range of tones — including whites, some intermediate grays and colors, and blacks — but lack the other inbetween tones. These images are said to be *high contrast*. Others are rather bland-looking, with a lot of individual tones spread throughout the image, but few true blacks or whites. Such images are said to be *low contrast*. The problem doesn't always lie with your camera: The lighting in your scene might be too contrasty or too low in contrast to render the scene attractively.

If your images are high or low in contrast, or are simply too dark or too light, you might be able to fix the problem in Photoshop or another image editor.

As you might expect, Photoshop has several tools that can help you. Some work well, but others are atrocious or intended only for beginners. In the following list, I run through all the tools so that you know which traps to avoid:

- The Auto tools: Photoshop includes three tools, Auto Tone, Auto Contrast, and Auto Color. They can analyze your photo and correct the brightness, contrast, and tonal values, as well as color, for you. These tools have no idea what kind of effect you're going for, so the results might or might not please you.
- ✓ The Brightness/Contrast controls: On the Image ⇒Adjustments menu. the Brightness/Contrast controls have a deceptively simple set of sliders that allow you to brighten or darken everything in an image or change the contrast of the entire image. Originally, this tool was problematic because you seldom want to apply that sort of adjustment uniformly to every pixel in an image. Lighten the shadows with the Brightness slider. and you probably made the highlights too light. Slide the control to the left, and your too-light highlights turn an ugly gray while your shadows turn black. You could expect the same poor overall results with the Contrast slider. Adobe made this pair of controls considerably smarter. The Brightness/Contrast controls now work proportionately, so you can change the amount of detail in the highlights and shadows without affecting all the other tones. If you prefer to use the "bad old" tool, mark the Legacy box in the dialog box to return to Photoshop's old behavior.
- The Shadow/Highlight controls: These controls are a more intuitive way of doing what the Brightness slider should have done all along. They let you adjust the brightness of the shadows and highlights individually by using a dialog box like the one shown in Figure 12-9. This one's a keeper, and I explain it in more detail in the following section.
- Levels: The Levels dialog box lets you specify how tones are distributed in your image. I explain this one in the section "Working with levels," later in the chapter.
- **Curves:** The Curves dialog box gives you full control over the tones in your image. The section "Working with curves," later in this chapter, tells vou more about this tool.

Working with the Shadow/Highlight controls

When you activate this dialog box, it defaults to settings suitable for fixing images that have been backlit, with the shadows much too dark. The Shadow slider starts at 50 percent and the Highlight slider at 0 percent. If you select the Show More Options check box, you see the full dialog box, as shown in Figure 12-9.

The full dialog box has three areas: one for shadows, one for highlights, and one for adjustments. The Shadow and Highlights areas have the same three sliders. Here's how you can use each one to fix contrast in an image:

Chapter 12: Fixing Up Your Images

- Amount: The degree of change that you want to apply. A higher number equals a more drastic application of the tonal change.
- ✓ Tonal Width: This represents the number of tones, from the 256 different tonal levels in the image, that are affected. For example, if you set Tonal Width to 25 percent, one quarter of the 256 tones (64 tones) are modified. A value of 50 percent affects 128 tones and produces a more pronounced change.

You can best decide what value to use by watching your image while you move the slider. Use a small value to brighten only the very darkest shadow areas or to darken only the lightest highlight areas. Increase the value to brighten more of the dark areas or darken more of the highlights. Don't use very large values, or you end up with glowing haloes at the boundaries between the shadows and highlights.

Shadows			OK
Amount:	50	%	Cancel
0		_	
Tonal Width:	50	%	Load
·		-	Save
Radius:	30	рх	Preview
<u></u>			
Highlights			
Amount:	0	%	
<u>۵</u>		-	
Tonal Width:	50	%	
		_	
Radius:	30	рх	
- Adjustments			
Color Correction:	+20		
	3	_	
Midtone Contrast:	0		
Black Clip:	0.01	%	
White Clip:	0.01	%	

Figure 12-9: The Shadow/Highlight controls allow you to adjust tonal areas individually.

✓ Radius: The Radius slider helps Photoshop determine what qualifies as a highlight pixel and a shadow pixel. Ordinarily, the control examines each pixel's neighbor to make this determination. Increasing the Radius value enlarges the size of the neighborhood so that more pixels are counted as highlight or shadow pixels, rather than middle-tone pixels (which are *not* affected by the Shadow/Highlight control). Monitor your preview image to see whether you're getting the effect you want.

The third area of the dialog box, the Adjustments area, controls other parameters. These include

Color Correction: This slider isn't a color-correction tool as much as it's a way of compensating for color shifts that occur when you're fiddling with the tonal controls. Use it to remove these casts.

- Midtone Contrast: Although the shadow and highlight controls adjust only the darkest and lightest areas, this slider lets you apply some finetuning to the middle tones.
- Black and White Clipping: Use these controls to increase contrast intentionally by dropping (or *clipping*) a desired percentage of black or white tones from your image.

Working with levels

The Photoshop Levels dialog box allows you to control the tonal values of an image much more precisely than you can with the Shadow/Highlight controls. Most good Photoshop books have a whole chapter on using levels, but I can provide a good introduction.

The Levels dialog box shows a histogram graph, which is similar to the histogram you can view on the LCD (liquid crystal display) of your dSLR after you take a shot. Your camera histogram shows you only whether all the tones are being captured, and you can do little other than adjust exposure up or down or perhaps make a tonal setting change in your camera's menus. The one in the Levels dialog box (choose Image Adjustments Levels) actually lets you change the tonal values.

As you might know, a *histogram* is a graph that shows the relative number of pixels at each of 256 brightness levels. The more pixels at a particular brightness, the higher the bar at that level. Histograms provide a mountain-range-type curve, like the one shown in Figure 12-10, with most of the tones usually distributed in the middle and fewer trailing off toward the dark tones (left side of the graph) and light tones (right side).

The objective of the Levels command is to avoid wasting any of the 256

possible tones that can be represented. You do that by moving a trio of triangular sliders at the bottom of the graph:

- Move the black triangle to the right until it touches the edge of the black tones actually present in the image, as shown in the graph.
- Move the white triangle to the left until it touches the edge of the actual white tones.
- ✓ You can move the middle gray triangle to lighten or darken the overall image by adjusting the midtone position.

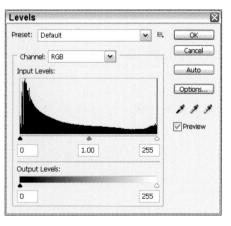

Figure 12-10: The Levels dialog box provides precise tonal control. Figure 12-11 illustrates this process. At top, the image is entirely too flat and lacks contrast. You can see that all the tones in the histogram mountain are clustered in the center. The black point at left and white point at right are too far from the base of the slope where the dark and light tones (respectively) trail off.

At bottom in the figure, I moved the black point toward the center, to the point where portions of the image that actually should be black reside. The white point triangle has also been shifted toward the center, where the white tones are located. The adjusted photo has more contrast and a better range of true dark and light tones.

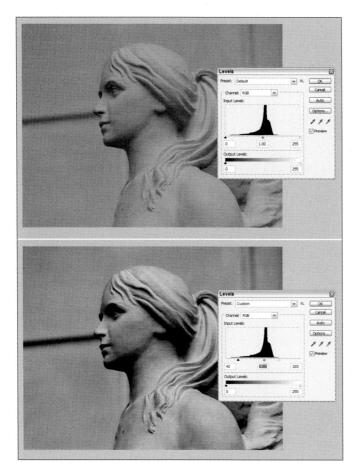

Figure 12-11: Adjusting the black and white sliders in the Levels dialog box improves the appearance of an image that's too flat.

If you remember these basics, you can improve your images significantly without understanding the additional fine-tuning capabilities of the Levels dialog box. If you want to spread your wings and discover more, I recommend *Photoshop CS5 All-in-One For Dummies,* by Barbara Obermeier (John Wiley & Sons, Inc.).

Working with curves

If the Levels dialog box is worth a chapter or two, the Curves dialog box, as shown in Figure 12-12, is worth an entire book! Adobe smartened up the Curves command for recent versions of Photoshop, providing new automatic presets that can bend tones for you and adding displays of histogram, clipping, and other information.

Curves are a way of changing the highlights, midtones, and shadows entirely independently. You can change the values of pixels at any point along the brightness-level continuum, so you have, in effect, 256 locations at which you can make corrections.

The Curves dialog box includes a two-dimensional graph, with the horizontal axis mapping the bright-

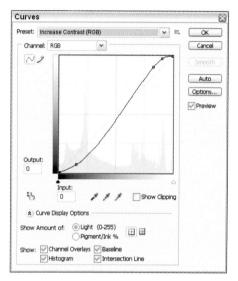

Figure 12-12: Curves allow you to control tonal values at 256 different brightness points in your image.

ness values as they are before you make image corrections. The vertical axis maps the brightness values after correction. By default, the lower-left corner of the graph represents pure black (0, 0), and the upper-right corner represents pure white (255, 255). When you open the dialog box, the graph begins as a straight line because, unless you make changes, the input is exactly the same as the output, forming a direct 1:1 correlation. When you change the shape of the curve, you change the values in the image at each point within the curve.

The best way to see what this tool can do is to play with it (press Ctrl+M on a PC, **#**+M on the Mac, to access the dialog box, or use the Image>Adjustments menu) or try out some of the preset curves to see how they affect your image. After you use Photoshop for a while, you begin to see how curves can provide the precise control that you need over tonal values.

Correcting those colors

Sometimes, despite the best intentions and competent technique, you end up with pictures that have bad color. Perhaps the picture has a green color cast caused by fluorescent lights, or it has too much red because you took it late in the day. Fortunately, image editors, such as Photoshop, let you fix these. You have a lot of tools at your disposal. You can easily use some of these tools, but others take a little practice.

Before you get started, keep in mind that you can't add color that isn't there in the first place. If your image is way too red, you can't compensate by adding its opposite color (cyan). Image editors work by *subtracting* hues. So, if your picture is dominated by red and has very little green or blue, when you remove the excess red, you don't end up with a correctly balanced image. You wind up with a picture that's grayish because a little bit of red, blue, and green are all that's left.

Photoshop's color-correcting tools include the following:

- Auto Color: This is another one of those pesky "auto" controls that uses Photoshop's guesswork to provide a possible correction to your color problems. Most likely, though, the correction isn't what you want.
- ✓ Color Balance: The Color Balance sliders (to access these sliders, press Ctrl+B on a PC, ૠ+B on the Mac) let you seemingly add red, green, or blue while subtracting their complements (cyan, magenta, and yellow). You can use the sliders while viewing your image to make color corrections. Of course, you can't really add a color to an image; the dialog box's operation just gives you an easier-to-understand representation of what's really going on. When you move the Red/Cyan slider to the right, Photoshop actually subtracts cyan. If you move it to the left (to "add" cyan), you're really subtracting red. If you understand what's going on, you aren't really fooled, but you don't mind, either. The same thing takes place when you adjust the Magenta/Green and Yellow/Blue slid-

ers. The Color Balance dialog box, as shown in Figure 12-13, allows you to apply these color changes to the highlights, midtones, and shadows.

Hue/Saturation: This control (which you can access by pressing Ctrl+U on a PC, #+U on the Mac) changes color by using different components than the standard Color Balance tools use. Instead of modifying the

Color Balance	9 6				ОК
Color	Levels: 0	0	0		Cancel
Cyan 📟		noospanaaa D	- data some medicense	Red	<u></u>
Magenta 📟		annonnana A		Green	Preview
Yellow	CONTRACTOR OF	db		Blue	
Tone Balanc	e				
Shadows	() Mi	dtones	Highli	ights	

Figure 12-13: Change color by subtracting red, green, blue, cyan, magenta, or yellow.

primary colors of light, it adjusts the overall color of the image *(hue)*, how pure or rich the colors are *(saturation)*, and the lightness or brightness of the color. Moving the Hue slider rotates the color clockwise or counterclockwise around the edges of the color wheel, as shown in Figure 12-14 (you don't see this color wheel in the dialog box). The Saturation slider adds richness, turning a muted pink into a deep rose or dark red, for example. The Brightness slider controls the overall luminosity of the image; you probably don't often need to use this slider. Photoshop CS5 has a Presets option that allows you to store saturation settings and apply them to any photograph.

- Variations: The Variations dialog box gives you a way to compare different color and darkness alternatives for an image. You get to choose the one that looks best, as you can see in Figure 12-15.
- Curves: I've come full-circle to the Curves tool again. You can use this complex tool for more than adjusting basic (grayscale) tonal values. You can actually control the tonal rendition of each of the primary colors in an image. Using the Curves tool in this way usually requires a lot of experience unless you're very adventuresome.

Figure 12-14: Control hue, saturation, and brightness separately by using this dialog box.

Figure 12-15: The Variations dialog box lets you choose the best rendition from a selection of versions.

Use whichever combination of color-correction tools works for you. They all have particular advantages and disadvantages.

Spot removers

Unwanted artifacts in your image might not be arty, but they are facts. Your job, should you choose to accept it, is to remove them. Several different causes of spots, speckles, and other naughty bits (and bytes) are in your images, and Photoshop has the tools to remove them. In the following sections, I offer an overview of how to use these tools.

Reducing noise

A little noise in your image can be a good thing. Noise can add an artsy, grainy effect and serve to add some texture to an annoyingly smooth surface. Indeed, detractors of one particular brand of digital SLR say that the remarkably noise-free results produced by that camera look plasticky. I am not going to mention the particular camera model because the rebels who prefer that brand see this lack of noise as a definite advantage.

This little tidbit isn't widely known among digital photographers who don't have a graphics-production background: One advantage of noise is that a little noise actually makes smooth gradients reproduce better because of the way press equipment and the half-toning process operate. Now you know.

However, for most folks, noise is unwanted. You can often prevent it by using your dSLR's noise reduction feature. But what do you do if noise turns up in your captured image?

You're in luck! Photoshop CS5 includes a Reduce Noise plug-in, which you can find by choosing Filter Doise. The dialog box, as shown in Figure 12-16, has four main sliders. You can specify the strength of the noise reduction, whether you want noise reduction done at the expense of image detail, how much to tone down the colored speckles that are endemic in most noisy images, and whether you want the remaining details sharpened after the noise has been removed. You can also have the tool search for and remove defects caused by JPEG compression. In Advanced mode, you can access a second tab that allows you to specify the noise reduction by color channel. You may find this useful because some channels, such as green, might be more prone to noise than others.

Figure 12-16: Decrease graininess with the Reduce Noise filter in Photoshop CS5.

Spotsylmania

Photoshop gives you several ways of eliminating other kinds of spots, scratches, and so forth. These include filters, such as

- ✓ Despeckle: This filter looks for areas of great contrast in your image because such areas are likely to be edges. Then, it blurs the non-edges, making any spots and speckles less obvious. Because the edges are still sharp, your image still might look relatively sharp. This filter works best on images that are sharp in the first place but plagued with artifacts, and it's less effective on images that are already somewhat blurry. You can also use it to eliminate halftone dots.
- ✓ Dust & Scratches: This filter actively hunts through your image for spots. It includes two sliders: a Radius slider that lets you specify the size of the area around a potential spot that you want the filter to search, and a Threshold slider that determines how distinct a spot must be before the filter considers it a defect.

Send in the Clone Stamp

You can use the Clone Stamp tool to remove spots and other defects by copying a portion of the surrounding pixels, which should have a similar color and texture, over the ailing portion of your image.

To use the Clone Stamp tool, follow these steps:

- 1. Select the Clone Stamp tool from the Tool Palette.
- 2. In the Option bar, select a brush of an appropriate size from the Brush drop-down list.

A soft-edged brush is usually best to provide a soft edge.

3. If you want to gently copy over the area that you plan to fix and blend the pixels more evenly, set the Opacity slider on the Option bar to less than 100 percent.

Anything from 25 percent to 90 percent works well — whatever works best for your particular photo.

4. Make sure that the Aligned check box is selected in the Option bar.

If you select this check box, you can stop and start the cloning process while retaining the same positional relationship with the origin point that you choose in Step 5. If you don't select Aligned, each time that you begin cloning again, the origin point goes back to the original location.

5. Place the cursor in an area near the portion that you want to copy over. Press and hold the Alt key (Option key on the Mac) and click in that area to select the origin point.

6. Move the cursor to the area that you want to copy over, press and hold down the mouse button, and paint.

Figure 12-17 shows you an example of what you can do with the Clone Stamp.

Healer, heal thyself

The Healing Brush, Spot Healing Brush, and Patch tools let you copy pixels from one place in an image to another, similar to the Clone Stamp tool, but these tools take into account the lighting, texture, and other aspects of the image. That makes for smoother, less obvious touch-ups. Here's how each one works:

- **The Healing Brush:** Works like a brush in much the way the Clone Stamp tool does. It copies pixels from a sample origin point that you specify.
- **The Patch tool:** Operates like a tire patch, pasting an area of pixels that you choose on top of the part of the image that you want to fix.

Figure 12-17: If your results are a little spotty, the Clone Stamp can help you out.

- The Spot Healing Brush: Works like the Healing Brush, but you don't have to specify an origin point; it automatically samples pixels around the area that you want to heal and uses them to copy over the defective spots. It has three optional radio buttons in the toolbar:
 - Proximity Match, which causes it to sample pixels in the surrounding area, like the Healing Brush
 - Create Texture, which tells the Spot Healing Brush to texturize the healed area using a pattern similar to that found in the surround-ing area
 - Content Aware is the most powerful option of all. When you select Content Aware, the Spot Healing Brush looks at the surrounding areas intelligently and creates an overlaid area that mimics the content surprisingly well.

Figure 12-18 shows an example of how the Content Aware Spot Healing Brush was able to remove an unwanted spectator from a dusk shot at the rim of the Grand Canyon.

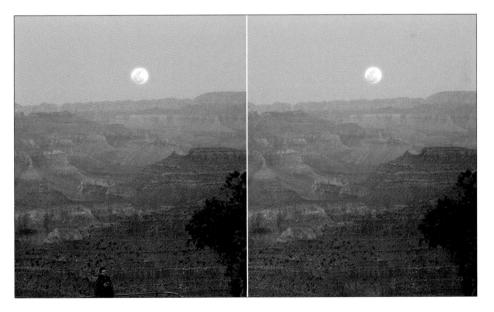

Figure 12-18: Gawking tourist (left), removed in seconds with the Spot Healing Brush (right).

Look sharp, be sharp

If you have an image that isn't sharp enough, or if you want to increase the contrast between one area and another by sharpening one part, Photoshop's varied sharpening tools can do the job for you. Keep in mind that sharpening works by increasing the contrast between transitions in tone of an image. So, while you're adding sharpness, you're also increasing contrast. You can easily end up with too much of a good thing.

If you want to sharpen the entire image, use the various sharpening filters. Choose Filter Sharpen to see a selection of choices. These filters include

- Sharpen: Applies a fixed amount of sharpening to the entire image or selection.
- Sharpen Edges: This filter seeks out the areas of transition in an image (the edges) and sharpens only those areas, preserving the smoothness in the rest of the image. Like with the two preceding filters, you can't specify the amount of sharpening that you want to apply.

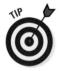

Sharpen More: Applies a stronger fixed effect.

Use either of these filters, Sharpen or Sharpen More, only when you need a touch of sharpening and don't need to be precise.

Smart Sharpen: This filter includes three tabs that let you specify sharpening parameters, like with Unsharp Mask, but you can also control sharpening separately in shadow and highlight areas.

Unsharp Mask: This filter does let you control the degree of sharpening, especially when you apply the filter to the edges of images. Make this filter your tool of choice for most image sharpening because it applies sharpening more intelligently and flexibly.

If you want to add some sharpness in specific areas quickly (say, to sharpen the eyes in a portrait), Photoshop has a Sharpen tool in the Tool Palette that lets you "paint" contrast. You can easily overdo this tool, so be careful.

Blurring for effect

Blurring is the exact opposite of sharpening: Instead of heightening the contrast difference between adjoining pixels, the color and brightness differences are reduced so that pixels are much closer to each other in terms of their color levels, brightness, and contrast. Your eyes see this change as a low-contrast blur effect.

Selective blurring can reduce the effect of noise or spots, or even make some areas seem sharper in contrast. You can blur one area while sharpening another to create an especially dramatic look, as shown in Figure 12-19. Of course, you can also go too far with blurring and end up with something that isn't even recognizable. Or you can fail to blur enough, leaving the content as distracting as ever. The key is to find a happy medium where you can still recognize objects, but nobody spends much time looking at them.

Figure 12-19: An apparent contrast in sharp and blurred areas of an image can add drama to your photo.

Photoshop has blur effects that match those in the sharpen category, including the Blur tool and filters, such as Blur, Blur More, Gaussian Blur (the equivalent of Unsharp Masking in many ways, but in reverse), and Smart Blur. Photoshop also has more specialized blur effects, including

- The kind of blur that you get from subject or camera motion at relatively slow shutter speeds (Motion blur)
- A blur produced by lens effects (Lens blur)
- A Radial blur, like you were photographing a record player turntable from above as it spun

- A Box blur, which blurs by using mosaic-like boxes
- $\blacktriangleright\!\!\!/$ A Shape blur, which uses your choice of odd ball shapes to blur your image

Fixing with filters

Filters can be your friends. Many filters available with Photoshop, in other image editors, and from third-party vendors are best known for their specialeffect capabilities. You can also use them to fix up your images, even if you're using the filter's image transmogrification features just to disguise an egregious problem in your photo.

That's what I did when I found myself with the photo shown in Figure 12-20. It had all the elements of a good picture: majestic water bird in flight, interesting birdie pose, magnificent clouds in the background, um . . . dSLR autofocus locking in on the clouds in the background, allowing the avian to become a messy blur (see the inset).

Fortunately, I have dozens of add-on filters at my disposal, including an interesting clutch from the fine folks at Alien Skin, who brought us Xenofex, Eye Candy, and now, Snap-

Figure 12-20: Oops. Autofocus leads to outof-focus when the sky confuses the dSLR's focusing mechanism.

Art 2. The latest version of this plug-in offers hundreds of ways of transforming great photos into great art by using media, such as colored pencil, comics, pastel, pen and ink, oil painting, and many more. And if you don't have a great photo that needs transforming, it can do its stuff on mediocre images, like mine (see Figure 12-21).

Snap-Art 2 offers many more options and fine-tuning parameters than the photo-art filters within Photoshop or other image editors. Snap-Art also includes hundreds of preset effects so that you can reproduce "canned" looks. Figure 12-22 shows how I turned my sorry excuse for a photo into a semi-abstract comic book rendition in the Roy Lichtenstein tradition (albeit with somewhat less artistic merit).

Figure 12-21: Alien Skin's Snap-Art plug-in comes to the rescue.

Figure 12-22: This comic book look is the best fix I can hope for.

You can use other filters to mend your defective images quickly and somewhat easily. For example, sharpening filters can often fix photos that are slightly out of focus. Blur filters can provide the illusion of reduced depthof-field if you want to isolate a subject by using selective "focus." Distortion filters, such as Photoshop's Lens Correction filter, can fully or partially eliminate some kinds of perspective distortion, remove *chromatic aberration* (colored fringing around subjects), and eliminate inward or outward curving *(pincushion distortion* and *barrel distortion*, respectively) caused by some telephoto and wide-angle lenses (also, respectively).

Combining and Reorganizing Your Images

In This Chapter

- Making selections
- > Removing and replacing objects in your photos
- Replacing boring backgrounds

.

Compositing images

ou gotta love those eye-catching magazine covers. *National Geographic* magazine moved the Great Pyramid to create an improved composition. *TV Guide* gifted Oprah Winfrey with Ann-Margret's figure — literally. More recently, *Newsweek* featured a full-length photo of Martha Stewart based on a head shot of the home economics queen grafted onto the body of a model. It's been estimated that someone creates a new fake image in Photoshop every 30 seconds. I want to find that guy and ask him when he finds time to sleep!

Perhaps you don't want to fool anyone into thinking that Forrest Gump actually received an award from John F. Kennedy. Your motives for doing some heavy-duty image manipulation are much purer. Maybe you want to add an extra wing onto your house to show around at your high school reunion. Or it's time to remove Madge from the group shot of your organization's Regional Sales Managers because Madge has been reassigned to the mail room.

Worse, you have an unsightly photo showing your mother-inlaw with a tree apparently growing out of her head, and you'd be happier if the image showed just the tree. You can do that sort of thing with an image editor, such as Photoshop. The simple editing and retouching tasks that I detail in Chapter 12 are cool enough on their own, but in this chapter, you get serious by performing *real* imaging magic to add or subtract objects, move them around, or combine photos.

This chapter focuses on image editing by using Photoshop. Your favorite image editor might work similarly or have cool features of its own.

Making Selective Modifications

A wag once said that time is what keeps everything from happening at once. The same can be said of selections in Photoshop: The capability to select one portion of an image makes it possible to modify only that selection while leaving everything else in the photo untouched. Selections are the basis for just about every variety of image manipulation that I describe in this chapter. You can see this is true the first time you use the Sharpen filter to enhance the sharpness of everything in an image — because along with sharpening that face in the foreground, the Sharpen filter can make some unwanted details in the background more visible, too.

What is a selection?

In Photoshop, a *selection* is all the stuff inside the crawling *selection border*, which is sometimes called *marching ants*. Selections can consist of an image area within straight or irregular outlines; include multiple disconnected areas in one selection; and have relatively solid edges or fuzzy, fading edges, as shown in Figure 13-1.

Figure 13-1: Selection edges can be sharp (left) or fuzzy (right).

Chapter 13: Combining and Reorganizing Your Images

A selection defines an area in which modifications can take place. You can create selections that have three kinds of edges: *anti-aliased* (smoothed), *feathered* (fading out gradually), and *non-anti-aliased* (jagged edged). You can make selections totally opaque, semi-transparent, or graduated in transparency.

Performing everyday changes with selections

After you successfully select part of your image, you can do a lot of things with the selection. These options include

- ✓ Copying: Move the selected area to an area of memory called the Clipboard, where it sort of sits around waiting (until you copy something new to replace it) so that you can paste it into a new layer of its own. The copied portion is surrounded by transparency, so it floats over the image area in the layers below it. Press Ctrl+C (or \#+C on the Mac) to copy a selected area.
- Cutting: Remove the selected area from your image. The cut portion ends up on the Clipboard, just like you copied it, and you can paste it until you replace it on the Clipboard with something else. Press Ctrl+X (or \mathbf{H}+X on the Mac) to cut a selected area.
- Changing: After you make a selection, you can change its boundaries, making them larger, smaller, and more or less feathered or irregular. You can also add other selections to your original selection, transform the size and shape of the selection, and invert it. Use the Select menu to adjust a selection.
- Filling: Add the contents of other selected areas or images that you've copied to the Clipboard, thereby pasting one image into another. Press Ctrl+V (#+V on the Mac) to paste an image that you've copied to the Clipboard.
- Painting, filling, or modifying: Use any of the brushlike and painting tools on the selected area while rendering the rest of the image (the non-selected area) immune to your fiddling. You can paint with color or fill the area with a color or pattern. To apply changes, you can use the Clone Stamp, Gradient tool, Dodge and Burn tools, Blur/Sharpen tools, and many more utensils.
- ✓ **Applying:** Use a filter only on a selected area, leaving the other areas untouched.
- Masking: Prevent selected areas from being modified accidentally. Use masking when you want to do a little brushwork on the background of an image but don't want to mess with a face in the foreground. Select the face as a protected mask (Photoshop lets you use selections as either an active or a protected image area) and go to town.

- ✓ Transforming: Change the selected area's size, shape, or perspective; flip it horizontally or vertically (or both); and rotate it. Choose Selects Transform Selection to apply these changes.
- ✓ Saving: Reselect the same portion of an image at a later time. Choose Selection ⇔Save Selection and store the selection as a file under a name that you choose.
- Converting: Make selections into vector-oriented paths that you can manipulate with the Pen tool. You can go the other way, too, converting paths to selections. Use the Make Work Path and Make Selection options, respectively, in the Paths palette.

Making Basic Selections

Photoshop has three main selection tools: Marquee, Lasso, and Magic Wand. Each tool has multiple variations. For example, the Marquee tool includes Rectangular, Oval, and Single Row/Column versions. The Lasso tool includes Polygonal and Magnetic varieties. The Magic Wand is pretty much the Magic Wand (it's magic, it's a wand, and that's about it) but does come in one variation, Photoshop CS5's Quick Selection tool, which (although its icon is also a wand) operates in a different way (by dragging around your object, as I explain in the section "Selecting pixels," later in this chapter). The tool that you use depends on the shape of the image you want to select. In the following sections, I offer the simple steps for using each tool.

Making rectangles, squares, ovals, and circles

Normally, you draw a Marquee selection by clicking and dragging to the correct size. Just follow these steps:

- **1.** Select one of the Marquee tools from the Tool Palette (the tools are all nested within the same icon) or press M to select the Marquee.
- 2. Click and drag in your image, releasing the mouse button when the selection is the size that you want. (See Figure 13-2.)

Cancel your selection by clicking outside the selection border when you use a selection tool or by pressing Ctrl+D (\Re +D on the Mac). Make its borders visible/invisible by pressing Ctrl+H (\Re +H on the Mac).

You can view all the nested tools hidden in a Photoshop Tool Palette icon by clicking the small triangle in the lower-right corner of the icon. When you hover the mouse cursor over an icon, the name of that tool pops up. To display all the tools, right-click (Control-click on the Mac) the icon.

Figure 13-2: Round things lend themselves to selecting with the Elliptical Marquee.

To radiate a selection outward with the clicked point as the center of the selection, hold down the Alt key (Option key on the Mac) while dragging. Hold down the Shift key while dragging to create a perfect circle or square.

The Option bar gives you increased control over your Marquee selection:

- To create a selection with particular proportions: Say that you want 5:7 so that you can crop to the shape of a 5-x-7-inch print; select Fixed Aspect Ratio in the Style drop-down list.
- If you want a selection that has specific pixel dimensions: Say you want 640 x 480 pixels; select Fixed Size in the Style drop-down list.
- To feather the edges of your Marquee selection: Feathering creates a fading border effect. Type a pixel value into the Feather box.

Selecting odd shapes

You can use the Lasso tool to make freehand selections of a part of an image by following these steps:

1. Select the Lasso tool from the Tool Palette (or press L).

You can choose from three types of Lasso:

- *The default lasso:* Sketches in a selection like you're drawing with a pencil.
- *The Polygonal Lasso:* Click multiple times to create odd-shape selections that have straight lines.
- *The Magnetic Lasso:* Looks for edges while you drag, and it hugs those edges by using Option bar options, such as width, edge contrast, frequency (number of magnetized points to lay down), and (if you use a pressure-sensitive tablet) pen pressure or line thickness. See Figure 13-3.
- 2. Drag around the outline of the area that you want to select.

Figure 13-3: The Magnetic Lasso clings tightly to outlines.

264

Chapter 13: Combining and Reorganizing Your Images

Selecting pixels

The Magic Wand tool, as shown in Figure 13-4, selects pixels that are similar in hue and value to the pixel that you first click. The Magic Wand is a good tool for selecting plain areas that have few contrasting details, such as the sky, blank walls, or solid colors. After you select this tool, use the Option bar to set how the tool should work:

- ✓ You can set the Magic Wand tool to select only pixels that touch each other *(contiguous)* or similar pixels anywhere in the image *(noncontiguous)*. Select either mode from the Option bar.
- Decide how fussy you want the wand to be by choosing a Tolerance setting from 0 (*really* fussy) to 255 (accepts just about anything).

A default value of 32 usually works best, but you can increase or reduce this number to select more or fewer pixels.

Select the Use All Layers box to tell the wand to select pixels based on information in all the layers of your image, rather than just the currently active layer.

Figure 13-4: The Magic Wand is good for selecting evenly toned, evenly colored subjects, like the sky in this picture.

You can drag the Quick Selection tool, nested in Photoshop CS5's Tool Palette with the Magic Wand, around the periphery of a relatively welldefined shape (one surrounded by a background that might be suitable for selection by using the Magic Wand, for example). While you drag, the tool creates a selection around your object. Although the selection may not look right at first — as shown in Figure 13-5, in which the selection border appears to be on the wrong side of the lighthouse spire — when you continue to define the selection, it corrects itself.

Figure 13-5: The Quick Selection tool allows you to drag a selection around the edges of an object.

266

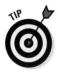

Mark the Auto-Enhance check box to allow the Quick Selection tool to more closely align the selection border with the object. You can make further improvements to the selection border by clicking the Refine Edge button after you complete the selection. Both toolbar controls are shown in the inset in Figure 13-5.

Painting selections

Photoshop's Quick Mask mode is a great way to create your selections by painting them with any size and shape brush that you want. While in Quick Mask mode, you can also use other selection tools, such as the Lasso tool or Magic Wand, to select areas that you then fill with the mask color. Follow these steps:

1. To enter Quick Mask mode, click the Quick Mask icon in the Tool Palette or press Q.

You can also choose Edit in Quick Mask Mode from the Select menu.

2. (Optional) Double-click the Quick Mask icon to set several options, such as the opacity and color of the tone used to represent the painted mask.

You can also choose whether the tone represents the areas that are selected for editing or the areas that are protected from editing (masked). I prefer to paint the actual selection that I want.

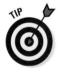

If you're working with a subject that contains a lot of red, you might want to use a mask painting color other than red. You can also select whether the painted area represents a *selection* (an area that you can work on) or a *mask* (a protected area).

3. With the Brush, paint the area that you want to select/mask.

For the image shown in Figure 13-6, I wanted to blur part of the background, so I painted a selection that included the parts to be blurred.

4. Apply whatever changes you want to make to the selected area.

In my example, as shown in Figure 13-7, I applied the Blur filter.

5. Press Q to exit Quick Mask mode.

Figure 13-6: Paint your selections by using Quick Mask mode.

Figure 13-7: The Blur filter makes the painted areas become fuzzy.

Chapter 13: Combining and Reorganizing Your Images

Fiddling with your selections

After you select part of an image, you can apply all sorts of effects to your selections, including marking the Anti-Aliased box in the Option bar to smooth the edges of freehand or elliptical selections. (Rectangles don't need smoothing.) Type a value into the Feather box to create a selection that fades out over the range of pixels that you specify. Add to a selection by holding down the Shift key while you drag with any selection tool to create additional selected areas. Subtract from a selection by holding down the Alt key (Option on the Mac) while dragging the area that you want removed. If you want the selection tool to default to normal, add, or subtract mode, you can also click the Normal, Add, or Subtract icons (natch) on the Option bar. Another handy tool is the Intersect button. It lets you create a selection.

You can also modify selections by using the Select menu. You find options for selecting everything in the image (usually, you can more easily press Ctrl+A, $\mathfrak{B}+A$ on the Mac, to select all) or to select nothing (press Ctrl+D or $\mathfrak{B}+D$ on the

Mac). You might also choose to select based on a range of colors that you specify; to feather the current selection; to modify the selection border width, size, and smoothness; to grow the selection to adjacent pixels meeting the current tolerance parameters; or to select pixels anywhere in the image that are similar to those chosen already. The Transform Selection option can be useful for sizing, rotating, or skewing a selection.

One handy tool in Photoshop CS5 is the Refine Edge facility, which you can access by clicking the Refine Edge button when a selection is complete. The Refine Edge dialog box, as shown in Figure 13-8, appears. It contains sliders for smoothing, feathering, expanding, or contracting the selection edge, plus increasing the size of the selection edge radius or enhancing the contrast. Photoshop can show you the effects of your changes in various modes (including Quick Mask mode, and the selection contrasted against a black or white background). There's an Edge Detection feature with a Smart Radius option that adjusts the radius

Refine	Edge					
d S	View Mode	Show	Radius	(J)		
\sim	view:	Show	Original	(P)		
	Edge Detection					
1777	Smart Radius					
	Radius: 🕥		0.0	рх		
	Adjust Edge					
	Smooth:		0			
	Feather: 🕞		0.0	рх		
	Contrast: 🕞		0	%		
	Shift Edge:	0	0	%		
	Output					
	Deco	ntaminate Col	ors			
	Amount:			%		
	Output To: Selecti	on				
	Remember Settings					
		Cancel		OK		

Figure 13-8: Refine Edge allows you to modify selections by using several different controls.

automatically for soft and hard edges. (Don't choose it if the border of your selection is uniformly hard or soft.) Decontaminate Colors gets rid of color fringes. Although Refine Edge isn't a magic tool, it does allow you to use the selection tools built into Photoshop more intelligently.

Adding to and Subtracting from Your Pictures

Instead of tearing all your wedding photos in half, you can replace your ex-spouse with a potted plant, which might be more appropriate than you think. Did your brother-in-law end up mugging in every single group photo taken at your last family reunion? Does that 1977 Pinto parked in the driveway otherwise detract from the beautiful landscaping in the photo of your stately manor home? Sure, you could've been smarter when you snapped the original photo, but at least you have the opportunity to redeem yourself by removing the offending person or object in Photoshop.

Evicting your ex-brother-in-law

Okay, your sister has untied the knot, and her former spouse has left the state. Why is he still haunting all the family photos? Your best move might be to take him out (unless you live in the kind of family where that phrase has a different context). Photoshop can do the job. Figure 13-9 shows a typical "problem" picture. The guy on the left is the one I want to get rid of. I can copy portions of the background over the parts of him that overlap areas I want to keep, and then crop the image to exclude the rest of him from the final photo. For shots with a background having a distinct pattern like this one, a paste-over job will look more natural than using cloning or Content Aware fill.

Figure 13-9: How can I get rid of the guy on the left?

Follow these fairly easy steps:

1. Use a selection tool to grab parts of the background to either side of the person whom you want to delete, and then copy the selections to a new layer.

A new layer is created automatically when you paste your copied selection. The resulting layer looks like Figure 13-10.

Make the initial selection by using the Lasso tool or do it in Quick Mask mode. Then, press Ctrl+J (or \Re +J on the Mac) to copy the selection directly to a new layer. This process is usually a lot faster than pressing Ctrl+C (\Re +C on the Mac) to copy, followed by Ctrl+V (\Re +V) to paste.

2. Move the background pieces so cover up the unwanted image area. that they cover the unwanted ex-relative.

Figure 13-10: Grab part of the background to cover up the unwanted image area.

After you paste them, the copied pieces reside in their own layer, so you can move them around in any way that you want within that layer.

3. Press E to select the Eraser and use an eraser brush to remove the edges of the background pieces so that they blend in with the original background, as shown in Figure 13-11.

I selected a soft-edged eraser brush.

- 4. Flatten the image (choose Layer=>Flatten) to merge all the layers.
- 5. With the Crop tool, trim the image so it includes only the two main subjects and some of the background around them, as you see in Figure 13-12.

Bringing a family closer together

In some situations, you want to bring closer together two subjects who are separated. Perhaps you deleted a person in the middle, leaving a huge gap. Or maybe the problem stems from a series of unfortunate seating events. You can use the same techniques from the preceding section to bring family members (or any other subjects) closer together.

Figure 13-11: Blend in the background pieces.

Figure 13-12: The photo without the evicted guy looks like this.

I started with the photo shown in Figure 13-12 and brought the people closer together by following these steps. Although every picture is unique, you can likely follow similar steps in your own photos:

Chapter 13: Combining and Reorganizing Your Images

- 1. I copied the fellow on the right and pasted him into his own layer.
- 2. I copied some of the background that surrounded him because that makes it easier to blend him in later on.
- 3. I clicked the Eyeball icon in the left column of the Layers palette to make the new layer temporarily invisible.
- 4. Going back to the original layer (click it to reactivate), I copied portions of the background surrounding his original location and pasted them in a new layer to cover up the original figure.
- 5. I blended in the new background so it looked natural.

With your own photo, you might need to lighten or darken the background (choose Image Adjustments Brightness/Contrast). Or copy some of the pixels from one area to the overlapping area by using the Clone Stamp to blend the transition.

- 6. I clicked the Eyeball icon in the hidden layer with the guy to make him visible again.
- 7. I used the Eraser to remove some of the edges so that the guy blended in with the two layers underneath.
- 8. I flattened the image (choose Layer Flatten) and cropped to produce the final photo, as shown in Figure 13-13.

Figure 13-13: Photoshop brought these brothers closer together.

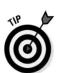

Part IV: Fine-Tuning Your Output

Adding New Backgrounds

You can't always count on having a background that's as interesting as your main subject. If you catch Renée Zellweger or Hugh Grant sneaking out the back door of a restaurant and the background is a pile of garbage cans, you end up with a photo that isn't worth a mention in Bridget Jones's diary. Go to work in Photoshop and replace those cans with, say, Central Park, and you might have something.

Adding a new background is easy, particularly if you can easily select the existing background by using the tools I describe in the section "Making Basic Selections," earlier in this chapter. Figure 13-14 shows a shot taken on an overcast fall day, when the foliage was at its most colorful and the clouds in the sky were dull and lifeless. I shot the photo anyway and let Photoshop come to the rescue.

Figure 13-14: A dull sky needn't ruin a perfectly good fall photo.

I used the following steps to improve the original background. You can follow these steps for any background that you want to replace:

1. Find some suitable background in another photo and paste it into a new layer in the photo that needs the face-lift.

Chapter 13: Combining and Reorganizing Your Images

Select the new background, and then press Ctrl+C (\Re +C on the Mac), followed by Ctrl+V (\Re +V on the Mac) in the document that needs the new background.

The new cloudy sky for my picture looked like Figure 13-15.

Figure 13-15: Along come some beautiful clouds, just when I need them!

2. Switch to the original layer, then use the Magic Wand to select the background that you want to replace and set a Tolerance level.

I selected the main, dull-looking sky area and used a Tolerance level of 32.

3. (Optional) If you have a lot of separate little bits of background (such as the little bits of sky that peeped through the leaves in my picture), choose Select Similar to expand the selection.

The selection now includes all the niggly little bits of background that would have been a pain to select individually.

- 4. Invert the selection by choosing Select☆Invert (or press Ctrl+Shift+I in Windows or ℜ+Shift+I on the Mac) so that everything *except* the sky and gaps in the leaves is selected.
- 5. Switch to the layer that contains the new background, and then press Delete to remove the replacement sky area that you don't need.

After I pressed Delete, I was left with only one broad patch of clouds, plus many smaller slivers, as shown in Figure 13-16.

6. Flatten that image like a pancake (choose Layer Flatten) to end up with your final, one-layer image.

I ended up with the dramatically improved photo shown in Figure 13-17.

Part IV: Fine-Tuning Your Output _

276

Figure 13-16: Every cloud has a sliver lining.

Figure 13-17: Nothing brightens a dull day more than some fluffy white clouds.

Combining Several dSLR Photos into One

About the most entertaining thing that you can do with a mouse (assuming you aren't a cat) is combining photographs to create a new image (also called *compositing*). One of my favorite tricks involves taking an everyday object,

Chapter 13: Combining and Reorganizing Your Images

such as my car (an aging convertible that's on its last legs), and placing it in exotic locales. You can drop a new object into an existing photo as easily as replacing a background — and in some respects, much more easily.

Figure 13-18 shows the automobile in question parked in a grungy gravel driveway.

Figure 13-18: Take this vehicle for a drive without even leaving Photoshop!

The process is fairly simple: Select the object and copy it to a new layer on an image that contains a suitable background. The only hard part is blending in the object so that it looks like it belongs there. Follow these steps:

- 1. Use the Lasso tool to select the object, including a lot of the background, and press Ctrl+J (#+J if you're using a Mac) to copy the selection to a new layer in the current document.
- 2. Click the Eyeball icon in the layer that contains the background to make it invisible, switch back to the copied layer, and use the Eraser tool to remove everything that isn't part of the object (in my case, my car).

By using the Eraser, you can easily remove the surroundings carefully, a bit at a time. If you make a mistake, press Ctrl+Z (#+Z on the Mac) to reverse your last step. If you don't catch a goof in time, work your way through the History palette one step at a time until you get back to the point where you want to resume erasing.

Part IV: Fine-Tuning Your Output _

A hard-edged eraser makes a good tool for working on straight edges (such as the top of the automobile), and a soft-edged eraser brush comes in handy for areas where you don't have to be precise (such as the undercarriage). I didn't need to be too precise around the underside of the car because I planned to blend that portion in with the road in the new background.

You want to end up with an image that looks like Figure 13-19.

Figure 13-19: Extract the object carefully so that you can blend it in with its new background.

3. Copy the extracted object and paste it in a second image.

I selected an image of a rural roadway in southern Spain.

4. Sprinkle in special touches, as needed.

The auto didn't look like it belonged in this setting, so I added a few special touches:

- I darkened the underside of the car (especially in front) to make it look like the car was casting shadows on the ground around it.
- Shadows from the surrounding trees were cast on the road, so I used Quick Mask mode to select some areas on the side (just beneath the side mirror) and darkened those areas to match the road shadows. I selected an area above the front wheel well (extending across the hood) and another on the back deck, and I lightened them, like a bright ray of sunlight was striking those surfaces.
- I used the Photoshop Lens Flare plug-in (choose Filters Render Lens Flare) to add a bright glare to the rear quarter-window.

5. When all looks satisfactory in your image, flatten it (choose Layer=:)Flatten).

I ended up with the version shown in Figure 13-20.

Figure 13-20: A successful composite requires a lot of work, but it's worth it.

The pitfalls of compositing images

You might need to do a lot of work to make the merger of two images look realistic. The pasted-in objects must have similar texture and lighting, and you must show them from the proper angle and perspective. You can't take a photo from a low angle on a cloudy day and paste an object from that image

Part IV: Fine-Tuning Your Output

into a background taken from a higher angle on an overcast day. If you do, you get a less-successful result, like the atrocity shown in Figure 13-21.

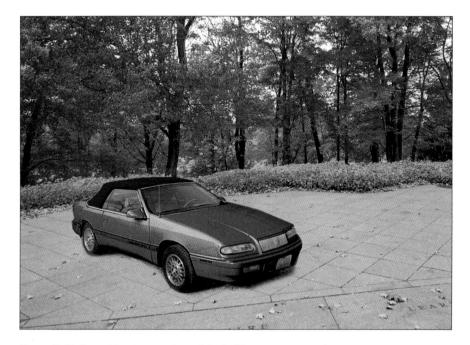

Figure 13-21: Something is wrong here; it looks like a cutout pasted onto a poster.

In this case, I started with the same automobile picture but decided to jazz it up a little. I copied the original car layer and painted the duplicate with various colors, including red for the body and brown for the convertible top.

Then, I merged the colored layer with the original layer by changing the Blending Mode options in the Layers palette from Normal to Overlay. That change combines the colors in the top layer with the detail in the layer underneath.

The car certainly looks sportier, but the scale is all wrong for the plaza it's now set in. The angle of view is too high, and the lighting is wrong because I took the background image on an overcast day. Not my best effort, but it serves as an example of what *not* to do!

Chapter 13: Combining and Reorganizing Your Images

Getting creative with compositing

Don't be afraid to experiment when combining images. You can create realistic composites, such as the one shown on the right in Figure 13-22, or completely preposterous fantasies, such as the one in Figure 13-23.

Figure 13-22: From so-so (left) to postcard-worthy (right) after a few minutes of compositing effort.

For the castle/moat photo, I added some clouds and then reversed the upper half of the photo to create a more vivid reflection in the moat. The Eiffel Tower on the shore of the Mediterranean Sea demonstrates what you can do if you have Photoshop and don't know much about geography. The entire photo is a visual joke, so don't e-mail me complaining that the reflections or shadows aren't realistic!

282 Part IV: Fine-Tuning Your Output

Figure 13-23: It seems like everyone in France takes off for the Mediterranean Sea in August, so why not *La Tour Eiffel, aussi?*

14)

Hard Copies Aren't Hard

In This Chapter

- > Waiting for your prints to come
- Deciding on output options
- Choosing your printer

ears ago, some wise futurists predicted that digital photography would spell the end of photographic prints, just as the advent of word processing, fax machines, text messaging, and e-mail would cause the Post Office to close its doors, overnight delivery services to go bankrupt, and manufacturers of file cabinets to switch to more profitable products, such as personal aeroplanes. If you believed these folks, you'd think that the paperless office would lead to the print-less home, and everyone would be reading and viewing photos on tablet computers, computer monitors, HDTVs, smart phones, or perhaps, a Kindle, Nook, or other e-book reader.

Oh, wait! We *are* doing much of our reading and photo viewing on those devices. I have an iPad, an iPhone, and a latest-generation iPod, and I use all of them for reading and photo viewing. Okay, so the predictions weren't totally bogus. But even so, modern society still creates tons of prints today because you can make those prints more easily than ever before at home or in the office, upload digital files to your local mega-mart for one-hour printing, or stop by a retailer's handy kiosk to custom-print hard copies for about the same cost as those automated machine prints you could get from film back in the photography Dark Ages.

Even in an age when many people are snapping photos with their cell phones and uploading them directly to their Facebook pages, then sending tweets to all their friends to go take a look, technology has helped create brand-new uses for images. These are all add-on applications for photography, and the original need for hard-copy prints continues. Electronic distribution of images has blossomed, but not at the expense of traditional applications for prints. This chapter outlines some of your options and shows you that hard copies really don't have to be hard.

Prints? What Prints?

As you can find out in Chapter 17, some photo-sharing sites are geared for serious photographers. They display your prize images in sharp-looking galleries, rather than the more amateur-oriented albums provided by consumer photo-sharing services. You can also display your images on your own web pages, e-mail them to friends and colleagues, exchange them over instant messaging services, or array them into PowerPoint presentations. A photographic image can spend its entire life as bits and bytes, created by a digital camera and viewed only on a display screen.

But you probably don't want to go that route for all your photos. Passing prints around and displaying framed photos on the wall or grand piano is one of the greatest joys of photography. Digital photography makes printing copies for distribution or festooning your furniture with frames easier than ever. Here are some very good reasons for making prints:

- ✓ Share with friends and family. Sharing is the traditional application for prints. Sure, you may look cool by passing around your smart phone at the family reunion and poking the touch screen while everyone crowds around to take a peek. But isn't passing around a stack of prints that several people can divvy up and enjoy individually or in groups a lot more convenient and fun?
- ✓ Display your work. Those LCD "photo frames" that feature a cycling array of photos can dress up your piano or mantel, but making an 11-x-14-inch or bigger enlargement to frame and hang on the wall is much more satisfying (and, possibly, ostentatious, as you can see by the ornate frame in Figure 14-1).
- Sell yourself and your work. Many photographers are turning to digital portfolios, but when you want to have images available for viewing by prospective employers or clients, a print is still the best way to show off your work.
- ✓ Submit for approval. You have the job; now, you need to secure the approval of your boss or client. You could e-mail a low-resolution copy to the person passing judgment, assuming that person can view the image on a computer, and that your recipient's monitor is calibrated to match yours. (Fat chance! Or do I mean *slim* chance?) Or you can print a fine-tuned proof that's an accurate representation of your image and use that print.

Figure 14-1: You can hang a print on the wall, but you have a hard time trying to frame a computer!

- Restore or re-create an existing photo. Not all digital prints need to originate from your digital camera. You may need to create a restored or enlarged copy of an existing print, with all the wrinkles and tears removed, and perhaps after you make improvements in your subject matter through judicious image editing. You may need only a scanner, inkjet printer, and an image-editing program.
- Create camera-ready or for-position-only art. Most professional printers today can work from digital files. However, you may want to have a print that you can paste into a layout, either for reproduction or to create a dummy that you can use for approval purposes.
- ✓ Make a teaser. My local newspaper prefers to receive submissions as high-resolution JPEG files on a CD or DVD. Even so, I always include a print or two of the shots that I want the editor to look at. A compelling print can bring my disc up to the top of the to-do pile.

You Pays Your Money, You Takes Your Choice

When it comes time to make a print, you need to choose between making it yourself, using an online service, or working with a local retailer/print lab. Oddly enough, with today's technology, you can sometimes end up using all three methods with a single print order. You can, for example, upload digital images online to your local retailer and then trot down and pick prints while making a few yourself by using the lab's kiosk.

Indeed, your choice of method for printing images isn't so much an economic decision as it is one of convenience, flexibility, and control. You can use some options more easily than others. Some options let you do more things with your image before you print it. Others give you absolute control over how your image looks. All of them end up costing roughly the same on a per-print basis, which is why many serious photographers use a mixture of methods.

Doing it yourself

If you're serious enough about photography to be using a dSLR, you probably want a photo-quality printer close at hand so that you can run off prints when you need. Here are some considerations to take into account for the do-it-yourself approach:

- ✓ Equipment: You need to invest in a printer. Good photo printers can cost \$100 to \$300 or (much) more, which isn't a lot when you consider how often you'll use the device over 2 or 3 years. High prices generally get you a large-format printer, capable of creating those gallery-worthy 11-x-17-inch (or larger) jumbo prints. Better printers are always coming along, of course, so you might want to upgrade sooner. Factor in the price of the printer, as well as consumables, such as paper and ink, when you calculate the per-print cost of your hard copies.
- Speed: You can most quickly get a hard copy in your hands by doing your own printing.
- Quality: When you become familiar with your printer's operation, you can often tweak your images to look their best with your particular setup. The fine-tuning may take place in your image editor, or you may need to use the printer's own controls.
- Flexibility: If you print your own images, you can use a larger variety of paper stocks than your local retailer may have available, make prints in oddball sizes, or print on *both* sides of a sheet (which you can do with some photo-quality printers that have duplexing capabilities, such as certain Canon Pixma models).
- Backup: Unless you have more than one color printer, you need your printer to stay healthy so that you can get your rush projects completed. Fortunately, if your printer fails, you can use one of the other printing options or run down to the local Quik-E-Mart and buy a new printer for \$50 or so.

Keep extra ink on hand!

Online output outsourcing options

The universe seems to be moving online. I'm sure that someday you'll find remote digital cameras set up at key tourist spots, such as the Taj Mahal — sort of super-high-res webcams, allowing you to take your vacation pictures without ever leaving home. About the only thing you can't do through the Internet is take your dog for a walk.

Meanwhile, you can order and distribute prints right from your computer. Snapfish, Shutterfly, Kodak Gallery, and other sites have web-based picture services that you can use to share and print your best efforts. Technically, you don't even need a computer or digital camera. Kodak Gallery, for example, allows cell-phone users to phone in images that they snap and place orders for prints. I recently stayed in a hotel in Seattle that had one of its printers online, with a URL provided that guests could use to direct photos from their laptop computers to the lodging's printer for later retrieval at the front desk.

Here are some considerations for the online option:

- ✓ Need for speed: Your digital SLR photos are likely to be megabytes in size, even if you're shooting in JPEG format. If you want to upload images from your computer to a web service, you definitely need a broadband connection. Although most digital photographers have broadband at home and work, sometimes you can't upload photos quickly, such as when you're traveling.
- ✓ Honest-to-gosh photo prints: When you order digital prints online, you can receive hard copies made the old-fashioned way, using conventional photographic paper and chemicals. If you value the quality and potentially extended longevity of traditional photo prints, online ordering is one way to get them. (You can also get real prints locally, as I explain in the following section.)
- ✓ Ordering prints for delivery: Online services make prints and mail them back to you or to a third party. So, you may find a web-print service especially useful for sharing prints with folks back home when, say, you're touring Paris and get a few minutes at *un café de cyber*. (Dozens of these cafes are in the City of Light, by the way, ranging from Jardin de l'Internet to Station Internet Rive Gauche.) A huge number of the hotels in the U.S. and overseas have either in-room wireless Internet access or a handy computer in the lobby that guests can use.
- ✓ Ordering prints to go: Retailers, such as Wal-Mart, let you upload images to their websites and specify pickup at your local store. Your prints are usually ready by the time you get there.
- Economy and ease: If you don't plan to edit your photos much (or the chore is already out of the way), you can't beat the ease and economy of ordering prints online. Just upload, specify print sizes and other details, and pay as little as ten cents or so per print. What could be easier?

Live and in person!

If you like, you can trot down to your local retailer or professional photo lab to get your prints directly. This approach can combine some of the advantages of making prints yourself and using an online service. For example, you can use a kiosk to perform cropping and some image editing, just like you can at home — even if you're on vacation hundreds of miles from your own computer. And a lab geared up to produce quantity prints can create your pictures with speed and economy.

Your in-person options range from using a stand-alone kiosk to view and print photos with the kiosk's printer, working with a kiosk that's connected to the retailer's digital photo lab, or handing your digital memory cards (or a CD that you burn) to a technician and leaving everything up to him or her. You might find these services at a retail store or avail yourself of a lab geared to serious amateur and professional photographers. Either way, you walk in, get your prints made, and walk out (or sometimes, return to pick up your pictures later).

Considerations to think about when choosing this option include

- Compatibility: You don't need to worry about having a broadband connection because retail locations accept your memory cards, USB thumb drives, CDs, DVDs, and other media. Digital SLRs generally use the universally accepted CompactFlash or Secure Digital (SD) cards, but if you happen to have some photos on a mini-xD or Sony Memory Stick Duo, find out in advance whether your chosen retailer can work with it.
- Choice of photo quality or printer quality output: Some retailers give you a choice of the type of output you receive. You can have a print made by using a kiosk's built-in printer or direct your order to the store's digital photo lab that uses conventional photographic paper and chemicals.
- Economy: Photo labs are geared to produce quantity prints. If you need a whole bunch of hard copies, a quick trip to your retailer almost always saves you money and time.

Choosing a Printer

Digital SLR owners have only one special consideration when choosing a personal printer for their hard-copy needs. As a serious photographer, you likely want really, really good prints to match the stunning images that you create with your sophisticated camera. As a result, just any old printer probably won't do. You want a printer that's especially good for outputting photographs, such as the snapshot photo printer, as shown in Figure 14-2.

Figure 14-2: Some printers do one thing — snapshots — and do it very well.

Fortunately, printer quality and flexibility have improved dramatically in the past few years. This section helps you choose the perfect printer.

Although, in the past, photo printers have included an array of competing technologies (including inkjet, dye-sublimation, thermal-wax, and even laser printers), inkjet printers are by far the most popular option today.

These models produce images by squirting tiny droplets of ink onto paper, using various methods to control the size and placement of the drops. For example, Epson uses piezoelectric crystals sandwiched between two electrodes to vibrate the ink cartridge with different levels of voltage, causing the crystals to vibrate in ways that adjust the colors and the amount of color sprayed through a nozzle onto the paper. Other inkjet printing systems use heat or other properties to control the flow of ink. With resolutions ranging from about 300 dpi (dots per inch) to 1,440 dpi and higher, inkjets can easily produce photo-quality images, assuming you use good-quality photo paper.

Current models run the gamut of features and prices, with many excellent models available from less than \$100 to \$300. To pay more than that, you probably need to buy a wide-carriage printer capable of handling paper wider than 8.5 inches. As a photographer, you may indeed want to make 11-x-14-inch or larger prints. Features to look for are

- Size and design: Some printers hog your desk space or feature clumsy paper paths that require a lot of space behind or in front of the printer for the paper trays. A few printers weigh a ton, too. If a printer is so unwieldy that you can't locate it near your computer, you end up doing a lot of walking or reaching to retrieve your printouts.
- ✓ Speed: Output speed is likely to be important to you only if you make a lot of prints and don't like to wait. Some printers can be two or three times faster than others, so if speed is crucial (say, you're toting your printer around to events to output prints for customers on demand), check your intended printer's specifications carefully. Make a test print, too, because vendors use best-case figures for a printer's specs, even though you probably end up printing under worst-case conditions.
- ✓ Number of inks: Most photo printers today use at least six colors of ink: black, cyan, magenta, yellow, photo cyan, and photo magenta. The two latter inks are "weak" versions that provide more subtle gradations of tone. A few printers add red and green tanks (see Figure 14-3), allowing the printers to create richer reds, additional orange tones, and more realistic greens. Some printers have both a photo black and text black ink. Generally, in terms of quality, the more ink tanks, the better. But you have to replenish those inks at a cost of \$11 or so per tank. (Ink prices vary by brand and cartridge type.) If you have slightly lower quality needs, you may be able to get away with using a printer that has fewer colors. I have both a four-color inkjet (used for quick and dirty printouts) and an eight-color model (used for slow and exquisite output).

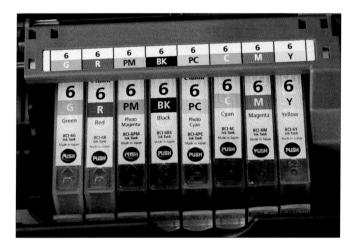

Figure 14-3: The more ink tanks you have, the more colors you can print.

- ✓ Resolution: More resolution is usually better (some models provide 1,200-x-4,800-dpi resolution), but the higher resolutions have some trade-offs, such as the traditional gamut versus dot-size dilemma. More inks produce a larger range of colors, but printers that offer extra color depth often use larger ink droplets. So, a printer that has only six colors and outputs 1-picoliter droplets can produce more detail but fewer colors than a printer that has eight tanks and 2-picoliter droplets. High-resolution printers that have tiny nozzles often suffer from clogging issues, too, and the special inks that they require may not have the same longevity.
- Paper handling: Some inkjet printers produce only 4-x-6-inch prints. They're designed to output snapshots only, quickly and economically. Others let you print 5-x-7- or 8½-x-11-inch prints, as well as other sizes. Investigate your printer's capability to handle various paper stocks and thicknesses, too.
- Memory card access/PictBridge capabilities: A printer that has built-in memory card slots (see Figure 14-4) or a PictBridge-compatible camerato-printer cable connection (see Figure 14-5) is especially convenient. Your digital SLR may allow you to specify images for printing right in the camera. Then you insert your memory card in the printer's slot or connect the camera to the printer by using a cable, and start the printing process.

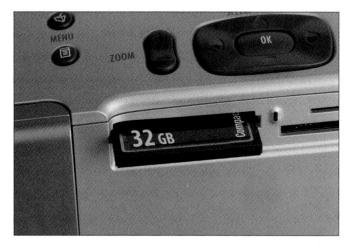

Figure 14-4: A memory card can go directly from your camera to the printer.

- **Duplex printing:** You can use the capability to print on both sides of a sheet automatically for more than just creating text documents. If you're preparing an album or portfolio, you can print on both sides of the sheet by using special dual-sided photo paper on printers that have duplexing capability.
- Input/output trays: The input tray(s) hold the paper that you're printing on; the output trays catch the finished prints when they come out. The higher the capacity of each, the better for you. One of my favorite printers has a vertical 150-sheet input tray that doesn't take up

Figure 14-5: Link your camera to the printer by using a PictBridge cable.

any space behind the printer and a second 150-sheet cassette that fits underneath the printer. I can put different types and sizes of stock in each — alternating, say, between 8¹/₂-x-11- and 4-x-6-inch sheets — or fill both with the same paper and print 300 sheets in a row. Your output tray should be large enough to catch all the prints that you make in a session without spilling any on the floor.

Controls: Printers have a plethora of controls that can adjust every function, perhaps an LCD that you can use to preview images, and a keypad that you use to navigate menus and options. Others may have a power switch, a paper-tray select button, and little more, requiring you to control every parameter from your computer by using the printer driver. Each approach has its advantages: You can use printers that offer you a lot of controls in portable or stand-alone mode without any computer attached (if those printers have memory card slots). Printers that rely heavily on the printer driver usually operate quickly and allow you to store groups of settings on your computer for reuse at any time.

Part V The Part of Tens

his Part of Tens gives you 30 very cool ways to get more enjoyment from your digital SLR photography.

Chapter 15 offers the ten easiest ways to improve your photography immediately with better lighting, improved perspectives, and clever use of interchangeable lenses. Chapter 16 serves up ten things that you might not have thought of doing with your digital SLR — or, if you have thought of them, you might not have explored them fully.

No single book contains all the answers, so Chapter 17 showcases ten online resources that can help you improve your images, gather the latest information about new products and techniques, and display your work for the world to see. Chapter 18 provides some deft definitions for a clutch of confusing terms, such as bracketing and chromatic aberration.

(15 X

Ten Ways to Improve Your dSLR Photography

In This Chapter

- Improving your lighting and angle
- > Choosing your resolution, aperture, focus, and lenses
- Shuttering with anticipation
- Working with noise
- > Understanding image editing, retouching, and compositing
- Reading the manual

ach chapter in this book is chock-full of tips that can help you improve the quality of your dSLR photos. Add them all to your shooting repertoire to put you well on the way to technical excellence and photo perfection. However, if you're looking for the top ten techniques that can provide you with instant results, you can't beat the collection of quality-enhancing approaches that I outline in this chapter.

Does Lighting Ever Strike Twice?

Yes, you can re-create good lighting if you know what you're doing. And nothing can destroy a photo faster than bad lighting. You can make a lot of improvements to a challenging subject simply by using good lighting techniques.

Part V: The Part of Tens

Your uncle's bald head, a teenager's less-than-perfect complexion, a harshly lit beach scene, a drop of falling water — you can portray all these subjects attractively by using effective lighting techniques. In your uncle's case, throwing the top of his head in shadow and avoiding shiny lights on his upper hemisphere can minimize the glare from his bare pate. The teenager might benefit from diffuse lighting that softens the texture of his or her face. You can fix up that glaring direct sunlight on the beach by using a reflector to bounce light into the shadows. And you can freeze a drop of water in midair with a halo of light added by an electronic flash.

To use light effectively and take your photography to the next level, here are some tricks to master:

- Managing the quality of light: Light can be highly directional, or soft and diffuse. It can cast sharp shadows and dot your subjects with specular highlights. Light comes in different colors, too.
- ✓ Using multiple lights: Photographers create some of the best pictures by using two, three, four, or more lights. You can use one source to illuminate the main part of your subject and others to outline its edges, fill in the shadows, or call attention to a particular area. Photographers use some lighting arrangements often enough that those arrangements have their own names: broad lighting (shown in Figure 15-1), rim lighting, paramount lighting, and so forth. You can create other arrangements yourself.

If you can master applying multiple lights so that they model and shape the appearance of your subjects, you have a powerful tool at your disposal.

Making best use of a light source's duration: Generally, electronic flash units are the main non-continuous light source that photographers put to work. Using the duration of the flash creatively requires practice and experience. Some techniques are simple. For example, you can use your flash's brief duration (particularly when shooting up close) to freeze even the fastest action. For a more complex technique, use repeating flashes to trace movement or balance flash output with ambient light to create combination exposures. People have written entire books on these topics, so you have a lot to discover.

✓ Subtracting light: Sometimes, you don't want to *add* light to a scene as much as you want to *remove* it so that you can create a particular lighting effect or look. *Barndoors* are little flaps that look like a horse's blinders and fit over an electronic flash or other light source to block the light or feather it onto a subject. Opaque sheets can block light coming from a particular direction, functioning as a sort of reverse reflector. Gadgets that stage-lighting directors call *cookies* or *gobos* can change the size and shape of a beam of light. With lighting effects, sometimes less is more.

Figure 15-1: A main light and fill light in the shadows were used to create this portrait.

Choosing a Righteous Resolution and Other Settings

Strictly speaking, the resolution of your digital SLR is the number of pixels captured — $4,928 \ge 3,264$ pixels for the typical 16-megapixel model. Most of the time, the top resolution is the one that you want to select. However, as I discuss in Chapter 9, the file format that you choose can affect the sharpness and file size of a digital image, too. You want to work with the overall sharpness — which is affected by resolution.

Some digital SLRs offer a choice of both compressed and uncompressed RAW files, perhaps a TIFF option (although this offering is exceedingly rare), and several levels of JPEG compression. You can always select the highest resolution,

Part V: The Part of Tens

least compressed, least processed image format. But if you answer "no" to any of the following questions, put some thought into your resolution/format/ settings decisions:

- Do you have unlimited memory card and hard drive space?
- Do you mind waiting while your pictures transfer to your computer?
- Do you want the ultimate in quality?
- Are you willing to spend at least some time with each shot in an image editor?

These questions give you only some of the things that you have to think about. In the following sections, I explain some situations that call for special considerations.

Changing environments

You're taking candid photos under conditions that vary abruptly and unexpectedly — say, at a concert or in a nightclub that has frequent lighting changes. Or you're outdoors at sunset, and both the quantity and color of the illumination changes over the course of 10 or 15 minutes.

Although the high resolution that your camera's RAW option affords has its value, in rapidly changing environments, place a higher premium on the RAW format's ability to

- Adjust white balance and exposure after the fact.
- Apply noise reduction.
- 🛛 🛩 Apply tonal curves.

Particularly when it comes to white balance, the manual changes that you make when the file is imported into your image editor are likely to be more accurate and more easily customized than the default or automatic settings that your camera applies. For details on how to correct these problems in an image editor, flip to Chapter 12.

Living with limited memory card space

You're leaving for a two-week vacation, and you have three 4GB memory cards, want to leave your laptop, netbook, or tablet computer at home, and don't own one of those portable DVD burners or hard-disk-based personal storage devices. None of the other options, such as uploading your shots to the Internet at a cybercafe or from your hotel's lobby or in-room Internet

Chapter 15: Ten Ways to Improve Your dSLR Photography

need to explore an option other than the

service, seems attractive. You likely need to explore an option other than the highest RAW resolution. For example, the following list illustrates one possible scenario out of dozens, given a particular camera (the numbers vary, depending on what camera you use):

- At the highest RAW setting: Say this particular camera gets approximately 500 shots per 8GB card, or about 36 shots per day over two weeks. You'd need to arm yourself with many, many memory cards and spend a good part of your vacation time swapping out used cards for empty ones.
- ✓ At the highest JPEG setting: That same camera gets nearly 1,000 shots per 8GB card, or 66 shots per day over two weeks. So, at this setting, the camera gives you a more reasonable number of photos for a very slight loss of versatility and post-processing options. But you still might not be able to get enough pictures per day for your two-week vacation, even if you have three 8GB cards.
- ✓ At the second-best JPEG quality: Say the 8GB card gets you nearly 2,000 shots with this particular camera, or 130 shots per day. You see 130 shots per day as a more desirable number of pictures, but on this camera, this JPEG quality limits prints to sizes no bigger than 5 x 7 inches.

Your best solutions might be to pick up a fourth or even a fifth memory card. Or use your digital SLR's second-best JPEG quality level for general shots, but switch to the highest JPEG quality level for any shots or sequences that you might want to enlarge beyond 5 x 7 inches. By using this approach, you can grab hundreds of snapshots for smaller prints but still come home with a good selection of higher-resolution photos for those special blowups.

Shooting for a low-resolution destination

You're shooting a bunch of pictures that you intend to send by e-mail, post on Facebook, or upload to a Flickr gallery, and the largest final image size that you need is about 1920 x 1280 pixels. Most of the time, you want pixels and image quality to spare because you can crop and edit to your heart's content before shrinking the original shot down to its finished size.

People sometimes capture e-mail or web pictures by using fixed setups on a sort of photo assembly line with the same background and settings. Those picture don't really need the maximum in resolution and sharpness for your main shots. In fact, all those extra pixels can slow you down. You might be better off shooting at a lower resolution, such as 1,600 x 1,200 pixels, to speed up the process. If you're *really* careful in your choice of composition and lighting, you might even be able to get away with taking photos at

Part V: The Part of Tens

something very close to their finished size, eliminating most post-processing altogether. Of course, the latest dSLRs (14 megapixels and up) probably don't have a resolution setting that low; 1,600-x-1,200 pixel options may be available only on cameras that have a lower maximum resolution.

Hurrying along

The highest resolution/lowest compression settings take longer to store on your memory card and require extra time to transfer to your computer. The huge size of the best images can affect your shooting in several ways:

- ✓ When shooting bursts of continuous shots: Some digital SLRs slow their continuous shooting mode when they save images in RAW or RAW+JPEG modes. Rather than 3 to 5 frames per second (fps), you might be able to grab only 2 fps at the highest resolution. A camera that has a large internal buffer or a memory card with a fast write speed might help, but simply reducing the resolution or boosting compression might give you speedier bursts with little loss of quality.
- ✓ When you transfer photos: You can usually transfer photos from your camera to your computer the fastest by using memory card readers. Some dSLR owners also depend on direct cable connections through a USB cable. Both card readers and cable connections might use the latest USB 3.0 specification or limp along with the slower USB 2.0 links. If you have a camera that uses SD memory cards, you can buy an Eye-Fi card that has built-in wireless capabilities, and then transfer photos directly to your computer over a wireless network while you shoot. The size of the file affects the speed of all these methods: A JPEG image might be only a few megabytes in size, whereas a RAW file can easily be 5MB to 20MB or more. If you're in a hurry for instance, you're covering a fastbreaking news event for your local newspaper you might find that a compromise in picture quality can save valuable time.
- When working on your computer: Huge image files take longer to load, longer to process in an image editor, and longer to save when you're finished with them than smaller files. If you want to speed your image along to its final destination, such as your printer, smaller file sizes can be your friend.

Stop! What's That Sound?

For the digital photographer, no sound is sweeter than the authoritative clicks that resound when you take a picture. Flipping mirrors and sliding shutter curtains mean that, once again, you capture your vision as digital bits. Then, reality sets in: Did you use the right shutter speed?

A speed that's too slow means any movement of the subject or the photographer's hands can result in shaky, blurry photos. A speed that's too fast might remove all sense of movement, creating a sports picture, for example, that might as well have pictured a statue. A speed faster than your camera's electronic-flash sync speed might mean your picture shows a shadow of the focal plane shutter, rather than a complete frame. The right shutter speed when you take flash pictures can mean that ambient light in the background produces a pleasing effect, but the wrong speed can produce ghost images.

As a digital SLR photographer, you have the responsibility to use the enhanced powers and control at your disposal to optimize your photos. That responsibility includes choosing a shutter speed that's appropriate for the picture you want to create. Figure 15-2 shows how a combination of careful timing and a slow ¼-second shutter speed produced an image in which three male ballet dancers are captured almost motionless, while the female dancers around them are blurred creatively.

Figure 15-2: A tripod steadied the camera, but the slow shutter speed creatively blurred the dancers.

Working the Right F-Stop

Mark Twain never said, "The difference between the right f-stop and the almost-right f-stop is like the difference between lightning and a lightning bug." But he might have said that if he'd been a digital photographer.

Part V: The Part of Tens

Sometimes, stopping down one or two aperture settings or opening up one or two stops can make a world of difference, so choosing the right f-stop can be an important part of optimizing your finished picture. Here are some examples:

- ✓ A couple stops can boost sharpness. Lenses designed especially for their speed — say, a super-expensive 28mm f/1.4 or a 400mm f/2.8 lens — are also designed to provide excellent sharpness when they're wide open. However, most other optics are their sharpest when they're closed down one or two f-stops from wide open. A 50mm f/1.8 prime lens or an 80mm-to-200mm f/4-to-f/5.6 zoom lens that produces pretty good results at maximum aperture might excel with an aperture that's two stops smaller.
- ✓ A few stops can help you stop camera or subject motion. Going the other way, the ability to open up an extra stop or two can do your pictures a world of good if it lets you use a faster shutter speed. Try shooting a basketball game indoors at ISO 400 and settings of $\frac{1}{200}$ of a second at f/5.6. Then compare your results with similar pictures taken $\frac{1}{250}$ of a second at a wider aperture, such as f/2.8. If the second set of images is carefully focused, the subjects are *a lot* sharper. It doesn't matter that your first batch of pictures has more depth-of-field (which I discuss in Chapter 7). You don't even notice the depth-of-field because of the subject blur.
- A couple stops can stretch your depth-of-field usefully or trim it for creative effects. Especially when shooting macro (close-up) photos, when you have to deal with a sharply limited depth-of-field. Stopping down or opening up an f-stop or two can produce dramatically different results.
- ✓ Too small is as bad as too large. Shooting wide open costs you depth-of-field and can impact lens sharpness, but using the smallest possible f-stop can be just as bad. After you stop down past f/8 or f/11, most lenses suffer from defraction, and any sharpness that you think you gain in depth-of-field is lost to the resolution-robbing effects of too-small f-stops. It's almost as if your image had a fixed amount of sharpness, and the smaller f-stop is simply spreading it out over a larger range of depth. In addition, small f-stops can accentuate the appearance of any tiny dust motes on your sensor that, at larger apertures, are fuzzy and virtually invisible.

Focus Is a Selective Service

Knowing how to use the right aperture to control depth-of-field is only half the battle. Also explore exactly how you can *apply* that depth creatively.

Chapter 15: Ten Ways to Improve Your dSLR Photography

Improve your photography by casting a wide depth-of-field (DOF) net to capture a broad range of subject matter or focus on a specific object by narrowing depth-of-field to a more selective range. Although you can use many different techniques to emphasize or de-emphasize parts of an image, you can easily master applying depth-of-field creatively, and this technique has almost unlimited potential.

Become familiar with the DOF characteristics of each of your lenses, their zoom settings, and their apertures. I am not suggesting that you memorize all kinds of figures and distances. Just work with, say, your favorite zoom lens and use photos that you take or glimpses with the depth-of-field preview to know approximately the sharpness ranges. For example, observe the sharpness at f/2.8, f/8, and f/16 when shooting close up (at 5 to 10 feet) and at infinity, using 25mm, 50mm, or 100mm zoom settings. Then, you have a better handle on how focal length, aperture, and distance choices affect your shot before you frame a picture.

Playing the Angles

Good composition often involves playing all the angles — *all* of them. Don't be satisfied with the different perspectives that you get with a 360-degree walk-around. Climb on a nearby rock or ladder, stand on a chair, or experiment with the view from a handy balcony. Or stoop low, lie on the ground, or get *under* your subject to see what a worm's-eye view looks like. Everybody shoots flowers from above the blossoms; you can take a picture down at the flower's level.

Choosing an offbeat angle can help solve creative challenges, too. When I went to shoot the Native American shown in Figure 15-3, I was dismayed by the unattractive background, which included canvas panels and bystanders. I laid down on the ground and shot upward at my subject, simultaneously isolating him from the distracting background and visually enhancing his stature.

Figure 15-3: Shooting from a low position isolated this subject from a distracting background.

Part V: The Part of Tens

You might be surprised at how different everything looks from a new vantage point. Even hackneyed and clichéd subjects can take on new life if you choose the right angle. If you find yourself at a popular tourist location and all the people are clustered around a recommended picture spot while you're flat on your back on the grass, you're probably on the right track.

Through a Glass Brightly

There's a reason why digital SLR photographers frequently succumb to a *lens lust* compulsion (the irrational need to add yet another interchangeable lens to one's camera bag at the expense of luxury items, such as food or clothing).

As I discuss in Chapter 7, lenses are the most powerful photography tools at your disposal. So, figure out how to leverage the capabilities of your optics, even if you own only the lens that came with your camera kit. That lens is likely to be a zoom, which makes it many lenses in one, so, even if your camera truly is a *single*-lens reflex, you can use a lot of capabilities that come built into your lenses. Here are some of the capabilities that lenses have:

Make subjects appear to be closer to the camera. Special macro lenses can capture lifesize images of subjects from only a few inches away, but many non-macro zooms and prime lenses focus close enough to provide a large image, such as the one shown in Figure 15-4. The world of the close-up is worth exploring, whether you're photographing flowers, insects, your stamp collection, or the texture of the rocks in your driveway. Even mundane objects

Figure 15-4: Getting closer to a subject than the normal view can bring a new perspective to the familiar.

gain interest when photographed up close.

✓ Bring distant things close. When you want to keep your distance from an erupting volcano, capture images of timid wildlife from 50 yards away, or take soccer pictures from the stands that look like they were grabbed from the sidelines, a telephoto lens can do the job for you.

- Make close things appear farther away. When your back is up against the wall and you can't squeeze everything you want into your image, a wide-angle lens can make your subjects back off to a more manageable distance.
- ✓ Flatter your portrait subjects. A short telephoto lens or zoom setting in the 85mm-to-105mm range (using 35mm equivalent focal lengths) provides a more flattering perspective of human subjects. Your victims will like the way their ears and noses don't look out of proportion. Depending on the lens-cropping (*multiplier*) factor of your camera, this 85mm-to-105mm range might be 53mm-to-65mm (with a 1.6X factor) to 65mm-to-81mm (with a 1.3 factor). A full-frame dSLR has no factor at all, and you can use your 85mm-to-105mm lenses. (See Chapter 2 for an introduction to the lens-cropping effect.)
- ✓ Insult or distort your subjects. A wide-angle lens causes apparent distortion in portrait subjects, which you can use for comical effect. With nonhuman subjects, you can have some creative fun by enlarging things that are very close to the camera while providing a seemingly distorted perspective on objects only a small distance away.
- ✓ Compress distances. Telephoto lenses tend to compress the apparent distances between objects, so you can make those utility poles seem like they're right on top of each other, or those approaching cars separated by 10 to 20 feet look like they're cruising along bumper to bumper.
- ✓ **Manipulate depth-of-field.** Telephoto lenses have less DOF at a given aperture, but wide-angle lenses have more. Choose your weapon, which decides the amount of depth-of-field that you have to work with.

Feel the Noize

If you're old enough to remember Slade or Quiet Riot, you know that *noize* rocks — as long as you're looking for a bit of multicolored speckly texture in your images. Like grain back in the film era, you can use a bit of digital noise in your images for artistic effect. Rather than avoid noise, you might want to enhance it. On the other hand, if you're looking for a satiny smooth finish on your digital images, you might want to minimize noise. Fortunately, the techniques for adding or avoiding noise involve the same sets of concepts:

✓ ISO setting: To increase the amount of noise in your photos, switch to a high ISO setting, such as ISO 1600 or ISO 3200. The higher the setting, the more noisy speckles you see in your images. To decrease the amount of noise, use a lower ISO setting, such as ISO 100 or ISO 200.

Part V: The Part of Tens

- Exposure time: Longer exposures (from 1 second to 30 seconds or more) increase the amount of noise in an image when the sensor heats up and begins to register that heat as spurious image information. If you want to minimize noise, use a larger f-stop and shorten the exposure time.
- ✓ Software: Applications such as Photoshop CS5 or Photoshop Elements 9 include Add Noise filters that you can use to spice up your photos with a little random grain (multicolored or monochrome, as you prefer). On the other hand, tools such as Noise Ninja (www.picturecode.com) can remove excess noise to a certain extent when you *don't* want it. Chapter 12 offers an introduction to using noise filters in an image editor.

Editing, Retouching, and Compositing Images

Sometimes, your best photographic techniques aren't enough to create the image you want. There's no shame in turning to an image-editing program to manipulate your photos.

High-quality image editors can perform three main kinds of modifications:

- Basic editing: This kind of work includes fixing colors and tonal values, rotating or resizing images or portions of images, adding textures and special effects by using filters, and other easy fixes.
- Retouching: If you're looking to remove red-eye effects, soften bad complexions, delete unwanted artifacts or people, and make other improvements to your images, you might want to delve into the realm of retouching.
- Compositing: With this kind of editing, you combine several images into one, move objects from one place to another in your photograph, add a more interesting background (see Figure 15-5), and create a brand new picture that might bear little resemblance to the originals.

Of course, you can find a lot of overlap among what you can do with editing, retouching, and compositing — and sometimes, you may use all three when you work on a particular image.

In Chapter 12, you can find an introduction to image editing and image editors. For more complete details on applying these modifications by using a specific image editor, check out other *For Dummies* books, such as *Photoshop CS5 All-in-One For Dummies*, by Barbara Obermeier (Wiley).

Chapter 15: Ten Ways to Improve Your dSLR Photography

Figure 15-5: Simple compositing techniques provide a more interesting sky background to this shot.

Reading the Funny Manual (RTFM)

If you're like me, you find the manual that comes with a digital SLR to be particularly unappealing when you first get the camera. The manuals are usually confusing, and you may find figuring out what you really need to know difficult. I'm always eager to get shooting, and I've used enough different digital cameras that I can usually fumble my way through their operation without using the manual. While I familiarize myself with a dSLR for the first few weeks, I refer to the instructions only when I can't figure out how to do some particular task.

Part V: The Part of Tens $_$

308

However, any dSLR is a complex machine, and after you become comfortable with its basic operation, the manual that perplexed you so much at first suddenly makes a lot of sense. You can find tricks that you never thought of ("Oh, I can reformat a memory card by pressing these two buttons simultaneously!") and capabilities that you didn't even know existed ("The depth-offield button is *where*?").

So, the best advice I can give you for becoming an expert in the use of your particular digital SLR is that, *eventually*, you want to Read the Funny Manual.

Ten Things You Never Thought of Doing with Your Digital SLR

In This Chapter

- > Exploring the secret world of infrared photography
- Playing with light
- Using time to your (photographic) advantage
- Making do-it-yourself effects
- Saturating your colors
- ▶ Going nuts with image editors

nybody can take a digital SLR, point it at something interesting, and come back with a good photo. It takes a genu-wine second-degree black belt photo master to turn the mundane into something special. One way to add excitement to humdrum photos is to apply some techniques that you probably never even thought of. This chapter provides a quick introduction to ten cool techniques.

Capturing the Unseen with Infrared Photography

If you're looking for a new type of photography to play with, infrared imaging with digital cameras can easily become your new playground. By ignoring visible light and

capturing subjects solely by the infrared light they reflect, you can picture the unseen — in more ways than one. That's because, thanks to the magic of the digital SLR, you likely have to shoot blind. The same techniques that shield your sensor from visible light also keep you from seeing anything through the viewfinder. Fortunately, workarounds exist.

Infrared photography lets you render foliage in eerie shades of white and the sky in an unearthly black color. Human skin takes on a soft, fuzzy glow. You'll either love or hate the effects.

First, get your camera set up for infrared photography. Because digital camera sensors are highly sensitive to infrared illumination, most camera vendors try to filter this light out by placing a filter called a *hot mirror* in front of the sensor. Some hot mirrors are more effective than others.

You can test your dSLR for infrared compatibility by taking a picture of a TV remote control pointed at the camera in a darkened room with a button on the remote depressed. If a spot of light shows up in your image, your camera is sensitive to infrared light.

After you know whether your camera can take infrared photos, follow these steps :

1. Get a filter that blocks visible light while letting the infrared illumination through.

I like the Hoya R72 filter, but other photographers have reported success with Wratten #87, #87C, #88A, and #89B filters.

2. Set up your camera on the tripod, compose your image, and then place the infrared filter on the lens.

SEINEMBER

Unfortunately, after you place the filter on your camera, the view through your finder is completely black.

Infrared exposures are likely to be very long (up to several seconds in duration), so use a tripod.

3. Set your white balance manually (check your camera's user guide to see how to do this) by using a subject that reflects a lot of infrared.

Grass is a good choice.

4. Take a few pictures by using manual exposure.

I recommend using a small f-stop because the infrared focus point isn't the same as for visible light, and your autofocus mechanism doesn't work when the filter is in place anyway. (You'll need to manually prefocus, perhaps before mounting the IR filter.) Small f-stops lead to even longer exposures, but your tripod keeps the camera steady. Start with an exposure of 0.5 to 1 second, and then double the exposure time for each successive picture. You might be able to see an image on your camera's LCD after the shot and gauge exposure that way.

Initially, your infrared (IR) images will be highly tinged with red. Set your color balance manually, using a subject such as grass that reflects a lot of IR, to make the red tinge vanish, as shown in Figure 16-1. (Your camera's guidebook explains how your particular model sets manual color balance.) Play around with your pictures in your image editor to adjust brightness, contrast, and color. (Chapter 12 introduces how to make these adjustments by using an image editor.)

Figure 16-1: Infrared shots can produce an eerie color scheme.

Lighting for All in Tents and Purposes

One of the challenges of shooting close-up pictures of small objects is providing even lighting. You can arrange one or two (or even more) lights but might end up with unsightly shadows, harsh illumination, and reflections. There are better ways to create even lighting.

Pros use handy setups, called tents, to provide soft, even illumination for their close-up pictures. *Tents* are exactly what they sound like tentlike arrangements of translucent material, such as cloth, arranged to cloak your item so that you can illuminate it from all sides through the covering. Just remember to leave a hole big enough for your lens to shoot through!

You can make a tent out of clothes hangers, bed sheets, or more elaborate devices. Plastic frictionfit plumbing pipes and joints make a good skeleton for tents of many sizes. You can assemble such a tent and tear it down on a moment's notice.

For small objects, you can make a free-standing tent, such as the one shown in Figure 16-2, out of a translucent plastic milk bottle. I cut off the bottom so that I could fit the tent over the object I was photographing, and I removed the spout and enough plastic from the neck to insert my dSLR's macro lens. I can illuminate my milk-bottle tent from all sides and create a soft, even lighting effect, like the one shown in Figure 16-3.

Figure 16-2: Cut up a gallon milk bottle to create a tent for shooting small objects.

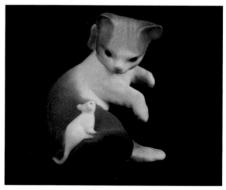

Figure 16-3: Small porcelain figurines, coins, and other shiny objects are often best photographed inside a tent.

312

Turning Your dSLR into a Pinhole Camera

You probably paid at least a few hundred dollars for the lens mounted on your dSLR right now. How would you like to play with a "lens" that costs you, maybe, five bucks? Now you, too, can turn your digital SLR into a pinhole camera by using the technique I explain in this section.

If you come to digital cameras from the film world, you might be way ahead of me. You likely experimented with pinhole cameras when you figured out exactly how cameras produce images. You can also use digital cameras as pinhole cameras. All you need is a pinhole!

An easy way to create a pinhole "lens" is to poke a hole in a body cap and attach it to your camera instead of a lens. (You might have to buy a real body cap if your camera came with a cheap plastic translucent cover instead.) The body cap already has a flange that fits your digital SLR's lens mount. Find the center of the cap and cut a hole in the center. You may end up cutting a too-large hole: The smaller and more precisely you make your pinhole, the sharper your pictures.

So, cover the hole you made with a piece of metal, as shown in Figure 16-4. Then poke a tiny hole in the metal. I used a piece of aluminum foil that I pierced with a sewing needle, but you can use a piece cut from a cookie sheet or other thin metal. The thinner the metal, the better. If you have a hobby hand drill that includes tiny bits, you can probably cut a precise hole in the metal sheet. Experiment with several different sizes until you get one that produces the sharpest image.

Figure 16-4: A hole pierced in a body cap can make a nifty pinhole lens.

After you mount your pinhole lens, you can look through the viewfinder and see a fuzzy, dim image. If you have extension tubes, try mounting one between your camera body and your pinhole lens to change the focal length of the lens. The f-stop of the pinhole is so small that you don't have to worry about focusing after you establish the correct distance away from the sensor to mount the pinhole. Virtually everything is in focus.

314 Part V: The Part of Tens _____

Figure 16-5: Pinhole photographs have a fuzzy, romantic look. Get used to it!

Of course, your aperture is so small that you have to mount the camera on a tripod and shoot time exposures, even in bright daylight. Figure 16-5 shows an image exposed for three seconds at f-whatever, using my own pinhole rig. (Actually, with a quick calculation based on the normal exposure times in bright daylight, I estimate that my pinhole is approximately f/256!) I always use manual exposure to make my pinhole pictures. If you're using your camera's meter, you might need to cover the viewfinder eyepiece to keep extraneous light from venturing inside and affecting the metering system.

Warping Time with Time-Lapse Photography

Time-lapse photography is a great way to show a flower unfolding, the sun marching across the sky, the process of building construction, and (over the course of a year) the change of seasons. You can take time-lapse photos in two ways. One of them is pretty easy, works only with some dSLR cameras, and might require special software. You can use the other way with any dSLR, don't need any special gadgets or applications, and have to put in a whole lot of work.

The easy way usually requires tethering your camera to a computer through a USB cable and working with software that can automatically trigger the camera to take a picture at intervals. Nikon and Canon dSLRs have applications that can take time-lapse photos (Canon's software is free, but Nikon's utility costs extra). There may also be a third-party remote control application that works with your dSLR, and some models have time-lapse capabilities built right into the camera itself.

The images automatically download to the computer when the camera takes them, so you can take many more pictures in sequence than you could fit on a single memory card. Connect your dSLR to an AC power source because even cameras that use very little juice eventually deplete their batteries if you leave them on and connected to a computer for hours at a time. (Your dSLR uses much more power when linked to a computer than when operating in stand-alone mode.)

The other way to shoot time-lapse photos requires more effort on your part. You don't need any special software, and you don't need to connect your camera to a computer. Instead, you can use a digital tool (that is, the index digit of your right hand) to trigger each picture. Set your camera on a tripod and press the shutter release (or use a remote-control/cable release) to take a picture at the interval you select. You may find this process tedious, and it actually works best for long-term sequences, such as construction progress pictures or changing seasons shots. Figure 16-6 shows the same monument in autumn (top) and in winter (bottom).

316 Part V: The Part of Tens _____

Figure 16-6: The same monument in autumn (top) and winter (bottom) has a dramatically different appearance.

To take a series of photos, set up your camera in the exact same spot at intervals. You can most easily position your camera in the same spot every time by mounting the camera on a tripod and recording the height of the legs, the extension of the center pole, and the tilt and angle of the tripod head. Then note the position of the tripod legs on the supporting surface. (The easiest way to do this is to remove your camera from the tripod when you're done shooting, and take a picture of the tripod itself and its surroundings.) By using this information, you can repeat your setup any time you want and take a series of pictures over the course of a few days or even a year. Be sure to use the same lens or zoom setting for each photo, too!

Expanding Your Creativity with Slow Shutter Speeds

Ordinarily, photographers consider blurry images a bad thing. When I use a shutter speed that's so slow my subjects are rendered as a big blur, I tend to say something like, "Oh, I *meant* to do that! I was showing the fleetingness of time against the backdrop of our fast-paced society." Yeah, that's the ticket.

On the other hand, you *can* get some interesting images by using a slow shutter speed if you allow some portions of your image to blur while other portions remain razor-sharp. The classic application of this concept is the photograph of the babbling stream, with the woodsy surroundings rendered in sharp detail, while the flowing water merges into a ghostly blur, as you can see in Figure 16-7.

The secret, of course, is to mount the camera on a tripod and use a slow shutter speed. Anything that moves is blurred, but the stationary surroundings are, in contrast, very sharp. You aren't limited to waterfalls and streams. Street scenes shot with long exposures typically feature blurry car headlights and taillights, which can add some foreground interest.

Look around. You can find a lot of subjects that you can make more interesting if you let them blur a little. Mount the camera on a tripod. Try different shutter speeds, reviewing your results on your dSLR's LCD until you find the speed that produces the effect you want. Use Shutter Priority mode and select a range of speeds, from $\frac{1}{20}$ of a second to about 1 second.

318 Part V: The Part of Tens _____

Figure 16-7: With a slow shutter speed, moving objects blur, but stationary objects are sharply rendered.

Capturing an Instant in Time with Fast Shutter Speeds

Some subjects move so quickly that the human eye normally could never observe them. However, a very fast shutter speed can freeze a moment in time. Falling water, a breaking light bulb, a bullet penetrating an apple, and other events that are over in an instant lend themselves to hyper-freezing techniques. Figure 16-8 shows the ripples and splashes produced by a drop of water landing in a glass. I illuminated it by placing an electronic flash off to the left and triggering an exposure manually. This method involves a lot of trial and error, but when you use a digital camera, you can easily take 30 or 40 pictures to get the exact one you want.

Figure 16-8: A tiny-fraction-of-a-second exposure can freeze the quickest action.

Most digital SLRs have shutter speeds of at least $\frac{1}{4000}$ of a second; some have speeds of $\frac{1}{4000}$ of a second. You can get even briefer shutter speeds by taking advantage of the fleeting duration of an electronic flash unit when you use it in Close-Up mode. Many strobes wink on and off in as little as $\frac{1}{4000}$ of a second when you use them up close. That's because only a very quick flash is needed to properly expose an image from that range, but you can use the effect to stop action.

If you want to try freezing action by using an electronic flash, use one that you can operate off-camera, connected with a cable. Or try mounting your camera on a tripod, darkening the room, and shooting a bulb exposure. During the exposure, trip the flash manually by pressing the Test button. Because the room is dark, the camera uses only the illumination from the flash for the exposure.

Making Your Own Effects Filters

Believe it or not, filters were originally something you put on the front of your lens — not a plug-in mini-application in image editors, such as Photoshop. Certainly, software filters can duplicate many of the effects of their glass or gelatin real-world counterparts, but you don't have to abandon the joy of using real, actual filters on your lens. You can find a lot of special effects tricky to duplicate in an image editor, such as polarization to remove reflections, or split-filter gradients to even out the bright sky and dim foreground.

You don't even have to *pay* for special effects filters. You can make your own. Manufacture them out of ordinary, fairly useless filters (such as skylight or ultraviolet filters), or better yet, purchase a Series *x* adapter ring. Series adapter rings come in various sizes to suit the front filter diameter of your lens, with the *x* replaced by the number of the ring suitable for your lens, such as Series V, Series VI, Series VII, or Series VIII.

A Series *x* adapter ring comes in two parts. One part has a thread that screws into the front of your lens. The second part screws into the first part, usually with a filter of your devising between the two, forming a little sandwich of two metal rings and your custom filter inside.

The Roman numeral designations show the relative size of the ring set. For example, Series IX rings are sized to fit lenses with filter threads of 72mm, 77mm, and larger. Series VIII rings are good for lenses with 62mm to about 67mm filter threads. You can purchase step-up and step-down adapters so that you can use, say, a Series IX ring on a lens with a 62mm thread. Mounting a larger ring on a smaller lens thread is always better — and make sure the rings don't cause *vignetting* (darkening) in the corners of your image (which you may find a particular problem if you use a wide-angle lens).

Here are some ideas for special effects filters that you can create on your own:

- Starry night: Use a piece of window screen cut to fit the Series rings to create a star filter that transforms each pinpoint of light into a star effect.
- Color your world: Cut a piece of gelatin filter material into a circle to fit in the Series ring to create a color filter.
- Color your world times two: Use two pieces of filter material of different colors to create a split-color filter. For example, you can use orange-red on top to give the sky a sunset color and blue on the bottom to add cool tones to the foreground. The (expensive) filters of this type that you

can buy have a smooth gradient between the colors, but a quickand-dirty split filter approach can work, too.

- Life's a blur: Smear the outer edges of a piece of round glass (or another filter) with petroleum jelly to create a romantic blur filter. This method is great for portraits of females, and teenagers who have complexion problems.
- Feature your filters: Try shooting through a feather or other textured material to create interesting effects.

Figure 16-9 shows some of these filters.

Figure 16-9: Create your own star filter (upperleft), smudgy portrait filter (upper-right), or split-field color filter (bottom).

Shooting the Works!

You don't have to wait until Independence Day to shoot fireworks. People commemorate a lot of other events and celebrations, including baseball games and auto races, with an aerial display. Perhaps you avoid shooting fireworks because you think capturing skyrockets in flight is too difficult. Or maybe you just want to watch the show, rather than fiddle with your camera. I'm here to tell you that you can do both!

The secret to shooting fireworks is to do a little planning. Here are some tips:

- Choose your spot. You can position yourself up close and capture the display from underneath the exploding canopy, or get farther back and shoot the fireworks against a skyline. Both approaches work great. What you *don't* want is a view that's obstructed by buildings, trees, or very tall fellow observers.
- **Use a tripod.** Set your camera on a tripod so that it remains rock-steady during exposures that can last several seconds.
- Check it out. Take a few pictures at the beginning of the display and evaluate them to make sure your manually-set exposures are reasonable. Try 2 to 3 seconds at f/8 for starters. Use manual focus set on infinity!
- **Go long.** Use longer exposures to capture multiple bursts in one frame, as shown in Figure 16-10.
- Shoot RAW. Use your dSLR's RAW option so that you can adjust exposure and other parameters as the image is imported into your photo editor.

Figure 16-10: A long exposure can capture multiple bursts.

- Don't use noise reduction. If your camera kicks into Noise Reduction (NR) mode automatically, disable that mode. Don't manually activate NR, either. The extra time required to create the noise reduction "dark frame" can cause you to miss the next blast-off. Even a several-second exposure still looks good without this extra step.
- Enjoy the show. After you set up your camera and frame an area of the sky where you expect the bursts to appear, just watch the display without peering through the viewfinder. Trigger your shots by pressing the shutter release button, or by using a remote control or cable release (if you can use one with your dSLR).

Going for Baroque

Normally, you want to set your camera's controls so that you get the bestexposed, most realistic image. However, at times, you might want to go for baroque and get a really over-the-top image right in the camera. Simply adjust your settings to get some off-the-wall results. Of course, if you shoot RAW (described in Chapter 9), you can manipulate your images when you import them to your image editor to get much the same effects, but adjusting the camera's controls is faster and repeatable.

Here are some techniques to try:

- ✓ Boost saturation/change the hue. Set your camera's color saturation controls to the max to generate rich, unrealistic colors. Film photographers favored Kodak Ektachrome films for this very reason, and digital shooters can do the same thing electronically. Increasing saturation can also provide good color on dull, overcast days. Or you can go overboard and really pump up the color richness while manipulating hues to create an otherworldly effect, as shown in Figure 16-11.
- Enhance contrast. Your dSLR probably has a contrast control intended to give you acceptable images of low-contrast subjects. You can subvert that control to produce high-contrast results of normal subjects. You lose detail in highlights and shadows, but that's what you go for when you use this effect.
- Add grain. High ISO ratings can add unwanted noise to your images except when you *want* the noise because of a creative decision. Crank your camera's sensitivity up all the way and then experiment. In bright light, you generally have to use high shutter speeds, small apertures, or both, but most digital SLRs can shoot photos on the beach at high noon at ISO 1600, even if it means using ¼000 of a second at f/16, or neutral density filters to cut down on the amount of light reaching the sensor.

Figure 16-11: Crank up your color saturation and manipulate the hues to produce an offbeat look.

Going Crazy with Your Image Editor

Many digital SLR users have more experience fiddling with images in Photoshop than they do taking pictures with a dSLR. After all, Photoshop has been around since 1990 and was an excellent tool for modifying scanned film images long before digital cameras began hitting their stride a decade later.

So, you probably have no fear of image editing — and you might, in fact, be

striving to create an image that's as close to your vision as possible *in the camera* in order to reduce the time you spend in post-processing.

All the more reason to take your image editor to its limit and work on special effects that unleash your creativity, such as the kaleidoscope effect in Figure 16-12. The image was created by adding a flipped top half of the photo, producing a mirror image on the bottom.

Figure 16-12: Every picture tells a story, but you can spice up even the best story with editing.

Ten Online Resources for Digital SLR Photography

In This Chapter

- Editing your photos with a web browser
- Displaying your pictures online
- Finding the best digital photography information on the web
- Checking out individual photographers' websites
- Buying and selling photography equipment online

ne advantage of using a digital SLR is that, in terms of new ideas, new techniques, new applications, and new add-on gadgets, the sky's the limit. Certainly, an imaginative photographer finds it challenging to wring every last bit of potential out of a non-SLR digital camera, and he or she can spend years doing so. But if the possibilities of an ordinary point-and-shoot camera are vast, the tricks that you can do with a digital SLR are easily twice as vast. The expandability and versatility of a dSLR mean that you have no excuse for doing things in a half-vast way (ahem).

An important tool to avail yourself of is the Internet, with its unlimited treasure-trove of ideas, showcases for your photos, equipment tests, and places to buy or sell dSLRs, lenses, and accessories. This chapter gets you started by introducing ten of the best online resources. (Although I give only ten resources the full-feature treatment, I sprinkle in a couple of bonus sites here and there.)

I provide all the links here, but you don't have to go to the trouble of typing them into your browser. Instead, go to www.dbusch.com/dslrlinks.htm, where you can find a page full of clickable links for these sites and many more.

About Facebook

www.facebook.com

Even if you're a regular Facebook user, you may not have explored all the things the world's leading social networking site has to offer for photographers. In addition to a page regularly visited by my "fans" (both of you), *David Busch's Photography Guides*, you'll find hundreds of other pages dedicated to your favorite photographers, photo topics, specific cameras, and all kinds of special interests, from sports photography to *Smart Photographers*, aimed at members of the high-IQ group, Mensa. These forums provide lots of valuable information and contact with folks who have photographic passions to match your own.

Of course, Facebook, shown in Figure 17-1, threatens to overtake sites like Flickr as a place to share photos, because Facebook is so much more than albums, and includes a lot of versatility in how you share your photos. You can create albums, of course, and then choose to share your pictures only with friends, friends of friends, or everyone. Add a photo to your Status to make sure all your friends know it's there. Tag individuals in your photos so other friends can find them. Facebook has been experimenting with facial recognition features so that pictures that contain your visage can be identified automatically and, if you opt in, tagged for searches.

Figure 17-1: Facebook has become a leading photo-networking site.

326

Chapter 17: Ten Online Resources for Digital SLR Photography

You can upload photos to Facebook from your computer, mobile device (such as a smart phone) or, if you have an Eye-Fi card, upload each shot you take automatically when you're near a Wi-Fi hotspot.

Online Editing with Photoshop.com

www.photoshop.com

If you want to upload your images to a photo-sharing site, check out Adobe's Photoshop.com web service, shown in Figure 17-2. If you travel and want to edit your photos online by using nothing more complicated than a web browser, definitely add Photoshop.com to your short list. And, if you rely on Photoshop Elements (Versions 7.0 and later) as the image editor for your computer, Photoshop.com is a must-have. You can find other photo-sharing sites and other tools that let you edit photos online, but none of them integrate so tightly with Elements, and few are as adept at linking with your existing Flickr, Facebook, and Photobucket accounts as Photoshop.com.

Figure 17-2: Create your own albums, edit photos, and share those photos by using Photoshop.com.

This site allows you to store up to 2GB of pictures for free with the Basic membership, which includes no-charge access to a full list of editing and correction tools. You can fix red-eye, trim and rotate your photos, and apply special effects, then store the corrected files in online albums that you can share with friends, colleagues, family, or the public at large — it's your choice. Upgrade to 20GB of storage for an annual fee of \$19.99.

All Your PBase Are Belong to Us

www.pbase.com

A ton of image-hosting sites out there let you upload your photos to a web page album so that anyone who has access to the Internet can view them. However, most of these sites are aimed at consumers, not serious photographers. You might receive limited album and image size, and you may find the things that you can do with the albums confined to a few levels of sharing (meaning that you might be able to share with everyone in the world, with a fixed list of users, or only by invitation). These sites can help you share a few pictures online and perhaps order some prints, personalized calendars, or photo coffee mugs.

PBase and the similar site SmugMug have become wildly popular for a good reason: Both go well beyond the album sites to provide true online photo galleries — and a lot more besides. Here's a sampling of the features found in PBase:

- Explain your settings. You can specify that you want the EXIF (image data) parameters of each photograph available to viewers, so other photographers can see the settings you used to create a particular picture.
- Search by keywords. A search engine enables visitors to look for photographs — including yours — by using specific keywords.
- ✓ Upload batches of photos at the same time. You can upload batches of photos that you've compressed into archives (such as .zip files) to save time. (Most of the album sites ask you to upload non-zipped photo files individually and limit you to five to ten images.) A typical PBase album collection is shown in Figure 17-3.
- Link galleries. You can link galleries that you create. So, if you start a gallery that shows off your sports photos, you can subdivide it into football, baseball, tennis, or other appropriate categories.

Link your photos to other forums. If you frequent any of the various online discussion forums, you can link directly to your photos.

Many compatible sites can display PBase photos right in your postings, with buttons that allow you to zoom in and out.

PBase is even a terrific information resource. It publishes a magazine compiled entirely from the efforts of members. The premiere issue highlighted the work of two photographers and provided some useful tips on sensor cleaning.

328

Chapter 17: Ten Online Resources for Digital SLR Photography

Figure 17-3: Forums in PBase are devoted to topics such as digital cameras.

Of course, something this good isn't free. You can check out PBase for 30 days with 10MB of online disk storage. If you like it, a hefty 1000MB of storage (enough for more than 4,000 images of an average 250KB size) costs \$23 a year (less than \$2 a month) at the time of this writing. If you need 2000MB of online space, that's \$43 a year; 3000MB is \$60 per year, and you can add more storage in 1000MB increments for a reasonable cost.

If you want to try out another leading non-free photo-sharing service aimed at advanced photographers, check out SmugMug (www.smugmug.com), too.

Digital Photography Viewed and Reviewed

www.dpreview.com

An incredible free resource is Digital Photography Review (usually called just DPReview). DPReview is a top-notch site for information about any digital SLR camera. A British chap named Phil Askey still publishes this site, with help from a knowledgeable staff, thousands of avid fans, and visitors. Amazon.com purchased this site, but it remains an unbiased resource that has evaluations and buying tips for retailers other than the parent company. Phil has recently added new reviewers and technicians to beef up the content, and established an office in the United States.

It's no exaggeration to say that I spend a minimum of 30 minutes at this site virtually every day of the year. Here are the kinds of useful features at DPReview that can keep you coming back for more:

- ✓ User forums: You can find individual forums for all the key digital SLR cameras (as well as non-dSLRs) from Canon, Nikon, Sony, Pentax, Kodak, Fuji, and Sigma. Topics such as Canon SLR Lens Talk, Nikon SLR Lens Talk, Lighting, Storage and Media, and Retouching even have their own separate forums. Those who own a particular camera model can enjoy the specialized forums for groups of cameras, including subcategories for each of the major Nikon, Canon, Pentax, Sony, and Olympus product lines. Even with all these subdivisions, most of the forums have hundreds of fascinating posts a day. I spend most of my time on this site just trying to keep abreast of the interesting discussions.
- Camera comparisons: The site has separate pages for each digital camera vendor. Each page lists all the most recent models, including complete specifications for every camera and links to reviews. For example, the Nikon page lists dozens of different Nikon models in detail and links to another dozen or so discontinued models. You can compare the features of cameras from different vendors, too, as shown in Figure 17-4.

			m
Side by side	Nikon D3109	Nikon D5100	Nikon D7000
ADD CAMERA	Amove leftmove right		
- Basic Information			
Buying options	Check prices	Check prices	\$1,870
Review / Preview	72% Read review Dec 21, 2010	76% Read review Apr 26, 2011	80% Read review Nov 30, 2010
Announced	Aug 19, 2010	Apr 5, 2011	Sep 15, 2010
Body type			
Body type	Compact SLR	Compact SLR	Mid-size SLR
Sensor			
Max resolution	4608 x 3072	4928 x 3264	4928 x 3264
Image ratio w:h			3:2
Effective pixels	14.2 megapixels	16.2 megapixels	16.2 megapixels
Sensor photo detectors Sensor size	14.8 megapixels		16.9 megapixels
	APS-C (23.1 x 15.4 mm)	APS-C (23.6 x 15.7 mm)	APS-C (23.6 x 15.7 mm)
Sensor type	CMOS	CMOS	CMOS
Processor	Expeed C2	Expeed 2	Expeed 2
Image			
ISO	Auto, 100, 200, 400, 800, 1600, 3200 (12800 with boost)	Auto, 100- 6400 (plus 12800, 25600 with boost)	100 - 6400 in 1, 1/2 or 1/3 EV steps (100 - 25600 with boost)
White balance presets		12	
Custom white balance	Yes (1)	Yes (5)	Yes (5)
Image stabilization	No	No	No
Uncompressed format	RAW	RAW	RAW
JPEG quality levels	Fine, Normal, Basic	Fine, Normal, Basic	Fine, Normal, Basic

Figure 17-4: DPReview's Side-by-Side comparison feature lets you pit one camera's features against another's.

Chapter 17: Ten Online Resources for Digital SLR Photography

Use this trove of information to compare cameras. For example, if you want to know the sensor size of the Canon Digital Rebel XTi compared to that of the Nikon D40x, simply retrieve that information with a couple of clicks.

- ✓ **Comprehensive reviews:** The DPReview evaluations of cameras and lenses are among the most complete and thorough available on the Internet. For example, the review of one recent Nikon dSLR is 26 pages long and includes a description of every feature, screen shots of each menu, tests, sample images, and an evaluation of the software that comes with the camera. You can even listen to the sound the shutter makes if that's important to you. These reviews don't appear the instant a camera comes on the market, but they're worth waiting for.
- Daily news updates: The main page provides a listing to the main digital photography news stories of the day and more than a few rumors. You can find information such as notices of the latest firmware updates for your camera, new product introduction announcements, and other breaking stories.
- An online glossary: Wonder what bokeh is? You can find a glossary on the DPReview site that explains this term — and just about any other photography term that you care to look up.

As I write this, DPReview has already passed one billion visitors since it began keeping track in January 1999. You should jump on the bandwagon, too.

For the Shutterbug in You

www.shutterbug.net

If you're an old-line photographer, someone who was a serious photo hobbyist back when people had to use something called *film*, you may appreciate the full-spectrum viewpoint provided by this venerable resource. It's an online adjunct to *Shutterbug* magazine and, as such, covers digital photography in depth, as well as recent and classic film cameras, photo techniques, and other topics of interest.

Like DPReview, Shutterbug's strength lies in its forums, which (like the magazine and main website) span a broad range of interests. You can find forums dedicated to Nikon, Canon, Pentax, Olympus, and Sony digital SLRs. Shutterbug also offers several forums for the film SLR counterparts (always a good source for information about compatible lenses and accessories), along with forums for inkjet, dye sublimation, and traditional silver halide printing. You can also find forums about color management, lighting and exposure, and collectible cameras.

Whereas DPReview's product evaluations are mostly devoted to digital cameras and lenses, Shutterbug looks at all kinds of items, including equipment bags, gadgets, books, and photo shows. You can find interesting monthly columns, too.

Pop Goes the Photo!

www.popphoto.com

Popular Photography & Imaging magazine has been the most authoritative resource for serious amateur photographers for longer than most of us have been alive. The addition of a website as a supplement to the magazine's coverage and increasing emphasis on digital photography prove that venerable doesn't have to equal stodgy or old-fashioned. PopPhoto.com remains as up-to-date as the latest digital camera, and most of the time, it's several steps ahead of the technology in its predictions. (In the interest of full disclosure, I should point out that I'm a contributor to *Popular Photography & Imaging* from time to time, but I've been a subscriber and avid reader since I was in high school.)

The PopPhoto.com website's strength is its authoritative voice when it comes to technology. The editors really, *really* understand all the finer points of digital and conventional photographic imaging, and their lab tests of equipment are unmatched. When you read the performance figures on various lenses or other equipment, you have information at your fingertips that you can use to go out and make purchases with confidence.

Nowhere else can you find solid information available in such depth. Can a 24.5MP digital SLR produce better results than a fine-grain ISO 100 film? What are the seven most significant breakthroughs in tripod design? What are some of the best photos taken in the last year? The answers are all available at PopPhoto.com. The site offers forums, of course, but it also provides a lot of tips and tricks, how-to's, workshops, and videos.

Landscapes Can Be Luminous

www.luminous-landscape.com

Calling The Luminous Landscape a website devoted to landscape and nature photography is a little like calling the *Encyclopaedia Britannica* a collection of articles. This site is, above all, amazingly comprehensive, with more than 2,000 pages of information, articles, tutorials, product reviews, and photographs.

Chapter 17: Ten Online Resources for Digital SLR Photography

This site has everything you'd want to know about nature photography, but it goes far beyond that. Here are just some of the features to check out:

- ✓ Understanding Series: The site's Understanding series of tutorials covers everything from SLR viewfinders and how they work to sensor cleaning. You can discover how to use unsharp masking, work with histograms, and use polarizing filters effectively.
- **Tutorials:** This series covers digital workflow, pinhole photography, high dynamic range photography, and other topics.
- ✓ Workshops: You can find lists of workshops occurring around the world. (China, Africa, Antarctica, Ireland, and Iceland are just six of the destinations where these workshops have been held in the past.)
- Locations: The descriptions of prime shooting locations for nature photography help you find new places to take photos.
- Columns, Essays, and Product Reviews: Oh, yeah don't miss the essays, regular columns, and hundreds of product reviews on cameras, tripods, and other essentials.

If you're interested in nature, landscape, or documentary photography, you must visit this site. However, everyone from sports photographers to portraiture specialists can discover something of interest.

Cult of Personality

When you search the web, you can find a ton of sites founded and operated by individuals, such as www.kenrockwell.com (good stuff, but focusing mostly on Nikon and *highly* opinionated), www.fredmiranda.com, and www.robgalbraith.com (which I discuss next).

Rob Galbraith

www.robgalbraith.com

Rob is probably best known for his exhaustive evaluation of CompactFlash (CF) and Secure Digital (SD) card performance data. He has tested virtually every CF and SD card available, with just about every camera on the market. You can find more than 20 pages of tables and data to pore through. If you want to know how a SanDisk Extreme III 8GB CompactFlash card performs with a Nikon D2Xs, you can find that information. These tests are quite literally the Bible of the industry.

Although Rob no longer offers forums, the site includes a good list of links to other useful web pages, from the American Society of Media Photographers (ASMP) to *National Geographic*. This site includes authoritative news and

reports, links to software upgrades, and the usual array of ads that help pay for the cost of publishing all this information online.

Most photographer-run sites focus more on promoting the photographer than providing solid information, but Rob's site is one exception.

Charmin' Miranda

www.fredmiranda.com

Another photographer who believes it's better to give than receive is Fred Miranda. His gorgeous site is bursting with valuable information, all arranged logically and easy to access. A lot of digital photographers agree: On a recent night when I logged in, nearly 1,500 *other* photographers were also using the site at that exact moment!

Of course, Fred does hawk some amazing software, but in an unobtrusive way. You almost have to stumble across the FM Software offerings, mostly Photoshop plug-ins and Actions that do tasks such as reduce noise, resize photos, or manage workflow.

You may find the forums, as shown in Figure 17-5, highly engaging. They're some of the best available forums online, with contributions from more than 70,000 members. You can also find useful articles and reviews, as well as image hosting. Even if you don't want to set up showcases of your own, definitely browse the hosted galleries. You can get a lot of ideas by viewing other photographers' best efforts.

Don't Miss eBay

www.ebay.com

Once called "the nation's garage sale," eBay is one online resource that really pays if you have old equipment to unload. Registered members can also use eBay to locate hard-to-find camera equipment at reasonable prices. Although KEH.com (www.keh.com), a real camera dealer in Atlanta; B&H Photo (www.bhphotovideo.com); and Adorama (www.adorama.com) are all reliable dealers and the go-to organizations for much new and used stuff, nothing beats eBay for variety — and, if you get caught up in bidding, excitement.

I know whereof I speak. I've had more than 8,000 transactions on eBay myself, and I ended up writing a book about my experiences, *The eBay Myth Buster* (Wiley). You can pick up a copy through my website at www.dbusch.com, or visit your local or online bookstore.

334

Chapter 17: Ten Online Resources for Digital SLR Photography

Figure 17-5: The forums are one of the more engaging parts of Fred Miranda's website.

eBay is a great place to locate new and used equipment at a price that you're willing to pay — especially if you do some research and have a good idea about what an item's truly worth. The venue does best with supplies (such as ink for inkjet printers), older cameras and lenses, and difficult-to-find accessories. For example, when I picked up a used 170mm-to-500mm zoom lens from my local camera dealer, it didn't come with a lens hood. The lens hood that I found on eBay was delivered to me in less than a week for quite a bit less than my dealer would've charged for a special order.

Perhaps you're looking for older, manual-focus lenses that are compatible with your dSLR. A manual focus (MF) macro lens for \$150 probably performs as well as a new autofocus (AF) version that costs two or three times as much, and you can probably get away with manual focus for precision close-up work anyway.

Perhaps you're upgrading to a new camera and want to sell your old one. Your dealer or a company, such as KEH, will gladly buy it from you, but they must offer enough less than the camera's worth to allow for some profit when they resell. Peddle the camera on eBay, and you might make a lot more cash than you would've gotten if you traded it in or sold it outright with a dealer.

Ever since I went all-digital, I've been slowly selling off my film cameras on eBay. Figure 17-6 shows an edited version of an eBay auction that I conducted for a beloved old half-frame camera I wanted to relocate to a new home.

Figure 17-6: Sell your old film gear on eBay and use the proceeds to buy new digital stuff!

Chapter 17: Ten Online Resources for Digital SLR Photography

Here are five keys to using eBay successfully:

- ✓ Check the seller's feedback. Each eBay ID has a Feedback Rating number to the right of it, which represents the net number of positive feedbacks (that is, positives minus negatives) received. Click the number to view the actual feedback comments. Sellers with 50 to 100 or more positives and no negatives are probably reliable. (eBay no longer allows sellers to leave negative ratings for buyers.) Those sellers who have fewer feedbacks or a few negatives might also be good eggs, but be sure to check a little further. The venue recently added more detailed feedback ratings that allow buyers to rate sellers on delivery promptness and other aspects of the transaction.
- ✓ Pay for your items by using your credit card through a service such as PayPal. Although eBay provides a modicum of buyer protection, if you use your credit card through PayPal, you have two extra levels of security. If a deal goes awry, PayPal might be able to get you a refund. If not, you can go directly to the credit card company and frequently get a charge back that way. Scams are fairly rare on eBay in the overall scheme of things. If you avoid deals that seem too good to be true (for example, a Nikon D5000 for \$200), you won't easily fall victim.
- Don't expect sensational deals on cameras or lenses that have just been introduced. It's unlikely that "used" ones are available, in any case, and the new ones are probably being sold by dealers who have a profit margin to make. New cameras are likely to be no more than about \$50 cheaper than you'd pay locally (if that), but you can save on local sales tax, unless you're a New York resident. In most cases, you can do better on newly introduced equipment at B&H Photo or Adorama.
- ✓ Don't buy memory cards on eBay. You can find a robust trade in counterfeit memory cards (mostly purporting to be SanDisk models), and an alarming percentage of rock-bottom CompactFlash or SD card offerings are bogus. Even though eBay stomps out evil sellers almost as fast as they appear, the odds are still against you. Unless a seller has hundreds or thousands of favorable feedbacks, you're better off buying your memory cards elsewhere.
- ✓ When purchasing used equipment, see whether you can get a moneyback guarantee or an inspection period. This gear is frequently sold as-is, which can be okay if the seller is well-respected (meaning he or she has a lot of positive feedback), but risky if the seller is new.

Part V: The Part of Tens _____

Ten (or More) Confusing Concepts Clarified

18 🔊

In This Chapter

- > Knowing the terms involved in taking your photos
- > Understanding what certain settings' names actually mean
- Making sense of your image editor's terminology

Photography is easy: It's the jargon that's difficult! Today's digital SLRs make it simple to point, shoot, and get great pictures right out of the box. Even the most basic dSLR is smart enough to save you from your own mistakes when your ambitions don't extend beyond simple scenes, simple setups, and simple subjects.

When you want to spread your wings and try different techniques, more advanced features and more advanced photographic concepts come into play. At that point, you may want to become comfortable with that jargon — not so that you can sound knowledgeable when hanging around with other photographers, but so you can put those sometimes-confusing concepts to work. I explain all the key terms throughout this book, but in this chapter, I single out a few of the trickiest terms that relate to cameras, photography, and image editing, and provide the depth and knowledge that you can use.

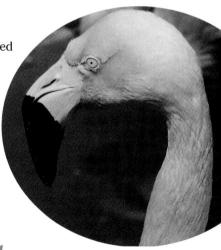

Ambient Lighting/Available Lighting

Ambient lighting is sometimes confused with *available lighting* or *existing lighting*, which are themselves often confusing for those not steeped in photo jargon. Available and existing lighting are the same thing (or should be) and are most commonly defined as the illumination that's already present in a scene, whether it is sunlight, streetlights, moonlight (outdoors), or lamps

and other light sources (indoors), including light that streams into the room from outside through windows, doors, or openings. You can consider add-on sources — including additional lamps or electronic flash — *available* (if you have them on hand), but they're not *existing*. (Hence the confusion.)

Ambient lighting, on the other hand, is something entirely different; although, in most cases, you'd consider it to be available or existing light. In practice, *ambient lighting* is non-directional lighting that appears to come from everywhere, rather than from a single source. It's soft and diffuse, and it's supplied by light bouncing off the ceiling, walls, or other objects in a scene. When used with a stronger primary light source, ambient light fills in dark shadows and pares the rough edges off contrasty lighting transitions. Ambient lighting is your friend — now that you know what it is and how to best use it.

Anti-Aliasing

Anti-aliasing is an edge-smoothing process applied by your camera and/or by an image-editing program to account for the fact that the seamless analog information in your original scene must be converted into discrete rectangular pixels when the picture is digitized.

Blocky little pixels work great for reproducing straight lines, but aren't so great for creating curves or diagonal lines. Without anti-aliasing, you end up with ragged edges, like the one shown at top in Figure 18-1. Antialiasing creates partially transparent pixels along these boundaries, which merge into smoother, non-jaggy lines when viewed (like the bottom of Figure 18-1).

Bracketing

Even small changes in settings can make a difference to finicky photographers. *Bracketing* is a way of providing several alternate takes at different exposures, with different color balance settings, or using other parameters so that you can choose the one that best suits your image.

Figure 18-1: Smooth a jaggy line (top) by using anti-aliasing (bottom).

Chapter 18: Ten (or More) Confusing Concepts Clarified

Many (but not all) digital SLRs have a bracketing feature that automatically takes successive exposures at incremental settings that you specify. For example, you can choose to take the first picture at the exposure setting determined by the camera's meter and a specified number of photos (typically three or five) at exposures that are less and more than the calculated exposure. You can take the bracketed exposures one at a time (until you complete the requested number of bracketed shots), or you can take them rapidly, one after another, when the dSLR is in Continuous Shooting/Burst mode.

Certain dSLRs may allow you to specify parameters other than just exposure, such as white balance or color, that you want to bracket; the order in which you want the bracketed shots exposed; or the size of the increment between shots (such as ½ stop, ½ stop, or one full stop). You may also be able to bracket electronic flash exposures, as well.

Figure 18-2 shows a series of bracketed exposures (top) and color balance changes (bottom).

Figure 18-2: Many digital SLRs can bracket exposure (top), color (bottom), or both.

Chromatic Aberration

Chromatic aberration (CA), which produces colored blurs and/or green/ purple fringes around the outlines of an object, is usually most obvious in backlit subjects, as shown by the purple fringes around the pine branches in Figure 18-3. CA is caused by the inability of the lens to focus all the colors of light at the same plane on the sensor. That differing response to colors splits the red/green/blue light into separate components, like a prism, and the stray colors are diverted to one side (with *lateral chromatic aberration*) or to form a color-tinged blur (with *axial* or *longitudinal chromatic aberration*). Neither form is much fun to find in your photographs.

Figure 18-3: Chromatic aberration can cause green or purple fringing.

Although you can partially reduce axial CA by using a smaller f-stop, you must avoid both types (by checking reviews before purchase to see whether a particular lens suffers badly from chromatic aberration), live with CA, or — if you have Photoshop or a specialized add-on tool — fix it. Photoshop's Lens Correction filter can counter some chromatic aberration, and DxO Labs (www.dxo.com) offers DxO Optics Pro, which has remedies for many types of lens and perspective distortion.

Dodging/Burning

Back in the film era, a skilled darkroom worker who was an artful dodger could hold back portions of an image while making a print by using an *enlarger*. (An enlarger is a type of vertical projector that cast an image through the negative or positive film on a piece of photosensitive paper.) By moving light-blocking tools (even the worker's hands) in the light path while making the exposure, he or she could make the portions of the image subjected to dodging lighter than they would've been if the worker allowed the exposure to proceed unhindered. The converse was true for *burning*, in which the darkroom maestro blocked all portions of an image except the portions exposed for an added period of time.

Dodging and burning allowed lightening or darkening of only certain portions of an image, thus toning down highlight areas that would otherwise be washed out and preventing shadow areas, which preserved detail. You can find similar techniques available in all image editors today, but many digital photographers confuse the two terms because they don't know where the terms came from. Now you know.

Fill Flash

Flash? *Outdoors*? What am I thinking? Actually, even if plenty of light is available for an acceptable exposure, that illumination may not provide a decent picture — especially in bright sunlight or other situations in which the highlights are much brighter than the shadows. The result? Shadows that are way too dark. Providing extra exposure to those inky shadows doesn't help: The highlights are then washed out.

The solution is to flip up your camera's built-in flash and let it do its stuff. A digital SLR is smart enough to recognize situations in which it should use the electronic flash at a lower power setting to fill in shadows without washing out the highlights. Your camera may do this for you automatically or may have a Fill Flash setting somewhere in the menus that tells the dSLR to throttle back the strobe. You want the camera to provide just enough of a kick with the flash to brighten the shadows, especially under the eyes, without making it obvious that a flash was used. As a bonus, you may find that the Fill Flash adds some useful sparkle to the eyes of human subjects who are looking directly at the camera, as shown in Figure 18-4. A reddish filter placed over the flash can add some warmth, too.

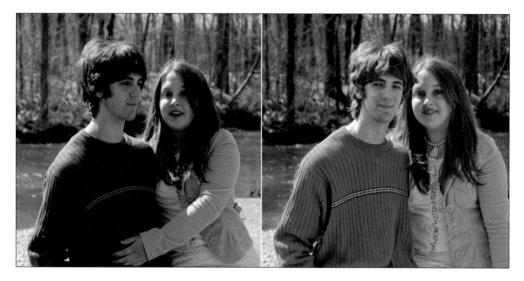

Figure 18-4: Fill Flash brightens dark shadows.

Hyperfocal Distance

The *hyperfocal distance* is a quick way of stretching your available depth-offield to make it most useful. This distance is a point of focus where everything in your scene from half the hyperfocal distance to infinity appears to be acceptably sharp.

For example, if a hyperfocal distance is 6 feet, everything from 3 feet to infinity would look sharp at the most common print sizes and viewing distances. (Apparent depth-of-field varies, depending on how close you are to the printed image and its magnification.) The actual hyperfocal distance varies by the lens and the f-stop in use; if you Google **hyperfocal length**, you can find web pages that have tables listing the hyperfocal distance for a particular focal length and f-stop.

Knowing the hyperfocal distance (even if only a rough estimate) can help you be ready for a "grab" shot. Turn off your dSLR's autofocus and set the lens at the hyperfocal distance for the f-stop that you plan to use, and you can snap off a picture quickly without having to wait for the camera to lock in focus.

Lossy/Lossless Compression

Lossy and *lossless* are terms that cause confusion, partially because the former uses a word that isn't officially a part of the English language (I know *lossy* causes Microsoft Word fits until you add it to your custom dictionary.)

Chapter 18: Ten (or More) Confusing Concepts Clarified

Lossy compression is the opposite of lossless compression. Both schemes squeeze down the size of image files (thus saving space on your memory card and computer hard drive) by replacing the long strings of information that represent the image data with shorter number series.

The TIFF and compressed RAW file formats are examples of lossless or virtually lossless file formats (some dSLRs can also use an uncompressed RAW format). *Lossless* methods do reduce file size but retain all the information in the original image so that the uncompressed version can be reconstituted at any time.

Lossy compression, used in JPEG files and some other formats, takes an additional step and examines an image for redundant information that makes little or no difference visually when the squeezed image is viewed. After you compress an image and some of the image data is discarded, you have no way to restore the original image. If you resave the same image as a JPEG file over and over, you lose some image quality each time.

Digital cameras and image editors that use lossy compression offer options for selecting the amount of compression (and the amount of information lost). You can end up with an image that's virtually indistinguishable from the original (as shown on the left in Figure 18-5) or one that's much smaller but has a noticeable amount of image information missing (as shown on the right in Figure 18-5), as well as every quality level in-between.

Figure 18-5: Lossless compression (left) preserves all the original image information, unlike lossy compression (right), which discards some information to reduce file size.

Moiré

As the old song goes, when a newscaster's tie hits you right in the eye, that's a moiré. If you've ever gotten dizzy watching a personality on the tube who's wearing a checkered neckpiece, you know exactly what moiré is. When two patterns — such as the pattern of the tie and the scanning lines of the television screen — interfere with each other, a maddening new pattern appears.

Moiré can be produced when you take digital photos of subjects that have a regular pattern, which is why virtually all dSLRs have an anti-aliasing filter placed over the sensor. This filter blurs the image slightly, reducing the moiré effect that would otherwise appear because of interference patterns that result under certain conditions when an analog visual image is converted to digital form.

One almost sure way to create moiré is to scan a picture that's already been published, which means that it was printed through a halftone screen. The scanner's own pattern frequently produces the effect.

The best cure for moiré, whether it appears in a digital photo or scanned image, is to blur the image slightly to disguise the interference. The Despeckle filter in Photoshop and Photoshop Elements can often do a decent job. You can sometimes improve scanned images by rescanning with the original at a slight angle to reduce the interference.

Saturation

Take a perfectly good can of red paint, dump in an equal quantity of white, and what do you have? Pink? Well, maybe, But in another sense, what you have is a less-saturated red. *Saturation* is the purity of a color — from a full, rich, vivid hue, progressing down to duller, less-rich colors until you reach gray. When it comes to paint, you can reduce the saturation by adding white, black, or gray paint, or by mixing in the complement of the original hue to dilute the color. With digital cameras and light, changing saturation is a little more complicated.

Defining saturation isn't easy when only the three red, green, and blue (RGB) channels in a digital camera image are available. You might think that an image that has a 100-percent brightness level in, say, the red channel, and a zero brightness level in the green and blue channels would have 100-percent saturation in the red. But if all the channels were equal, the saturation would be zero.

Unfortunately, RGB color does a poor job of providing absolute saturation values as the difference among the color channels. That's because the results aren't linear and can vary, depending on what's defined as the white point in an image. Instead, those who care about such things divide the characteristics of color into a different set of components: hue, saturation, and brightness

(or lightness/luminance), often called HSB or HSL. *Hue* is the absolute color, as seen on the color wheel (shown in Figure 12-14 in Chapter 12). *Saturation* is intensity of the hue, and *brightness* is the amount of light.

You need to understand these distinctions when you're adjusting the degree of saturation provided by the camera settings in your dSLR or modifying the saturation of an image in an image editor. A low degree of saturation produces a low-key, pastel image (as shown on the left in Figure 18-6), whereas exagger-ated saturation creates a garish look (as shown on the far right in the figure).

Figure 18-6: Low saturation (left), normal saturation (middle), and high saturation (right).

Threshold

Thresholds do more than provide a rite-of-passage for newly married couples. In digital imaging, *thresholds* determine how a given pixel is represented in an image. By understanding how thresholds work, you can better understand, for example, why some of your images lack shadow detail or have blown-out highlights.

When you take a photo, the individual photosites in the sensor begin collecting photons the instant the shutter opens. If fewer photons at a given pixel

Part V: The Part of Tens

position are collected than the sensor's threshold, that pixel is represented as black. Thousands of photons might have dropped into the photosite "bucket" while a neighboring photosite might have collected only a few, but unless the sensor's threshold is reached, both of those pixels are black in your finished picture.

After the number of photons captured by a photosite passes the threshold, additional photons gathered allow the pixel to show up as brighter shades of gray, then midtones, and finally white. Any additional photons collected don't register at all unless they happen to spill out of the bucket into adjacent photosites (producing a blooming effect). Increasing the ISO setting effectively lowers the threshold by multiplying the number of pixels actually collected until the sensor can count them. Thresholds are used in many different ways, particularly in image editors when you use a threshold to specify a contrast level that is used to apply, say, unsharp masking to an image.

Tolerance

Tolerance is an image-editing concept that confuses many. It generally refers to the range of both color or tonal values that a particular tool, such as the Magic Wand in Photoshop, selects. (Many people think tolerance involves only brightness, when in fact, color is also factored in.)

Tolerance is usually specified in values from 0 to 255 because that range represents both black-and-white and color brightness values (from 0, which is black, to 255, which is white). Low tolerance settings mean that the tool selects only pixels that are very close in brightness or color value. For example, if you click a pixel that has a value of 220 by using the Magic Wand that has the tolerance set to 10, adjacent pixels that have color or brightness values within 10 of 220 are chosen; a value of 64 would select a much larger set of pixels.

When you make selections in an image editor, set tolerance levels that you determine through experimentation (or experience) are, like Goldilocks's choices, just right. If you use a too-low tolerance, you don't select enough pixels to be useful, whereas a too-high tolerance selects pixels that you really don't want.

Unsharp Masking

The term *unsharp masking* often throws new photographers because the process doesn't make images *less* sharp — it makes them sharper. The confusion comes from unsharp masking's origins as a technique originally used with photographic film.

A darkroom worker would take a sheet of negative film and create a positive image that's slightly blurred. Like any out-of-focus image, the blurred positive spreads out a little. Then, when the worker placed the original negative and positive together in a sandwich, the dark areas of the negative partially cancelled out *(masked)* the equivalent light areas of the reversed positive, except at the edges, where the blurring produced lighter and darker lines on each side of the boundary between those edges. Copying the sandwich produces a new image that emphasizes the edges, enhancing the appearance of sharpness.

Image editors retain the name *unsharp masking* because photographers who were familiar with the process were early users of these programs. However, the Unsharp Mask filters do all their work electronically, searching for pixels that differ in value from their surrounding pixels based on a threshold level that you specify. When pixels differ more sharply from their neighbors, the image editor judges that it has found an edge and thus increases the contrast to make the edge seem sharper.

350 Part V: The Part of Tens _____

.

• Numerics •

.

3D photography, 71

• A •

accessories close-up equipment, 98 for connectivity, 93-97 filters. 83-86 flash unit, 90-92 GPS (Global Positioning System), 96-97 second/spare camera. 97 sensor-cleaning kit. 98 tripod, 86-90 across the frame, subject moving, 191 action photography close up/distant subject, 191 diagonal motion, subject moving in, 191 with flash, 194 manual focus, 119 panning, 191-193 peak action, 193-194 relative speed of subject, 191 shutter lag first-shot delays, minimizing, 186-187 flash delays, minimizing, 188–189 minimizing, 185–186 overview, 182-183 shot-to-shot delays, minimizing, 187-188 sources of, 184 stopping action, 190-191, 319-320 toward the camera, subject moving, 191 add-on battery pack/grip, 189 Adobe Camera Raw, 149, 178 Adobe Photoshop CS5 advantages of, 228-229 Content Aware tools, 228 disadvantages of, 230-231 overview, 226-227 Puppet Warp tool, 228-229

Adobe Photoshop Elements 9.0 advantages of 231-233 disadvantages of, 233 overview, 231 Adorama, 334 advanced amateur/semi-pro dSLR cameras, 63 air blowers, 98 Allway Sync, 81 alternative image editors, 233-234 ambient lighting, 339-340 amp glow, 147 amp noise, 147 angles choosing creative, 303-304 subject flattering, 207 animal photography, 138 anti-aliasing, 38, 340 anti-dust, 71 anti-shake, 72 aperture (f-stop) choosing, 301-302 ND (neutral density) filters, 84 overview, 36, 42-44 Aperture Priority mode, 115-116 Apple Camera Connection Kit, 93 architecture photography composition, 215-217 framing, 217 lighting harsh. 216 mixed. 216 overview. 215 too little light, 216 too much light, 216 uneven, 216 overview. 212 perspective, 212-214 prime lenses, 129 tilting the camera, 213-214 archiving RAW file format, 175

Askey, Phil (Digital Photography Review), 329 atmospheric conditions and telephoto lenses, 140 Auto Color control (Photoshop), 247 Auto tools (Photoshop), 242 automatic focus, 120–122 available lighting, 339–340 axial chromatic aberration, 342

• 3 •

background adding new, 274-276 composition, 204-205 out-of-focus, 134-135 backup media, 78–79 balance in travel photography, 220 balancing lighting, 116 sky and foreground, 84 ball head tripods, 89 barndoors, 296 baroque photography, 323–324 barrel distortion, 214, 258 basic dSLR cameras, 59-61 basic image editing, 306 Bayer, Bryce, 39 Bayer pattern, 39 B&H Photo, 334 Bibble Pro, 178, 180 blooming, 37, 104 blower bulbs, 98 blurring (selective), 238, 254-256 bokeh, 134-135 bracketing, 111, 340-341 bridge (transitional) cameras, 65-66 brightness, 346-347 Brightness/Contrast controls (Photoshop), 242 buffer memory, 48, 187–188 built-in dust removal system, 158 built-in HDR, 71 burning, 343 burst (continuous) shooting mode, 65, 71, 186, 189–190, 300 Busch, David D. eBay Myth Buster, 334

• (•

CA (chromatic aberration), 214, 258, 342 camera shake image stabilization, 149, 153-155 myths about, 150 overview, 149-150 solutions for, 152 testing for, 151-152Canon cameras, 58 image stabilization, 153 lenses, 140 capacity of memory cards, 74, 75-76 Capture One Pro, 178 card reader adapters, 78 catadioptric telephoto lenses, 135 categories of cameras advanced amateur/semi-pro dSLR cameras, 63 basic dSLR cameras, 59-61 bridge (transitional) cameras, 65-66 enthusiast dSLR cameras, 62-63 EVF cameras, 65-66 mirrorless cameras, 65-66 overview, 59 professional dSLR cameras, 63-65 superzoom cameras, 65-66 CCD (charge-coupled device), 38, 69 CD/DVD burners, 78 center of interest, 203 center weighted metering, 110 changing environments, resolution in, 298 chromatic aberration (CA), 214, 258, 342 chrominance, 166 circular polarizers, 85 cleaning sensors, 25 Clone Stamp tool (Photoshop), 251-252 close-up equipment, 98 close-up images action photography, 191 flash photography, 188 close-up (macro) photography manual focus, 119 prime lenses, 130 telephoto lenses, 138 cloud storage, disadvantages of, 81

CMOS (complementary metal-oxide semiconductor), 38, 69 Cokin, 86 Color Balance sliders (Photoshop), 247 color correction, 238, 247-249 CompactFlash (CF) memory card, 48, 74, 75 Composer/Composer Pro (Lensbaby), 141 (compositing) combining photographs, 276-282, 306 composition architecture photography, 215-217 background, 204-205 center of interest, 203 horizontal, 203-204 intent, knowing your, 203-205 landscape photography, 217–219 message, knowing your, 203-205 overview, 202-203 point-and-shoot cameras and dSLRs compared, 201-202 portrait photography, 206-209 publicity and public relations (PR) photography, 210-211 Rule of Thirds, 205–206 subject, distance and angle to your, 204 subject arrangement, 204 travel photography, 219-221 vertical, 203-204 viewfinder, with a more accurate, 11-12 compression, 138 computer correcting images without, 28 resolution for computer work, 300 connectivity iPad apps, 93 smart phone apps, 93 tablet apps, 93 uploading through smart phone, 96 through tablet, 96 to web, 95 to your computer, 94 Wi-Fi transmission, 93-96 Content Aware tools (Adobe Photoshop CS5), 228 continuous autofocus, 121

continuous shooting mode, 65, 71, 186, 189–190, 300 contrast detection, 46 Control Freak (Lensbaby), 142 cookies, 296 Corel Painter 12, 234 Corel PaintShop Photo Pro X3, 234 Corel Photo-Paint X5, 233 crop factor, 52–54, 133–134 Crop tool (Photoshop), 241 cropping, 32, 237, 238–241 Curves dialog box (Photoshop), 242, 246, 248

• () •

DCT (Discrete Cosine Transformation), 166 defects, in portrait photography use diffuse lighting to diminish, 208 defocus control, 133 demosaicing, 39 depth-of-field control. 16-17 creative application of, 302-303 increasing, 136 overview, 47 preview, 12 telephoto lenses, 139 Despeckle filter (Photoshop), 251 diagonal motion, subject moving in, 191 diamonds, grouping people in, 209 digital negatives, RAW file format as, 173 - 180Digital Photo Professional, 176-177 Digital Photography Review, 68, 329-331 digital single lens reflex (dSLR) accessories close-up equipment, 98 for connectivity, 93-97 filters, 83-86 flash unit, 90-92 GPS (Global Positioning System), 96-97 second/spare camera, 97 sensor-cleaning kit, 98 tripod, 86-90

354

digital single lens reflex (continued) components of aperture, 36 dual memory cards, 50-51 exposure, 42-44 lenses, 35, 47 light-sensitive component, 36 Live View, 44-47 medium for storing captured image, 36 overview, 35-36 sensors, 37-41 shutter, 36 storing images, 47-49 viewfinder, 44-47 viewing system, 35 features, 8-9 improvements in cleaning, 25 in-camera editing, 28 Live View preview, 25–27 overview, 1-2 superwide lenses, 23-24 video, 28 weight, 27 improving your photography with composing your shots with a more accurate viewfinder, 11-12 depth-of-field control, 16-17 ease of use, 20-21 image editors, freedom from, 22-23 lens flexibility, 21-22 noise reduction, 14-16 overview, 10-11 sensors, 12-14 speed, 17-20 quirks of crop factor, 52-54 sensor cleaning, 51–52 selecting categories of cameras, 59-66 key features, 67-72 overview, 55-57 upgrade potential, 57–58 direction, have everyone look in same, 209 Discrete Cosine Transformation (DCT), 166 distant subject, photographing, 191 dodging, 343 do-it-yourself image printing, 286

downsampling, 34 DPReview, 68, 329-331 Drobos, 81 dropping pixels, 34 dSLR. See digital single lens reflex dual memory cards capacity, 77 fast card/slow card, using, 77 identical cards, using, 77 older cards, recycling, 77 overview, 50-51, 76-77 duplex printing, 292 Dust & Scratches filter (Photoshop), 251 DVD burners, 78 DxO Labs, 342 dynamic focus area, 121 dynamic range, 68, 105, 241

• E •

ease of use, 20-21 eBay, 334-337 eBay Myth Buster (Busch), 334 Edgerton, Harold (professor), 194 editing in-camera computer, correcting images without, 28 Internet distribution, lower-resolution version of image for, 28 overview, 28 special effects, applying, 28 TIFF (Tagged Image File Format) file format, 169 electronic viewfinders (EVF), 11-12 enlarging images, 32 enthusiast dSLR cameras, 62-63 EOS Utility, 176 EVF cameras, 65-66 existing lighting, 339–340 exposure histograms, 106-108 metering system center weighting, 110 choosing, 109-110 how it works, 109 multipoint/evaluative/matrix metering, 110 options, 111-112

overview, 109 spot metering, 110 modes Aperture Priority, 115–116 choosing, 112-118 Manual Exposure, 116–117 overview, 112-113 Program, 113-114 Scene, 114 Shutter Priority, 115–116 overview, 42-44, 104-105 shutter speeds, 42 simple method for adjusting, 112-113 systems, 69, 198 exposure time, 42 extension tubes, 98-99 external hard drives, 78-79 Eye-Fi, 93-96 eyeglasses, avoiding reflections off, 208 eye-points, 26

• F •

Facebook, 326-327 fast lens for night photography, 146 fast shutter speed, 319-320 feathered edges, 261 file formats choosing, 168-173 JPEG (Joint Photographic Experts Group) lossy compression, 166–167 memory, 171-172 overview, 166-168 post-processing, 170 quality, 170 software compatibility, 170 web display, 170 when to use, 170-172 JPEG + RAW, 172 overview, 161-164 PixelPaint, 164 proprietary, 164 RAW archiving, 175 as digital negatives, 173-180 image-editing applications for, 175-180 overview, 168, 172 salvaging images from, 173-174 when to use, 173

TIFF (Tagged Image File Format) editing, 169 file size, 165 lossless compression, 165 memory, 169 overview, 164-165 post-processing, 169 quality, 169 when to use, 169 Fill Flash, 343-344 filters creating, 320-321 Despeckle, 251 Dust & Scratches, 251 infrared, 85 Lens Correction, 214, 258, 342 ND (neutral density), 84, 86 overview, 83-84 polarizing, 85 Reduce Noise, 149, 250 special effects, 86, 320-321 upgrade potential, 58 fireworks photography, 321-323 fixes and repairs blurring (selective), 238, 254-256 color correction, 238, 247-249 cropping, 237, 238-241 overview, 237-238 sharpening, 238, 254 spot removal, 238, 249-253 tonal adjustments, 238, 241-246 flare, 140 flash memory, 48 flash photography for action, 194 add-on battery pack/grip, using, 189 close-up images, 188 disadvantages of, 196 exposure system, 198 front-curtain sync, 197 high-speed sync, 198 inverse-square law, 195-196 overview, 195-196 rear-curtain sync, 197 reducing flash power, 188 setting off external flash, 199-200 shutter lag, 188-189 slave device used for setting off external flash, 199

flash photography (continued) slow-sync, 198 syncing with shutter, 196-198 using, 188-189 wireless trigger used for setting off external flash, 199 flash sync speed, 196–198 flash unit communication with camera by, 90 hardwired, 92 hot-shoe, 92 monolights, 91 overview, 90 PC (Prontor-Compur) connection, 92 slave unit, 91 speedlight, 90 for sports photography, 91 studio, 91 telephoto lenses, 139 triggering, 91-92 types of, 90-91 wide-angle lenses and, 138 wireless mode, 91-92 fluid head tripods, 89 focal length, 47 focal length range, 68 focal plane shutter, 197 focus automatic, 120-122 continuous autofocus, 121 deep, 136 locking out focus ranges, 121 manual, 119-120, 186 overview, 118, 186 selective, 118 single autofocus, 122 zones, 186 focus assist lamp, 121 focus control portrait lenses, 132 focusing systems, 69–70 foreground distorting, 136 emphasizing, 136 form factor, 74 Foveon sensors, 40 frame rates, 145 frame, having subject look into, 207 free image editors/albums, 234

350

front-curtain sync, 197 f-stop choosing, 301–302 ND (neutral density) filters, 84 overview, 36, 42–44 Full HD video, 145 full-frame cameras, 10

• G •

Galbraith, Rob (photographer), 75, 333–334 gobos, 296 Gorillapod, 88 GPS (Global Positioning System), 96–97 GraphicConverter, 178 groups, photographing, 208–209

• H •

hard drives, 79-81 hardwired flash unit, 92 harsh lighting, 216 HDMI connector, 146 HDR (high dynamic range) photography built-in HDR, 71 tripods used for, 87-88 Healing Brush (Photoshop), 252 high contrast, 241 high ISO settings causing noise, 14–15 highest JPEG setting, resolution at, 299 highest RAW setting, resolution at, 299 high-speed sync, 198 histogram, 25-26, 244 horizontal composition, 203–204 horizontal lines skewed, avoiding, 136 hot mirror, 157 hot-shoe flash unit, 92 hue, 346-347 Hue/Saturation control (Photoshop), 247 - 248hyperfocal distance, 344

•]•

image editing with Adobe Photoshop CS5 advantages of, 228–229 Content Aware tools, 228

_ Index

disadvantages of, 230-231 overview, 226-227 Puppet Warp tool, 228-229 with Adobe Photoshop Elements 9.0 advantages of, 231-233 disadvantages of, 233 overview, 231 alternative image editors, 233-234 background, adding new, 274–276 basic, 306 choosing an image editor, 226–235 (compositing) combining photographs, 276-282, 306 Corel Painter 12, 234 Corel PaintShop Photo Pro X3, 234 Corel Photo-Paint X5, 233 with filters. 256-258 fixes and repairs blurring (selective), 238, 254-256 color correction, 238, 247-249 cropping, 237, 238-241 overview, 237-238 sharpening, 238, 254 spot removal, 238, 249-253 tonal adjustments, 238, 241-246 free image editors/albums, 234 freedom from image editors, 22-23 JPEG (Joint Photographic Experts Group) file format, 170 manipulation of images with image editors, 306 overview, 225 Photoshop.com, 234 RAW file format, 175-180 removing people from images, 270-271 retouching, 306 selections changing, 261 converting, 262 copying, 261 cutting, 261 filling, 261 with Lasso tool, 264 with Magic Wand tool, 265-267 with Marquee tool, 262-263 masking, 261 modifying, 269-270 overview, 260-261

painting, 261, 267-268 pixels, selecting, 265–267 saving, 262 selecting shapes, 262-264 transforming, 262 separated subjects, bringing together, 271 - 273special effects with, 324 TIFF (Tagged Image File Format) file format, 169 Windows Live Photo Gallery 2011, 234 workflow, 235-237 image processors, 68–69 image stabilization, 39, 149, 153-155 improvements in digital single lens reflex (dSLR) cleaning, 25 in-camera editing, 28 Live View preview, 25–27 overview, 1-2 superwide lenses, 23-24 video, 28 weight, 27 improving your photography angles, choosing creative, 303-304 depth-of-field, creative application of, 302-303 with digital single lens reflex (dSLR) composing your shots with a more accurate viewfinder, 11-12 depth-of-field control, 16-17 ease of use, 20-21 image editors, freedom from, 22-23 lens flexibility, 21-22 noise reduction, 14-16 overview, 10-11 sensors, 12-14 speed, 17-20 f-stop, choosing, 301-302 image editors, manipulation of images with, 306 lenses, utilizing capabilities of your, 304 - 305with lighting techniques, 295–297 manual, reading your, 307-308 noise, enhancing, 305-306 resolution, choosing, 297-300 shutter speed, choosing, 300-301

in-camera editing computer, correcting images without, 28 Internet distribution, lower-resolution version of image for, 28 overview. 28 special effects, applying, 28 individual portraits, 207-208 indoor sports photography, 129 infrared cutoff filter. 39 infrared filters, 85 infrared (IR) photography, 157-158, 309 - 311inks for printing, 290 input/output travs for printers, 292 Internet distribution, lower-resolution version of image for. 28 interpolate, 39 inverse-square law, 195-196 iPad apps, 93 IrfanView, 178 ISO (International Organization for Standardization) described, 14 settings new normal for, 117-118 for night photography, 147 isolation, 138

• 7 •

joystick head tripods, 89 JPEG + RAW, 172 JPEG (Joint Photographic Experts Group) file format highest JPEG setting, resolution at, 299 lossy compression, 166-167 memory, 171-172 overview, 166-168 post-processing, 170 quality, 170 second-best JPEG setting, resolution at, 299 software compatibility, 170 web display, 170 when to use, 170-172 judder, 145

• K •

KEH (website), 334
kiosk/professional lab option for printing images, 288
Kodak Gallery, 287
Kurosawa, Akira (film director), 136, 202

• [•

landscape photography composition, 217-219 manual focus for, 219 overview. 217-219 prime lenses, 130 Rule of Thirds, 218 sunrises, 219 sunsets, 219 tripods, using, 218 vertical orientation for, 219 Lasso tool (Photoshop), 264 lateral chromatic aberration, 342 LCD preview eye-points, extended, 26 histograms, 25-26 infrared imagery, 27 Lens Correction filter (Photoshop), 214, 258, 342 Lensbaby, 141-142 lenses bokeh, 134-135 Canon. 140 catadioptric telephoto, 135 compatibility with earlier cameras, 140 - 141concepts, 133-135 creative use of telephoto lenses, 138-140 wide-angle lenses, 136-138 flexibility, 21-22 focal length range, 68 focus control portrait, 132 for low light, 124 macro, 128, 131, 132 mid-range, 131 Minolta/Konica Minolta/Sony Alpha, 140 mirror telephoto, 135

Nikon, 140 Olympus, 141 optical image stabilization, 132 overview, 8-9, 35, 47 Pentax, 141 perspective control, 132 prime, 47, 128-130 quality of, 67 sensors, relationship with, 133-134 for sharpness, 125 short-tele to telephoto, 131 and shutter speed. 124 special, 132-133 special effects, 141-142 special features, 68 switching between, 8-9 telephoto, 127, 131, 138-140 tilt-shift, 68 utilizing capabilities of your, 304-305 UV (ultraviolet), 133 wide-angle, 125-126, 131, 136-138 zoom, 47, 128, 130-131 Levels dialog box (Photoshop), 242.244-246 lighting ambient, 339-340 architecture photography harsh lighting, 216 mixed lighting, 216 overview, 215 too little light, 216 too much light, 216 uneven lighting, 216 available, 339-340 existing, 339-340 small objects, lighting for shooting, 312 techniques for improving your photography, 295-297 linear polarizers, 85 Live View LCD preview eye-points, extended, 26 histograms, 25-26 infrared imagery, 27 overview, 25-27, 44-47 viewfinder compared, 45-47 locking out focus ranges, 121 long exposures causing noise, 16 longitudinal chromatic aberration, 342

long-term storage of images, 79–81 lossless compression, 165, 344–345 lossy compression, 166–167, 344–345 low contrast, 241 low light, lenses for, 124 lower resolution, shooting in, 188 low-resolution destination, shooting for a, 299–300 luminance, 166 Luminous Landscape, 332–333

• M •

macro lenses, 128, 131, 132 macro (close-up) photography manual focus, 119 prime lenses, 130 telephoto lenses, 138 Magic Wand tool (Photoshop), 265-267 magnification factor, 23 manual, reading your, 307-308 Manual Exposure mode, 116-117 manual focus, 119-120, 186, 219 marching ants, 260 Marquee tool (Photoshop), 262-263 medium for storing captured image, 36 megapixels (MP), 10, 31. See also pixels memory buffer, 48, 187-188 JPEG (Joint Photographic Experts Group) file format. 171-172 TIFF (Tagged Image File Format) file format. 169 memory cards capacity, 74, 75-76 CompactFlash (CF), 48, 74, 75 dual capacity, 77 fast card/slow card, using, 77 identical cards, using, 77 older cards, recycling, 77 overview, 50-51, 76-77 form factor, 74 limited memory card space, resolution with, 298-299 overview, 48-49, 73-74 printer access, 291 Secure Digital (SD), 48-49, 74, 75

memory cards (continued) Secure Digital Extended Capacity (SDXC). 48 - 49Secure Digital High Capacity (SDHC), 48 - 49upgrading, 188 write speed. 74-75 mergers, 220 Micro Four Thirds, 66 mid-range lenses, 131 Minolta/Konica Minolta/Sony Alpha lenses, 140 Miranda, Fred (photographer), 334 mirror telephoto lenses, 135 mirrorless cameras, 65-66 mixed lighting, 216 moiré, 346 monolights, 91 monopods, 88 movie camera feature overview, 9, 72 video advantages of, 145 frame rates, 145 Full HD, 145 judder, 145 overview, 28, 144-146 playback, 146 resolution, 145 Standard HD, 145 moving objects, 84 multipoint/evaluative/matrix metering, 110 Muse (Lensbaby), 141 myths about camera shake, 150

• / •

ND (neutral density) filters, 84, 86 Neat Image, 148 night photography fast lens for, 146 ISO settings for, 147 shutter speed for, 147 tripod for, 146 Nikon cameras, 58 Capture NX 2, 175–176 image stabilization, 153 lenses, 140 noise enhancing, 305–306 generated by sensors, 68 high ISO settings causing, 14–15 long exposures causing, 16 overview, 14–16 reducing, 148–149, 249–250 sensors, 40–41 sources for, 147–148 Noise Ninja, 148 non-anti-aliased edges, 261 non-compatible flash, 116

• () •

Obermeier, Barbara Photoshop CS5 All-in-One For Dummies, 231, 246, 306 Olympus image stabilization, 153 lenses, 141 online options for printing images, 287 online resources Digital Photography Review, 329-331 eBay, 334-337 Facebook, 326–327 Fred Miranda (website), 334 Luminous Landscape, 332–333 PBase, 328-329 Photoshop.com, 327 PopPhoto, 332 Rob Galbraith (website), 333-334 Shutterbug, 331-332 SmugMug, 329 Optic Swap system (Lensbaby), 142 optical image stabilization, 132 outdoor sports photography, 129–130 out-of-focus backgrounds, 134-135 overexposed images, 107

• p •

panning, 191–193 panorama, tripods for, 87 pan/tilt head tripods, 89 Patch tool (Photoshop), 252 patterns, arranging subjects into interesting, 209 PBase, 328–329

PC (Prontor-Compur) connection, 92 peak action, 193-194 Pentax cameras, 58 lenses, 141 Pentax/Samsung image stabilization, 153 personal storage device (PSD), 78 perspective and architecture photography, 212-214 perspective control lenses, 132 perspective distortion, 213-214 phase detection, 46 photons, 14, 37 Photoshop CS5 All-in-One For Dummies (Obermeier), 231, 246, 306 Photoshop.com, 234, 327 photosites, 31, 37, 104, 133-134, 347-348 PictBridge compatibility, 291 pincushion distortion, 214, 258 pinhole camera, 313-314 PixelPaint, 164 pixels adding, 33 cropping images, 32 density, 134 dropping, 34 enlarging images, 32 manipulating images, 32 number needed, 32 overview, 29-31 print sizes and printers, 33-34 printer resolution, 32 resolution, 31-32 superfluous, 34-35 playback for video, 146 Pocket Wizard, 91 point-and-shoot cameras and dSLRs compared, 201-202 polarizing filters, 85 PopPhoto, 332 portrait photography angle that flatters subject, using, 207 composition, 206-209 defects, use diffuse lighting to diminish, 208 diamonds, grouping people in, 209 direction, have everyone look in same, 209 eyeglasses, avoiding reflections off, 208 into frame, having subject look, 207 groups, 208-209

individual portraits, 207-208 overview, 206-207 patterns, arranging subjects into interesting, 209 prime lenses, 130 problem areas, de-emphasizing, 207–208 relaxed and comfortable, making sure your subject is, 207 triangles, grouping people in, 209 positioning with tripod, 87 post processing (image editing) with Adobe Photoshop CS5 advantages of, 228-229 Content Aware tools, 228 disadvantages of, 230-231 overview, 226-227 Puppet Warp tool, 228–229 with Adobe Photoshop Elements 9.0 advantages of, 231-233 disadvantages of, 233 overview, 231 alternative image editors, 233-234 background, adding new, 274-276 basic, 306 choosing an image editor, 226-235 (compositing) combining photographs, 276-282, 306 Corel Painter 12, 234 Corel PaintShop Photo Pro X3, 234 Corel Photo-Paint X5, 233 with filters, 256-258 fixes and repairs blurring (selective), 238, 254-256 color correction, 238, 247-249 cropping, 237, 238-241 overview, 237-238 sharpening, 238, 254 spot removal, 238, 249-253 tonal adjustments, 238, 241-246 free image editors/albums, 234 freedom from image editors, 22-23 JPEG (Joint Photographic Experts Group) file format, 170 manipulation of images with image editors, 306 overview, 225 Photoshop.com, 234 RAW file format, 175–180

post processing (image editing) (continued) removing people from images, 270-271 retouching, 306 selections changing, 261 converting, 262 copying, 261 cutting, 261 filling, 261 with Lasso tool, 264 with Magic Wand tool, 265-267 with Marguee tool, 262–263 masking, 261 modifying, 269-270 overview, 260-261 painting, 261, 267-268 pixels, selecting, 265-267 saving, 262 selecting shapes, 262-264 transforming, 262 separated subjects, bringing together, 271-273 special effects with, 324 TIFF (Tagged Image File Format) file format. 169 Windows Live Photo Gallery 2011, 234 workflow. 235-237 prime lenses, 47, 128–130 printers choosing, 288-292 duplex printing, 292 inks, number of, 290 input/output trays, 292 memory card access, 291 overview, 289 paper handling, 291 PictBridge compatibility, 291 print sizes and, 33-34 resolution, 32, 291 size and design, 290 speed, 290 printing images do-it-yourself, 286 duplex printing, 292 kiosk/professional lab option, 288 online options, 287 options for, 285-288 reasons for, 284-285 professional dSLR cameras, 63-65

362

professional lab option for printing images, 288 Program mode, 113–114 proportions, watching, 137 proprietary file format, 164 PSD (personal storage device), 78 publicity and public relations (PR) photography, 210–211 Puppet Warp tool (Adobe Photoshop CS5), 228–229

• () •

quality
JPEG (Joint Photographic Experts Group)
file format, 170
of lenses, 67
quick-release plates, 90

• R •

Radio Popper, 91 RAW file format archiving, 175 as digital negatives, 173-180 highest RAW setting, resolution at, 299 image-editing applications Adobe Camera Raw, 178 Bibble Pro, 178, 180 Capture One Pro, 178 Digital Photo Professional, 176–177 EOS Utility, 176 GraphicConverter, 178 IrfanView. 178 Nikon Capture NX 2, 175-176 overview, 175 third-party applications, 177–180 overview, 168, 172 salvaging images from, 173-174 when to use, 173 rear-curtain sync, 197 Reduce Noise filters, 149, 250 reducing flash power, 188 reducing noise, 148-149 Refine Edge (Photoshop), 269–270 reflex viewing, 123 relative speed of subject, 191 relaxed and comfortable, making sure your subject is, 207

removing people from images, 270-271 repairs and fixes blurring (selective), 238, 254-256 color correction, 238, 247-249 cropping, 237, 238-241 overview, 237-238 sharpening, 238, 254 spot removal, 238, 249-253 tonal adjustments, 238, 241-246 resolution in changing environments, 298 choosing, 297-300 for computer work, 300 for continuous shooting mode, 300 at highest JPEG setting, 299 at highest RAW setting, 299 with limited memory card space, 298-299 lower resolution, shooting in, 188 low-resolution destination, shooting for a, 299-300 overview, 10 and pixels, 31-32 and printers, 291 at second-best JPEG setting, 299 for transferring photos, 300 and video, 145 retouching, 306 Rob Galbraith (website), 333-334 Rule of Thirds landscape photography, 218 overview, 205-206

• 5 •

Safe-Sync, 200 salvaging images from RAW file format, 173–174 saturation, 346–347 Scene mode, 114 Scout (Lensbaby), 142 second-best JPEG setting, resolution at, 299 second/spare camera, 97 Secure Digital Extended Capacity (SDXC) memory card, 48–49 Secure Digital High Capacity (SDHC) memory card, 48–49 Secure Digital (SD) memory card, 48–49, 74, 75 selections border, 260 changing, 261 converting, 262 copying, 261 cutting, 261 filling, 261 with Lasso tool. 264 with Magic Wand tool, 265-267 with Marquee tool, 262-263 masking, 261 modifying, 269-270 overview, 260-261 painting, 261, 267-268 pixels, selecting, 265-267 saving, 262 selecting shapes, 262-264 transforming, 262 selective blurring, 238, 254-256 selective focus, 118 sensor-cleaning kit, 98 sensors CCD (charge coupled device), 38, 69 cleaning, 51-52 CMOS (complementary metal-oxide semiconductor), 38, 69 components of, 38-40 dynamic range of, 68, 105 Foveon. 40 lenses, relationship with, 133–134 noise generated by, 40-41, 68 overview, 12-14, 37-41 professional dSLR cameras, 65 sensitivity, 40-41 types of, 38 separated subjects, bringing together, 271 - 273sequence photography, 189–190 Seurat, Georges (artist), 30 Shadow/Highlight controls (Photoshop), 242 - 244sharpening, 238, 254 sharpness, lenses for, 125 short-tele to telephoto lenses, 131 shot-to-shot time, 19 shutter lag first-shot delays, minimizing, 186–187 flash delays, minimizing, 188–189

shutter (continued) flash photography, 188-189 minimizing, 185-186 overview, 19-20, 182-183 point-and-shoot cameras compared to dSLRs, 182-183 shot-to-shot delays, minimizing, 187-188 sources of, 184 overview, 36 speed choosing, 300-301 fast, 319-320 and lenses, 124 ND (neutral density) filters, 84 for night photography, 147 overview, 42 slow, 136, 317-318 telephoto lenses, 139 Shutter Priority mode, 115-116 shutter release, responsiveness of, 8 Shutterbug, 331-332 Shutterfly, 287 Shuttersnitch, 96 simple method for adjusting exposure, 112 - 113single autofocus, 122 single lens reflex (SLR), 7 slave device, 91, 199 slow shutter speed, 317-318 slow-sync, 198 small objects, lighting for shooting, 312 smart phone apps, 93 SmugMug, 329 Snap-Art 2 (Alien Skin), 256-257 Snapfish, 287 solutions for camera shake, 152 Sony image stabilization, 153 spare camera, 97 special effects filters, 86, 320-321 with image editing, 28, 324 lenses and, 141-142 Manual Exposure mode, 116 special features anti-dust, 71 anti-shake, 72 built-in HDR, 71

burst modes, 71 lenses, 68 movie-shooting, 72 overview, 70-72 sweep panorama, 71 3D photography, 71 Wi-Fi, 71 special lenses, 132-133 speed overview, 17 printers, 290 shot-to-shot time, 19 shutter lag, 19-20 wake-up time, 17-19 speedlight, 90 sports photography, 138 Spot Healing Brush (Photoshop), 253 spot metering, 110 spot removal with Clone Stamp tool, 251-252 with Despeckle filter, 251 with Dust & Scratches filter, 251 with Healing Brush, 252 methods for, 251 noise, reducing, 249-250 overview, 238 with Patch tool, 252 with Spot Healing Brush, 253 stand, tripod used as camera, 87 Standard HD video, 145 steady, tripod used for holding camera, 87 stopping action, 190-191, 319-320 storing images backup media for, 78-79 cloud storage, disadvantages of, 81 long-term, 79-81 options for, 78-79 overview, 47-49, 77 RAID (Redundant Array of Inexpensive Disks) setup for, 81 strobes, 194 studio flash unit, 91 subject, distance and angle to your, 204 subject arrangement, 204 sunrises, 219 sunsets. 219 superfluous pixels, 34-35

supervide lenses, 23–24 superzoom cameras electronic viewfinders, 11–12 overview, 65–66 sweep panorama, 71 switching between lenses, 8–9

• 7 •

tablet apps, 93 telephoto lenses creative use of, 138-140 crop factor, 52 overview, 127, 131 testing for camera shake, 151-152 third-party applications for RAW imageediting, 177-180 3D photography, 71 threshold, 37, 347-348 through-the-lens (TTL) metering, 198 TIFF (Tagged Image File Format) editing, 169 file size, 165 lossless compression, 165 memory, 169 overview, 164-165 post-processing, 169 quality, 169 when to use, 169 tilting the camera for architecture photography, 213–214 tilt-shift lenses, 68 time exposure, 42 time-lapse photography, 156-157, 315-317 tolerance, 348 tonal adjustments Auto tools (Photoshop), 242 **Brightness/Contrast controls** (Photoshop), 242 Curves dialog box (Photoshop), 242, 246 Levels dialog box (Photoshop), 242, 244-246 overview, 238, 241-242 Shadow/Highlight controls (Photoshop), 242 - 244tools for, 242-246 toward the camera, subject moving, 191 transferring photos, 300 transitional cameras, 65-66

travel photography balance in, 220 composition, 219-221 mergers, avoiding, 220 overview, 219-221 unexpected images, 220 triangles, grouping people in, 209 triggering flash unit, 91–92 tripods ball head, 89 choosing, 88-90 disadvantage of, 88 features of. 88-90 fluid head, 89 joystick head, 89 landscape photography, 218 for night photography, 146 overview, 86-87 pan/tilt head, 89 quick-release plates, 90 uses for, 87-88 TrueImage Home, 81 TTL (through-the-lens) metering, 198 twin-lens reflex, 123

• 11 •

underexposed images, 108 uneven lighting, 216 unexpected images, 220 unique angle, shooting from, 136 unsharp masking, 348–349 upgrade potential, 57–58 upgrading memory card, 188 uploading images through smart phone, 96 through tablet, 96 to web, 95 to your computer, 94 upsampling, 33 UV (ultraviolet) lenses, 133

• 1 •

Variations dialog box (Photoshop), 248 vendor support for older model cameras, 58 vertical composition, 203–204 vertical lines skewed, avoiding, 136

vertical orientation for landscape photography, 219 video advantages of, 145 frame rates. 145 Full HD, 145 judder, 145 overview, 28, 144-146 playback, 146 resolution, 145 Standard HD, 145 viewfinder electronic viewfinders (EVF), 11-12 Live View compared, 45-47 overview, 8, 44-47 viewing system, 35 vignetting, 138 visual noise enhancing, 305-306 generated by sensors, 68 high ISO settings causing, 14–15 long exposures causing, 16 overview, 14-16

366

reducing, 148–149, 249–250 sensors, 40–41 sources for, 147–148

• UV •

wake-up time, 17–19 web display, 170 weight of camera, 27 wide-angle lenses creative use of, 136–138 crop factor, 53 overview, 125–126, 131 Wi-Fi transmission, 93–96 Windows Live Photo Gallery 2011, 234 wireless flash unit, 91–92, 199 workflow, 235–237 write speed, 74–75

• Z •

zoom lenses, 47, 128, 130-131